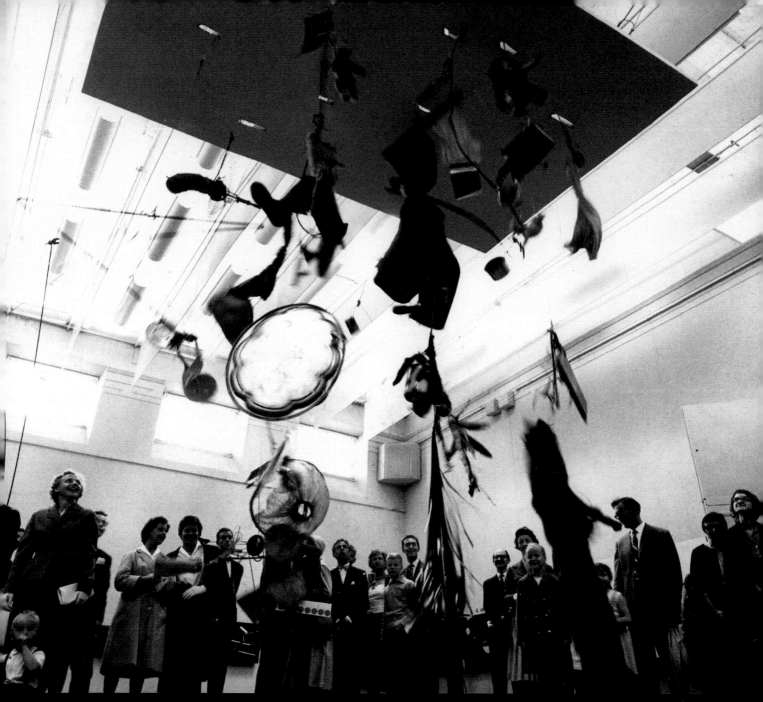

Jean Tinguely *Le Ballet des Pauvres* (Ballet of the Poor), 1961 Photo Lennart Olson

Cover image: George Vantongerloo *Cocon, chrysalide, embryonnaire* (Cocoon, chrysalid, embryonic), 1950.
Collection of Chantal + Jakob Bill
Back cover image: Gego *Chorro* (Stream), 1971. Foto: Paolo Gasparini

This exhibition proposes a new reading of art produced between, approximately, 1920 and the 1970s. It reflects a continuing concern with art as a possible model of the universe, and takes as its thematic key the early mobiles of Alexander Calder and the work of Georges Vantongerloo after 1945. Without overstepping the parameters of the 'abstract' or the 'non-representational', the show traces certain solid if not immediately visible lines of evolution in the art of the 20th-century, in which art is considered as a process of speculation on flux and the void, as a series of metaphors of space and time, as affording new ways of understanding the body in space and space in the body.

In seeking to define its central concept and its field of interest, this exhibition engages in a continual serial exchange between the macrocosm and the microcosm, between the physical and the biological, between universe and mind, between what is outside and what is inside. The pursuit of these interests on the part of the artists is revealed as a genuinely global movement, made up of contributions from artists from very different origins.

The exhibition also sets out to re-assess certain aspects of the kinetic art of the 1960s, a tendency all too frequently ignored or trivialized in the history of art. We felt there was a need for a new presentation of many of these works, above all for the younger generations, who have had no first-hand experience of the language of movement. At the same time, the exhibition establishes new and revealing connections between groups of works conventionally seen by art history as being at opposite poles, or even mutually antagonistic, such as the 'concrete' and 'informal' tendencies of the late fifties.

Among the artists represented here are such classic figures as Pol Bury, Alexander Calder, Marcel Duchamp, László Moholy-Nagy, Piero Manzoni, Dieter Roth, Takis, Jean Tinguely and Georges Vantongerloo. There is also an important Latin American presence, with works by artists such as Sérgio Camargo, Lygia Clark, Gego, Julio Le Parc, Hélio Oiticica, Jesús Rafael Soto and Mira Schendel. Drawing receives particular attention with works by Sol LeWitt, Wols, Henri Michaux, Gordon Matta-Clark and Lucio Fontana, among others.

It goes without saying that the exhibition makes no claim to be exhaustive, and the list of names could easily have been extended in various directions. We are dealing here not with a history of kinetic art, but with something more like an essay, in which we are confronted with works that would perhaps find no place in the existing 'official' genealogy. As on so many occasions in the course of history, concepts that might at a given moment have been extremely radical end up being 'naturalized' by a system which transforms into mere signification what was originally of a structural character. The profile of the kinetic is absolutely open. This being so, the present show has sought to emphasize that aspect of openness, of non-closure, that sets itself in opposition to those historicist and idealist paradigms in terms of which modern art has been defined (this applies especially abstract art, which from Kandinsky on has frequently expressed itself in terms of a reference to mind, the universal and the transcendental). The kinetic, as it is presented here, seeks to centre our attention not so much on the aesthetic plenitude of the work, but on its lack; that is to say, not on the Utopian premises of abstraction, but on its aporias. In this way the show attempts to trace a discourse that does not follow the established canon, but chooses instead to explore relationships which deviate from it and which generate tensions between the formal vocabulary and rhetoric of an epoch and the meanings put forward by individual artists. **MANUEL J. BORJA-VILLEL** Director, Museu d'Art Contemporani de Barcelona

GUY BRETT **The Century of Kinesthesia**

Would anyone today dare put on an exhibition without any interpretive text or didactic material? It is hard to imagine, and indeed my question is bound to sound rhetorical and even vain at the beginning of what is clearly going to be an interpretive essay. Nevertheless, *Force Fields*, which this publication accompanies, would like to be such an exhibition. It would like to invite the visitor to use it primarily as a device of sensitisation. It would like to concern itself deeply with the visual aspect of our nature. As you walk through the rooms you can pass from experiences which alter or destabilise the body's experience of space to ones that draw in the eye to examine the minutiae of visual marks; you can pass from silent phenomena to ones that combine sound with light and movement; you can compare material and scale between a large electro-magnetic machine and a tiny etching; you can see works that proceed from the ultra-rational application of a system and others that seem to be the product of an uncontrolled spontaneity, with many stages apparently in between. Of course all these works have been brought together for a purpose, but that purpose should emerge through the concrete experience of their diversity. It is not a survey but an essay, which takes two bodies of work – Vantongerloo's late paintings and constructions and Calder's earliest mobiles, both insufficiently appreciated in their audacity and vision I believe as *leitmotifs*. Here the phenomenon of the visual is immersed in the phenomenon of energy.

In particular this exhibition should sensitise the viewer to the existence of a 'language of movement', which surely remains one of 20th-century art's great unknowns. In the normal run of things it is hard for a contemporary audience to become aware of the physiognomy and poetics of this language for a number of reasons. For one thing, there is very little kinetic art on show in museums. Museums, on the whole, have not cared to meet the challenge of this sort of work – which is only partly a technical and conservational challenge. And it is obviously only a static image which survives in photographic reproduction, still the normal form of information dissemination in art books, catalogues and magazines. To this impoverished visibility must be added the tendency to treat the historical phenomenon known as Kinetic Art as a kind of side-show, or entertainment, in 20th-century art, not to be treated with the same high seriousness as, say, Minimal Art, Conceptual Art, or for that matter Pop Art. True, much of the work produced was pedestrian and boring, but that is true of any movement, and the result has been that the radical implications of the best work for the evolution of art have been ignored.

Again, this begins and ends very much as a matter of sensitisation. The static image in which a kinetic work survives may be the very antithesis of its nature. As a revealing example of what comes into existence with movement, of the transformation when movement begins, one could take works which come from opposite ends of the kinetic spectrum: a Von Graevenitz motorised relief – so systematic, repetitive and formal – and a Tinguely *Baluba*, in Pontus Hulten's words, "the wildest and most extravagant works Tinguely ever produced".

"At rest", Hulten goes on, "[the *Balubas*] are rather disappointing – a few feathers, some scraps of cloth, pieces of iron – so the electric motor plays a decisive role ... the melancholy engendered by the assorted junk is transformed into gaiety as it suddenly springs into life."[1] While the motor in the *Baluba* is hilariously visible and swept up in the contortions it brings about, in Von Graevenitz's relief it is hidden. It causes the small, evenly-spaced, identical visible tabs to do no more than revolve. But since the relationships of these movements are random, their interconnections become extremely complex. Poverty of information, predictability, banal calculation, is transformed into the incalculable.

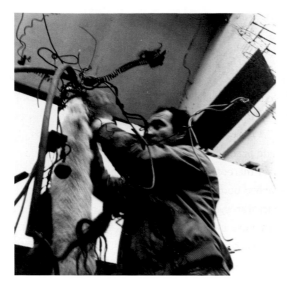

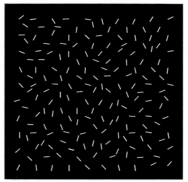

Gerhard von Graevenitz *Kinetisches Objekt, weiße Streifen auf Schwarz* (Kinetic Object, White Lines on Black), 1964

Jean Tinguely making a *Baluba*, Paris 1962
Photo Vera Spoerri

Perhaps it is the coming into being of this movement, this life, out of its unpromising elements which is the real pleasure. A paradox emerges, the first of many which have dogged – or inspired – this show: a paradox of the kind which probably caused Marcel Duchamp to exclaim that movement did not exist. Referring to Gaston Bachelard and his book *Le Nouveau Esprit Scientifique* (1934), Duchamp joked to Denis de Rougement: "What does he call movement, your fellow? If he defines it in opposition to rest, that doesn't work, because nothing is at rest in the universe. So? His movement is nothing but a myth."[2]

Likewise his repose. There are only movement and repose relative to one another: the movement of the elements of a work relative to its static base or frame or environment, the movement of the spectator relative to the work, the movement of the drawing hand relative to its resulting marks. That is why this exhibition does not take movement literally and gives as much attention to 'static' works. It is not movement in itself which is important but the intensity with which a work can reveal space, time and energy (there may be an object which literally moves but is stultified and stale in its formal conception; similarly there are works still done in art's most ancient modes – such as drawing – which are more radical and dynamic in their formal structures).

But a formal structure signifying what? A second premise of this exhibition is that artists, no less than scientists, make 'models of the universe'. Their models are arrived at intuitively but are no less valid, no less a form of knowledge. A thread of 'cosmic speculation' can be followed in the work of many artists between the loose dates of 1920 and 1980 that this exhibition covers. It is a thread of fascinating intricacy, precisely because the structures that artists have arrived at combine an investigation of reality with an investigation of the aesthetic. It is as if speculation on the structure of the universe, for these artists, is inseparable from a transformation of the formal structures of art, and vice versa, that the formal transformation of art is itself a proposition on the structure of the universe. It is surprising that such a widespread enquiry has been so little studied. Its implications are considerable, both in the way they question the art historical categories and schemas which have been handed down to us, and for what they reveal about the nature of 'abstraction'.

An overt reference to cosmic concerns has not been a criterion for inclusion of work in this exhibition. Nevertheless a surprising number of verbal statements of intention by artists can be found. Thus, in 1965, the Venezuelan artist Jesús Soto could say that in his work he was seeking to discover the relationship between "the principle which governs the picture and a general law of the universe which

governs everything" (in this case he was referring to the process of dissolution of material into vibrations that he had demonstrated within the work).[3] Georges Vantongerloo declared that art such as his (in Margit Staber's paraphrase) "can give insights into the structure of the universe" which cannot be communicated by "any other than aesthetic means".[4] Alexander Calder maintained that his work, from his earliest abstract wire constructions of 1930 "and practically ever since" had derived its "underlying sense of form [from] the system of the universe, or part thereof". His vision was vivid and precise:

"What I mean is the idea of detached bodies floating in space, of different sizes and densities, perhaps of different colours and temperatures, and surrounded and interlaced with wisps of gaseous condition, and some at rest, while others move in peculiar manners, seem to be the ideal source of form. I would have them deployed, some nearer together and some at immense distances. And great disparity among all the qualities of these bodies, and their motions as well."[5]

In his reminiscences, Calder linked together two powerful formative influences, "necessary shocks", that led to his finding his own language as an artist. One was the experience of a celestial event as a youth, when, "off Guatemala I saw the beginning of a fiery red sunrise on one side and the moon looking like a silver coin on the other. Of the whole trip this impressed me most of all: it left me with a lasting sensation of the solar system."[6] The second, "bigger" shock, administered eight years later, was his visit to Mondrian's studio in Paris when he saw Mondrian's room "with the walls painted white and divided by black lines and rectangles of bright colours, like his paintings."[7] Cosmos/abstraction/kinetics was clearly a unity in Calder's mind. He titled his first exhibition of abstract work at the Galerie Percier in Paris in 1931, *Volumes-Vecteurs-Densités*.

Whose universe? Whose abstraction? An image of the cosmos in the crystalline planes of *l'art concret*, or in the visceral scribblings of *l'informel*? Van Doesburg ("The truly exact work of art is a metaphor of the universe"[8])? Or Michaux ("Space that is teeming, a space of gestation, of transformation, of multiplication, whose swarming, even if only an illusion, would give a better idea than our ordinary vision of what the cosmos is like"[9])? Both have a basis in reality, the given, (corresponding roughly to the worlds of physics and biology), but each is an intense expression of individual desire, psyche and out-of-the-ordinary vision.

We could turn from the image of structural rigour, and from formless flux, to a third metaphor for the universe: the void. Nothing, emptiness, null, zero, the limitless and dimensionless: a mental construct denoting a space of potential in which all things originate. The paradox of referring to 'everything' by 'nothing' has been a key recourse in eastern philosophy and religion – Indian Tantrism, Tibetan mysticism, Taoism, and Zen Buddhism. As we will see in more detail later, the notion of the void surfaces again in mid-20th-century art as a generative and inspirational idea, reflecting an extensive interconnection at the time between western and eastern artists. A remark which very succinctly expresses the dynamic involved, from a visual artist's point of view, comes from Ad Reinhardt: "The Eastern perspective begins with an awareness of the 'immeasurable vastness' and 'endlessness of things' out there, as things get smaller as they get closer, the viewer ends up by losing (finding?) himself in his own mind."[10]

In defining its central concept, therefore, and its field of interest, in the notion of space and energy it explores, this exhibition works along a continuum between macrocosm and microcosm, between the physical and biological, and investigates the perennial relationship between universe and mind, between the 'out there' and the 'in here'. Reinhardt's image of losing and finding oneself fittingly describes the

everyday dilemma of setting limits and boundaries in this experience of flux, which, in a curious way, also applies to the selection of artists and works in an exhibition such as this.

Anyone who sets out to construct an exhibition on a particular theme soon becomes aware of a whole web of connections which links the theme they have chosen with others, and links 'their' artists with other artists according to all sorts of ties (even ones of hostility). The mind begins to wander and the theme seems arbitrary. Isn't the endlessly proliferating web more real, more true, than our tidy constructs? This process seems equally odd and even absurd when one's subject is the 'universe' – yet especially poignant too since, in relation to something so vast or so tiny, the work of art itself can only be a model. It can be no more than a model, example, limited case, or map, like everything else that falls within the human sensory spectrum compared with everything outside it.

Limits having become inevitable, therefore, they were enthusiastically embraced. Leaving aside the choices dictated by contingencies of various kinds, it was decided to steer the exhibition on a course that would avoid familiar patterns of art history. Thus, while it does attempt a (surely much needed) reassessment of early kinetic art, the show sets this in a much wider context – the irony is that it brings together tendencies which often believed themselves in violent opposition to one another. It is an anthology of 'moments', as much as of artists, since very particular choices are made within artists' total oeuvres. The preoccupation with space, time, matter and energy at this period is identified with 'abstraction' (for example, among Wols's water-colours and Michaux's *Mescaline Drawings*, those with any figurative references were excluded). Many branching themes are hinted at without being pursued: the monochrome, 'accumulation', the all-over, social implications and applications of artists' researches, and others. All in all, works have been put together, not to expound an idea or conduct a survey, but to intensify visual (or more broadly, sensory) experience. At a certain point I was struck by the importance of a play-element in the work we were considering, and also by its presence in the construction of the exhibition. Liberties are taken. Did not Jean Tinguely take wonderful liberties with Malevich and Kandinsky in his early machine-sculptures? Is this why much of his work has not been considered serious? May there not be a connection between a lack of presumption and insight into the universe? At least, as Hans Richter wrote, speaking of Duchamp, "*Homo Sapiens* never acquired wisdom: why not give *Homo Ludens* a chance?" [11]

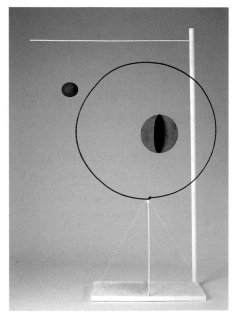

Alexander Calder
Object with Red Ball, 1931
Private Collection, New York

The Space of Abstraction

I have hinted how cosmological speculation, scientific discoveries and theories of the universe in the 20th-century problematised the whole question of representation. Of course, celestial phenomena or the microscopic world could continue to be depicted with traditional methods, but theories of relativity and uncertainty were bound to throw into question the detached status of the work of art from the reality it represented. If similar forms of energy run through all things, the 'model' must needs take on a new relationship to the reality it models. The proposal of a profound change in the notion of the artistic work was succinctly expressed by Lucio Fontana in 1955: "As a painter … I do not wish to make a painting; I want to open up the space, to create a new dimension for Art, to tie it to the cosmos as if it was expanding beyond the restricted plane of the painting."[12]

It seems futile to dispute whether art or science takes a lead in these changes of perception, to look for a precise pattern of cause and effect, especially if you are as ill-equipped to do so as I am. Soto calls it "dangerous" for an artist to undertake the systematic study of any science. A field of scientific knowledge which is as complex as art is may "swallow him up in its depths", he writes.[13] Without wishing to be so prescriptive, in this exhibition we have nevertheless pursued the artist's investigation of reality as a practice leading to a particular kind of knowledge.

This exhibition is not set out as a chronological narrative but does contain a kind of historical prelude, which gives way to a more substantial investigation of a period from the end of the second world war until the 1970s. Linking both are two bodies of work, neither very well known even now, which may be taken as a *leitmotif* for the show as a whole: Alexander Calder's abstract wire constructions and first motorised sculptures of the early 1930s, and Georges Vantongerloo's paintings and objects of wire and perspex made from the end of the war in 1945 until his death in 1965.

In the earlier part of the century this 'investigation of reality' on the part of visual artists seems to have progressed by two procedures. On the one hand there was the effort to work through to a new concept on the basis of what the eye sees, or the accepted constructs of what the eye sees. On the other hand there were 'propositions', provocative actions by artists which often shook the conceptual limits of the field of art itself. In the first category, in the field of painting, the outstanding example is Mondrian. Mondrian's progression from his own brand of Impressionism/Postimpressionism, through Cubism, to the *Ocean* and *Pier and Ocean* paintings of 1914–1915 (sometimes called the 'plus/minus' paintings), is emblematic of a widespread transformation of perception. In a process of gradual abstraction from the visible world, in which visual nuance and subtlety remained very important, Mondrian simultaneously, or reciprocally, discovered active energies within the pictorial elements. Out of his 'destruction' of form he arrived at a 'force field'. A work like *Composition 10 in Black and White*, 1915 (in the Kröller-Müller Museum, Otterlo), while still conveying the emotion of space we feel when looking out over the sea, is a pattern of wave-movement, oscillation, vibration, generated between the visual marks. Complexities of movement have been resolved into simple oppositions between horizontal and vertical lines of different lengths, still retaining that experiential complexity of space, but introducing a universal dialectic between positive and negative forces. Mondrian, thereby, even arrived at a form of symbolism (evoking ancient formulations of the interpenetration of opposites, positive/negative, active/passive, such as the Taoist Yin/Yang). He was not looking for it presumably, having turned his back on the anthropomorphised symbolism of some of his early paintings.

A parallel phenomenon can be found in some of Brancusi's sculpture. His ovoid objects are obviously 'models of the universe'. On the one hand they evoke the 'cosmic egg' of ancient symbolism, on the other they are propositions of form shorn of traditional narrative and emotional associations. Revealingly, Brancusi titled the four pure ovoids he produced either *Beginning of the World* or *Sculpture for the Blind*. He connected infinite cosmic space with an intimate, primary apprehension of form. They seemed designed to meet in a new space. "In the case of the ovoid, I take it, Brancusi is meditating upon pure form free from all terrestrial gravitation."[14]

Among seminal 'propositions' we could point to Marcel Duchamp's and Man Ray's *Rotary Glass Plates* (*Precision Optics*), of 1920, and Naum Gabo's *Kinetic Sculpture*, also of 1920. It is fascinating, considering that they can have had no contact with one another, that Duchamp's and Gabo's machines were made in the same year and that both artists thought – though perhaps for different reasons – that their devices had little to do with art. Duchamp did not want people to see in his *Rotary Glass Plates* or his *Rotary Demi-Sphere* (1925) or *Rotoreliefs* (1935) "any other thing than optics". He was intrigued by the physiological illusions, the virtual volumes, his machines produced as a way of going beyond the whole painterly, or 'retinal', tradition of art. A virtual volume is likewise produced by the vibrating vertical rod of Gabo's *Kinetic Sculpture*. Simple as it may look today, to produce this 'standing wave' in the precarious conditions of Russia in 1920, to find or improvise the components in a country immersed in civil war and scarcity, took tremendous determination and ingenuity, testifying to the intensity of Gabo's visionary enthusiasm. However, Gabo himself regarded it as only a limited demonstration: "When I showed it to the students I made it emphatically clear that this was done by me in order to show them what I mean by 'kinetic rhythms' ... nothing more."[15] Gabo never believed there was sufficient technical basis for an artistic language using actual motion, while Duchamp soon became absorbed in other interests.

Whether paintings, sculpture or machines, one thing all these works have in common as 'models' is that they propose the interaction of an object with its environment. This was indeed the process by which Mondrian arrived at his 'force field' in the plus/minus paintings. As the Dutch art historian Carel Blotkamp has pointed out, in the evolution of these paintings Mondrian gradually "did away with all distinctions between the original components of the representation: the sea, the pier and the sky", so that "all now appear to be made of the same ethereal substance".[16] Later Mondrian extended this interplay between an object and its surroundings to the canvas itself by experimenting with the edge and frame, and also by the transformation of his studio walls with coloured rectangles that so impressed Calder. The high polish that Brancusi gave many of his bronze objects can be seen as something of an equivalent in sculpture. The surface was dissolved by reflections, at the same time as the surrounding world was mirrored in a form which distorted the 'rational' geometry of the perspective system. Duchamp's *Rotary Glass Plates* and Gabo's *Kinetic Sculpture* produce forms whose outlines, or boundaries, between themselves and the surrounding air are illusory; furthermore they only exist because the speed of the moving parts is relatively greater than the speed of the camera shutter or the viewer's eyesight.

One of the purest and most dynamic expressions of this conception of the art object is László Moholy-Nagy's *Light-Space Modulator* (1922–1930), which was conceived in the experimental atmosphere of the Bauhaus. It is sometimes called the *Light-Prop*. Rather than being an autonomous expressive object, it exists only as a means of reflecting, deflecting and mixing the light beams falling on it, which in turn animate the surrounding space. The object becomes an event. Although seventy years old, the audacity of Moholy-Nagy's machine is still apparent if you think of the number of art works produced even today which have not absorbed its dialogic structure.

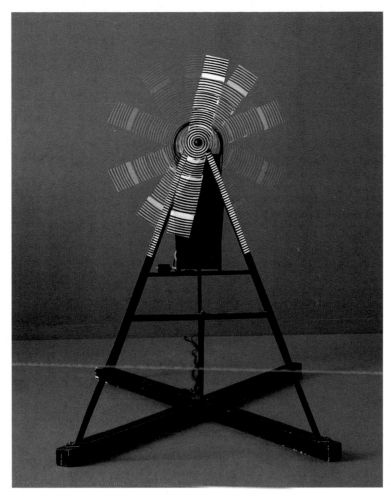

Marcel Duchamp (with Man Ray)
Rotative plaques-verre (optique de précision)
(Rotary Glass Plates [Precision Optics]), 1920

Calder is of course the epitome of this tendency, with his life's work dedicated to the interaction of an object with its surroundings. He introduced an intricate dynamic of dispersed and reciprocal forces that took the notion of sculptural mass beyond the uni-directional force of gravity, and he opened it up to outside influences, air currents of course, and also the spectator's 'push' (although the thrill of setting a Calder in motion must be becoming a rarer and rarer experience as his now priceless objects retreat behind their wall of security). There is a link in terms of personal contact and mutual influences between Mondrian's paintings, Duchamp's optical machines, Moholy-Nagy's *Light-Space Modulator* and Calder's early abstract-kinetic sculpture. There was something undogmatic and very human about this concurrence: Duchamp suggested the name 'Mobile' to Calder and Calder suggested to Mondrian that "perhaps it would be fun to make the rectangles [that Mondrian had painted on the walls of his studio] oscillate". Mondrian gravely declined: "No, it is not necessary, my painting is already very fast."[17] Nevertheless, Calder's works are a perfect expression of Mondrian's ideal of 'dynamic equilibrium'.

Calder's huge production and the canonisation of the typical Calder mobile has tended to obscure the fascinating work he did when these contacts were at their height in the early thirties. At that moment he was simultaneously discovering abstraction and the then new theories of the solar system and the vastness of space which stimulated a passion for the cosmos he had had since childhood.

The critic Joan M. Marter has researched Calder's astronomical interests in detail. She has unearthed a number of revealing statements of intent, such as the following: "From the beginning of my abstract work, even when it might not have seemed so, I felt there was no better model for me to choose

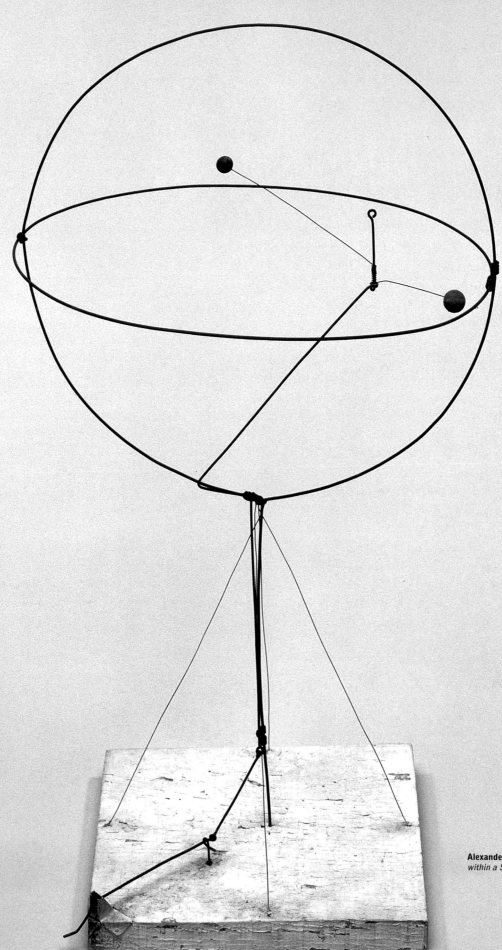

than the universe ... spheres of different sizes, densities, colours and volumes, floating in space, traversing clouds, sprays of water, currents of air, viscosities and odours – of the greatest variety and disparity."[18]

Joan M. Marter has also documented the clear visual connection between works like Calder's *Little Universe* (1931), or *Two Spheres Within a Sphere* (1931) and astronomical instruments such as 17th-century orrerys and armillary spheres. Such connections were not illustrative. They served Calder's development of abstraction, which passed beyond a system of representation to a system of forces acting in space and time. For Calder the notion of abstraction was closely aligned with those realities which he had studied from the pragmatic point of view in his courses of mechanical engineering and kinetics as a young man at the Stevens Institute of Technology in New Jersey: "How does art come into being? Out of volumes, motion, spaces carved out within the surrounding space, the universe. Out of different masses, light, heavy, middling – achieved by variations of size and colour, out of directional line – vectors representing motion, velocity, acceleration, energy, etc. – lines which form significant angles and directions, making up one, or several totalities. Spaces and volumes, created by the slightest opposition to their mass, or permeated by vectors, traversed by momentum. None of this is fixed. Each element can move, shift, or sway back and forth in a changing relation to each of the other elements in this universe."[19]

However, such parallels and declarations only go so far to explain the beauty of these early Calders. Why is his handling of space still so thrilling in its sensitiveness and spareness? Jack Burnham, writing in the sixties, accurately pointed to the element of parody in Calder's treatment of scientific instruments, but he seemed to imply that Calder's humour had no real aim. "If we compare the amateur crudeness of his little spool-and-belt-driven contraptions with the consummate precision of 17th-century astronomical clocks, we grasp what must have occurred to Calder as an absurd situation."[20] Absurd only if we forget Calder's playfulness, which reveals space as a form of liberty. Mechanics and kinetics are passed through the filter of the 20th-century avant garde's advocacy of the child's methods against the official seriousness of high art and academicism. Calder's parallels are Paul Klee and Picasso, as well as the impoverished children of Africa and elsewhere who make models of technical marvels out of wire and tin. While expressing wonder, Calder seems to mock gently those historical instruments of discovery and navigation, which also became symbols of power and global domination. These elements in turn are inseparable from others. One can also find in these 'cosmic' works the trapezes and acrobats of Calder's earlier Circus. It is the precarious balance, and the space of the acrobat's leap or swing which doubles with the orbits of the little spheres: the line of wire is the trajectory of both.

Calder in his studio in the rue de la Colonie, Paris, 1931
Photo Marc Vaux © ARS, NY.

While Calder's early abstract structures are usually seen as a prelude to his principal body of work, Vantongerloo's late paintings and 'sculptures' (the word is clumsy and inappropriate) have been described by such words are "odd", "mysterious" and "naive" in comparison to his earlier abstraction. This is only one of several curious symmetries and disparities between the specific periods of the work of these two artists which have been made a *leitmotif* of the exhibition. In very general terms, both artists moved from a rigorous form of abstraction (related to mechanics in Calder's case and to mathematics in Vantongerloo's) to something more 'naturalistic', or at least associative. But whereas in Calder's work it is the earlier, more abstract sculpture which seems to seek for enlarged dimensions of space and time (references in later mobiles and stabiles become increasingly terrestrial), in Vantongerloo's case it is the late work which is preoccupied with the boundlessness of the universe, and, in some way which is not easy to define, proposes a new relationship of the artistic 'model' to reality.

Margit Staber has called Vantongerloo "the inventor of the mathematical approach in art".[21] In both paintings and three-dimensional constructions of the 1930s, "he applied mathematical formulae without disguise as the organising principle and as the titles of the works."[22] According to Jane Livingston, Vantongerloo's grasp of mathematical problem-solving was such that he "amazed those who witnessed his analyses and instant verbalisations of the equations determining Mondrian's compositions."[23] Mathematics was not an end in itself. Vantongerloo objected to those who accused him of 'reducing art to mathematics' by saying that, rather, he sought to "arrive at an artistic expression by geometric forms". Even the mathematician, he argued, did not seek "merely mathematics": mathematics was a means of formulating and recording ideas.[24]

However, in the late 1930s, and especially after World War Two, Vantongerloo moved away from geometrical formats to an "increasingly free-form, random-seeming and colouristically subtle and ambiguous approach to lines on the surface."[25] In painting he became preoccupied with the equivalent of a kind of transcription of forces and energies directly on the surface, giving his works titles like *Radio Activity, Radiation, Electro-Magnetic (Atmospheric Zones)-Phenomenon*. In sculpture he made small objects of wire and wood resembling free variations on the model of the atom. From 1950 until his death in 1965, he increasingly adopted the then novel material of plexiglass as his preferred medium.

Vantongerloo in his studio, c. 1950s
Photo Ernst Scheidegger

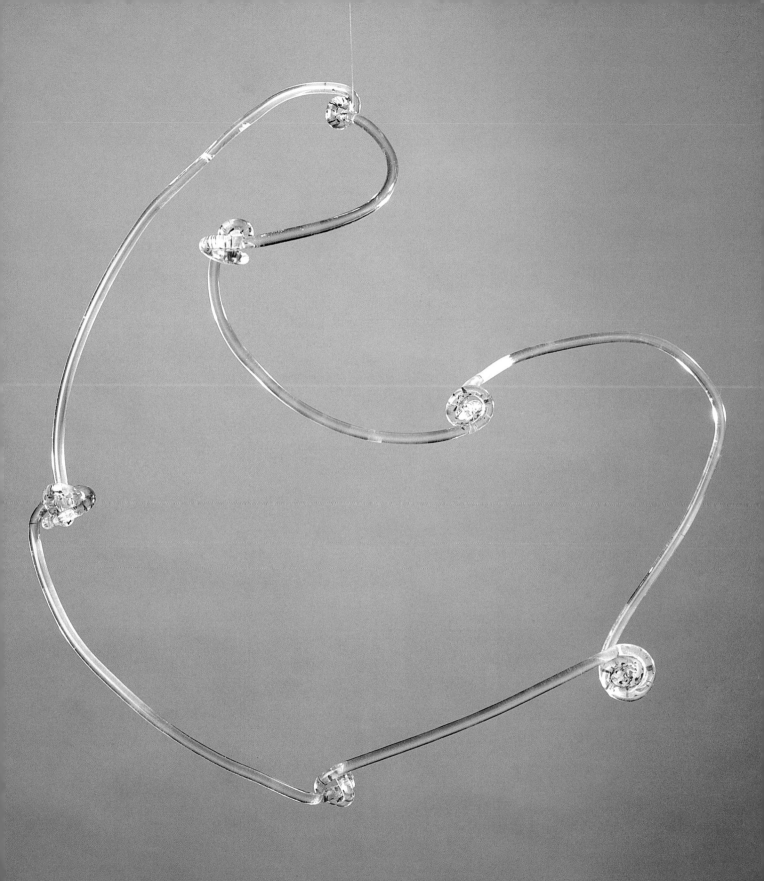

Georges Vantongerloo *Des éléments (ligne fermée)*
(Elements [Closed Line]), 1954

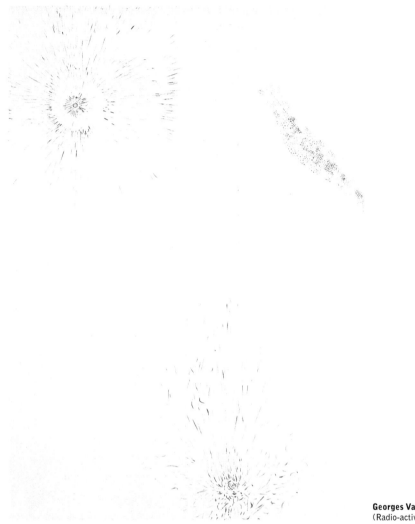

What are these objects in the material sense? A few coils of perspex, some clear, others with coloured particles embedded in them; further coils, globes or boxes supporting prisms which produce their own changing coloration by refracted light; a model 'comet' 30 cms long. In another context the comet might simply look like a toy. But in the context of art its role changes: it changes by changing art, the customary notion of the way the aesthetic object relates to reality. Vantongerloo's works have remained obscure perhaps because they have been considered difficult and demanding, "fundamentally different from anything else produced", in Max Bill's view.[26] They have divested themselves of the expected forms of presentation and address and sum up in another way the outcome of a lifetime's thought and observation. "My works represent a conception of creation and have nothing in common with so-called modern art."[27] One of the most powerful aspects of Vantongerloo's trajectory is that he moved from 'constructivism', from the confident application of spatial measurement and the rationalisation of form, to the pursuit of invisible and intangible energies. He identified these with measurelessness, or the "incommensurable" as he called it. The problem his late works pose is: how can a delineated object suggest the limitless; how

can an aesthetic object sensitise us to nature without defining it, since, Vantongerloo said, "nature cannot be defined, to define it would be to set limits to it"?[28]

This may also hold the key to Vantongerloo's progression from an abstract, ideational approach to an "increasing preoccupation with natural phenomena", as Jane Livingston has described it.[29] The artist often spoke of his enchantment by the spectacle of the Aurora Borealis, which he went to Sweden especially to see in 1960. But the notion of observation in relation to nature is paradoxical, as Vantongerloo stressed again and again in his writings. The spectacle cannot be confused with the phenomenon itself. "When we believe we see something as existing, this thing, before being transformed into another state, corresponds to the speed of our senses. That is to say, its position at a given moment is maintained long enough to allow our senses to perceive it, or register its presence ... Through our senses we are unable to perceive the infinite, for our senses are themselves limited. This does not affect the existence of the infinite, and we are subject to it..."[30] While we are perceiving a phenomenon we believe we see it, yet we do not see its perpetual transformation. All is born, lives and dies for our senses, but not for the universe."[31] Despite this, man possesses a "more or less developed sensibility ... an imagination ... and the ability to observe and deduce. Thus he can see the invisible or, if you like, take a sounding on the incommensurable."[32]

The relation between what our senses can perceive and the universe: this is clearly the place where Vantongerloo inserts his object as a 'sounding', as an imaginary construct. It is a model addressed to the aesthetic sense (or the 'sensibility', as he liked to call it). In his last years Vantongerloo was largely ignored by the art world, and what he produced was hampered by "insufficient means and bad working conditions."[33] Nevertheless the scale and nature of Vantongerloo's objects must also reflect his essential modesty and delicacy before the 'splendour of the universe'. Max Bill, Vantongerloo's long-time supporter and advocate, once likened the Belgian artist to the Douanier Rousseau: an interesting comparison, by which he presumably meant that a certain naivety, and perhaps innocence, is inseparable from a direct perception of a new reality. The fluid sense of form of Vantongerloo's late works, their reconciliation of the physical and the biological in plasma-like fluxes, seems extraordinarily contemporary and perfectly in key with unfolding scientific knowledge of the cosmos. It also sets the scene for the unavoidable and fruitful dualities which underlie artistic metaphors of the universe during the 1950s and 1960s.

Le Concret and *l'Informel*

With hindsight, and in the light of bodies of work such as Vantongerloo's, the inherited classification of modern movements, usually based on the positions of warring factions and isms, comes to seem increasingly wobbly and rudimentary. Or it may be that the dialectic of opposition between tendencies understood at one level is shot through with other patterns of connection and difference, leading to much more complex relations than envisaged. This certainly seems the case if we follow our theme into the artistic scene in Europe and elsewhere between the end of World War Two and the early 1970s. Considering the rationalising drive of artists like Mondrian, Moholy-Nagy, or the Vantongerloo of the De Stijl period, we might assume that 'insight into the structure of the universe' would necessarily follow the kind of orderly pattern evoked by the word 'structure': associations of clarity, equilibrium, light, calm and objectivity. But the forces of nature can also be understood in terms of the dark side of chaos, excess, brute matter and the incoherencies of subjectivity. In art, after the Second World War, these two understandings were polarised in tendencies that were constitutionally antipathetic to one another: *l'art concret* and *l'art informel*. Artists identified with each side were often mutually hostile at the time (the kinetic/science-oriented Zero Group attacked Wols, for example).

'*Informel*' artists like Wols or Henri Michaux have always been associated with the subjective and emotional, with the unconscious, but hardly with science. Time, however, has dissolved these antagonisms and brought into new prominence bodies of work whose very interest lies in the way they exist between these poles, such as that of Lucio Fontana, who could easily be claimed for both schools. Fontana's example, or Vantongerloo's move from geometry to the visualisation of fluid, bio-physical 'energy-fields', intimating an enlarged perception of space and time: these allow us to detect a common thread between many apparently unconnected productions of those years, giving new parameters to the phenomenon of abstract art. Such readings are not, in fact, without precedent.

In the 1960s, when he was putting forward his theory of the 'open work', Umberto Eco effortlessly combined informal abstraction and constructivist/kinetic work in his discussion. He gave precedence to science in creating a "certain vision of things"[34] out of which artistic propositions emerge; nevertheless his description of the relationship is illuminating: "When we encounter an artist who uses scientific terminology to define his artistic intentions we will not assume that the structures of his art are a reflection of the presumed structures of the universe; rather we will point out that the diffusion of certain notions in a cultural milieu has particularly influenced the artist in question; so that his art wants and has to be seen as the imaginative reaction, the structural metaphorisation of a certain vision of things (which science has made available to contemporary man)."[35]

The specific notion from science which Eco draws on is that of the 'field', or field theory. Translated to artistic work it becomes "form as a field of possibilities"[36] and provides the characteristics of the 'open work': "The notion of the 'field' is provided by physics and implies a revised vision of the classic relationship posited between cause and effect as a rigid, one-dimensional system: now a complex interplay of motive forces is envisaged, a configuration of possible events, a complete dynamism of structure."[37]

These traits are characteristic of the open work which Eco discusses by reference, on the one hand, to the work of Wols, Fautrier, Bryen, Dubuffet, *tachisme*, action painting, *art brut*, *art autre*, etc.; and on the other to Gabo, Calder, Munari and those "experiments aiming at the introduction of 'movement' into painting".[38] All such works are open in that they propose "a wider range of interpretive

possibilities, a configuration of stimuli whose substantial indeterminacy allows for a number of possible readings, a 'constellation' of elements that lend themselves to all sorts of reciprocal relationships."[39]

His words serve as a succinct description of much of the work in this show, from Camargo to Manzoni, from Takis to Medalla, from Wols, via Von Graevenitz, to LeWitt and Matta-Clark, for example. Within these concurrences are profound differences which seem to render the whole paradox of concurrence and difference, in relation to a notion such as 'energy', more mysterious. Emblematic of this process might be a comparison between certain works of François Morellet and certain of Henri Michaux and Wols.

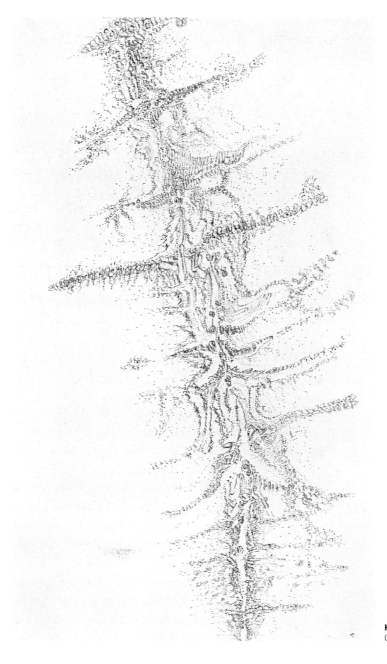

Henri Michaux *Dessin mescalinien*
(Mescaline Drawing), 1958

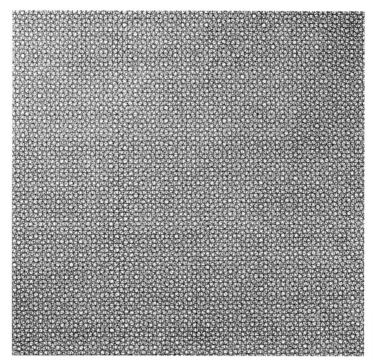

François Morellet
4 doubles trames traits minces
0° – 22°5 – 45° – 67°5
(4 Double Meshes Thin Lines
0° – 22°5 – 45° – 67°5), 1958

Calculation and Hallucination

Morellet's *Trames* (Meshes) and Michaux's *Dessins Mescaliniens* were produced more or less contemporaneously in the 1950s (though Morellet was in his early thirties and Michaux in his mid fifties at this time). Morellet's is a series of paintings and Michaux's of drawings and watercolours, but their most striking difference is the procedures by which they were made. Morellet's *Trames* are the product of a fully-conscious, pre-planned, rational and systematic procedure, straight lines painted across the canvas at certain angles and in certain numbers. A simple system generates a very large number of configurations. Michaux's drawings (which it seems banal to label 'informal abstraction') emerged from his experiments – committed and systematic as well as audacious, conducted in the "laboratory of his home"[40] – with the hallucinogenic drug mescaline, whose physiological and psychological effects he carefully monitored and described both in drawing and in masterly literary prose.

It is obvious that in both series of works form is dissolved into an energy field, one of great density and delicacy. They answer to Eco's description of a "configuration of stimuli whose substantial indeterminacy allows for a number of possible readings". Especially fascinating is the fact that, despite their differences, each seems to partake of the qualities of the other. In the Morellet, calculation and a foreseeable system produces the improbable, ambiguous and unpredictable: perhaps one could say the hallucinatory. And in the Michaux the apparently uncontrolled and chaotic is revealed to have certain recurring structures. "I went on this dazzling, far-out journey from galaxies to electrons in a picture by Morellet," Victor Vasarely wrote after a visit to the artist at the beginning of the sixties.[41] Michaux under mescaline described himself as "caught up in infinite turbulence".[42] "Mescaline provokes a vibratory state, multiple vibrations, almost overwhelming at first, of abnormal amplitude and with a great many

Henri Michaux *Dessin de réagrégation*
(Post-mescaline Drawing), 1966
© Photo IVAM, Institut Valencià d'Art Modern,
Generalitat Valenciana

points."[43] He also speaks of "waves, wavelets, undulations, oscillations".[44] "Infinite nature of mescaline ceasing of the finite, of the mirage of the finite, of the illusory conviction of the existence of anything finite, concluded, completed, stopped."[45] In rendering these visions by drawing, Michaux professed to a sense of inadequacy in both his materials and technique, especially for the colours: "I had first of all to record the rhythms accurately, and the process of infinitisation through the infinitesimal".[46]

We can say that both artists were concerned with energy as an intense, pure and continuous phenomenon, identified visually with the 'all-over' composition (in Morellet as a matter of conceptual principle, in Michaux as the usual outcome). It seems that we cannot separate the expression of this energy from the phenomenon of mind. Morellet stands back and looks outward: his visual energy emerges from an analysis of the elements of graphic expression, of pictorial dynamics (following on from Mondrian's plus/minus paintings). Michaux plunges in: he deranges the senses and in the mescaline experience approaches close to madness. Energy emerges via the mind in another way: as a "neuronal dance", in the words of Jean-Jacques Lebel.[47]

Paradoxically, just as we feel from Michaux's drawings that he came into an intimacy with some principle of force which runs through everything, we find him regretting that he was losing in the process what it is to be human. "Tawdry" was the spectacle mescaline produced, he wrote in the revealingly titled *Misérable Miracle*, and "robotic". He describes the sense of joy, after emerging from his trance, at rediscovering his will. "Not to let themselves be carried away, to remain master of their speed seems to be the underlying, the constant secret preoccupation of all men, no matter how metaphysical or worldly their occupation may be. Below the man who thinks, and much deeper down, there is the man who controls, who controls himself."[48] Paradoxically again, perhaps, he had to abandon this state of self-control in order to value it.

In a beautiful text on Henri Michaux written at the end of the fifties, Octavio Paz attempts again and again to deal with the conundrum of the mescaline drawings: the relation between "space, space, pure vibration" and the self. In uncertainty he writes: "Equidistant from sanity and insanity, the vision Michaux describes is total: contemplation of the demoniacal and the divine – there is no way around these words – as an indivisible reality, as the ultimate reality. Of man or of the universe? I do not know. Perhaps of the man-universe. Man penetrated, conquered by the universe."[49]

Why did Michaux emphasise the infinitesimal? The word contains both the 'tiny' and the 'infinite'. By concentrating the drawing hand and the eye down to minute strokes and dots, he accords the sheet of paper its utterly relative and arbitrary position between the scales of microcosm and macrocosm. The same can be said of Wols, and to some extent of Bernard Réquichot. In fact Wols keenly appreciated this relativity: "We tell our little earthbound tales / on little bits of paper".[50] The exhibition aims to reflect the same relativity towards size and materials.

The earthbound, the visceral, the hairy ... which is also the cosmic. The Wolses tell their story immediately, without words, when seen and compared with the crystalline and geometric end of the spectrum of abstraction. Historically, they have epitomised the link of *informel* with existentialism. For Sartre, impressed no doubt by Wols's self-destructive lifestyle, the visual evidence of his art denoted anguish. Sartre saw "the universal horror of being in the world. The ugly withering of a wart in stone, the churlishness of larval fauna and flora which expresses the impossible refusal to exist, everything is gathered together in his retina, which is soaked in darkness."[51] Yet Sartre was also of the opinion that "Wols's superiority consists in the fact that the things in his watercolours are unnameable".[52] Wols's improvisation presents the physical world of objects (animal, vegetable, mineral) in a state of 'transubstan-tion permanente'. And it is this quality that is emphasised here: not the projection of 'horror' but the improvisation of extraordinarily subtle and complex formal structures, combining in unpredictable patterns of nodes and efflorescences, the biological with the galactic. "Wols arrived at structures which serve as parallels to nature".[53] The tiny draws you in so deeply it becomes vast, or rather the tiny becomes inter-changeable with the vast. An American critic at the time called Wols 'the first painter of the atomic age'.

It becomes a very interesting reflection on the nature of abstract art *vis-à-vis* reality, if you pursue the notion of the universal (or infinite, eternal) through, for example, Vantongerloo and Wols. Of course a selection of their work could be made which emphasised their polar difference. But this would only make more striking a certain convergence in their visualisation of an energy beyond human senses. A convergence too, with a different inflection, in their thinking about the human place in the universe:

"Being ourselves part of creation, the infinite, we would not be able to live without the infinite. We are within it, as in the air, like fish in water. All this is one and the same thing from different aspects." (Vantongerloo)[54]

"Man only sees things in the light of their use to man, and so it is that he fails to understand the very being of these things. He himself is of no use to nature; he partakes of it and cannot be of the slightest service to it." (Wols)[55]

Wols *Untitled (Uranus)*, 1943

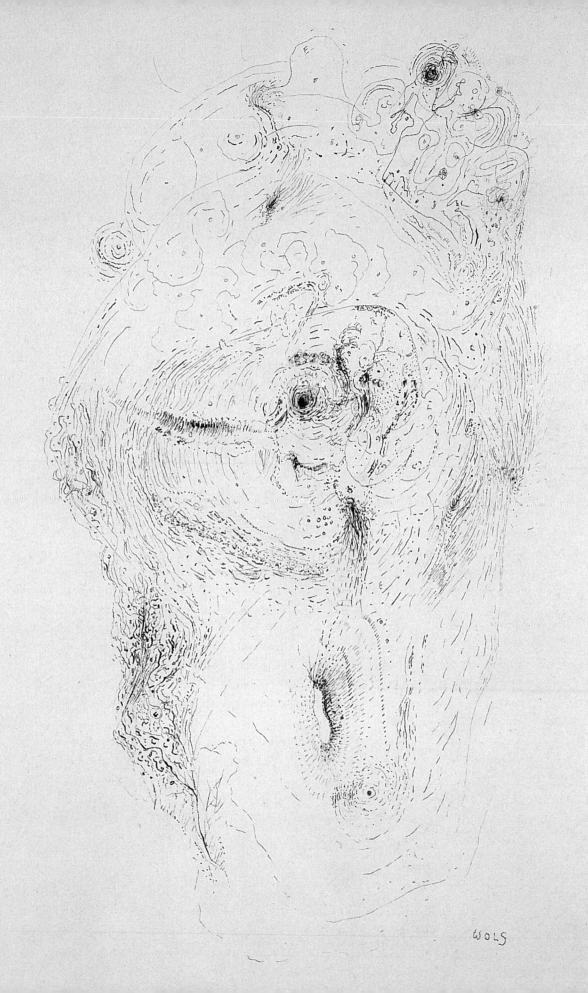

Force of Nature and Aesthetic Choice

One major difference between the concrete/kinetic tendencies and the *informel* artists was their attitude towards materials and genres. Drawing on the examples of Duchamp, Moholy-Nagy, Gabo and others, concretist/kineticists identified new technological materials with the new vision, and experiments with actual light and movement were part of this. Most informalists were comfortable with the traditional formats of painting and sculpture. To Pierre Restany in the late fifties, gathering together the artists he collectively called New Realists (who included Yves Klein, Jean Tinguely and Raymond Hains), the prevailing *informel* abstraction was "worn out", and an "art of evasion". Realism signified a "concrete vision of the real world", and New Realism for Restany constituted an attitude of rupture with the abstract expressionist pictorial structure. Instead artists would make "a direct appropriation of the real".[56]

Of course the products of all these schools are now in the museum, which makes all the more delicate our task of mediating between the way they appeared then and the way they appear today. On the one hand, time has mellowed the sense of rupture, and certain radical proposals are now seen to deal in complex ways with inherited artistic traditions. On the other hand, time has done nothing to change the conservative attitudes of institutions, and the radical nature of these proposals remains unassimilated, and for that reason potent. This contradiction does, I think, invite a consideration of the relationship between matter/energy 'in the real' and aesthetic forms. The 'bridging' position of Lucio Fontana between tradition and innovation here becomes crucial.

The *White Manifesto*, signed by a group of Fontana's students in Buenos Aires in 1946, (and presumably written with Fontana's collaboration) was seminal in articulating a new conception of the relationship between the forces of nature and artistic creation. The "worn-out aesthetic of fixed forms ... stock images with no sign of vitality", were out of date in a perception of the world of "constant dynamism" in which "change is the essential condition of existence".[57] The Manifesto sought "an art springing from materialism (not from ideas) ... which in a sense generates itself in accordance with natural forces free from all aesthetic artifices ... We take the energy specific to matter, its need to exist and develop."[58] It is often forgotten that Fontana's oeuvre from 1947 on has one encompassing collective title. Before it was a painting, sculpture, environment or light-work, it was a *Spatial Concept*. Indeed it can be read as a very elegantly and ironically staged collision between the 'energy of matter' and the traditional formats and supports of art: a collision in which the boundaries, and attributes, of painting and sculpture, and the formal and informal, are confounded and conflated. In Fontana there may be said to be a contradiction between man as wilful protagonist (epitomised in the 'violent' gesture of cutting the canvas or gouging a ball of clay), and the 'needs' of matter or nature, but this only points to the problematic separation between the internal (subjective) and external (objective) world, which was fixed in the categories of informal and concrete.

Takis *The Impossible: A Man in Space*,
Galerie Iris Clert, November 1960
Photo Hans Haacke

The dialectics are subtle. What was taken at the time by many as a destructive gesture was seen by Fontana as the opposite: "By 'hole' I meant going outside the limitation of the picture frame and being free in one's conception of art ... I did not make holes in order to wreck the picture. On the contrary I made holes in order to find something else".[59] The cut revealed the canvas to be material fact, but also a permeable membrane separating one space from another (in 1955 the Gutai group artist Saburo Murakami made a parallel proposal in dramatic form by jumping through a framed paper screen). Today we have to feel our way through again to that 'something else' which has been subsumed in the acculturation of Fontana's work as elegant paintings.

Takis's work can be seen in terms of a literal and metaphorical 'breakthrough' effects of which have both changed and remained the same. In a passage full of tell-tale period details, Alain Jouffroy describes the moment – more than forty years ago – when Takis made his first magnetic sculpture:

"Then suddenly, one evening in April 1959, I bumped into Takis on the pavement of the rue de la Huchette where I was going with a friend to hear some jazz musician who had just arrived in Paris. 'It's happened', said Takis, 'I've got it.' It sounded exactly like Archimedes's Eureka! Yes, joking apart, it was moving and beautiful. And he showed me the first Telemagnetic sculpture (it was I who coined the name the day after), in which metallic elements are held in suspense in the air by a magnet ... Takis's joy and enthusiasm was ineffable, he was almost weeping."[60]

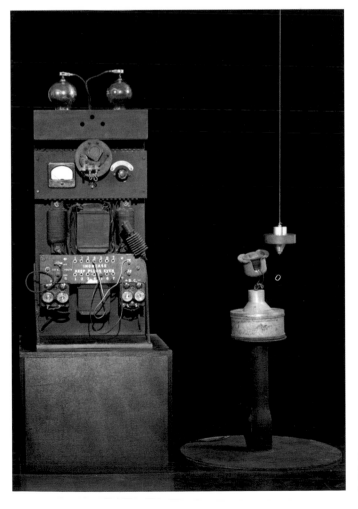

Takis *Télélumière "Une ligne verticale touchant une fleur"* (Telephoto "A Vertical Line Touching a Flower"), 1962

Jouffroy refers to the sculpture Takis was carrying as if it was a scientific discovery. For many writers at the time, myself included, it seemed that in their nakedness and rawness, Takis's objects came from outside art and were defined in terms of that difference. For example, Jean Clay writing in 1966:

"The forms of nature make a direct contribution in his work. For him it is a question of tapping into reality itself, rather than transcribing a symbolic schema of reality's involvement onto a two- or three-dimensional support."[61]

Takis's spectacular event in which he introduced magnetism – his *The Impossible: A Man in Space* at the Iris Clert Gallery, Paris, in 1960 – did indeed propose a kind of collision between the worlds of art, science/technology and contemporary reality. Five months before Yuri Gagarin became the first human to escape earth's gravitational pull, Takis floated the poet Sinclair Beiles in space through a system of magnets. From his position of levitation, Beiles recited a poem, "I am a Sculpture".[62]

But it was not through polemical play with conceptual definitions that Takis made his challenge in art. It was through an investigation of materials, their behaviour and properties, that he had carried out since his youth. Essentially it was his own version of a 'truth to materials' (an ancient paradox stemming from the contradiction between nature and artifice): that metal, for example, has its own *élan*. The good way of using it "must consist of following its profound spontaneity".[63] His take on this notion was completely contemporary. Takis's first incorporation of magnetism in his work was seen as a breakthrough by him and by others because it resolved the search he had been making in terms of a beautiful paradox. Magnetism created the little gap of empty space where all the energy is, where there is nothing to be seen or touched. It makes matter present by its absence, it shows that matter *is* energy. Its defiance of gravity takes our minds beyond gravity as a merely terrestrial force – always implicit in the tradition of monumental sculpture – to a universalised, multidirectional gravity.

These are the bare bones. But what we experience today, when we see Takis's work of the sixties and early seventies brought together, and in action, is the extraordinary richness and finesse of his 'language of movement'. We feel, through countless nuances, where 'real forces' merge with 'aesthetic decisions' and aesthetic decisions are invigorated by real forces. In a work like *Télélumière: Une ligne verticale touchant une fleur* (Telephoto: A Vertical Line touching a Flower), (1962), electricity as a fact, as dealt with by science, becomes linked with our tenderest longings, even with sexual explorations, producing a complexity of relationships between 'material' and 'human' at the highest level. The machine is sensitised. The controlling, switching, simple binary mechanisms are converted into the sensitive advance/retreat, approach/reproach, of a dance.

Jesús Rafael Soto *Untitled*, 1960

Over his work as a whole, the way in which the electro-magnetic source emerges is extremely diverse, ranging from the dark and eruptive, as in many of the *Télélumières*, where the electricity has the force of a visitation (one cannot imagine remaining exposed to it for very long), to the floating and contemplative, where the defiance of gravity continues in a pure but elastic state of exquisite balance for years on end. Between these poles are the trickling currents picked up by the dials, the lonely and remote lights of the *Signals*, and many cross-overs, or inter-stimulations, where movement issues as sound, light as movement, and the invisible and immaterial plays against solid mass. We speak of a 'machine aesthetic': it seems to me that Takis has made an 'electromagnetic aesthetic' of a kind which has yet to be properly appreciated, and of which, unfortunately, many in the 'mainstream of contemporary sculpture' remain oblivious.

The work of Jesús Soto is usually seen as belonging in the concrete and constructivist tradition. Around 1960, however, after a rigorous process of experimentation with the picture plane in which he had dissolved form into optical vibration by means of superimposition, Soto entered into an 'informal' phase. He began to introduce masses of pigment, tangles of wire, old pieces of wood and metal into his paintings. Saved from an association with a Soto 'trademark' style of later years, these works produce a joyful and fragile meeting of two supposedly opposed trends. Soto was able to place side by side, or to interweave, the presence of 'matter' in the self-evident manner that Fontana recommended (and others such as Fautrier practised) and 'energy' in the form of an optical vibration which he produced from the moiré phenomenon. Later he simplified the elements again to facilitate concentration on the optical processes of transformation.

One of the most interesting things about Soto's work in the sixties is its maintenance of the painting tradition, or legacy, through a process of dynamisation: again a position against which much of today's work looks retrogressive. It was not painting as a craft which was preserved, but the philosophical proposition of a space separated from 'reality' – philosophically separated but physically interactive. Thus, 'forces of nature' in the form of air-currents, or the viewer's movement or physical intervention, bring about a dissolution of the solid elements in the viewer's vision. It becomes impossible to say which is more real: solid object or immaterial vibration. With irony and poise, however, Soto does not allow the energy to upset a pictorial equilibrium, a kinetic play which both respects and destabilises painting's traditionally iconic stasis. We may see this as an expression of Soto's particular search for harmony in conditions of uncertainty and instability that we now ascribe to the universe.

Soto's *Penetrables* are brilliant inventions of visuality (though they have no surface or plane). Made of non-precious and renewable materials, they extend the contradiction between the pictorial space and the world out into the public arena, and people can pass bodily from one state to the other. The optical play between dissolution and solidity sets up an easy communication between people both inside and outside the 'work', and so becomes a social experience.

We begin to see that 'natural phenomenon' and 'aesthetic decision' were at this time in a shifting and reciprocal relationship to one another. The working-out of natural processes was allowed to change the conception of the beautiful; artists ceded their 'will to form' to certain degrees and in certain ways, and allowed natural events to prevail, which was seen as an emancipatory process, and to offer deeper insight into reality. Artists opened their work to chance and the random, but as Wols put it: "Chance exists in our eyes alone"[64]: what we call chance is actually the universal pattern which we cannot see. Indeed we might say that it was modesty before this fact which constituted the aesthetic attitude. It seemed a point of honour to demonstrate an equivalence of matter and energy with the greatest possible economy and wit. To do so laboriously would be a contradiction in terms. The new structure would achieve

greater freedom and depth by being transparently simple, by being both ordinary and cosmic at the same time. This was characteristic of a 'model': an incredible variety of phenomena distilled down to a few simple relationships, but different from a scientific model in that it must be capable of imaginative expansion in the viewer's mind. This is true of both David Medalla's and Hans Haacke's kinetic work of the 1960s.

In Medalla's sculptures the machine, with its overt repetitiveness and uniformity, becomes the agent of rhythms which are organic, sensual, unpredictable and playful. They represent a meeting between mechanical energy and various forms of pulverised, elastic or soluble materials: water, mud, grains of rice, dust, sand, powdered coal, glue-pearls, granulated coffee-beans, dried seeds, soap, salt, oil, steam, smoke, etc. "I was looking," the artist wrote, "for materials that, in sculpture, would be analogous to the smallest biological unit, the cell; materials that would be capable of multiplication."[65] Meanings seem to cross backward and forwards between analogies with spontaneous growth (as in the *Bubble Machines*, begun in 1963, in technical terms no more than a collection of containers out of which air pumps expel foam from a mixture of soap and water), and with writing/drawing/painting, as in the *Mud Machine* (1967), where, by means of revolving discs, sponges at the end of wires delve with abandon and also considerable delicacy into a mixture of mud and oil and drag it to form patterns on a lighted glass screen.

The genius of the 1964 *Cloud Canyons (bubble machine)*, one of the seminal works of kinetic art, was its combination of sophistication with simplicity. An audacious and provocative re-conceptualisation of the tenets of sculpture went together with a spectacular beauty, a subtlety of movement and luminosity, for which the analogy with clouds was no exaggeration. The foam was allowed to follow its aleatory paths, emerging and forming according to its own energies, interacting with gravity, air currents, atmospheric pressure and the shape of the containers, never the same two days in a row. An unchecked largesse did not hide, however, at the structural and philosophical levels, a dialectic which challenged every received notion of the finished or unitary work of art. Creation proceeded inseparably from destruction, the fullness and monumentality of form was accompanied by its complete evaporation, it was simultaneously a material 'something' and an immaterial 'nothing'. A seething activity went together with an overall calm. Chaos and order coexisted; motion and rest.

Later in 1964 Medalla made the *Sand Machine*, quite a different sort of structure. In place of liquidity and flow there was something brittle and dry. A flimsy, motor-driven structure dragged a suspended metal coil or helix slowly round a circular patch of sand which it marked with its own tracks like an antediluvian plough. Medalla called the work *Lament* and said it was "the death of metal, stone, all the materials of the past".[66] But one could read it in a generative sense too, since the circular movement and the constant re-marking of the sand made it appear that energy was never lost.

Hans Haacke's works exhibiting natural forces and processes of transformation were either carried out as outdoor events or encapsulated as exhibitable objects: both were honed down in material and visual terms to emphasise movement and ephemerality: a fan ruffling a huge length of cotton near the

David Medalla *Mud Machine*, 1967 (detail)

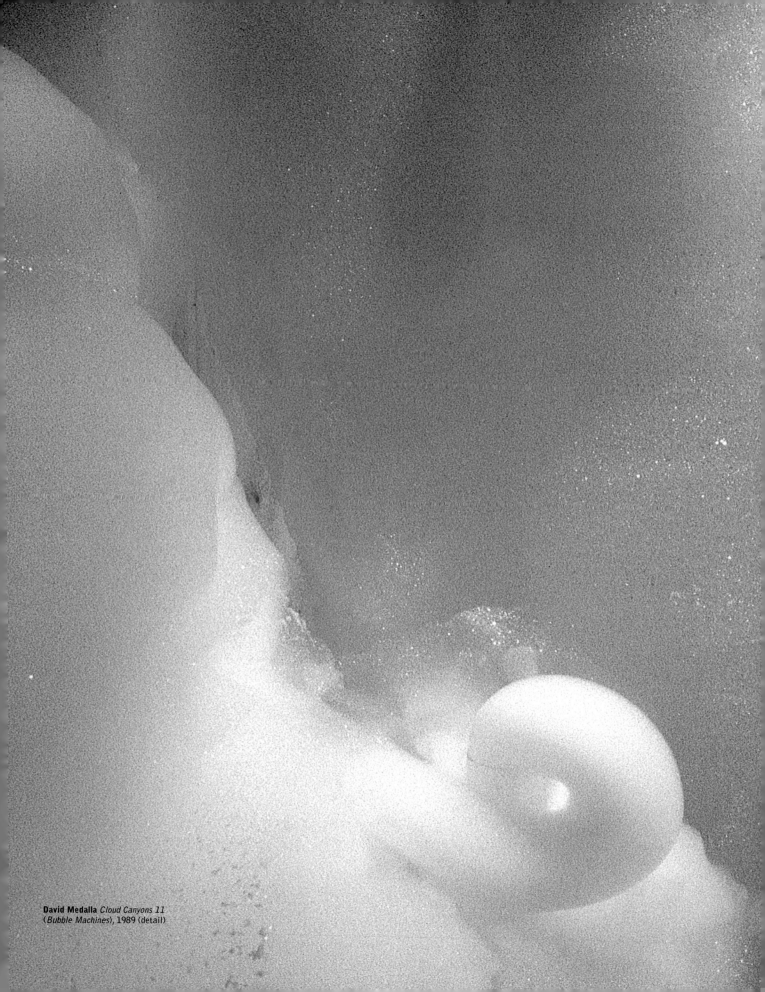

David Medalla *Cloud Canyons 11*
(*Bubble Machines*), 1989 (detail)

floor (*Narrow White Flow*, 1967–1968), or floating a square of chiffon in mid-air (*Little Sail*, 1965), liquid circulating in branching arteries of plastic tubing laid directly on the floor (*Circulation*, 1969), and so on. Haacke was more interested in the natural processes of change, interdependent systems, environmental response and instability than in making a durable object, and for this reason his kinetic work too has been unjustly neglected in the history of modern art. It can be clearly seen today how a work like Haacke's *Condensation Cube* (1963), or Medalla's *Bubble Machines* are parallel to, and offer a provocative critique of, Minimalist sculpture. Minimalism had freed itself to some degree from the element of individual expression and taste by cultivating various systems of cellular, serial, uniform and repetitive structure. The plain white boxes of Medalla's early foam machines acknowledged this tenet of Minimalism, but the emerging foam disturbingly exceeded these orderly and static forms and introduced quite a new and dynamic understanding of the cellular and repetitive. The same can be said of Haacke's cube, which challenges the inert presence of the mass of the conventional sculpture in its environment by precipitating its formal elements from the air itself!

Hans Haacke *Narrow White Flow,*
1967–1968 Photo Hans Haacke

Linear and Cyclical (or Speed and Stability)

To be more accurate one might say that the kinetic object and the static sculpture are moving at different speeds. The sculpture is undergoing a slow process of change and decay, whatever the museum does to arrest it. One of the achievements of kinetic art was to reveal the subtleties in the phenomenon of speed and time, as an experience generated between work and spectator. The early work of Pol Bury, for example, plays on the kind of attention span that an exhibition-goer normally gives to a work. Out of this comes the surprise that a cluster of stems or balls which seemed static suddenly makes a small movement, or there is a seething of activity close-to that was not visible from a distance. For Eugene Ionesco, writing on Bury's work in 1966, this revelation of instability in what was assumed to be stable, was frightening, and he mocked the illusion of the ordered universe that humans cling to.[67] For Bury, however, the kind of movement he engineered, the particular speed he fabricated, was an indicator of freedom: "Between the immobile and mobility, a certain quality of slowness reveals to us a field of 'actions' in which the eye is no longer able to trace an object's journeys … Only the quality of slowness allows [an object] to obliterate its own tracks, to be an eraser of memory, to make us forget its past … journeys avoid 'programmatisation' to the degree that they are endowed with a quality of slowness; they finally achieve a real or fictional liberty, a liberty acting on its own account and for its own pleasure."[68]

The white wood reliefs that Sérgio Camargo made in the 1960s do not move, but they incorporate into their structure the movement of light, either the actual movement of a light source, or the numberless changes of quality and intensity of daylight from day to day and season to season. It is light which reveals them as another type of energy field, one in which volume has been broken down into particles. Each particle has the same constituent features, a curved surface and an angular plane, which allows the light falling over the relief to be both firmly articulated and softly diffused. The elements combine and recombine endlessly in a matrix on the borderline between order and disorder, the geometric and organic. In a sense Camargo's energy field can never be experienced in a museum because its 'speed' is adjusted to the everyday world and is obliterated by the museum's optimum and constant lighting conditions.

Kineticism, therefore, has woven into the usual linear experience of time (things simply aging), one that is also cyclical. The introduction of external sources of energy into the works meant that, although the material objects might age, they themselves are endlessly renewable. There would always be fresh gusts of wind, or currents of electricity, or the spectator's hand or body, to bring the present moment back into a material object which was no longer of the present moment. I believe that the new experiences generated by this combination of linear and cyclical senses of the passage of time in relation to the work of art have barely been discussed. They are one of the unprecedented aspects of these art forms which were wasted or dropped from view as art fashions changed. In the case of recent exhibitions reviewing Takis's work of the 1960s, for example, this experience has been particularly poignant, perhaps because the inevitable mellowing which always takes place with art works has not happened with electricity before. It is as if the raw force (elemental) was reborn within the manners, the turn of phrase, the formal relationships of a particular epoch, providing a fascinating retake on history.

'Speed/stability' was the dichotomy underlying one of the great creative collaborations of the post-war period: Jean Tinguely's and Yves Klein's *Vitesse Pure et Stabilité Monochrome* (Pure Speed and Monochrome Stability, 1958). Like Takis's *Man in Space*, this was one of the audacious events which Iris Clert staged at her gallery in a moment of intense creative energy in Paris in the late fifties and early

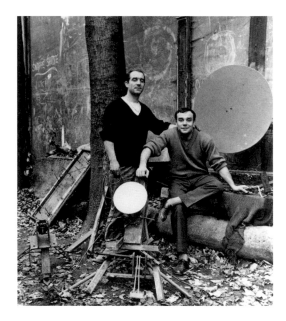

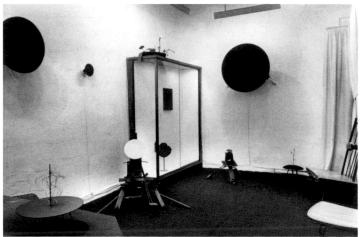

Jean Tinguely and **Yves Klein** *Vitesse pure et stabilité monochrome* (Pure Speed and Monochrome Stability) at the Galerie Iris Clert, Paris, 1958 Photo Robert David

Tinguely and **Klein** at Tinguely's studio, Impasse Ronsin, Paris, 1958 Photo Martha Rocher

sixties. In photographs of the time the gallery interior has the raw look of a rough and ready laboratory. Objects constituting the most incongruous combination of machinery and painting squat on the floor or cling to the walls. In another photo, the sculptor and the painter appear to be interrupted in the midst of their collaborative endeavour and face the camera, Tinguely with a length of electric cable in his hand and Klein holding a paint roller. There is that air of pride in the 'moment of discovery'. Essentially it was a moment of the dismemberment of old notions of space and the boundaries of artistic genres, and the discovery of a new concept of space/time through this clash of painting and sculpture. One machine is called *The Excavator of Space*. Each machine has a monochrome disc of a different size, a different colour (white, blue or red), spinning at a different speed (from 450 to 10,000 revs. per minute). An eye-witness described the scene at Tinguely's studio, a short while before the works were moved to the gallery:

"Then our whole attention was caught, hypnotically, by the rotating disc, which was clearly revolving so fast that it appeared to be standing still. 'Vitesse stabilité!' Tinguely proudly declared ... The optical sensation sprang from the transformation of the rotating disc into a volume. A virtual, immaterial volume that seemed to hover over the rusty iron contraption like a tiny cloud of colour. I exclaimed: 'It's pulsating, it's breathing, it's moving, it's expanding, it's turned into thin air!' And Yves beamed, and Tinguely danced on the spot, revolving on his own axis and beating his breast."[69]

While in motion painting maintained its quality of contemplative stasis (evoking the 'void' that Klein had proposed a few months previously by emptying the Iris Clert Gallery, painting it white, and opening it as his exhibition); but while transcendental it remained anchored in the world of everyday exertion and bricolage represented by Tinguely's machines. Some massive lumps of iron stabilised the spinning discs and absorbed their vibrations. Tinguely called this the "chassis".[70] The combination may explain the vaguely anthropomorphic appearance of these objects, with Klein's disc as the dreaming head and Tinguely's mechanics as the workaday body.[71]

Elevated and Base

The Tinguely-Klein collaboration suggests that any consideration of artists' models of the universe would have to give equal importance to a strain of exaltation and a strain of down-to-earthness in the human psyche (without attributing either quality exclusively to particular individuals). A tendency towards the other-worldly and sublime is constantly checked by a Dada spirit of debunking, which usually implies a protest against pretension, dogma and oppressive authority in whatever field. (This combination would in fact be very similar to the approach of many ancient techniques of truth-seeking and enlightenment.) Yves Klein stressed the immaterial. His monochromes were 'zones of pictorial sensibility' ("stabilisées, amovibles, et expansible à l'infini").[72] He identified himself with the void and with the leap into space. Pierre Restany has movingly described Klein's visionary enthusiasm and the effect it had on him:

"Very rapidly, I understood what fascinated me about him, it was the realism within utopia, within myth, the pragmatic side of a fundamental intuition. Klein's great emotional power made him extremely sensitive to the phenomenon of cosmic energy circulating freely in space [...]. It was close to what appeared to me to be the emotional affectivity of an entire era in transition, which I saw building itself before my eyes. This power of energetic impregnation was contagious and it was by means of this contact that I freed myself from all my traditional points of reference. Klein taught me to think larger, to see further, to feel more deeply."[73]

Interestingly enough, Jean Tinguely was inspired by his collaboration with Klein to expose the motors he had previously hidden behind the visible surfaces of his works. From being the unseen driver of the formal elements, the motor, 'heart of the organism', in Restany's words, "will become the emotional catalyst of his works".[74]

From 1958 to around 1960 was a extraordinarily innovative period in Tinguely's work, and really marked the stages of his move from 'pure forms' to 'junk'. His *Meta-Malevichs* and *Meta-Kandinskys* (c. 1955) set in motion the elements of geometric abstraction (albeit with a wit that immediately distinguished them from the more solemn, science-inspired examples of kinetic art). Then came works which though modest in size and not so well known among Tinguely's oeuvre, are marvellous studies of kinetic energy. In the *Variations for Two Points* (1958) the points dart about over the disc like crazed particles. The wire tangles of the *Indeterminate Constants* (1959) produce virtual volumes of great delicacy. Eventually the found scraps which had already begun to appear among the elements of the meta-reliefs blossomed in the *Balubas* (1960–1961).

Tinguely had travelled in Africa and Brazil before making the *Balubas*. Besides the obvious inspiration of dance, Tinguely felt engaged politically. Seventeen states had newly emerged from colonialism in Africa in 1960 and the continent was rocked by the aftershocks of independence. According to Pontus Hulten, "Tinguely took a particular sympathetic interest in the fate of the headstrong Patrice Lumumba (of the Baluba people of the Congo) [...] It was in a combination of irony and respect for a confused and struggling people that Tinguely chose *Baluba* for the large series of sculptures he had started."[75] I will not try to improve on Hulten's description of the Balubas' *joie de vivre* already given (elsewhere Hulten also mentions the presence of Niki de Saint-Phalle, who had met Tinguely in 1956, as a decisive influence on the achievement of precisely this quality). I will only note the artist's own excitement and complete absorption in the possibilities of movement. He had no need to make drawings, he said, because in that "période des fous":

"It was by means of machines that I could do things differently. I could draw directly in space, with the materials themselves. It was very simple. I always used the same motor (a Lilliput), with a reducer (gear), always turning at the same speed: I think it was about 100 rpm; and this 100 rpm was inevitably tortured in a thousand different ways. I made experiments, I beat up the motors, I put together the most incongruous materials. That was the Balubas!"[76]

One of the elements of magic in Tinguely's machines is that they confound apparently opposed qualities within one another. The impression of complete ramshackle chaos is achieved with functional relationships which are extremely precise. In essence each work is a complete organism: there are no inert parts, no hidden computerised controls and so forth. At bottom is the electric motor whose uniform, repetitive motions are transformed into gestures of anarchic freedom. Items from the vast mass of rejected material that accompanies civilisation are minutely re-animated by the finesses of the carnival dancer, the strolling player, the clown. Tinguely often said that he shared with Dada "a certain distrust of power". He was against all forms of oppressive authority, an attitude which he felt was general and expressed a "politique de base".[77] It is above all in the *Balubas* that Tinguely is capable, as Hulten writes, of "elevating to the sublime the abject and despairing aspects of everyday life".[78]

This we can certainly equate with a 'model of the universe'. And Hulten's words fit perfectly other models in the exhibition, which, in either overt or subtle ways, mount a dialectic of the elevated and base: Medalla's extraction of radiant, cloud-like forms from soap and water, or calligraphy from mud, Soto's pairing of the immaterial vibration with the lump of matter, Manzoni's *Achromes*, Schendel's nucleic paper *Droguinhas* (Little nothings), Gego's late *Dibujos sin Papel* (Drawings without Paper), Wols's etchings, and so on.

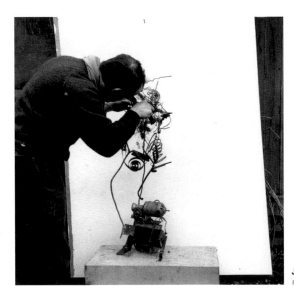

Jean Tinguely early 1960s
Photo Vera Spoerri

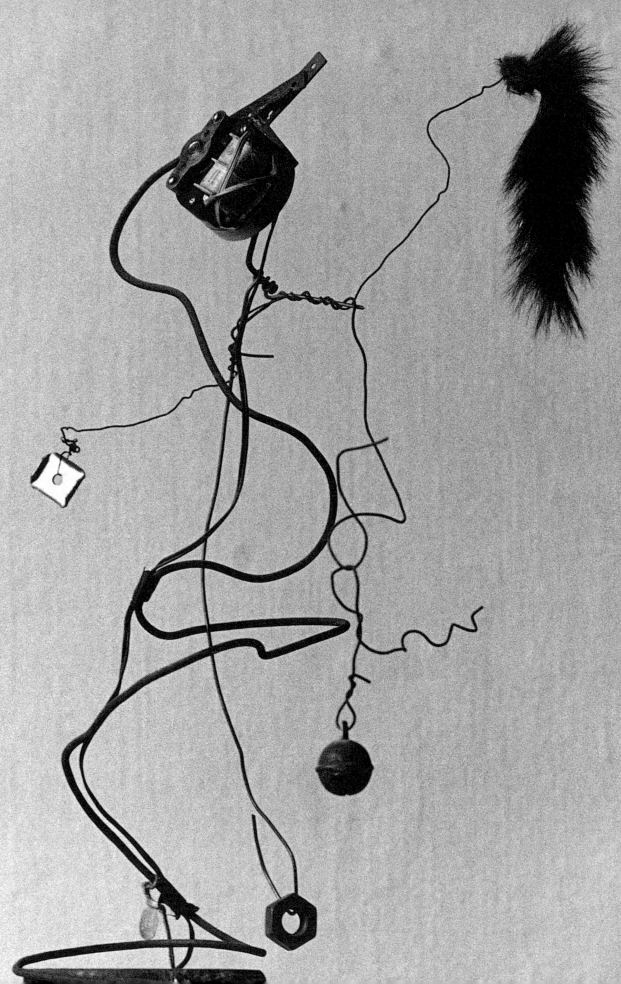

Jean Tinguely *La Folie*
(Madness), 1961

Sign and Trace

The problematic we raised about the relationship of force of nature to aesthetic choice obviously has a corollary in the static media of painting and drawing. There is, in fact, an ongoing parallel between the 'visualisation of energy' in the scientific and in the artistic domains, since science has recourse to graphic devices to make visible to the eye phenomena that are beyond human vision. Our experience of the 'forces of nature' is in so many instances today a graphic one, mediated through seismographs, remote sensors, bubble-chamber photographs, encephalograms and so forth. Artists have in the past sometimes replied by offering up their canvas as a straightforward blank surface to receive the imprint of natural energies, such as Yves Klein's *Cosmogonies*, one of which was an attempt to capture wind patterns by strapping a still-wet canvas to the roof of his car on a journey from Paris to Nice (a somewhat quixotic gesture), or his fire paintings. The relationship between a literal trace and a sign – a configuration with pre-thought and more complex meanings – therefore becomes multivalent and ambivalent, with traces acting as signs and signs acting as traces. In the tran*script*ion of energies drawing often approaches *script*, or writing.

An overview of this area of fruitful uncertainty would stretch from Michaux and Fontana to Pollock, Matta-Clark and Schendel and would include eastern artists like Atsuko Tanaka and Li Yuan-chia. The borderline between transcription and script is particularly interesting because it makes for comparisons between artists raised in cultures where drawing and writing are traditionally connected (such as China and Japan) and Westerners deeply sympathetic to those examples (comparisons which certainly do not lead to simplistic or polarised relationships, a point which will be returned to). It is first of all a surprise to find how directly the awareness of energy has been translated into graphic form in drawing between the fifties and seventies. These bodies of work are not so well known as they might be, for example Fontana's scribbled 'turbulences', Matta-Clark's 'Arrow' and 'Energy-form' drawings, or Tanaka's studies connected with her *Electric Dress* (1956), drawings somewhere between circuitry and calligraphy. These expressions are connected by their dynamic rather than by historical moment or geographical locale.

Gordon Matta-Clark's drawings are a little-known aspect of his work. The remarkable series based on the 'arrow' is a sort of crazy mixture of expressive gesture and diagram. It is as if the process whereby forces of nature (or social interactions) are notated and schematised, 'calmed' as signs, to become part of an orderly human discourse, had been reversed and signs were turning back into traces again.

In many of these drawings, powerful trajectories mingle with tiny eddies. The construct of the arrow explodes line into scores of directional vectors simultaneously. Traces of natural forces like those obtained by scientific instruments are intensified by the artist's vision. Information on Matta-Clark's drawings and their place in his oeuvre is scarce, but hints that they were produced rapidly one after another in a mood of concentrated energy ring true.[79]

Another series, the *Energy-form Drawings*, were originally pages of a notebook and repay being exhibited as a group, since individual compositions flow rapidly one after another in a morphology of movement. Some drawings contain words which suggest they could be linked to dance performance, but they may equally be taken as the traces of particles: their level of abstraction encompasses both. If Matta-Clark, Fontana and the Japanese artist Atsuko Tanaka place the emphasis on the graphic figure itself, in other artists' work it is the emptiness of the sheet which is important, as the Brazilian artist Mira Schendel said of her monotypes of the mid-sixties:

"I would say the line, often, just stimulates the void. I doubt if the word stimulate is right. Something like that. But what matters in my work is the void, actively the void."[80]

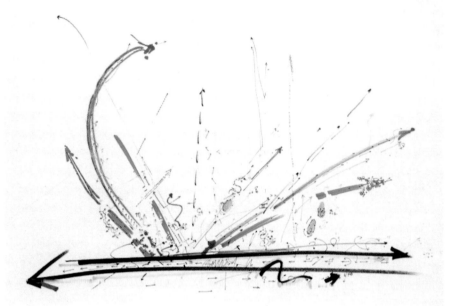

Gordon Matta-Clark
Drawing (Arrows), 1973–1974
Courtesy Generali Foundation, Vienna
Photo Werner Kaligofsky

Schendel reiterates in new terms a characteristic principle of Chinese literati landscape painting, a tradition in which Li Yuan-chia was educated in Taiwan in the 1940s and fifties. By the early sixties Li was working in Italy as part of a group with connections to Fontana and Manzoni: there he simplified his calligraphy to often tiny marks on monochrome surfaces (either of paintings or scroll-like books). This tiny dot in the empty field Li conceptualised at the 'cosmic point'. In its relationship to the space around it, it signifies the beginning and end of creation, all and nothing.

An Yves Klein *Fire Painting* seen in an exhibition today bears only a remote relationship to the actual circumstances in which this series of works was originally produced. Klein began them during his exhibition at the Museum Haus Lange in Krefeld in 1961, as imprints taken from the two startling phenomena that dominated that show. Set up in the garden was a wall of flame produced by a grid of 50 gas burners, and, nearby, a huge plume of fire rising from the earth. Immediately after the show Klein was able to work in the testing centre of Gaz de France in Plaine Saint-Denis, outside Paris, using the advanced equipment there, a situation whose dramatic possibilities he exploited to the full. He was both filmed and photographed directing a huge blow-torch in an extravagant transformation of the traditional image of the painter before the canvas.

In a sense Klein theatricalised the whole action of the painter in order to expose its limitations. After all, he referred to the physical objects he produced as "the ashes of my art": a phrase almost literally true in the case of the *Fire Paintings* since they were formed on the point of being consumed. If we accept his position, his 'art' was immaterial. It was the propagation of an attitude of mind in which an acceptance of the void, and of space, would lead humans to another, freer, manner of inhabiting the earth. Nevertheless, the hundred-odd *Fire Paintings* he produced have a history in the sense that they evolved from a literal trace of the rosettes of the gas-burners at Krefeld to subtly nuanced surfaces whose cloudy monochromes metaphorise the interstellar spaces.

The trace/sign dialectic reaches a fascinating suggestiveness with the works by the British artist John Latham included in the exhibition. These are from a series called *One-Second Drawings*, produced in the early 1970s. Assuming the tradition of painting/drawing, the making of marks is pulled into a new era by Latham's proposition. He throws into a new light the relation of the artist's will to random events, the operation of time in the process of creation, and the search for a visual equivalent for the new understanding of the physical cosmos. A Dadaist humour in searching for this equivalent among the mundane practical processes of our everyday lives is also present.

The *One-Second Drawings* were made with one-second bursts of paint from a spray-gun onto assorted panels. These panels were discarded off-cuts of wood collected from timber-merchants' floors, "indeterminately-edged surfaces"[81] rendered hard, white and smooth by the artist. Anyone could operate the spray-gun of course: what strikes one immediately is the infinite and incalculable diversity of the marks produced by this brief, supposedly automatic action. We are drawn in to examine the most minute visual phenomena: dots and yet tinier dots. We are sensitised, not by the artist's aesthetic sense, but by such simple evidence of the wonder of the incommensurable. A resemblance to photographs of galaxies and star clusters is obvious and noteworthy, but Latham disturbs a tendency to read the image illusionistically or romantically by stamping each panel, sometimes over the marks themselves, with a record of its fabrication. The stamp gives the time and date of the drawing, the 'operator's' initials, and the mysterious word "Noit". 'No-it' (no thing – nothing: another void) is the reverse of the English '-tion', the suffix which converts verbs into abstract nouns. By reversing it, "language is used against itself … an activity defies its own definition … in order to challenge the process of turning actions into things".[82]

In general, if I interpret him correctly, Latham believes verbal language is inadequate to describe the 'dimensionality' of the universe because it is constituted by the common-sense view of the relation of objects in space. Latham would like to move consciousness beyond this to a time- or event-based structure. The universe is temporal before it is spatial, in Latham's view, as is suggested in contemporary physics which sees the universe as an "event arising from and terminating at a dimensionless point".[83] By the startling 'plurality of worlds' that can arise from one-second jets of art's traditional liquid medium, Latham apparently seeks to bring to awareness, and to redress, a duality which privileges space over time.

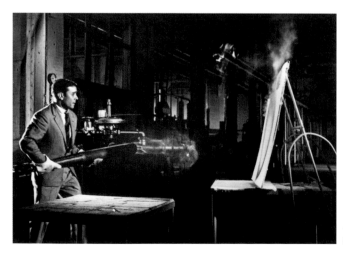

Yves Klein 'painting with fire' at the testing centre of Gaz de France, 1961

John Latham *Five Noits (one-second drawings)*, 1970 (detail)

Continuum

We arrive in fact at a mysterious crossing-point of signs that hover between pattern and pulsation, between order and chaos, will and surrender. In his *Misérable Miracle*, Michaux wrote that he harboured a "desire above all others". "I would like a continuum. A continuum like a murmur, never ending, similar to life, which is what keeps us going, more important than any other quality."[84] One can see implicit here a critique of traditional representation with its hierarchical composition, its firmly delineated boundaries, its glut of images and symbols. Michaux evokes the continuum Mondrian achieved with his resolution of nature's contraries into a structure of 'plus-minus' lines. Indeed Mondrian himself was pleased on one occasion when a viewer compared his painting with the rhythm of breathing. Looking at a picture this person had turned to Mondrian and said simply, "Je respire", and Mondrian wrote later to a friend: "That's exactly what it should be in my view, namely that one breathes, feels free, through seeing a canvas."[85] But where does Michaux's quality "similar to life" lie? Where does the notion of a continuum acquire the ability to make us feel free, and where does it turn into a pattern of repetition without vitality? Mondrian was acutely aware of this problem. In 1919 he produced two 'checkerboard' paintings, apparently the first announcement in 20th-century art of a complete 'all-over' distribution on the canvas. In considering why Mondrian abandoned this discovery as soon as he made it, Yve-Alain Bois suggests that Mondrian realised "that for an artist it is impossible to reject entirely the arbitrariness of composition". Composition, Mondrian himself wrote, "leaves the artist the greatest possible freedom to be subjective – to whatever extent this is necessary". "[Mondrian] has the courage," Bois continues, "to abandon a formidable gesture, noncompositionality, on which artist after artist would dwell after World War II" (Mondrian did in fact return to it at the end of his life in a different way).[86] The kind of inertness Mondrian feared did become only too familiar in the fields of kinetic and concrete art, but it was not strictly speaking the result of adopting an all-over system. One can point again to the presence of paradox, and sometimes irony, as an essential part of the poise that individual artists achieved between 'pattern and pulsation'.

Thus Gerhard von Graevenitz's reliefs are uniform and dull when static: it is the movement between the elements which creates the continuum of nuance which, within these strictures, never repeats. In dom sylvester houédard's *Typestracts* of the 1960s ('visual poems' made with a typewriter), it is the repetitive, unidirectional and standardised nature of the writing machine which becomes the agent of a fluid space and fluctuating densities. dom sylvester houédard (he always wrote his name in lower case) was a Benedictine monk, poet, artist, and one of the most remarkable intellectuals in Britain. He developed a unique compressed prose style to theorise the discoveries of kinetic art and concrete poetry. In the work of Dieter Roth, early examples of which are represented in the exhibition, one finds a form in which the surface of the book page or print is only one layer in a graphic continuum that extends both laterally from page to page and vertically, by means of holes that descend into the body of the book, and sometimes by overlays of collage and re-photographed material (the anticipation of computer-printing in both houédard's and Roth's work of the fifties and sixties is remarkable and is one of those instances where technology has not surpassed the quality of an artist's experimentation). Roth is another artist whose work is impossible to contain within the canonical compartments of 20th-century art history, which, in his case, extends from matters of style and material to media of communication, since he made "artist's books, paintings, poetry, graphics, sculpture, music, installations, letters and postcards".[87] In the fifties and sixties Roth experimented with permutation in both 'clean' constructivist forms and 'messy' biological or organic figures.

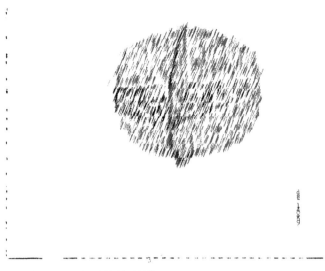

dom sylvester houédard *Untitled,* 1969

For their part, Piero Manzoni's *Achromes* seem to find a point of poise between emptying the canvas of "artificial colours and unnatural significance", as he wrote in 1960, and reconstituting its surface as 'white light' to reconnect it with the material world with an implied limitless extension.[88]

Sol LeWitt made a number of drawings in the 1970s which seem naturally to 'fit' within the remit of this exhibition, while at the same time being somewhat atypical of the artist's work as a whole. Their procedure follows LeWitt's method described in the celebrated 'Paragraphs on conceptual art' (1970), a "form of art [where] all the planning and decisions are made beforehand and the execution is a perfunctory affair".[89] Thus: *Vertical Lines, Not Straight, Not Touching* (1978) or *Ten Thousand Lines, 5" Long, within a 7" Square* (1971). However, for all the apparent aesthetic indifference of its conception, perceptually LeWitt's procedure resulted in a series of 'energy fields' varying subtly in their visual qualities, in such a way that their titles, by a process of reciprocity, resonate with a sense of the richness of phenomena. Perhaps this is what LeWitt meant when he referred to the connection in his work between a 'simple idea', the 'simplicity of a cube', for example, and "the chaotic materialisation of a great deal of form".[90]

The Venezuelan Gego's work is a beautiful example of a dialogue between 'system and sensibility' in pursuit of a continuum, (as well as being a signal contribution to abstract art which is still barely known in Europe). Gego (her appellation is a contraction of her original name Gertrud Goldschmidt) was a Jewish refugee from Nazi Germany who came to Caracas in 1939 at the age of twenty-seven. Her work developed in the atmosphere of Venezuela's post-war modernising boom, its optimistic architectural and urban renewal schemes, based on constructivist principles and fed by oil revenues. She remained, however, somewhat quiet and apart from this movement's creation of new artistic heroes, while carrying out, nevertheless, one or two distinguished environmental commissions in Caracas. The notion of a continuum is announced in Gego's work by the use of repetitive geometric elements in non-hierarchical compositions. At first these elements are arranged in parallel configurations, rigid, with a somewhat massive metallic presence (relative at least to the delicacy of her later works). From objects merely occupying space, her works become, increasingly, indicators of space, keeping the systematic rationale of their structures while at the same time articulating them with growing flexibility and fluidity.

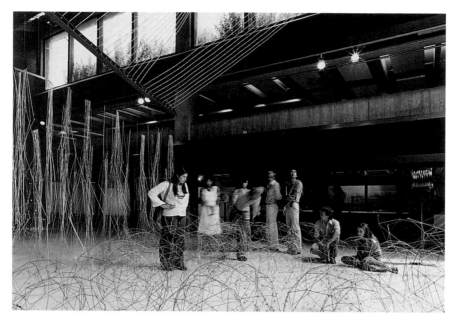

Gego Exhibition at the Museo de
Arte Contemporáneo, Caracas, 1977
Photo Paolo Gasparini

This is expressed in Gego's system of joints and links, entirely personal to her. Rings, loop attachments, small tube joints and clamps mark the meeting and crossing-points of lines. One might call them visual equivalents of the 'node', as a universal principle of physical and biological structures, carried out with graphic beauty and technical simplicity. Gradually, from packs of unidirectional lines which could be mounted on a base, she moved to aerial webs and nets based on a triangular module, suspended from the ceiling or attached to the walls, culminating in the marvel which is preserved in the Galeria Nacional de Bellas Artes in Caracas: *Reticulárea ambiental* of 1969. Here, in a white space with curved walls, the visitor can walk in and be surrounded by these metallic webs forming a structure, in Hanni Ossoff's words, "open and of infinite modulation".[91] Gego is another artist with a particular way of playing on the relationship between a structural model and an aesthetic object. The objective transcription of a system of forces (with parallels in physics, biology and engineering) is continually tested and teased by a subjective, emotional imagination, especially at the points where these lines of force meet and cross.

Her testings were made as much in drawing as in sculpture: indeed her late metal sculptures are called *Dibujos sin papel* (Drawings without Paper). Here, apparently, order and system collapse into a few fragmentary twists of wire on faltering frameworks. They might look expressionistic if one were not aware of how they evolved step by step from the geometric rationale. Paradoxically, through what the critic Luis Pérez Oramas calls Gego's "abject transmutations [of the] imaculate constructivist image",[92] the presence of structure, the 'murmur' of a continuum through an indeterminate space, is intimately felt in these precarious works.

Mechanics and Optics

In 1920 Marcel Duchamp made, with Man Ray's help, the *Rotary Glass Plates*. Four glass rectangles of different lengths mounted on a spindle and legs, marked at the ends with slightly curved black and white lines, revolved at speed, producing the illusion, for the viewer facing it, of a single continuous disc. Five years later Duchamp made another machine, his *Rotary Demi-Sphere*. A half-sphere painted with off-centred concentric circles produced powerful spiral effects in the viewer's vision as it revolved. Duchamp called these experiments, collectively, *Precision Optics*. He later extended the principle with his multiple *Rotoreliefs*, so-called because the circular movement of the painted cards on a turntable produced a virtual three-dimensional relief form. The critic Robert Lebel gave great significance to what he called the passage from the retinal to the optical in Duchamp's work. It marked for him the definitive abandonment of the painterly tradition (in which Duchamp had made his earlier experiments in depicting motion, such as *Coffee-Mill* (1911), and *Nude Descending a Staircase* (1913)), and the adoption of motorised motion. Duchamp professed himself interested in the physiological aspects, the creation of a third dimension optically. Lebel compared the *Rotary Demi-Sphere* to a huge Cyclopean eye, but was also interested in the broader 'idea' behind the work: the introduction into art of time through the fourth dimension. This was cemented in the combination of optics and the machine.

In 1922 László Moholy-Nagy started work on his *Light-Space Modulator*, another optical machine. There is a very natural transition between the actions of the *Light-Space Modulator*, the black-and-white film he made based on its movements, projections and reflections – a masterpiece of abstract film – and his photograms. Franz Roh's description of the photograms in 1930 could equally serve for the other two phenomena: "Weird spheres of light, often of marvellous transparency, that seem to penetrate space. Sublime gradations, from gleaming white through a thousands shades of grey down to deepest black, can be produced thus. And by intersection either extreme nearness, or the most distant distance is suggested."[93] The marriage of light, optics and the machine forms a distinct pattern in the 20th-century if one considers the experimental drive of the avantgarde in its widest form. The attempts to perfect a 'colour organ' (visual music), from Thomas Wildred to Charles Dockum; the invention of special cameras, projectors and printers, from Raymond Hains's *Hypnagogoscope* to the 'home-made hardware' of animated film-makers like Norman McLaren, Oskar Fischinger, or the Whitney brothers; Len Lye's alternating production of abstract film and kinetic sculpture; the isolated and largely unsung experiments of Abraham Palatnik in Brazil ('cinechromatic' machines, begun in the 1950s), and P.K. Hoenich in Haifa ('sun projections', or Robot Art, from the 1960s); the light machines of Le Parc or Liliane Lijn. If all these machines are considered for what they have in common, whether we place them in the category of autonomous

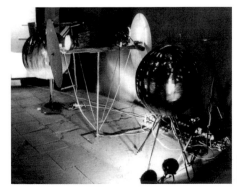

Otto Piene *Light Ballet*, 1963
for the exhibition *Europäische Avantgarde*,
Frankfurt 1963

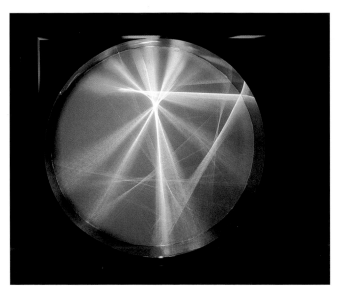

sculpture, or instrument, or tool,[94] we begin to see why for Len Lye the defining characteristic of kinetic art in the broad sense was its emphasis on motion rather than the object.

A large number of light machines loosely revolve round the notion of a screen and projection (the screen carrying memories of the painting surface). If we look at Liliane Lijn's *Liquid Reflections* (1966–1967) or Julio Le Parc's *Continuel-Lumière-Cylindre* (Continous-Light-Cylinder; 1962), we see how imaginatively this may be interpreted. The basis for both works, essentially, is a beam of light and a motor which merely revolves. In *Liquid Reflections*, the movement of the disc, of the liquid within the disc, the circulation of the acrylic balls above, in counter-movement, together and apart, the reflections generated between all these bodies, combine to impart an intense freshness to the light. In the Le Parc, a light beam enters into a circular mirror-edged arena placed vertical to our sight. It is only the interruptions to this beam produced by the slow counter-movement of two irregular fan blades out of sight below the relief that creates the endlessly intricate deployment of lines of light across the surface. Similarly, Grazia Varisco's *Variable HGsuAL (Mercuriale)*, 1964–1965, produces its sense of optical liquidity by the motorised interaction of two surfaces which become one to the human eye.

P. K. Hoenich spent a large part of his life experimenting with 'sun art', while working as Professor in the Department of Architecture of the Israel Institute of Technology in Haifa. He never tried to market or claim copyright in his invention, preferring to publicise it in lectures, and journals like *Leonardo*, since he considered it a tool or method, freely available for other artists to take up and develop. He invented a system of manipulable reflectors and filters to produce patterns from sunlight on the walls of a darkened room. Sometimes he manipulated the apparatus himself, sometimes he left it to operate as a robot, "a kind of cosmic film-projector, with the sun its lamp and the earth its motor that moved rows of reflectors relative to the sun".[95] Film and photographs survive from these experiments. What is especially intriguing here is the curious combination of nature and artifice. Building no doubt on chance effects of reflection noticed in everyday life, Hoenich's machine reveals unexpected structures within the medium of light. The normal fall of sunlight on the earth is interrupted and is somehow transformed into a 'galactici-sation' or 'micro-cellularisation' of sunlight. This was evidently a crucial matter of balance: best when the

artist resisted his 'artistic' inclination to over-orchestrate the natural (another instance of the problematic relationship between force or nature and aesthetic choice).

According to Jack Burnham, Len Lye's 'tangible motion sculptures', presented in April 1961 at the Museum of Modern Art in New York, were "the first successful type of motor-driven kinetic sculpture in the United Sates."[96] Since Lye has been absorbed into the historical category of kinetic art, it is difficult today to recapture the sense in which his appeared at the time a unique, almost eccentric figure, out on a limb of his own. On the other hand, it has become clear today the extent to which 'kinesthesia', as a principle of life-experience, and as the "basic element of abstract expression prevalent in 20th-century art",[97] informed everything Lye made, from films, to machines, to doodle-drawings. He looked at the nature of each medium very differently, but this itself can be seen as an aspect of his particular sensibility for motion. Thus the bounding metal of *Universe* (1963), or *Blade* (1972–1976), can be placed without awkwardness beside the fitful figures of light emerging from blackness in *Particles in Space* (1957), Lye's last film, made by scratching directly on the celluloid strip. While the sculptures are thoroughly corporeal and aural (Jack Burnham accurately described Lye's work as giving out "a feeling of barely harnessed physical power – half material and half pure energy"[98]), the latter is purely optical. *Universe* was originally called *Loop*, Lye changed the title when a small boy said its sound made him think of the universe. The best description of this extraordinary work is Lye's own:

"*Universe*, a 22-foot strip of polished steel, is formed into a band, which rests on its back on a magnetised bed. The action starts when the charged magnets pull the loop of steel downwards, and then release it suddenly. As it struggles to resume its natural shape, the steel bounds upwards and lurches from end to end with simultaneous leaping and rocking motions, orbiting powerful reflections at the viewer and emitting fanciful musical tones which pulsate in rhythm with *Universe*. Occasionally, as the boundless loop reaches it greatest height, it strikes a suspended ball, causing it to emit a different yet harmonious musical note, and so it dances to a weird quavering composition of its own making."[99]

Two films by James Whitney, *Yantra* (1957) and *Lapis* (1966), are included in the exhibition as exhibits on a par with those of other artists. This is partly to stress a continuity between abstract film and other kinds of art object, and partly because Whitney's films are a perfect elucidation of this exhibition's theme. Connections between abstract film and the 'mainstream of modern art' have been

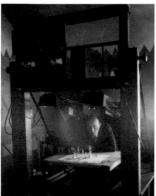
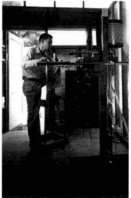

Thomas Wilfred with the first home *clavilux*, 1930 Photo courtesy Sterling Memorial Library, Yale University New Haven, Connecticut

Oscar Fischinger in his studio, Munich, 1924–1925

James Whitney with sound pendulums, 1944 Photo courtesy William Moritz

James Whitney at his optical printer, California, 1945 Photo courtesy William Moritz

minutely researched and eloquently expressed by the Californian poet and critic William Moritz. Much of it is a secret history: Moritz reveals, for example, the part played by Thomas Wilfred's clavilux, and his 'colour music', in Jackson Pollock's formation as a painter.

For Moritz, James Whitney is "one of the great masters of visionary cinema."[100] Whitney grew up in California at a particularly interesting period, not only for his own art form (Fischinger had moved there in the mid-thirties and Whitney became part of a circle that included like-minded film-makers like Jordan Belson and Harry Smith), but for his whole outlook. He was strongly attracted both to scientific theories of the universe (the Californian Institute of Technology was then a centre for advanced physics and perceptual physiology) and eastern philosophy and spirituality (fermenting in a Californian matrix through the presence of figures like Krishnamurti and mystical-leaning writers, artists and musicians like Aldous Huxley, Arnold Schoenberg, Allan Watts, and of course the Beats and hippies).

All cinema is of course kinetic. Much abstract cinema, as well as the 'cinechromatics' of visual artists, is close to the formal languages of abstract painting or photography. What makes Whitney's films quite different and radical is his destruction of form, its atomisation so to speak, into optical energy fields. He searched for a long period for his language. First he experimented with reducing "movement-form" to a modular system, patterned after the twelve-tone serial principles of Schoenberg. Then he worked with a "form alphabet" consisting of "all possible movements as pairs of opposites: Vertical/horizontal/diagonal, straight/curved, positive/negative, fast/slow, connected to the frame edge/not connected to the frame edge", and so on. Finally, "a thought occurred that a better solution was to break movement structure down to its simplest component which is a point (or dot)". Thus, "a space was created in which the intensification and volatisation of particles was the constant condition".[101] This is a precise description, of both *Yantra* and *Lapis*. *Yantra* is more explosive in its molecular dynamics, and *Lapis* more centred within its ceaseless transformations, its paradox of stillness and flow, in the manner of a mandala.

The time differential between the process of making *Yantra* and its running time is quite staggering: eight years, according to Moritz, as against eight minutes. The dot patterns were made with pin-pricks of light pierced through thousands of seven- by five-inch cards. Whitney developed the film by hand and polarised sections of it. In *Lapis* Whitney was able to use a computer to position the dots accurately for minute gradations of movement, but the film was still largely handmade. Whitney approached the making of films with disciplined craftsmanship, itself a form of spiritual exercise (it's interesting that in between work on his films Whitney practised *Sumi-e* brush painting and made *raku* ceramic ware). *Yantra*, he wrote, was "basically a creation myth, an attempt to bring about a unity of cosmic happenings and inner psychic happenings, a bringing together of outer and inner realities."[102]

Thus Whitney approaches in his own way the riddle of universe and mind. Descriptions can slip easily from analogies with galaxies and atoms to the film as "a vast metaphor of neural activity in the visual system of the brain"[103] (*vide* Michaux). Mind, however, for Whitney, was a meeting-point of the physical and spiritual. His later films, up to his death in 1982, move increasingly towards simplicity, towards the pure white void of projection light and "an infinite plasmic sea of movement."[104]

The transition from the retinal to the optical that Lebel celebrated in Duchamp still seems applicable to Whitney's working process (much abstract film appears to go back to the retinal in Duchamp's sense: even so, it has never been intimately connected with the history of 20th-century painting in the way it deserves). In particular, there is a connection, as William Wees points out, between the imagery in Whitney's film and phosphenes, afterimages, and other 'subjective visual phenomena'.

Wees writes: "What is 'on the screen', as distinct from what is 'in the eye' becomes increasingly hard to distinguish" (true also, incidentally, of Soto's 'vibrations' in painting).[105] This opens up the whole question of the physiology of vision, and the relationship therein between human imagination and neuronal energies. As Jonathan Crary describes in his book *Techniques of the Observer: On Vision and Modernity in the Nineteenth Century*, a study of afterimages was taken up by Goethe and continued by the Czech scientist Jan Purkinje in the early 19th century. Purkinje made drawings of his own closed-eye visions which bear striking resemblances to both macrocosmic and microcosmic phenomena. The import of Purkinje's studies, as Crary pointedly observes, was to indicate "the paradoxical objectivity of the phenomenon of subjective vision. Were we able to see the original drawings in colour, we would have a more vivid sense of their unprecedented overlapping of the visionary and the empirical, of 'the real' and the abstract."[106] In the end we cannot tell where objectivity ends and subjectivity begins, and vice versa. As Helmholtz sardonically remarked in the 19th-century, "even now there are many of the phenomena described by Purkinje which have never been seen by anyone else."[107]

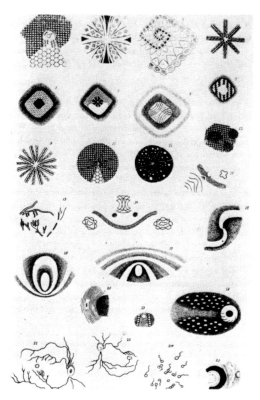

Jan Purkinje *Afterimages,* 1823 Courtesy MIT Press, 1990

László Moholy-Nagy *Untitled drawing,* 1945

Eye and Body

The concentration on optics, the visual sense, as a vehicle for the exploration of movement and space/time, can be exploded, even from within visual art itself, by another tendency. Indeed, the premise for the 'techniques of observation' which Crary analyses in his book, from the Renaissance to the 19th century, is the separation of the visual from the other senses, the eye from the body. This is epitomised in the device of the *camera obscura* and all its progeny, the dark room in which one obtains an image of the living world while being bodily cut off from it. Crary makes his analysis in a critical spirit of wishing to supersede this dichotomy between eye and body. In this his thoughts connect with the experiments of certain artists since the war. Devices which disturb, or manipulate, the body's sense of space through a play on the optic nerve – such as Gianni Colombo's work in Italy, or the participatory games of the Groupe de Recerche d'Art Visuel in Paris in the sixties – lead on to the much more radical reorientation of our bodily experience, and our thinking, proposed by Lygia Clark.

Gianni Colombo's *Spazio elastico* (1967), is exactly what its title implies. The perceptual experiment is accomplished with the elegance of pure abstraction. A grid structure of fine thread is set up within a dark cube which can be entered by the viewer, who sees only the lines, picked out by ultraviolet light. Motors mounted in the walls gently pull the grid into certain deformations, instantly changing our co-ordinates for reading the space we are in. Effectively, Colombo leads us back to an awareness of the body by a total isolation of the visual sense and its ingrained habits, dependent on the conventions of linear perspective and sight-lines. By contrast, many of Lygia Clark's works make us aware of our other senses and the totality of our bodies by blocking the visual sense, or by turning it inward and submerging it in the sensorium as a whole. Thus her *Sensorial Hoods* (1967), made of cloth and other materials, hold a cluster of sensations close to the eyes, ears and nose, and her *Abyss Masks* (1968), which hang upon the head and cover part of the body, incorporate a blindfold, so the participant feels a powerful sense of volume, space, weight, etc., not distanced by sight, but in close contact with, or even 'inside', the body.

Gianni Colombo *Spazio elastico*
(Elastic Space), 1967

Lygia Clark *Máscaras abismo* (Abyss Masks), 1968
Photo (above) Michel Desjardins, (right) Guy Brett

Why abyss? To answer this one has to consider the evolving conception of space and time which can be followed through Lygia Clark's works of the fifties and sixties. "I began with geometry but I was looking for an organic space where one could enter the painting," she said.[108] All Clark's early works deriving from concrete abstraction question the boundary between inside and outside, between the set-aside, or fictive, space of the 'painting' and the rest of the world. Clark constructs relations of fluid exchange between these entities:

"The space [in the *Unidades*, a series of abstract reliefs of the late fifties] then becomes revealed as a moment of the surrounding space.[109] [...] What I wished to express was the space itself and not to compose within it."[110]

Rather than simply apprehend the fluidity of that space through planar equivalents, Clark then took the radical step of suggesting that the 'spectators' create it themselves in time, through their action. This was her proposition *Caminhando* (Going; 1963). One glues a strip of paper into a Mobius loop, takes a pair of scissors and after making a hole cuts along the strip continuously as it unfolds ("If I use a Mobius for this experiment it is because it breaks our spatial habits: right/left, above/below, front/back, etc.").[111] All her participatory works follow from this.

Clark's address to the 'spectator' was always in the mode of an invitation to play, complex thoughts crystallised by a very simple model. Nevertheless, she was much preoccupied by what she saw as the profound implications of a departure from the 'plane', as a human construct situating us in space and time. It was both frightening and potentially liberating to escape "the laws of spiritual gravity". "Contemporary man ... learns to float in the cosmic reality as in his own inner reality. He feels overcome by dizziness. The crutches which supported him fall from his arms. He feels like a child who has to learn to steady his balance in order to survive".[112] Like all Lygia Clark's manipulable, or "relational" objects, to use her term, the *Abyss Masks* mediate between a sense of inner and of outer space. In Lula Vanderlei's words, they "dissolve the notion of surface and are lived in an imaginary inwardness of the body where they find signification."[113] A challenge by a visual artist to the separation of eye and body initiates a process by which the cosmos becomes interiorised.

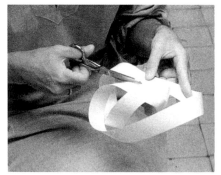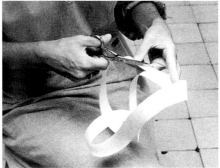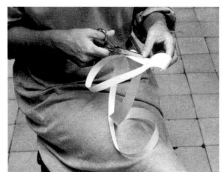

Lygia Clark *Caminhando* (Walking), 1963 Photo Felicio Beto

Containment and Expansion

Lygia Clark's *Air and Stone* (1966) invites you to take a clear plastic bag in your hands, inflate it, seal it with a rubber band and place a pebble in one of its cavities. As you press the bag between your hands the weight of the pebble counteracts the weightlessness of the air, and vice versa, in a perpetual opposition which is communicated sensuously, as another body analogous with your own. Absurdly simple. One of the characteristics of the 'model' of space, or of infinity, that artists produce is that it has to be conscious, often wittily conscious, of the impossibility of its task. This means a consciousness of paradox, for example to suggest the limitless through a strict imposition of limits. Or deliberately to hide what cannot be shown. This was Manzoni's strategy in his *Linee*, or Lines (begun in 1959), which consisted of lines drawn in ink on rolls of paper of various lengths which were then sealed in cardboard tubes and labelled. Manzoni wrote: "The nature of the *Lines* is eternal and infinite, the concept is everything. I put the *Lines* in a container so that people can buy the idea of the *Lines*. I sell an idea, an idea enclosed in a container".[114] Obviously, the paradox here is connected with the problem of comprehension: the process by which a figure of the known and familiar can expand in the receiver's mind into the unknown. In the 1960s David Medalla liked to quote certain Buddhist teachings as an example, such as the metaphor Buddha would use in order to explain the length of one *kalpa* – the life-span of one cosmic system:

"If you imagine a cube of solid rock which is four metres square, and at the end of every century a man were to stroke it once with a fine piece of Benares muslin, the rock would be worn away before the kalpa came to an end."[115]

This may explain why artists have been so fond of the device of the container, the box, or even the book, in contemporary art. Of course, the notion of the book as the 'container' of an idea, or ideas, raises a host of further perspectives, to which the huge variety of 'artist's books' already testifies. Returning again to the theme of the universe, I received a particularly powerful impression from Agnes Denes's *Book of Dust*.[116] It falls neither into the genre of scientific treatise, nor of literary reflection, but is really a conceptual work of art, which attempts to draw out a credible connection between the scale of our lives and the scale of the cosmos by proposing that everything is made of dust: a simultaneous apprehension of composition and dissolution which is already encapsulated in the book's title.

Two of the most sophisticated developments of the idea of the container in recent art have been Robert Smithson's *Vortex* boxes, and *Site/Non-Site* works, and Hélio Oiticica's *Bolides*. They represent a moment of convergence between two artists, presumably unknown to one another, whose trajectories were very different but actually have a number of subtle affinities. Smithson's inaugural *A Non-site, Pine Barrens, New Jersey*, followed some four years after Oiticica began his *Bolides* in Rio de Janeiro, but Smithson's explanation of his rationale has echoes of Oiticica's concept: "the bins or containers of my *non-sites* gather in the fragments that are experienced in the physical abyss of raw matter," Smithson wrote.[117] Smithson's works at this period were structured around a dialectic between the 'gallery space' and the rest of reality. *Four-sided Vortex*, 1965, is a box containing mirror-planes in crystalline clusters. As one gazes down into it, one finds, in Smithson's own description of a comparable work, "a concatenated interior. The interior structure of the room surrounding the work is instantaneously undermined. The surfaces seem thrown back into the wall. 'Space' is permuted into a multiplicity of directions."[118] In the later *Non-site* works, the severe contrast between rocks brought from the unseen place, usually the chaotic site of an abandoned mine or mineral deposit, and the orderly rectilinear boxes, photographs and maps of the gallery installation, turns out, the more one thinks about it, to be a reciprocal structure of complicities and mirrorings.

Hélio Oiticica *Bólide vidro 4 Terra*
(Glass Bolide 4 Earth), 1964

'Bolide' translates from Portuguese as 'fire-ball' or 'meteor', immediately suggesting the idea of a blazing energy-source. As an object Oiticica's *Bolide* was a class of container: a bottle, box, bag, basin, bed, flask, and so on (perhaps human culture is an endless series of containers and frames!). Some of the boxes were to be opened and explored, such as *Box Bolide 9* (1964), albeit containing certain spaces which could not be reached, or light that was seen only by reflection. One Bolide appealed to the sense of smell (*Olfactic*; 1967), a large bag which released a smell of coffee through a tube. All operated by giving a quantity of material a new presence as part of the world by the contradictory act of removing it and isolating it in a container. The early *Bolides* were ravishingly beautiful in the intensity of their mass of colour pigment, but very soon Oiticica extended the concept to include "appropriations" of objects from the natural and social context. He took, for example, a wire basket of eggs, a builder's barrow of gravel, a flask of shells, and the flame burning in a roadside marker. He designated these latter works by the Portuguese verb 'estar', to be, "as a quality of things as they are in themselves" in contrast to 'ser', to be as a quality of beings. "I call these *Bolides* 'Estar' [because] I want to draw attention to their real meaning as immanent structures", he wrote.[119] Later he extended the idea again with *Area Bolides* (1968) and the *Bed Bolide* (1968): nuclei of action, leisure or reverie, where the spectator could physically enter and stay. In essence these were spaces set aside with fairly simple delineations and qualitative differences. Oiticica described them as 'open' works. He wanted the participant to "act" upon these areas, "looking for 'internal meanings' within himself rather than trying to apprehend external meanings or sensations".[120] They provided a "mythical place for feelings, for acting, for making things and constructing one's own interior cosmos".[121] The idea of an 'interior cosmos', linked with the notion of corporeal lived experience, was the special contribution of the Brazilians Clark and Oiticica.

Ephemerality and Monumentality

The essence of paradox is that it reveals itself by contraries. An aspect of the 'impossible' is the impossible stasis which the art institution — museums, the art market — imposes on the object and the thought or action embodied in it, against the reality of time and transformation. Oiticica was very aware of this and always tried to incorporate his earlier work within some schema or framework which would renew it according to his current ideas. Thus, eventually, he produced a *Counter-Bolide*. It was called *To Return Earth to Earth* (1979). In a small ceremony attended by some friends, he took a bare wooden frame to a desolate patch of wasteland in the city of Rio de Janeiro, filled it with black earth brought from another site and then removed the frame so that the volume of earth stayed on the earth. The original act of removing matter to form a nucleic object was reversed and matter went back into circulation and the general flux. The object (the frame) was the minimum necessary to register the concept and had no meaning outside the action. The old *Bolide* was buried and a new one arose. The dialectics involved are fascinating: here the negation of containment renewed the process of expansion in the mind.

By re-rendering a durable object as an ephemeral act, Oiticica pinpointed one of 20th-century art's inner struggles. How does a perception which is all the time veering away from monumentality — "from mass to motion" (Moholy-Nagy), "emphasis on motion rather than the object" (Lye), etc. — deal with the legacy of the monument? It was not as easily escaped as might be imagined. The monument edges back at a certain point into the work of many 'kinetic' artists, into Calder for example, even into Tinguely. In Venezuela kinetic art even became an official national style, resulting in a series of public commissions which compelled an incongruous re-marriage with monumentality. The terms of the conflict are very subtle and once again laced with paradox. For example, Medalla's *Bubble Machines* play an ironic game with monumentality. They pour out sculptural form in profusion, and on any scale from the art gallery to the public square, but incipient monumentality literally evaporates into the air as continuously as it is formed. Mira Schendel made an analogy between Medalla's foam and her *Droguinhas* ('little nothings') of the mid-sixties: cellular or nucleic 'sculptures' made by rolling up and knotting the rice paper she was using in her drawings She considered them "in open opposition to the 'permanent' and 'ownable'". They were never meant to be kept: the conundrum was that "whoever 'owns' it won't let it 'be'".[122] Nevertheless they were kept. Today these ephemeral things which were almost thrown away have increasingly come to appear as powerful concentrations of energy, possessing a density and charge quite belied by their fragility.

Hélio Oiticica *Contra Bólide. Devolver a Terra a Terra* (Counter-Bolide. Returning Earth to Earth) Rio de Janeiro, 1979
Photo Andreas Valentin

Mira Schendel *Droguinha* (Little Nothing), 1965

Fontana's life work could be read in terms of a struggle between the crafted, durable work of art of tradition (a tradition into which Fontana was born since his father was a monumental sculptor; Fontana himself made funerary monuments in his youth in Argentina and later allegorical sculptures for the Italian state) and the negation of this tradition implied in his 'Spatial Concept'. Fontana was well aware of the relativity of durability, saying: "In the face of eternity art that lasts only a minute is just as valid as an art that lasts a millennium."[123] He had great technical gifts but also a suspicion of technique. His best achievement, he felt, was his 'discovery' of the hole (a void, the part of his work without material substance) because it fulfilled his belief that art should take 'thought' forward.

Tinguely's relationship with monumentality is intriguing too. After the early period of his discovery of movement, culminating in the wild and ephemeral Balubas, and the self-destruct ensembles ('anti-monuments') like Study no. II for an End of the World (Nevada desert, 1962), which he described as "a lunatic end to everything monstrous in the world", Tinguely's work became more massive in its form, more restrained in its movement, more sober in its colouring (Bascules, etc.). If the Balubas had a youthful joie-de-vivre that Tinguely never really surpassed, it may be because his work accompanied closely the stages of his life and its changing sources of inspiration. Certainly the 'monumentality' of Tinguely's large-scale late machines like Cenodoxus, inspired by Mathias Grünewald's "Isenheim Altar", is convincing and deeply moving, shot through as it is with carnival humour and an awareness of death.

An artist like Gego, on the other hand, was 'monumental' in her youth and produced her lightest and most dematerialised work in her old age. In a curious way the ephemeral/monumental dialectic links with that of the contained/expansive. The conundrum of setting limits, arranging the frame, cannot be escaped and it involves everyone responsible for mediating and contextualising an artist's work, even after their death, and including the writer of this essay. The 'monument' may be imposed later on a production which was originally 'ephemeral'; conversely the energy may be drawn out again from a body of work apparently exhausted by consumption (Oiticica's strategy). Some artists have been highly conscious of exhibition-making: Yves Klein for example. The ensemble of his famous 1961 Krefeld show was minutely planned by him. He criticised his own first showing of his Monochromes at the Galerie Colette Allendy in 1955. They were arranged in a group and, as a result, he felt the public were "reassembling the paintings as components of a polychromatic decoration. They could not enter into the contemplation of the colour of a single painting at a time".[124] In other words, they could not feel what Restany called "the density of their optical radiance".[125] Klein's concept of space was close to that of sacred space. Fontana devised public installation, or environmental, versions of the current stages of his Spatial Concept, making his work appear very differently from the way it does in a posthumous retrospective today. Lygia Clark vociferously denounced collectors and lenders of her early manipulable Bichos who refused to allow them to be touched. On the other hand, Henri Michaux presumably had little thought for the exhibition of his Mescaline Drawings when he was producing them. They were the reportage, the notebooks, of an experiment. Yet how they are framed and grouped today would seem intimately to affect the perception of their energy.

Material and Spiritual

In Michaux the scientific experimenter or clinician could hardly be separated from the spiritual searcher. And this inevitably leads to another pair in these clusters of contraries. It is remarkable with what ease terms that have been used in the characterisation of 'kineticism' – energy, vibration, space, time, cosmos – can be traded between the scientific world and that of the occultist or spiritualist fringe. Has one group hijacked them from the other? If so, which one? Most commentaries on James Whitney's films have stressed his spirituality (Taoist, Buddhist, or alchemical) as the inspiration of his life and work, but his imagery can as easily be seen as a cinematic equivalent of the structure of matter. Whitney's position has a considerable history in modern art. Recent studies testify to the simultaneous interest in scientific theory and spiritual or mystical theory (especially of a Buddhist-derived kind), at a popularised level, among artists in the avant-garde centres of Paris, Moscow, Munich and New York in the early part of the last century. Mondrian's celebrated interest in theosophy, on the one hand, and Malevich's interest in beliefs about an n-dimensional geometry, on the other, could be taken as co-ordinates. According to Maurice Tuchman, Malevich's Suprematist works "were intended to represent the concept of a body passing from ordinary three-dimensional space into the fourth dimension".[126] The scientific and the mystical could be said to converge in the pursuit of energy, but this energy could only be approached through some relationship to the tradition of artistic representation. Tuchman was concerned to trace a history of "the spiritual in abstract art", and therefore to make a 'spiritualist' reading of works he defined as abstract. Accordingly, he included many works which make obviously spiritual references – to sacred geometry, 'thought forms', cosmic diagrams and other symbolisations or illustrations of the spiritual. (An equivalent could have been done if the desire had been to trace a history of the 'scientific' in abstraction).

In the event the thematic bias only serves to make more clear the distinction between such work and that of, say, Mondrian, Malevich, or Albers. These artists rejected traditional representation and proceeded from a rigorous and rational, 'materialist' analysis of the pictorial order: the surface, frame, edge, plane, colour, line. There was implied, or openly stated, the view that inherited codes of representation covered over elementary energies contained, for example, in horizontal/vertical relationships (Mondrian), in the interaction of colours (Albers), or in black and white (Malevich). And yet it is still hard to know if the new visual energy released in their work is 'material' or 'spiritual', the result of a quasi-scientific investigation of the real, or of an imaginative vision. Artists themselves were often remarkably (or necessarily) ambiguous on this point, wavering between the artistic and scientific. Vantongerloo, as we have seen, could at one moment say that his constructions and paintings were entirely the result of mathematical calculation, and at another that art such as his could give insights into the "structure of the universe" which could not be communicated "by any other than aesthetic means".

The authors of the *White Manifesto*, advocated the primacy of matter, yet also spoke of the importance of the philosophical/spiritual notion of the void. This position seems remarkably similar to that of the Gutai Group artist Jiro Yoshihara, writing in the first *Gutai Manifesto* (1956): "The material is not absorbed by the spirit. The spirit does not force the material into submission. [...] Keeping the life of the material alive also means bringing the spirit alive, and lifting up the spirit means leading the material to the height of the spirit."[127]

Indeed, what is especially striking about the period covered by this exhibition, in the social and historical sense, is the large number of artists interested in or inspired by eastern thought, usually by some combination of Buddhism, Zen and Taoism. It is remarkable for crossing geographical/cultural

boundaries and also those of the isms of art. Examples of those represented in *Force Fields*, either well-documented or that I know of personally, would include Clark, Fontana, houédard, Klein, Li Yuan-chia, Lijn, Medalla, Michaux, Oiticica, Palazuelo, Schendel, Takis, Whitney and Wols. Eastern influences would usually be combined with others, and with cultural sources from the artist's own origins (if we are speaking only of 'western' artists). In fact, these amalgams of cultural influences in the late 20th-century are so complex they can only be approached with a sense of relativity, and even of the incongruous. How does one compare, for example, the impact of Zen on western artists like houédard or Klein; on an eastern but displaced artist like Li Yuan-chia, who travelled from mainland China to Taiwan, then to Italy and then to Britain where he lived for thirty years; or on a western but displaced artist like Mira Schendel, who was born in Zurich, moved to Italy and went at the age of thirty to live in São Paulo (a city with a large Japanese community; she practised meditation with a Zen community there and was equally involved with western religious thought and philosophy)?

One thing we can be sure of is that such phenomena explode the simplistic patterns of Eurocentric art history. The broad map of experimentality in the 1950s and 1960s, as well as the specific thread of 'cosmic speculation' we have linked it to here, bypassed the hegemony of the Western cultural institution in ways which have never been properly recognised or discussed. Any list of major or minor figures in the tendency loosely called kinetic art would consist of people born at all points of the compass, with considerable emphasis on countries of the third world. In relation to this phenomenon it would be absurd to claim for North America the dominance of post-war art it is usually given. Kinetic work expressed the notion that there is no one centre. It was a focus for the aspirations of diverse peoples to be absolutely modern, to speak in universal terms, and to evolve further the contemporary perceptions of space and time. This process often involved artists in a critical dialogue with both the dominant culture and their own intellectual, ethical and spiritual inheritance, in terms of ways of conceiving of a human relationship to the universe.

Contingency and Infinity

Perhaps the best way of linking the investigation of energy with the pervasive influence of eastern philosophy is to invoke the Taoist notion of 'Qi'. 'Qi' is considered to be untranslatable into a single English word, but it can be taken to refer to that of which everything in the universe is composed, accepting that matter and energy are interchangeable ('Qi' is "matter on the verge of becoming energy, or energy at the point of materialising."[128]) As a concept, or a reality, 'Qi' crosses without hindrance between the fields of philosophy, art, spirituality, natural science and medicine. It could inform both the elegant vitality which the calligrapher sought to achieve in his brush-stroke, and the psychosomatic functioning of the body. And as such it could provide a metaphor for the efforts of 20th-century artists to reconcile the contingent and the infinite. In this exhibition we have stressed the 'infinite' side of the equation, the speculation on, or longing for, in Agnes Denes's words, "nature beyond human laws and lines of demarcation".[129] Such a state of mind was eloquently described by Gaston Bachelard in terms of reverie: "When a dreamer of reveries has swept aside all the 'preoccupations' which were encumbering his everyday life, when he has detached himself from the worry which comes to him from the worry of others, when he is thus truly the author of his solitude, when he can finally contemplate a beautiful aspect of the universe without counting the minutes, that dreamer feels a being opening within him. Suddenly such a dreamer is a world-dreamer. He opens

himself to the world, and the world opens itself to him."[130] (Obviously, to be 'universal', Bachelard's 'he' should be de-gendered here).

It would not be hard to divide the history of 20th-century art between apparent representatives of the 'infinite' and the 'contingent'. Mondrian could stand for the first and an artist like John Heartfield for the second. If Mondrian sought the equivalent of a harmony of universal energies in the visual field, Heartfield deconstructed and reconstructed the dynamics of the visual image to intervene directly in the nitty-gritty of human political and social affairs. Yet these two great artists hardly deserve a simplistic pigeonholing. Mondrian's effort, according to his friend Charmion von Weigand, was to evolve "a conceptual structure of the twentieth century which would be liberated, flexible and equilibriated"[131] – a 'model' in other words, capable of many interpretive applications in the minds of his viewers. Mondrian himself prophesied an art dissolved into life. Defining the relationship of art to the social is always open to paradoxical reversals. Again, it would be easy to contrast the engagement of Heartfield with the celebrated 'indifference' of Duchamp, but could not the following description of Duchamp's practice also apply to John Heartfield's *exposé* of the rhetoric of dictators, exploiters and bigots? "In his purpose of 'changing the definition of art' Duchamp had no power to exclude, he could only widen the language, only make us more aware that art is all-pervading."[132] To "widen the language of art": certainly, what Heartfield, Mondrian and Duchamp had in common was a notion of creativity and efficacity beyond the confines of the museum, whether they decided to contest directly (with appropriate wit) the museum's function of narrowing creativity, or intervened more broadly in social and environmental structures (or a combination of the two).

In *Force Fields* it was decided to accept the museum's limitations, or rather to profit from the museum's set-aside, contemplative space, in order to intensify the visual and spatial energies in the artists' works, the particular class of objects they have made. But *Force Fields* could equally have been an anthology of interventions in the 'contingent' (a documentary anthology): interventions of many different kinds and occurring at different moments in an artist's life-history. It would have represented the Moholy-Nagy, for example, not only of the *Photograms* and *Light-space machine* but the pedagogic and activist Moholy-Nagy who, whenever he mentioned a formal or artistic innovation always went on to discuss its social possibilities. He always looked at art in a participatory sense. It would have represented

 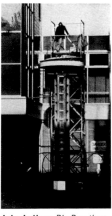 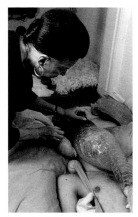

Takis *The Perpetual Motion Bicycle Wheel of Marcel Duchamp* (a study for Sea Oscillation), 1968

John Latham *Big Breather*, 1973

Lygia Clark, *Terápia (Estrutura-çao do self),* (Therapy [Structuring of the Self]), Rio de Janeiro c. 1976–1982 Photo Sergio Zalis

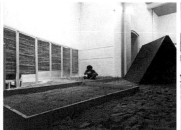

Agnes Denes *Wheatfield – A Confrontation,* 1982 Two-acre wheatfield planted and harvested by the artist on a landfill in Manhattan's financial district, a block from Wall Street, near the World Trade Centre, and facing the Statue of Liberty across the Hudson. Public Art Fund Commission

Hélio Oiticica *Eden,* 1969 Whitechapel Art Gallery, London. Photo John Goldblatt

Yves Klein and **Walter Ruhnau,** design for a climatised environment with an air roof Drawing by Claude Parent and Sargologo, 1959

the Vantongerloo of the airport and bridge projects. It would have continued with the next generation and considered how artists' respective cosmologies emerged in forms of social intervention.

Takis would be seen, for example, as an activist both in the politics of the art world and in the field of technology. On 3 February 1969, in a small but seminal gesture, Takis removed by force one of his sculptures which had been exhibited at the Museum of Modern Art in New York without his consent. His assertion of artists' right to control their work came at a moment when groups like Art Workers Coalition and Guerilla Art Action Group were challenging the coercions implicit in the links between the museum and the American political and business establishment. Takis has also given a practical extension to his electro-magnetic researches. He invented a floating wheel to extract energy from the undulations of sea-waves (prototype made at MIT in 1969 in collaboration with the scientist Ain Sonin), pumps operating on photo-voltaic power to extract water from deserts and to provide water to extinguish forest-fires, and magnetic attachments to feet or wrists which regulate the body's energies (the latter two projects are both current). Takis's medical experiments form a fascinating link – quite outside the mind-set of the art world – with Lygia Clark's *Terapia,* a form of psychotherapeutic treatment using her Relational Objects, developed and carried out by the artist in Brazil between the mid-seventies and early eighties.

Again, in a link probably unknown to both parties, John Latham in Britain also invented a machine to extract energy from the sea: his *Big Breather* (1973), a 32-foot-high 'lung' to be filled and emptied by the six-hour cycle of tide levels in river-estuaries. Latham, with Barbara Steveni, was also instrumental in founding the Artists Placement Group (now O+I), a carefully theorised project for inserting artists as "incidental persons" into social and industrial institutions. Independently and separately, both John Latham and Robert Smithson planned or carried out land reclamation projects at the sites of industrial wastage in northern England and the United States respectively.

In 1982 Agnes Denes, author of *Book of Dust,* planted a wheatfield in downtown Manhattan. She called *Wheatfield* "a confrontation". "My decision to plant a wheatfield in Manhattan instead of designing just another public sculpture grew out of a long-standing concern and need to call attention to our misplaced priorities and deteriorating human values," she wrote. "To attempt to plant, sustain, and harvest two acres of wheat here, wasting valuable real estate … was an effrontery that made it the powerful paradox I had sought for calling to account."[133] A thousand pounds of healthy wheat was harvested from Battery Park landfill, at the foot of the World Trade Center and a block from Wall Street.

I doubt if a link has been made before between Yves Klein in France and Hélio Oiticica in Brazil. But for all that their political and spiritual philosophies may have differed, both were 'world-

dreamers' in Bachelard's sense. In fact Oiticica had a concept he called *World-Shelter*. It was a poetic intimation of the earth made habitable, which for him signified a kind of uprooting and wandering over the world, "to open oneself to the WORLD and experience it as LAIR, SHELTER ... "[134] For this desired state his participatory *Parangolé*, *Penetrables*, *Nests* and *Barracão* were 'rehearsals'. Oiticica's vision bears a certain relation to Klein's *Architecture of the Air*, the project he sketched out with the architect Werner Ruhnau at the end of the fifties. It involved locating all services and industries underground and 'climatising' the terrestrial space by means of air, fire and water, as a beneficent habitable nature. Klein's 'climatisation' was clearly a projection of the 'zones de sensibilité picturales' or 'climats picturaux' proposed by his monochromes. "The control of temperature", he wrote, "will become a reality when the human sensibility will be merged with the cosmos."[135] Klein saw the principal activity of his dream-world's inhabitants as "leisure". Similarly, Oiticica, in the 'mind-settlement' environment he created at the Whitechapel Gallery in London in 1969, and called *Eden*, launched the concept of Creleisure. Superseding the work/leisure dichotomy of industrial societies, Creleisure was to be a manifestation of the social "in the fullest sense of the term": "The world which creates itself through our leisure, around it, not as an escape, but as the apex of human desires."[136]

Other artists are known for the startling transformation of their 'kinetic' phases into other modes of operation. They remained true to the understanding of reality as energy-fields and dynamic systems of relationships, but they side-stepped the dead-end of the trademark commodity and the

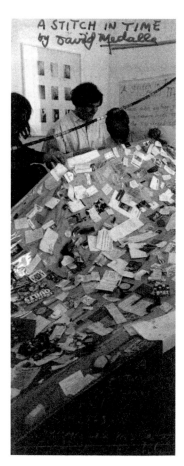
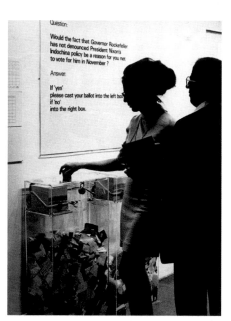

Hans Haacke *MOMA-Poll*, installation for audience-participation, 1970
Information exhibition, Museum of Modern Art, New York, 1970

David Medalla *A Stitch in Time*, 1968, participation-production-propulsion
View of version made for *A Quality of Light*, Tate St. Ives, England, 1997

monument. David Medalla, for example, described by Dore Ashton as an "authentic luftmensch" (impractical dreamer),[137] and by Yve-Alain Bois as the "inventor of virtuality",[138] has been through many incarnations in pursuit of the enigmatic connections between art and life. While keeping the universal aspect of his work of the sixties, he responded rapidly and deftly to changing times. He was one of those who saw that the nature metaphor of kinetic work could be translated to a social frame of reference without losing its essence. Medalla moved to collective, participatory art works in the 1970s which focussed creativity and were capable of unlimited growth (*A Stitch in Time*, 1968, *Eskimo Carver*, 1977). Later he turned to performance, the peripatetic author of countless impromptu masquerades which wittily investigate the projects of historical visionaries amidst the contingencies of their times.

In a parallel (but perhaps more systematic) sense, Hans Haacke also moved from nature-kinetics to 'society', keeping the model of interdependent systems and working with powerful precision and effectiveness on the disjuncture between the art space and the rest of the world. His new orientation was announced by his celebrated 'polls', the second of which took the form of an exhibit in the *Information* exhibition at the Museum of Modern Art in New York in 1970. He invited visitors to record an opinion on the implication of Nelson Rockefeller (the Governor of New York State, with extensive family connections with the running of the MoMA) in a policy of support for the war in Vietnam.

In a sense all these examples prove something that everyone already knows: that human beings are multi-faceted. The contemplation of a measure beyond human affairs does not preclude action in the human world. They can be aspects of the same person or characterise a person at different moments. The 'model of the universe' is itself always an expression of the contingencies in which it was produced.

Coda: Irony and Awe

It will seem obvious that what has been developing through all this discussion has been a system of contraries. In an evocation of the 'all' (universe), each thing or quality has been presented with its opposite, with the paradoxical suggestion that the entity that the pair form is more real, more true, than either separately. One model of this was the entity formed by the historical warring factions of *l'informel* and *le concret* (conflicts which could equally well be embodied in a single artist). The curious thing is that the pairs of contraries themselves seem endlessly inter-related: the problem of the dichotomy force of nature/aesthetic choice is a facet of the conflict trace/sign, which is a facet of the conflict hallucination/calculation which is a facet of the conflict materiality/spirituality, contingency/infinity, and so on. And it is as if all these contradictions could be aspects of another contradiction, perhaps a larger one, or perhaps the one most enveloping for this particular discussion: the distinction between reality and art. What is the relationship between them? In a definition nicely mixing the two terms, Paul Klee spoke of artistic works as "oddities that become realities, realities of art which help to lift life out of its mediocrity". We are immediately led to another duality: that between, if you like, what merely is, and what 'shines' or inspires.

The cosmic speculation of artists from the 1920s to the 1970s was not a merely passing phenomenon, but neither has it continued unchanged into the present. Instead the kind of concerns charted in this exhibition have been much affected in more recent years by a critical consciousness of the social-cultural processes of the production of meaning. If earlier artists pursued energy, contemplated space-time, in a spirit of clearing away, starting from zero, from a tabula rasa, lately artists have presented such a

search as enmeshed in culture, as inescapably mediated, as charged with a multitude of subjectivities. If one looks at a number of recent works by artists internationally, one finds an outlook on the universe which is still filled with awe, but also laced with irony.

Sometimes this irony is satirical and bitter, as in Ilya Kabakov's 1982-88 installation *The Man who Flew into Space from his Apartment*. According to Didier Ottinger, Kabakov's installation "opposes the sordid reality of a Soviet communal lodging, with its human relationships based on indifference or betrayal and that otherwere of a celestial, cosmic, or paradise world dreamed of in all traditions".[139] An empty homemade launching-chair, suspended from massive rubber bands, is spot-lit below an enormous hole in the ceiling where the inhabitant is supposed to have been ejected from the small cramped room lined with posters. The irony may be gentle and lyrical, as in Gabriel Orozco's photo-record of a 'planetary system' of oranges arranged on the empty stalls of a popular market (*Crazy Tourist*, 1991), or it may be subtle and enlightening as in Martha Fleming's intervention in the cases of the London Science Museum (*Atomism and Animism*, 1999), or it could be cool and witty like Cornelia Parker's postcard image of interstellar space made by enlarging a patch of chalk from an equation on Einstein's blackboard (a relic preserved in the Museum of the History of Science in Oxford), *Einstein's Abstract*, 1998. A somewhat similar concept, in Spain, is Joan Fontcuberta's dark, star-studded heavens made by printing the negative image of a car windscreen spotted with impacted flies. The mind oscillates between the mundane and the measureless.

The satirical edge of Kabakov's irony would not be shared, for example, by Susan Hiller, who is more likely to speak in terms of the "shared plight" of both artist and audience in living the effects of a cultural conditioning which tends to cover over or relegate to the fringes powerful forces and emotions. It is intriguing to compare the thought of entering a room filled with the detached bodies floating in space of Calder or Takis, with a space filled by the hubbub of sounds of Hiller's *Witness* (2000). *Witness* is an audio installation consisting of hundreds of tiny speakers in a tangle of wires. As one moves among them one hears voices, of different timbres, in different languages, relating numerous first-hand accounts of sightings of UFOs and extra-terrestrial beings, collected from many parts of the world. "Some of the texts are prosaic and descriptive, like legal testimony; some are visionary and marvelling; all are social facts."[140]

The 'social facts' are the multitude of tones of the reports, testifying to what is essentially a common experience of something 'beyond', greater, frightening, alluring, etc., the collective and suppressed or marginalised aspect of which has always fascinated Hiller. The universal experience here was taken as given: the artist's time and effort went into collecting the languages, locations, circumstances and subjectivities in which it was expressed. "Bringing the cosmic home", in her own words. Just as the light we see in the distant sky is 'ancient', so, in relative terms, are the concerns that Hiller wrily surveys: UFOs and encountered beings may be the equivalent of "devils, angels, government cover-ups, or chariots of the gods."[141]

If dualities will always be with us, isn't it better that our awe should be mixed with irony and our irony with awe?

1 Pontus Hulten. *Museum Jean Tinguely Basel – The Collection*. Basel: Museum Jean Tinguely, 1996, p. 156.

2 Marcel Duchamp, quoted in Denis de Rougement, *Journal d'une époque*, Paris, 1969.

3 Jesús Rafael Soto. 'Statements by kinetic artists', *Studio International*, vol. 173, no. 886, London, February 1967, p. 60.

4 Margit Staber. *Georges Vantongerloo: Bilder 1937–1949*. Zurich: Galerie Lopes, 1977.

5 Alexander Calder. 'What abstract art means to me', *Museum of Modern Art Bulletin 18*, Spring 1951, quoted in Joan M. Marter. *Alexander Calder*. Cambridge: Cambridge University Press, 1991, pp. 110-111.

6 Alexander Calder. *Calder: An Autobiography with Pictures*. New York: Pantheon Books, 1966, p. 113.

7 Alexander Calder, quoted in Marter. *Calder*, p. 102.

8 Theo van Doesburg. 'Principles of neo-plastic art', *Bauhaus book*, no. 6, 1925, p. 33. Reprinted in English by Lund Humhries, London, 1969.

9 Henri Michaux, *Misérable Miracle*. Translated by Louise Varèse. San Francisco: City Light Books, 1963, p. 36.

10 Ad Reinhardt, 1954, *Reinhardt Papers, Archives of American Art*, quoted in Helen Westgeest. *Zen in the Fifties*. Zwolle: Waanders Uitgevers, 1996, p. 77.

11 Hans Richter. 'In memory of Marcel Duchamp', *Form*, no. 9, Cambridge, April 1969.

12 Lucio Fontana, 1955, quoted in Mário Pedrosa. 'Da dissoluçao do objeto ao vanguardismo brasiliero', reprinted in Mário Pedrosa. *Mundo, Homem, Arte em Crise*. São Paulo: Editora Perspectiva, 1975, p. 165.

13 Jesús Rafael Soto, in Marcel Joray and Soto. *Soto*. Neuchâtel: Editions du Griffon, 1984, p. 46.

14 Ezra Pound. *The Little Review*, vol. 8, no. 1, London, Autumn 1921.

15 Naum Gabo. 'The Kinetic Construction of 1920', *Studio International*, vol. 178, no. 914, London, September 1969, p. 89.

16 Carel Blotkamp. *Mondrian: The Art of Destruction*. London: Reaktion Books, 1994, p. 87.

17 Alexander Calder. *Autobiography*, p. 113.

18 Alexander Calder, quoted in Joan M. Marter. 'Alexander Calder: cosmic imagery and the use of scientific instruments', *Arts Magazine*, col. 53, no. 2, October 1978, p. 108.

19 Alexander Calder. *First Almanac of Abstraction-Création*, 1932, quoted in Marter. *Calder*, p. 112.

20 Jack Burnham. *Beyond Modern Sculpture*. London: Allen Lane the Penguin Press, 1968, p. 32.

21 Margit Staber. *Vantongerloo*, p. 22.

22 Ibid., p. 23.

23 Jane Livingston. 'Introduction to Georges Vantongerloo', in *Georges Vantongerloo*. Washington: Corcoran Gallery of Art, 1980, p. 12.

24 Staber. *Vantongerloo*, p. 22.

25 Livingston. *Vantongerloo*, p. 12.

26 Max Bill. Introduction. *Georges Vantongerloo*. London: Marlborough Fine Art, 1962.

27 Georges Vantongerloo. 'Conception of Space. 2', 1960, in Anthony Hill. *Data, Directions in Art, Theory and Aesthetics*. London: Faber, 1968, p. 31.

28 Georges Vantongerloo, quoted in *Vantongerloo*, 1962, p. 8.

29 Livingston. *Vantongerloo*, p. 13.

30 Georges Vantongerloo. 'To Perceive', in Hill. *Data*, p. 23.

31 Georges Vantongerloo. 'Conception of Space, 2', in Hill. *Data*, p. 30.

32 Georges Vantongerloo, in Hill. *Data*, p. 22.

33 Staber. *Vantongerloo*, p. 27.

34 Umberto Eco. *The Open Work*. Trans. Anna Cancogni. Cambridge (Mass.): Harvard University Press, 1989, p. 88.

35 Ibid., p. 103.

36 Ibid., p. 14.

37 Ibid., p. 14.

38 Ibid., p. 84.

39 Ibid., p. 84.

40 Jean-Jacques Lebel. 'The Neuronal Dance', in *Michaux: Dibuixos Mescalínics*. Barcelona: Tecla Sala, 1998, p. 151 (English translation).

41 Victor Vasarely, quoted in Serge Lemoine. *François Morellet*. Zurich: Waser Verlag, 1986, p. 143.

42 Henri Michaux. *Infinite Turbulence*. Trans. Michael Fineberg. London: Calder & Boyars, 1975, p. 8.

43 Henri Michaux. *Misérable Miracle*, p. 30.

44 Henri Michaux. *Infinite Turbulence*, p. 7.

45 Henri Michaux. *Connaissance par les Gouffres*. Paris: Gallimard, 1967. Quoted by Victoria Combalía, in *Michaux*, p. 150 (English text).

46 Henri Michaux. *Henri Michaux*. Paris: Galerie Daniel Cordier, 1959. Trans. John Ashbery. Reprinted in *Henri Michaux*. London: Whitechapel Gallery, 1999.

47 Jean-Jacques Lebel. *Michaux*, p. 151 (English text).

48 Henri Michaux. *Misérable Miracle*, p. 88.

49 Octavio Paz. 'Henri Michaux', in *Alternating Current*. New York: The Viking Press, 1973, p. 82.

50 Wols. 'Aphorisms', in Werner Haftmann (ed.). *Wols Aufzeichnungen, Aquarelle, Aphorismen, Zeichnungen*. Cologne, 1963. English translation in *Wols Photographs, Watercolours, Etchings*. Stuttgart: Institut für Auslandsbeziehungen, 1988, p. 27.

51 Jean-Paul Sartre. 'Finger and Not-Finger', in Haftmann. *Wols*, p. 34ff. English translation in *Wols*. Cologne: Galerie Karsten Greve, 1998, pp. 112-113.

52 Ibid.

53 Ewald Rathke. Introduction. *Wols Photographs, Watercolours, Etchings*, p. 20.

54 Georges Vantongerloo. 'To perceive', *Data*, p. 23.

55 Wols. 'Aphorisms', *Wols Photographs, Watercolours, Etchings*, p. 26.

56 Pierre Restany. 'La prise en compte réaliste d'une situation nouvelle: un entretien avec Pierre Restany', *Nouveau Réalisme*, p. 18.

57 'Manifiesto Blanco (Spazialismo)', 1946, reprinted in Spanish and English in Michel Tapié. *Devenir de Fontana*. Torino: Edizioni d'Arte Fratelli Pozzo, undated (1960s), unpaginated.

58 Manifiesto Blanco. Ibid.

59 Lucio Fontana, in Tommaso Trini. 'The last interview given by Fontana', *Studio International*, London, November 1972, pp. 164-65. Reprinted in *Fontana*. Amsterdam/London: Stedelijk Museum/Whitechapel Gallery, 1988. p. 34.

60 Alain Jouffroy. 'In the centre of all things'. Trans. Sebastian Brett. *Signals*, London, vol. 1, nos. 3&4, October-November 1964, p. 4.

61 Jean Clay. 'Les Magnétrons de Takis', Paris: Galerie Alexandre Iolas, 1966.

62 In his poem Sinclair Beiles proposed that all nuclear weapons be turned into sculptures.

63 Takis, *Signals*, p. 2.

64 Wols. 'Aphorisms', in *Wols Photographs, Watercolours, Etchings*, p. 26.

65 David Medalla. 'Biokinetics: a memoir on motion', London, 1967, unpublished. Quoted in Guy Brett. *Exploding Galaxies: The Art of David Medalla*. London: Kala Press, 1995, p. 53.

66 Hermine Demoriane. 'From Kathakali to biokinetic theatre', interview with David Medalla, *International Times*, London, no. 42, December 1968, p. 8. Quoted in *Exploding Galaxies*, p. 56.

67 Eugène Ionesco. 'Pol Bury', New York: Lefèbre Gallery, 1966.

68 Pol Bury. 'Time Dilated', *Strates*, no. 3, Brussels, 1964. English translation by Simon Watson Taylor, *Studio International*, London, January 1965.

69 Heinz Mack. 'Ein Besuch, November 1958, Paris' ('A visit, November 1958, Paris'), in *Tinguely's Favourites: Yves Klein*. Basel: Museum Jean Tinguely, 1999, p. 25 and p. 17 (German and English versions).

70 Ibid.

71 Heinz Stahlhut considers that "Klein equated Tinguely … with the material and himself with the spirit" [*Tinguely's Favourites*, p. 96 and p. 40]. Klein's own account of their collaboration would seem to support this: 'The immaterial blue colour presented in April '58 at Iris's had rendered me inhuman and had excluded me from the world of tangible reality. I was an externe of the society, an inhabitant of space who could not come back to earth – Jean Tinguely perceived me in space and made the sign of speed to me, to show me the volumetric way of the return to the ephemerality of material life. This is what I called my 'rescue' by Tinguely – 'Vitesse pure et stabilité monochrome' was a triumph of deep and total collaboration' [Yves Klein. 'Vitesse pure et stabilité monochrome", Ibid., p. 113 and p. 44].

72 Yves Klein. 'Le réalisme authentique d'aujourd'hui' (1959), *KWY*, no. 11, Paris, spring 1963.

73 Pierre Restany. *Nouveau Réalisme*, p. 18.

74 Ibid.

75 Pontus Hulten. *Jean Tinguely: Méta*. London: Thames & Hudson, 1975, p. 77.

76 Jean Tinguely. 'Parole de l'artiste (extraits d'une interview recueillie par Charles Georg et Rainer Michael Mason', 1976. Reprinted in Pontus Hulten. *Jean Tinguely*. Paris: Centre Georges Pompidou, 1988–1989, p. 361.

77 Jean Tinguely. 'Tinguely parle de Tinguely (extraits d'une émission de la Radio-Télévision belge)', 1982. Reprinted in Pontus Hulten. *Jean Tinguely*, p. 362.

78 Pontus Hulten. *Jean Tinguely: Méta*, p. 308.

79 The artist Mary Heilmann recalls: "Even when he was making drawings, he would work in a state of frenzy. His face would get determined ... and he'd do a little devil dance. He'd take coloured pencils, dig in, press real hard and fast, and would scribble along. I loved those writing pieces. He would do that automatic writing in a way that was otherworldly, mysterious." (Joan Simon, interview with Mary Heilmann. *Gordon Matta-Clark: A Retrospective*. Chicago: Museum of Contemporary Art, 1985, p. 141).

80 Mira Schendel, letter to the author, 1965.

81 John Latham, in conversation with the author, 19 August 1999.

82 John A. Walker. *John Latham: The Incidental Person – His Art and Ideas*. London: Middlesex University Press, 1995, p. 110.

83 John Latham. *Event Structure: approach to a basic contradiction*. Calgary: Syntax, 1981.

84 Henri Michaux. *Misérable Miracle*, quoted in Lebel. *Henri Michaux*, p. 150.

85 Piet Mondrian, quoted in Hendrik Matthes. 'Aphorisms and Reflections by Piet Mondrian', *Kunst & Museumjournaal*, vol 6, no 1, 1995, p. 57-62.

86 Yve-Alain Bois. 'The Iconoclast', *Piet Mondrian*. Milan: Leonardo Arte sri., p. 342.

87 Ann Goldstein. 'Dieter Roth', *Dieter Roth*. Chicago: Museum of Contemporary Art, 1984, p. 9.

88 Piero Manzoni. 'Free dimension', *Azimuth*, no. 2, Milan, 1960. Reprinted in *Piero Manzoni*, London: Serpentine Gallery, 1999, pp. 130-132.

89 Sol LeWitt. 'Paragraphs on conceptual art' (1970), in *Critical Texts*. Adachiara Zeri (ed.). Roma: I libri di AEIVO, Incontri Internazionali d'Arte, 1994.

90 Andrew Wilson. 'Sol LeWitt interviewed', *Art Monthly*, no. 164, London, March 1993.

91 Hanni Ossoff. *Gego*. Caracas: Museo de Arte Contemporaneo, 1977, p. 90.

92 Luis Pérez Oramas. 'La invención de la continuidad', in *La Invención de la Continuidad*. Caracas: Galería de Arte Nacional, 1997, p. 19.

93 Franz Roh. 'On 60 Fotos by Moholy-Nagy', Berlin: Klinkhardt & Biermann, 1930. Reprinted in *Moholy-Nagy*, ed. Richard Kostelanetz. London: Allen Lane the Penguin Press, 1971, p. 49.

94 "We looked upon toolmaking as a natural aspect of our creative occupation. We treated this facet of endeavour with respect, designing with care even the appearance of an instrument, for example." John Whitney, quoted in *Film as Film: Formal Experiment in Film*. London: Arts Council of Great Britain / Hayward Gallery, 1979, p. 152.

95 Hoenich. 'Sun Art', *Leonardo*, London, vol. 19, no. 2, 1986, p. 123.

96 Jack Burnham. *Beyond Modern Sculpture*, p. 269.

97 Len Lye. 'Is Film Art?', *Film Culture*, no. 29, Summer 1963, p. 38.

98 Jack Burnham. *Beyond Modern Scupture*, p. 269.

99 Ibid., p. 270.

100 William Moritz. 'James Whitney', *Sightlines*, vol. 19, no. 2, winter 1985–1986, p. 25.

101 James Whitney, quoted in Takashi Teramaye, 'Towards being choicelessly aware: conversations with James Whitney', unpublished interview, 1974. With kind permission of the archives of La Cinémathèque Québécoise, Montréal.

102 Ibid.

103 William C. Wees. *Light Moving in Time: Studies in the Visual Aesthetics of Avant-Garde Film*. Berkeley: University of California Press, 1992, p. 141.

104 James Whitney. 'Towards being choicelessly aware...'.

105 Williams Wees. *Light Moving in Time*, p. 144.

106 Jonathan Crary. *Techniques of the Observer: On Vision and Modernity in the Nineteenth Century*. Cambridge, Massachusetts: MIT Press, 1990, p. 104.

107 Quoted in Nicholas J. Wade (ed.). *Brewster and Wheatstone on Vision*. London: Academic Press, 1983, p. 228.

108 Lygia Clark, quoted in Guy Brett. 'Lygia Clark: In Search of the Body', *Art in America*, New York, July 1994, p. 61.

109 Lygia Clark. 'Lygia Clark busca na pintura a expressão do próprio espaço', *Folha da Manhá*, São Paulo, 27 September 1958. Quoted in *Lygia Clark*, Barcelona: Fundació Antoni Tàpies et al., 1997, p. 102.

110 Lygia Clark. 'Lygia Clark e o espaço concreto expressional'. Jornal do Brasil (Rio de Janeiro). 2 July 1959. Quoted in *Lygia Clark*, p. 84.

111 Lygia Clark. 'Livro-obra', Rio de Janeiro, 1983. Quoted in *Lygia Clark*, p. 151.

112 Lygia Clark. Ibid., p. 117.

113 Lula Vanderlei. 'The Memory of the Body', 1993, unpublished. Quoted in 'Lygia Clark: In Search of the Body', *Art in America*, New York, July 1997, p. 58.

114 Piero Manzoni, quoted in *Piero Manzoni*, London: Serpentine Gallery, p. 110.

115 Quoted by David Medalla in *Exploding Galaxies*, p. 64.

116 Agnes Denes. *Book of Dust: The Beginning and the End of Time and Thereafter*. Rochester, New York: Visual Studies Workshop Press, 1989.

117 Robert Smithson. *Slideworks*. Ed. Guglielmo Bargellesi-Sveri. Italy: Carlo Frua, 1997, p. 140.

118 *Robert Smithson: The Collected Writings*. Ed. Jack Flam. Berkeley: University of California Press, 1996, p. 328.

119 Hélio Oiticica, letter to the author, 12 April 1967.

120 Hélio Oiticica, letter to the author, 27 October 1967.

121 Ibid.

122 Mira Schendel, letter to the author, 1965.

123 Lucio Fontana, quoted in Sarah Whitfield. 'Handling Space', in *Lucio Fontana*. London: Hayward Gallery, 1999, p. 15.

124 Yves Klein. 'Ma position dans le combat entre la ligne et la couleur' (1958), reprinted in *Nouveau Réalisme*.

125 Pierre Restany. 'Ein Titanentreffen', in *Tinguely's Favourites*, p. 22 and 15.

126 Maurice Tuchman. Introduction to *The Spiritual in Art: Abstract Painting 1890–1985*. Los Angeles: Los Angeles County Museum of Art, 1986–1987, p. 37.

127 Jiro Yoshihara. 'Gutai Manifesto', *Geijutsu Shincho 7*, no. 12, December 1956, quoted in Kristine Stiles. 'Uncorrupted joy: international art actions', in *Out of Actions*. Los Angeles: Museum of Contemporary Art et al, 1998, p. 237.

128 Ted. J. Kaptchuck. *Chinese Medicine*. London: Rider, 1983, p. 35.

129 Agnes Denes. *Diomede Project: Sun Triangle in the Arctic Circle – An Observatory*, 1989. Quoted in *Agnes Denes*. Jill Hartz (ed.). Cornell University: Herbert F. Johnson Museum of Art, 1992, p. 130.

130 Gaston Bachelard. 'Reverie and Cosmos', in *The Poetics of Reverie*. Trans. Daniel Russell. Boston: The Beacon Press, 1971, p. 173.

131 Charmion von Weigand, interview with Margit Staber. *Piet Mondrian Centennial Exhibition*. New York: Guggenheim Museum, 1971, p. 85.

132 Richard Hamilton. Introduction. *The Almost Complete Works of Marcel Duchamp*. London: Arts Council of Great Britain/Tate Gallery, 1966.

133 Agnes Denes. 'Wheatfield: a confrontation', in *Agnes Denes*, p. 118.

134 Hélio Oiticica, quoted in Catherine David. 'The great labyrinth', *Hélio Oiticica*, 1992, p. 258.

135 Yves Klein; Werner Ruhnau. 'Projet pour une architecture de l'air', 1958, *Nouveau Réalisme*.

136 Hélio Oiticica, quoted in Guy Brett. 'The experimental exercise of liberty', *Hélio Oiticica*, 1992, p. 232.

137 Dore Ashton. 'Forward – an impromptu for David Medalla and Guy Brett', in *Exploding Galaxies*, p. 8.

138 Yve-Alain Bois. 'Envoi: virtuel', in *Exploding Galaxies*, p. 214.

139 Didier Ottinger. 'Ilya Kabakov', in *Cosmos: from Romanticism to the Avant-garde*. London: Prestel, 1999, p. 332.

140 Susan Hiller. *Witness*, unpublished statement. Quoted with the artist's kind permission.

141 Ibid.

EXHIBITION

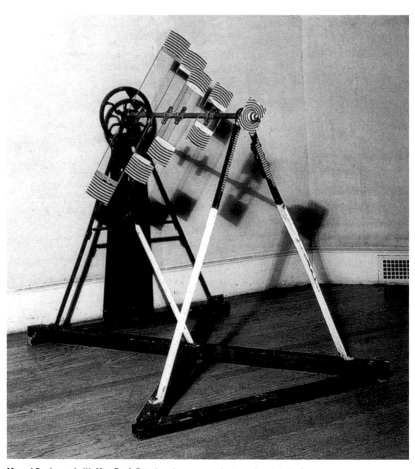

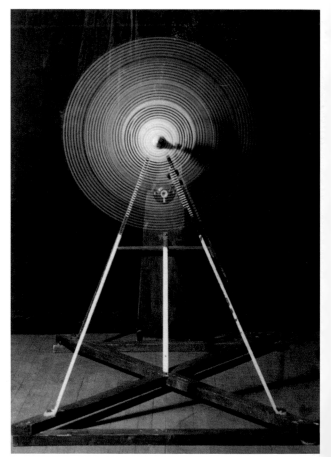

Marcel Duchamp (with Man Ray) *Rotative plaques-verre (optique de précision)*
(Rotary Glass Plates [Precision Optics]), 1920

László Moholy-Nagy *Licht-Raum Modulator*
(Light-Space Modulator), 1922–1930

Alexander Calder *A Black Ball, A White Ball,* 1930 (reconstruction 1969)

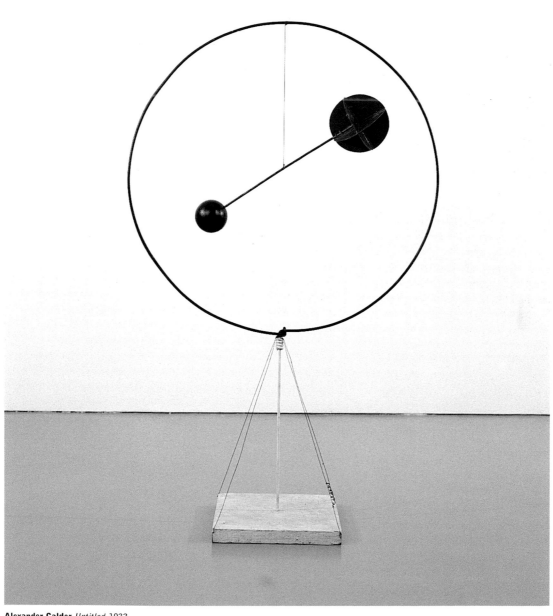

Alexander Calder *Untitled,* 1933

Georges Vantongerloo *Variante* (Variant), 1939

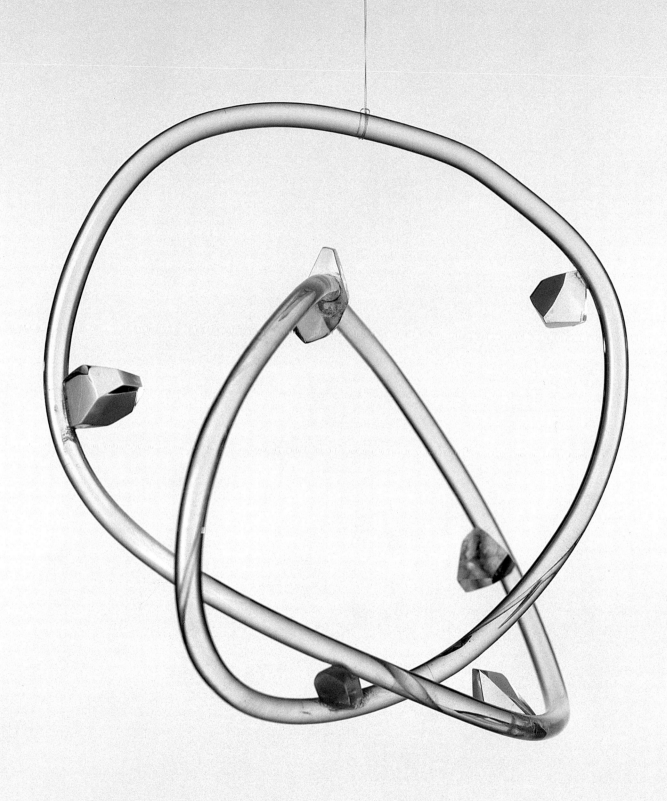

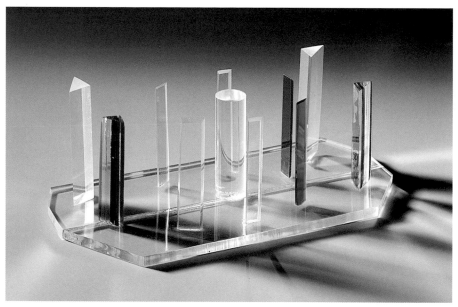

Georges Vantongerloo *Plusieurs éléments* (Several Elements), 1960

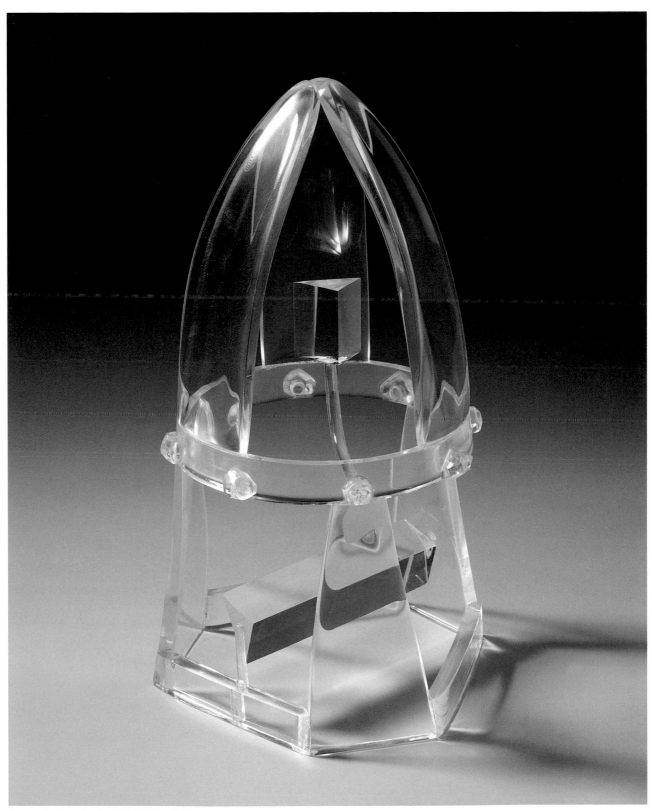

Georges Vantongerloo *Le dôme* (The Dome), 1959

Georges Vantongerloo *Deux zones de l'espace: Action-réaction* (Two Zones of Space: Action-Reaction), 1949

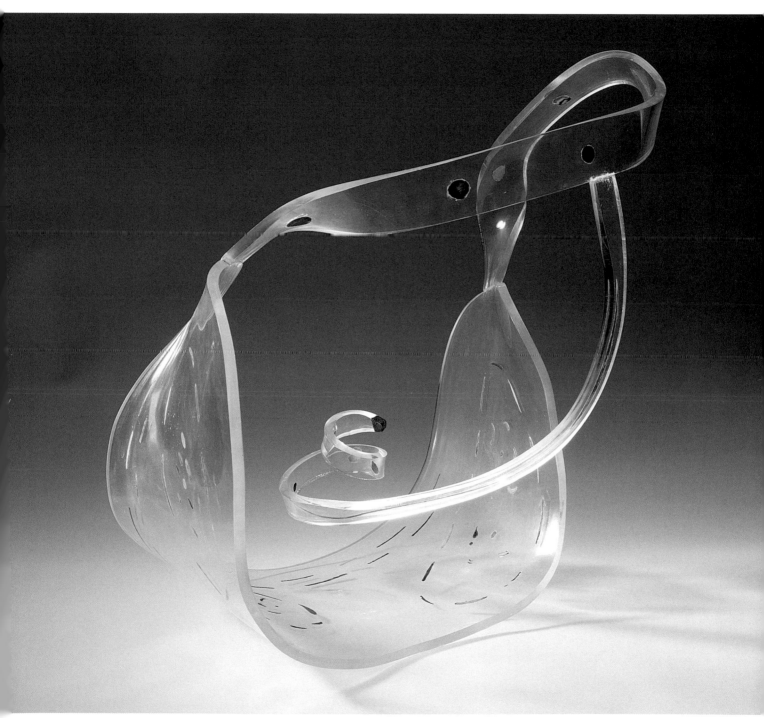

Georges Vantongerloo *Des formes et des couleurs dans l'espace*
(Forms and Colours in Space), 1950

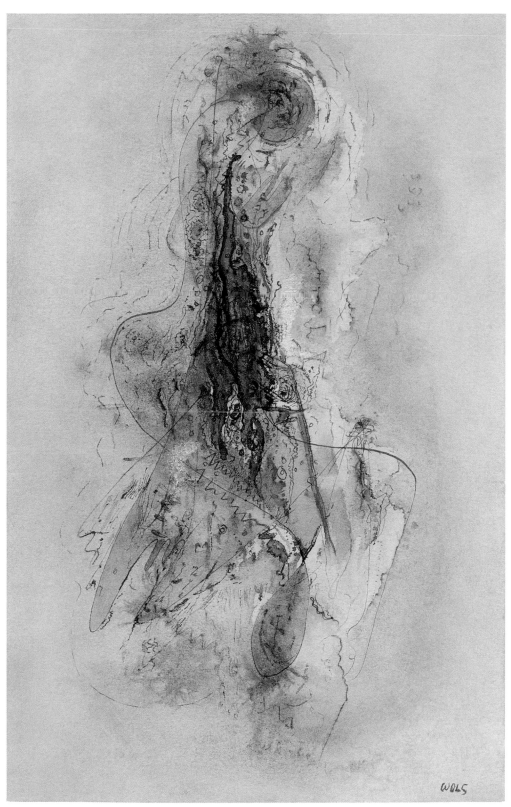

Wols *Untitled (La Plaie),* (The Wound), 1944

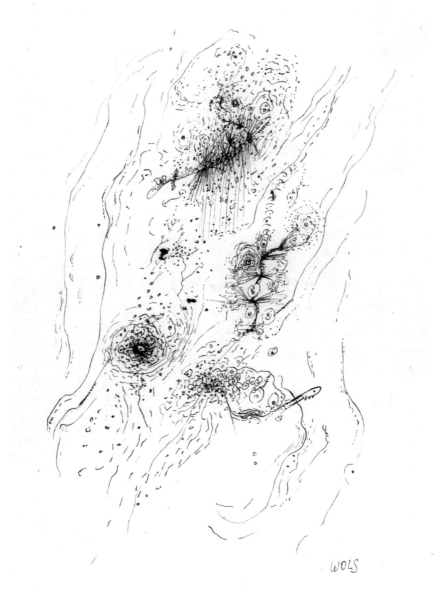

Wols *Untitled,* 1940–1942

Wols *Untitled (Crâne de Poète)*
(Poet's Skull), c. 1944

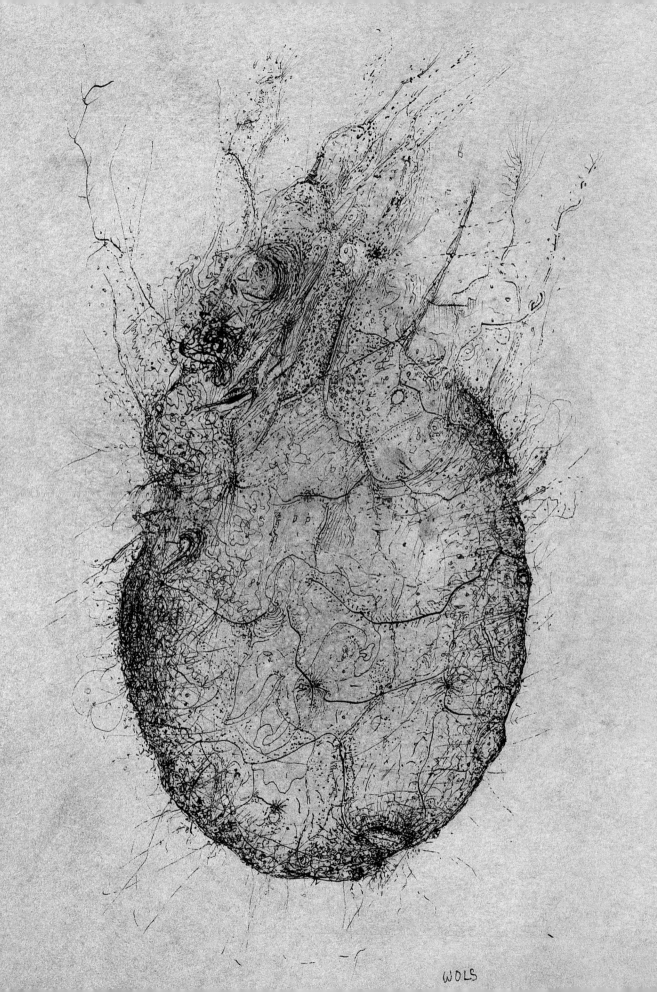

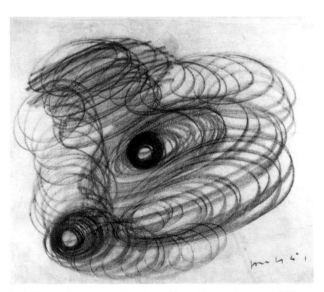

Lucio Fontana *Concetto spaziale evoluzione* (Spatial Concept Evolution), 1951

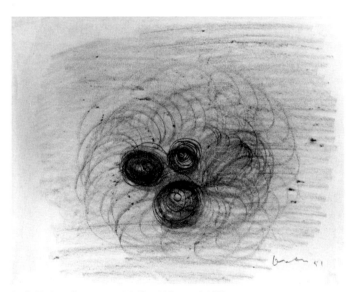

Lucio Fontana *Concetto spaziale* (Spatial Concept), 1951

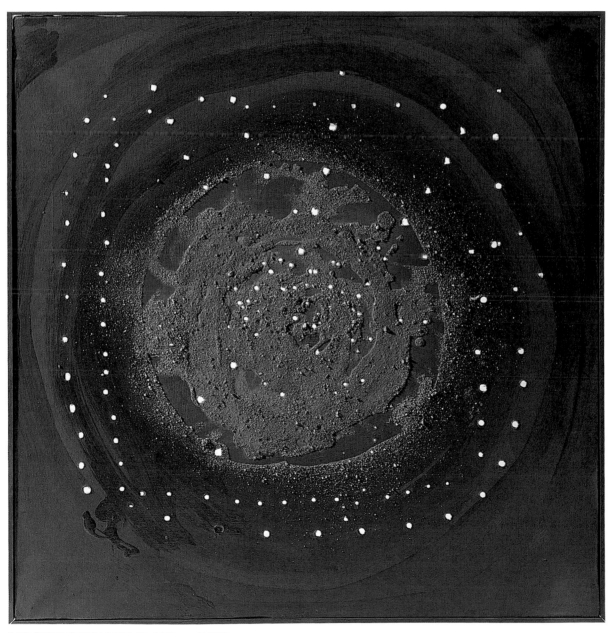

Lucio Fontana *Concetto spaziale* (Spatial Concept), 1951

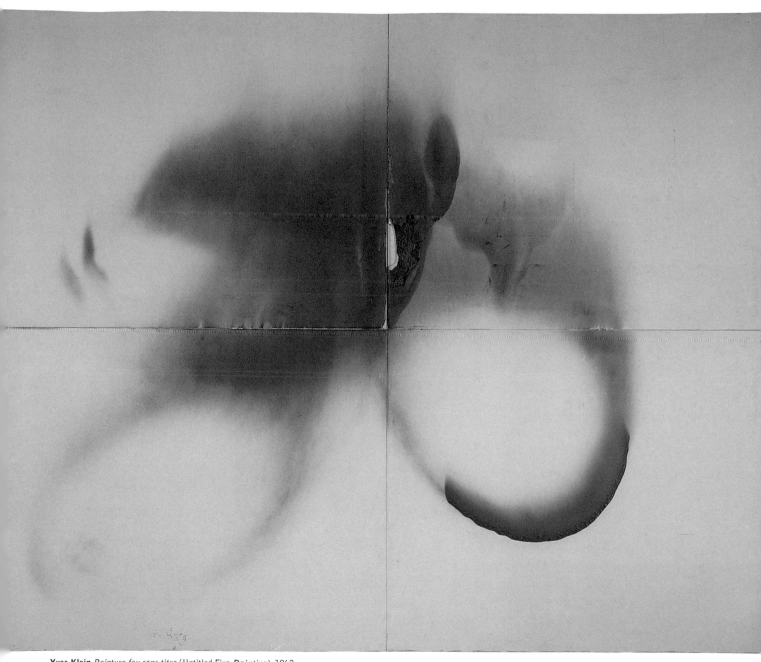

Yves Klein *Peinture feu sans titre* (Untitled Fire Painting), 1962

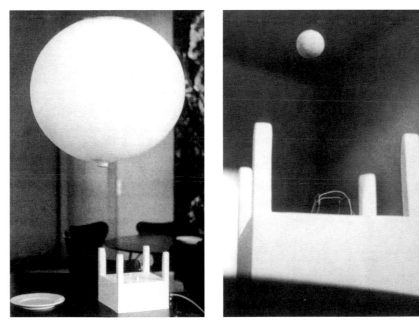

Piero Manzoni *Scultura nello spazio* (Sculpture in Space), 1960 Photo Ole Bagger

Piero Manzoni *Achrome,* 1961

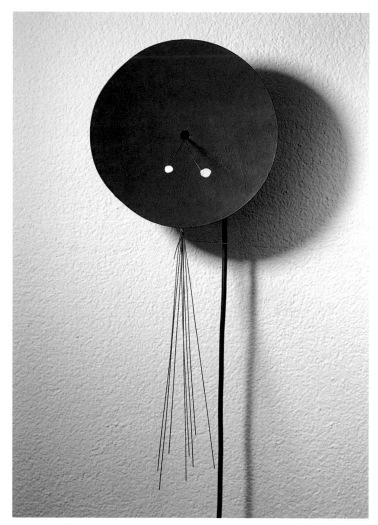

Jean Tinguely *Variation pour deux points* (Variation for Two Points), 1958

Jean Tinguely *Baluba XIII*, 1961–1962

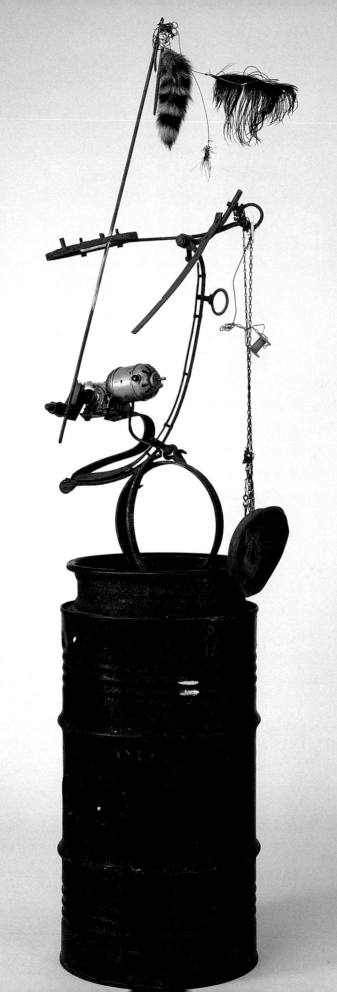

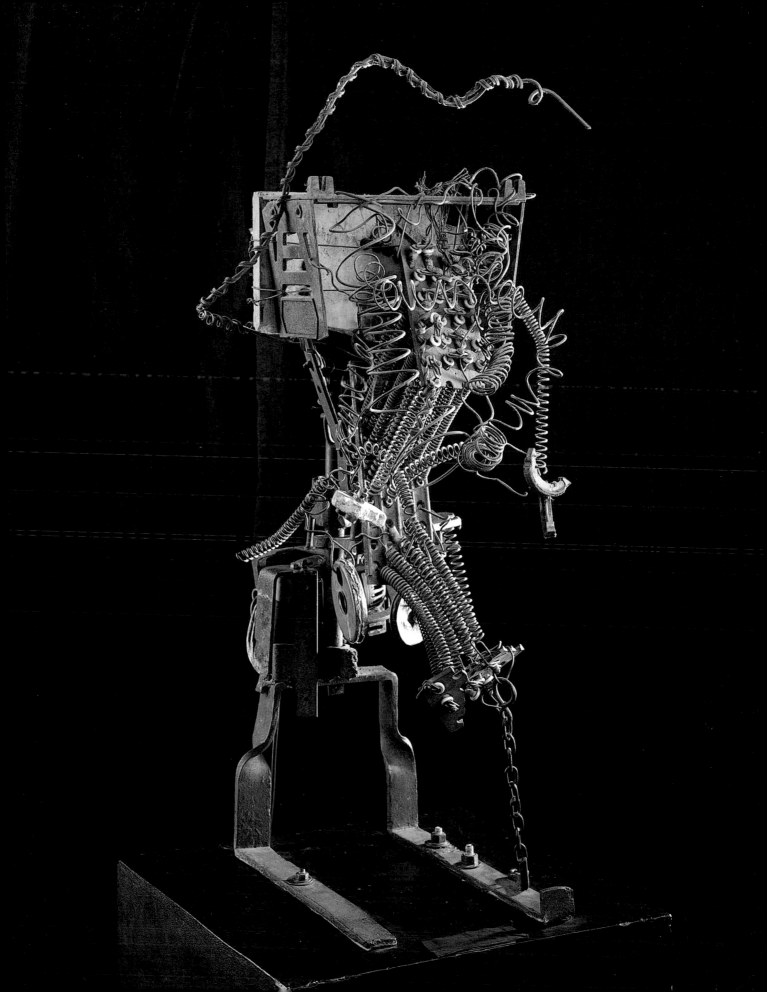

Henri Michaux *Dessin mescalinien* (Mescaline Drawing), 1958–1959

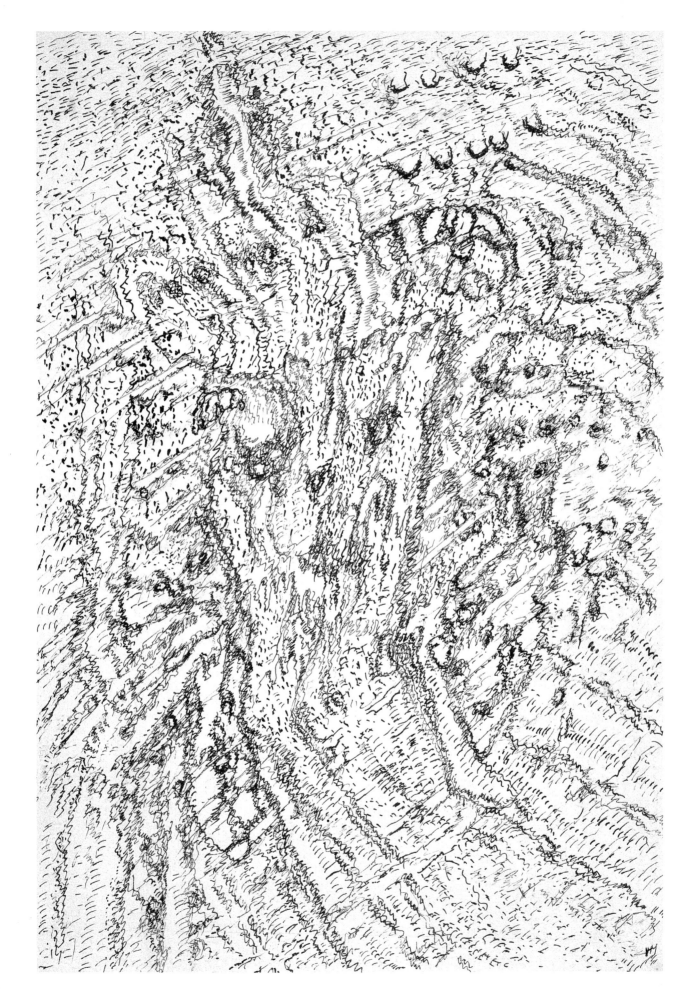

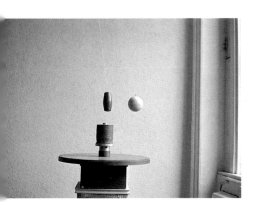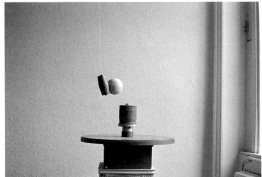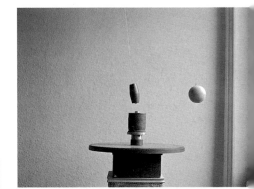

Takis *Ballet magnétique* (Magnetic Ballet), 1961

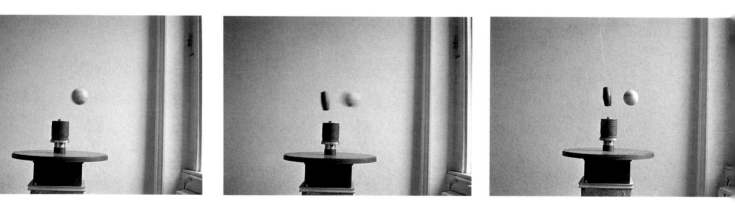

Takis *Telemagnetic Installation*
Alexandre Iolas Gallery, New York, 1960

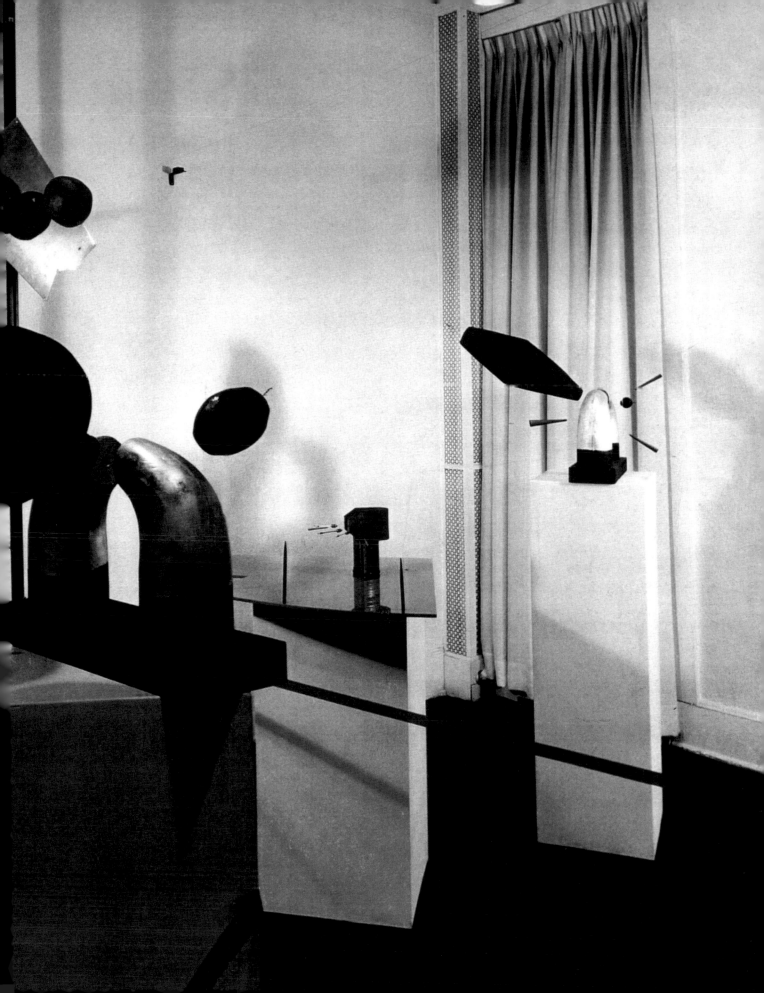

Takis *Dial*, 1969 (modified in 1988)

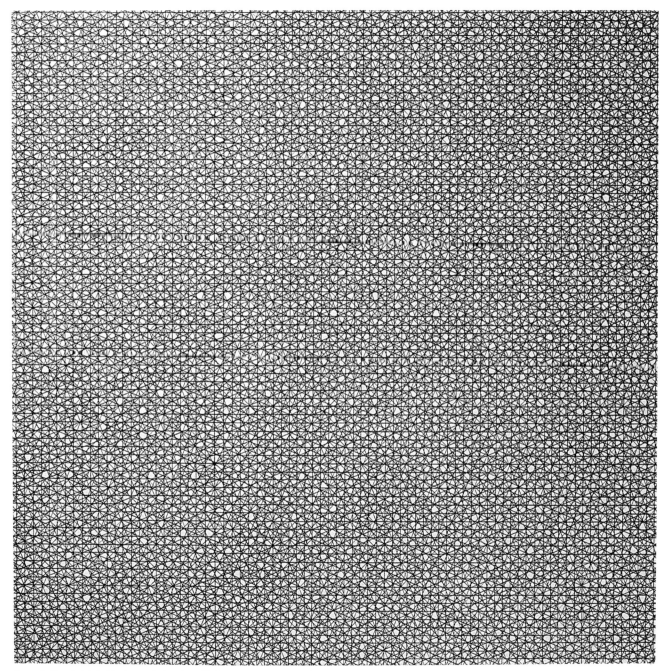

François Morellet *4 doubles trames traits minces* (4 Double Meshes Thin Lines)
0° – 22°5 – 45° – 67°5 , 1958

François Morellet *6 trames* (6 Meshes) *0°–20°–70°–90°–110°–160°*, 1959

François Morellet *22 trames* (22 Meshes) *0°–8°–16°–24°–32°–41°–50°–58°–66°–74°–82°–90°–98°–106°–114°–122°–131°–140°–148°–156°–164°–172°*, 1960

Jesús Rafael Soto *Hommage à Yves Klein* (Homage to Yves Klein), 1961

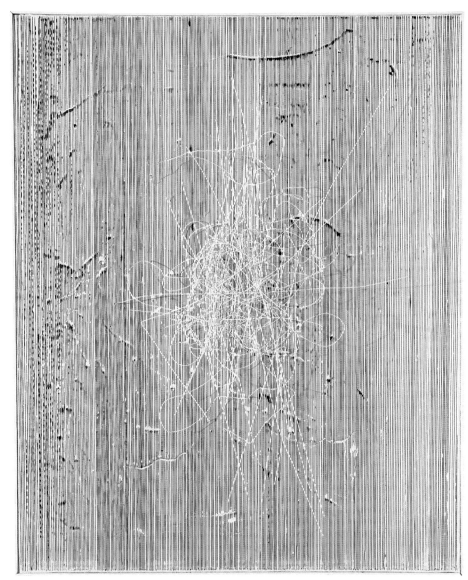

Jesús Rafael Soto *Vibración blanca* (White Vibration), 1959

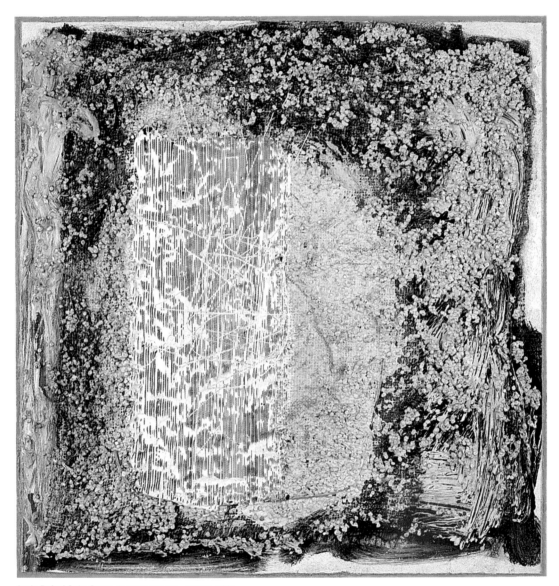

Jesús Rafael Soto *Puntos de goma* (Rubber Points), 1961

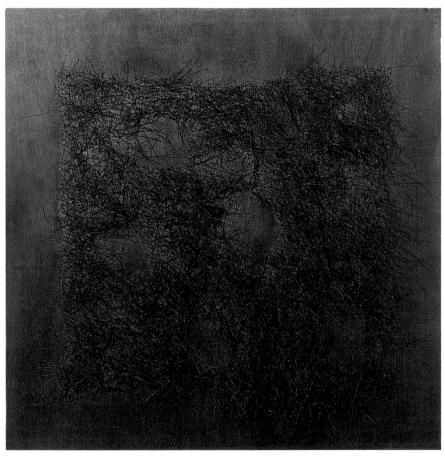

Pol Bury *Ponctuation (points blancs),* (Punctuation [White Points]), 1964

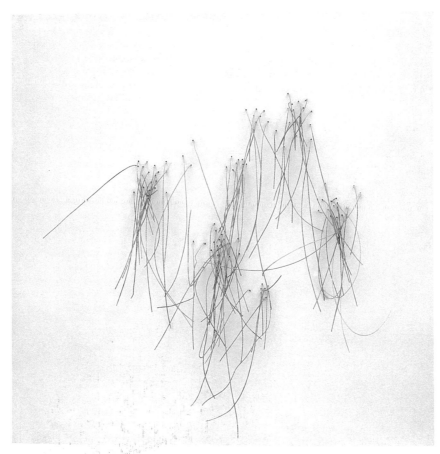

Pol Bury *Surface vibratile* (Stimulated surface), 1960

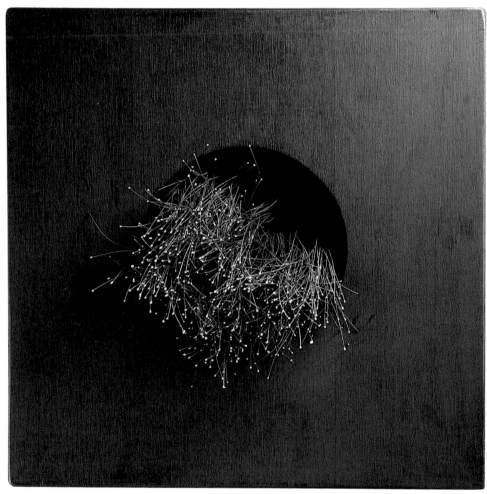

Pol Bury *1110 White Dots Leaving a Hole – Punctuation,* 1964

Bernard Réquichot *Sans titre* (Untitled), 1960

Sérgio Camargo *No. 289A*, 1970

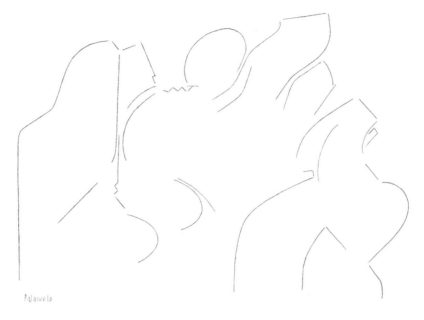

Pablo Palazuelo *Curva IV* (Curves IV), 1954

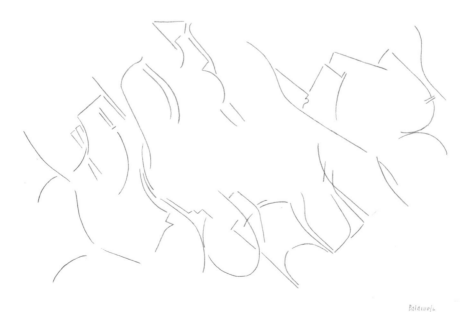

Pablo Palazuelo *Curva II* (Curves II), 1954

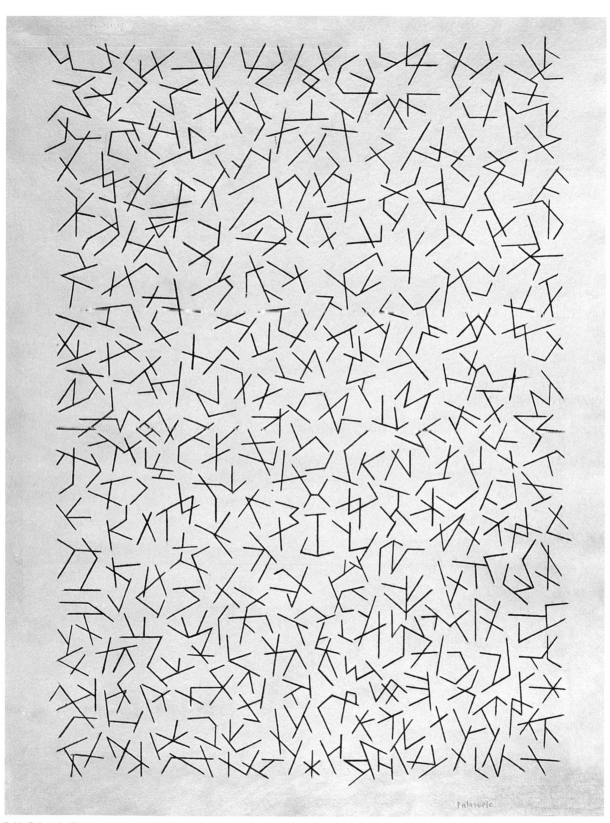

Pablo Palazuelo *El número y las aguas* (The Number and the Waters), 1978

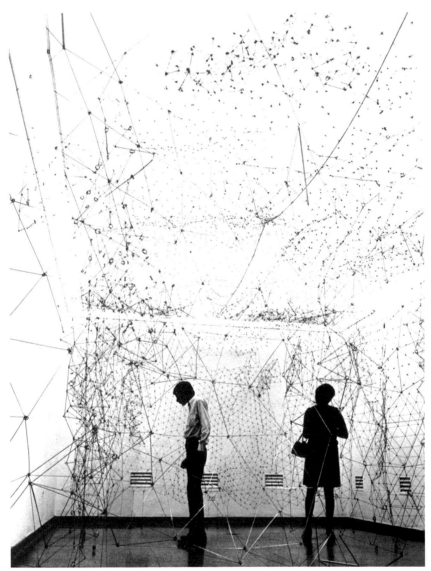

Gego *Reticulárea* (Reticularia), 1969, installation view

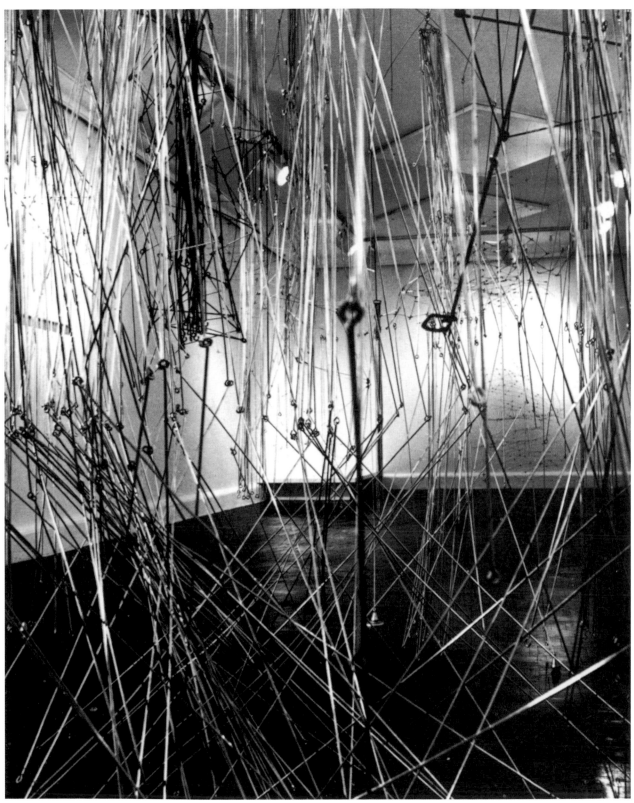

Gego *Chorros* (Streams), 1971, installation view

Gego, *Reticulárea cuadrada* (Square Reticularia), 1971–1972

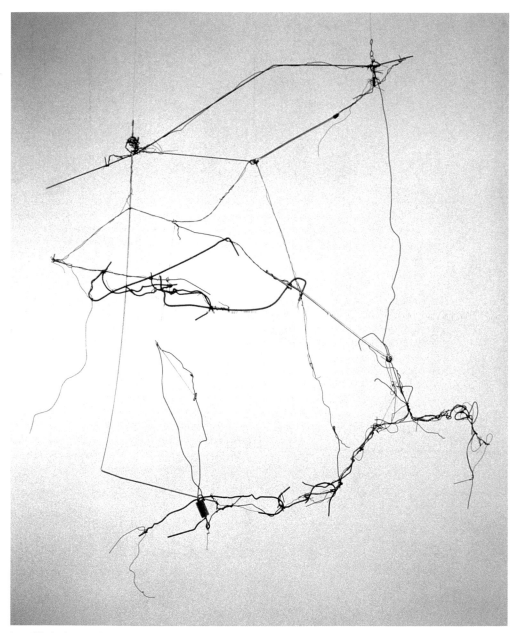

Gego *Dibujo sin papel 5* (Drawing without paper 5), 1985

Atsuko Tanaka *Untitled (Studies for Electric Dress),* 1956

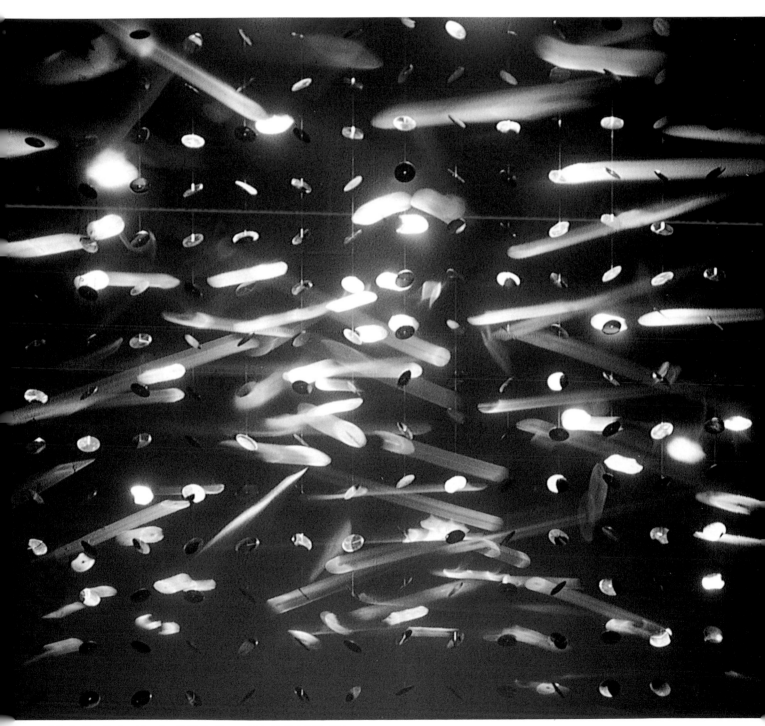

Julio Le Parc *Continuel-Lumière-Mobil* (Continuous-Light-Mobile), 1960–1966

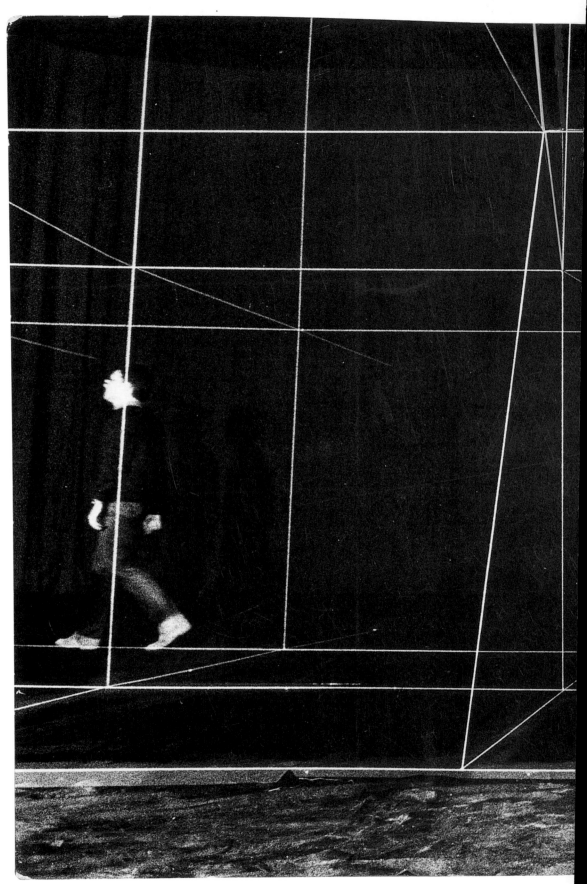

Gianni Colombo *Spazio elastico* (Elastic Space), 1967

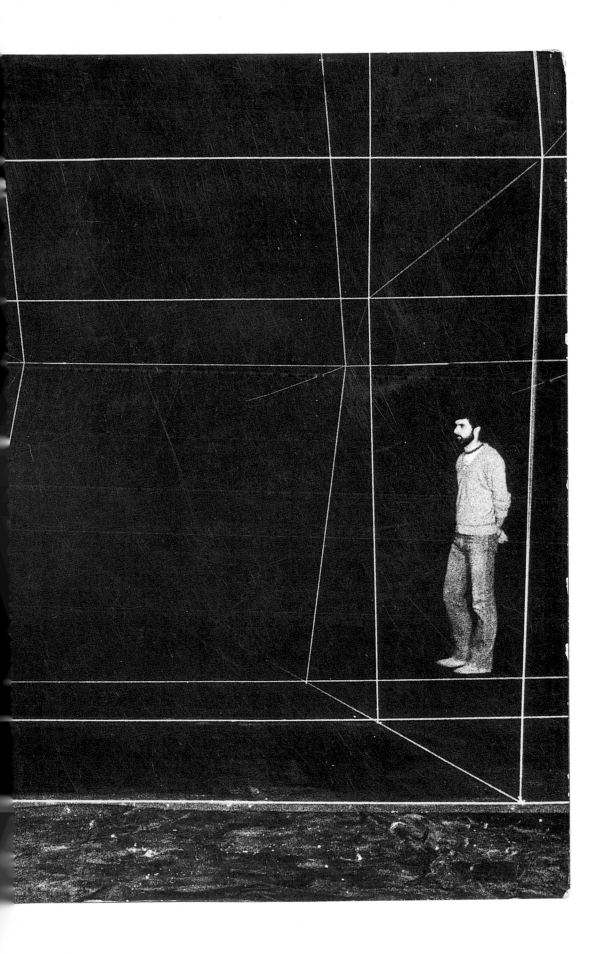

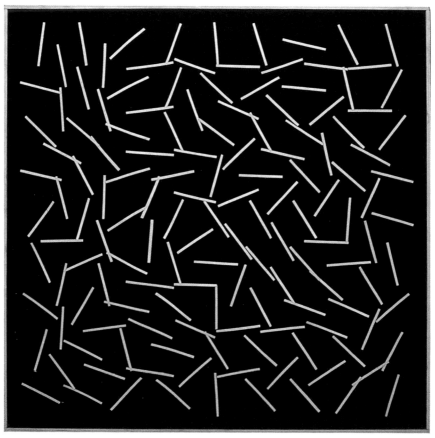

Gerhard von Graevenitz *Kinetisches Objekt. Weiße, kurze, exzentrische Streifen auf Schwarz*
(Kinetic Object. White, Short, Eccentric Strips on Black), 1963–1966

Gerhard von Graevenitz *Kinetisches Objekt mit 37 weißen Scheiben auf Weiß*
(Kinetic Object with 37 White Discs on White), 1967

Hélio Oiticica *Bólide caixa 9* (Box Bolide 9), 1964

Hélio Oiticica *Bólide vidro 6 (metamorphosis)*
(Glass Bolide 6 [metamorphosis]), 1965

Hélio Oiticica *Bólide vidro 14 (ESTAR I)*
(Glass Bolide 14 [TO BE I]), 1965–1966

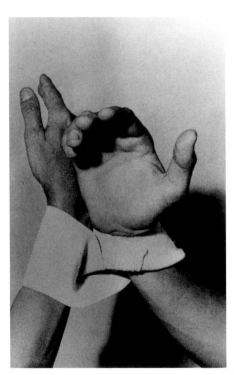

Lygia Clark and **Hélio Oiticica** *Diálogo de mãos*
(Dialogue of Hands), 1966

Lygia Clark *Respire comigo* (Breathe with Me), 1966

Previous page: **Mira Schendel** *Droguinhas* (Little Nothings),1965

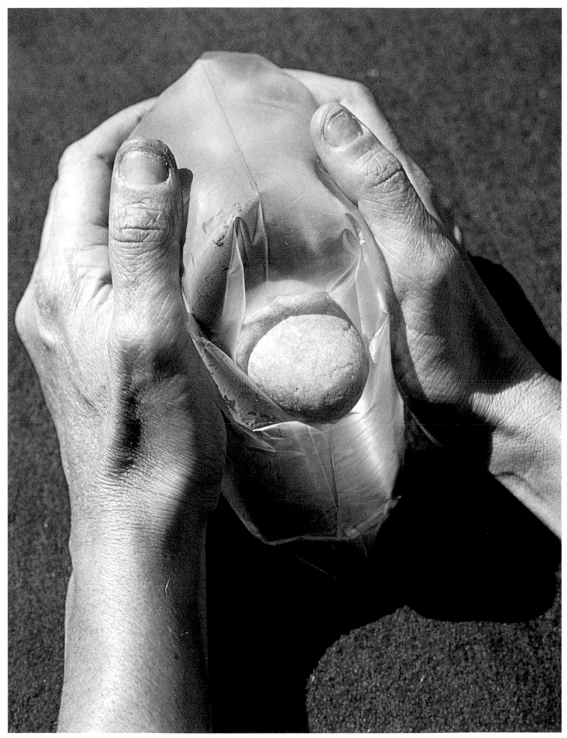

Lygia Clark *Pedra e ar* (Air and Stone), 1966

Robert Smithson *Four-sided Vortex*, 1965

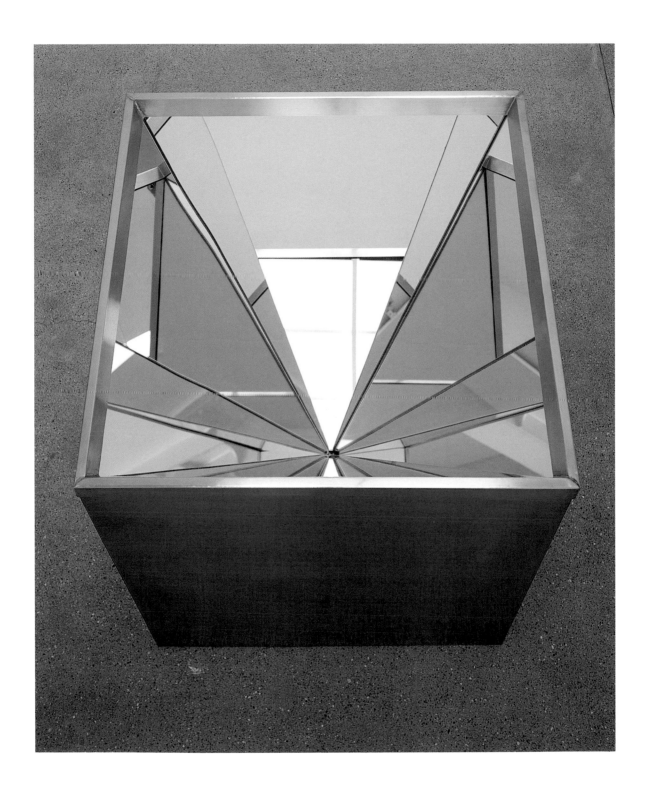

Sol LeWitt *Untitled*, 1971

Sol LeWitt *Short Straight Lines, Not Touching, Drawn at Random and Evenly Distributed Over The Area*, 1972

Gordon Matta-Clark *Arrows,* 1973–1974

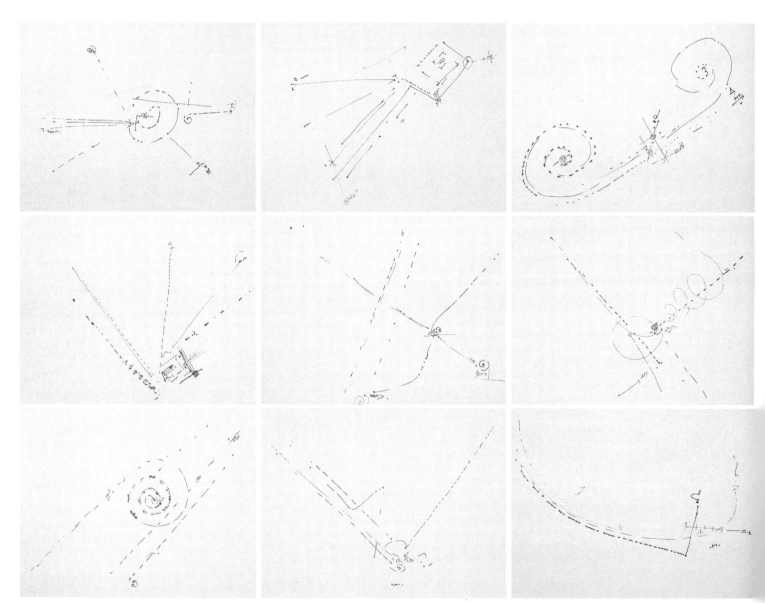

Gordon Matta-Clark *Energy-Forms* (notebook), 1964

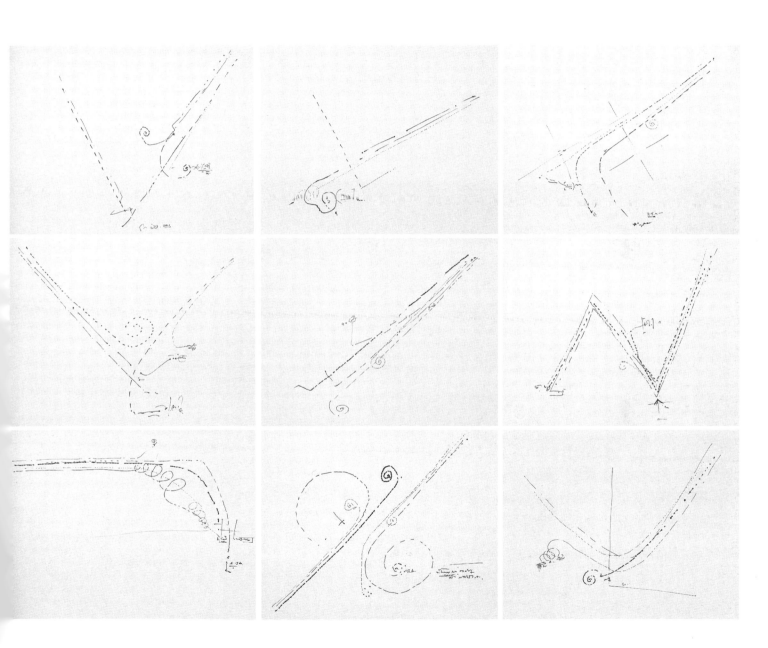

Agnes Denes *Snail People – The Vortex,* 1989

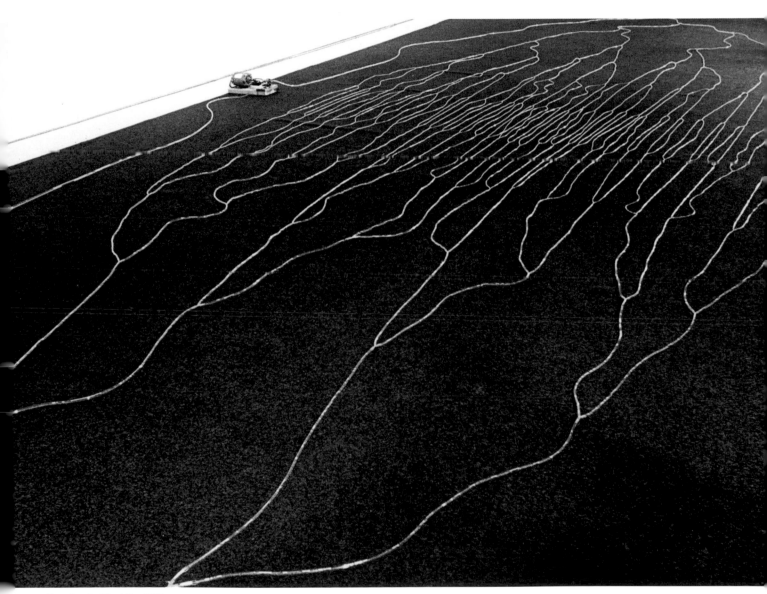

Hans Haacke *Circulation,* 1969

Hans Haacke *Sphere in Oblique Air Jet,* 1967

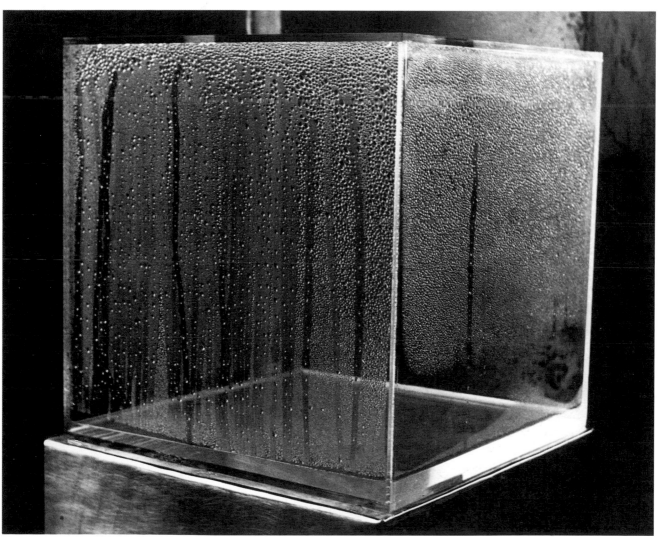

Hans Haacke *Condensation Cube,* 1963–1965

David Medalla *Mud Machine*, 1967

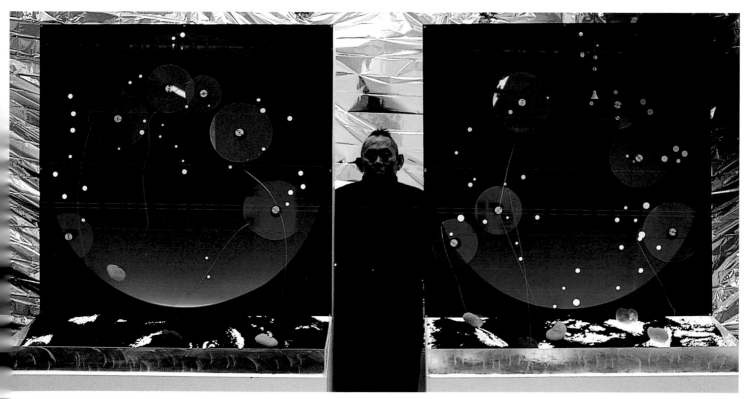

David Medalla *Mud Machines*, 1994 (Installation view)

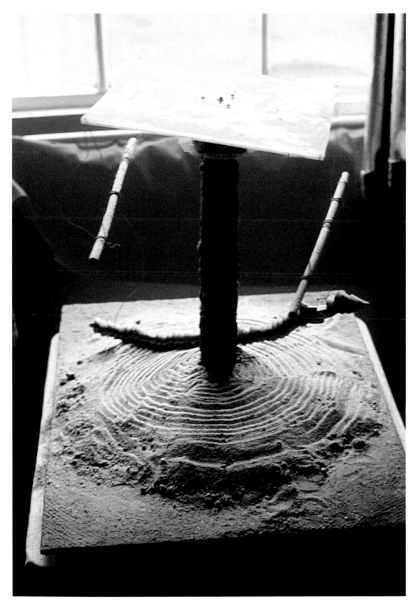

David Medalla *Sand Machine,* 1964

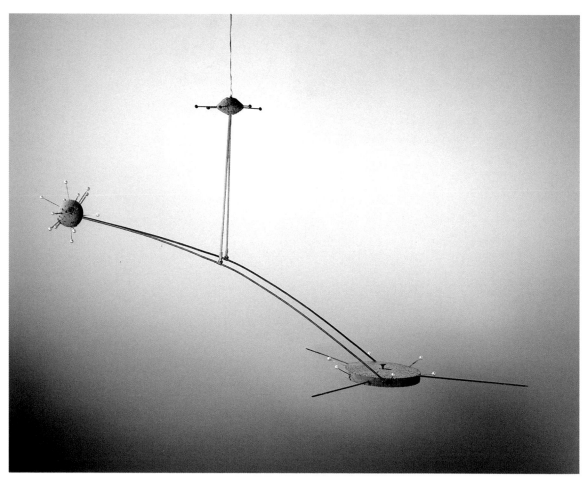

Leandre Cristòfol *Ralentí* (Slow Motion), 1957

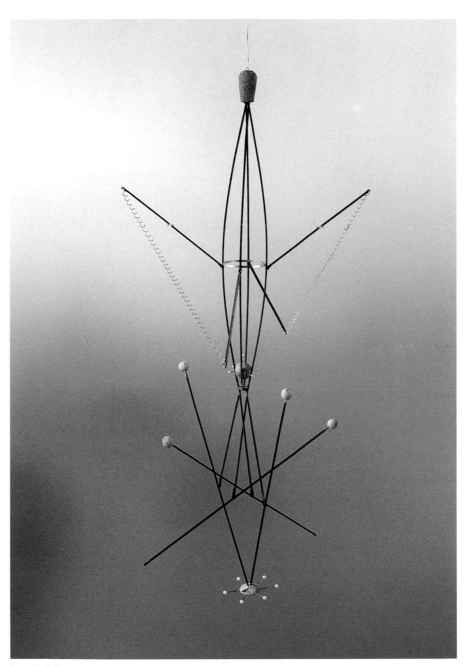

Leandre Cristòfol *Metamorfosi constant (Ralentí)*
(Continuous Metamorphosis [Slow Motion]), 1957

4 cubes

dom sylvester houédard *4 Cubes,* 1966

moonblase - 3

crescent
increscent

dom sylvester houédard *Moonblase-3, crescent, increscent,* 1967

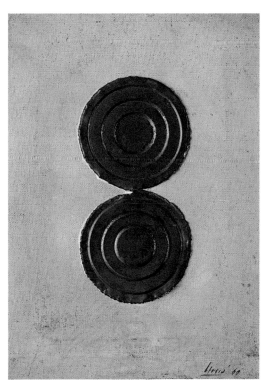

Joaquim Llucià *Sense títol* (Untitled), 1962 **Joaquim Llucià** *Relacions* (Relations), 1960

P. K. Hoenich *Sun Pictures – Robot Painter*, Haifa, 1960s

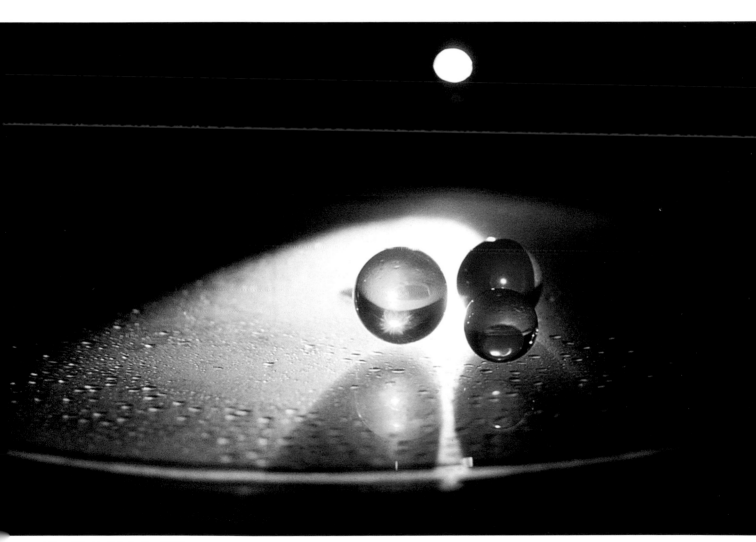

Liliane Lijn *Liquid Reflections,* 1967

Grazia Varisco *Variabile HG su AL (Mercuriale),* (Variable HG on AL [Mercurial]), 1964–1965

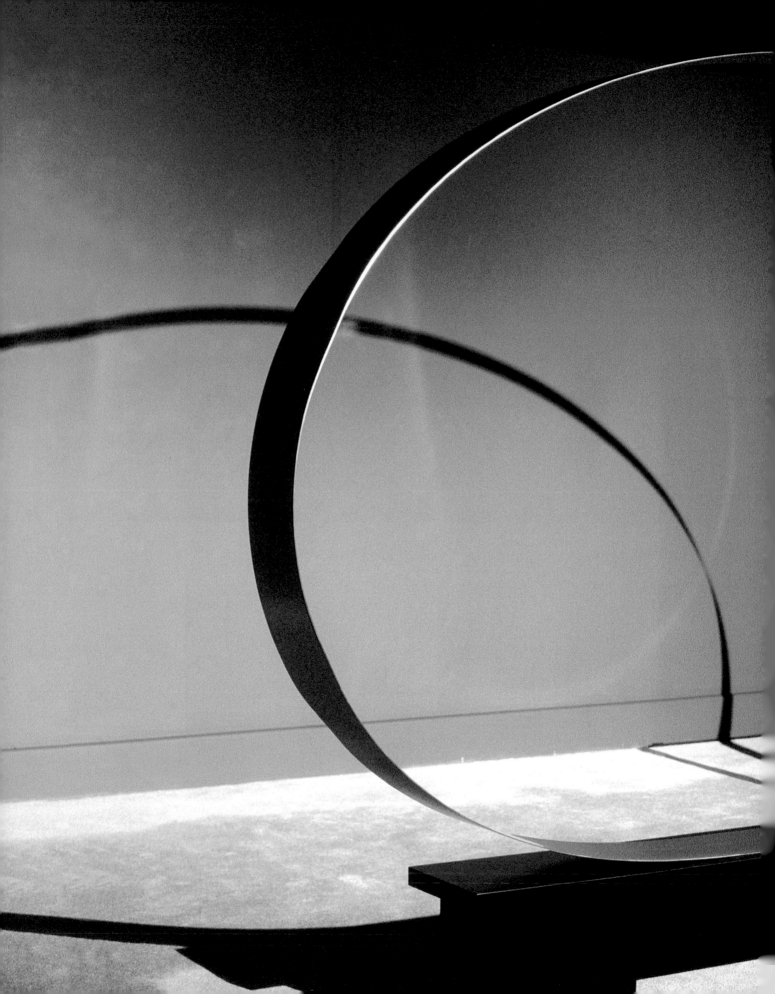

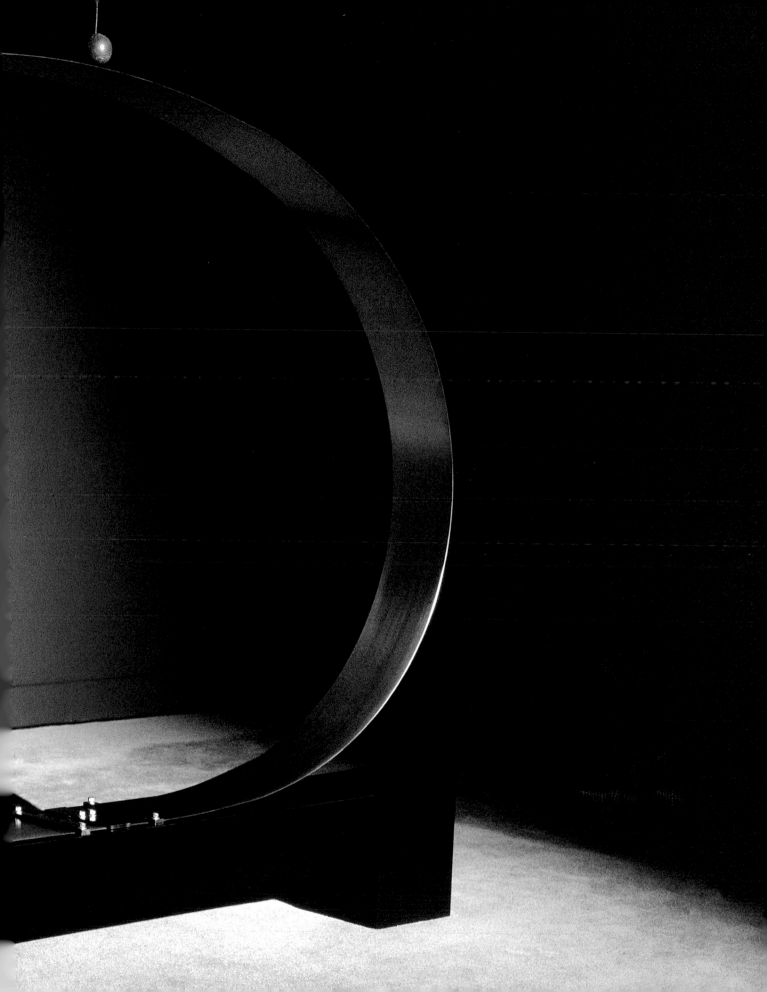

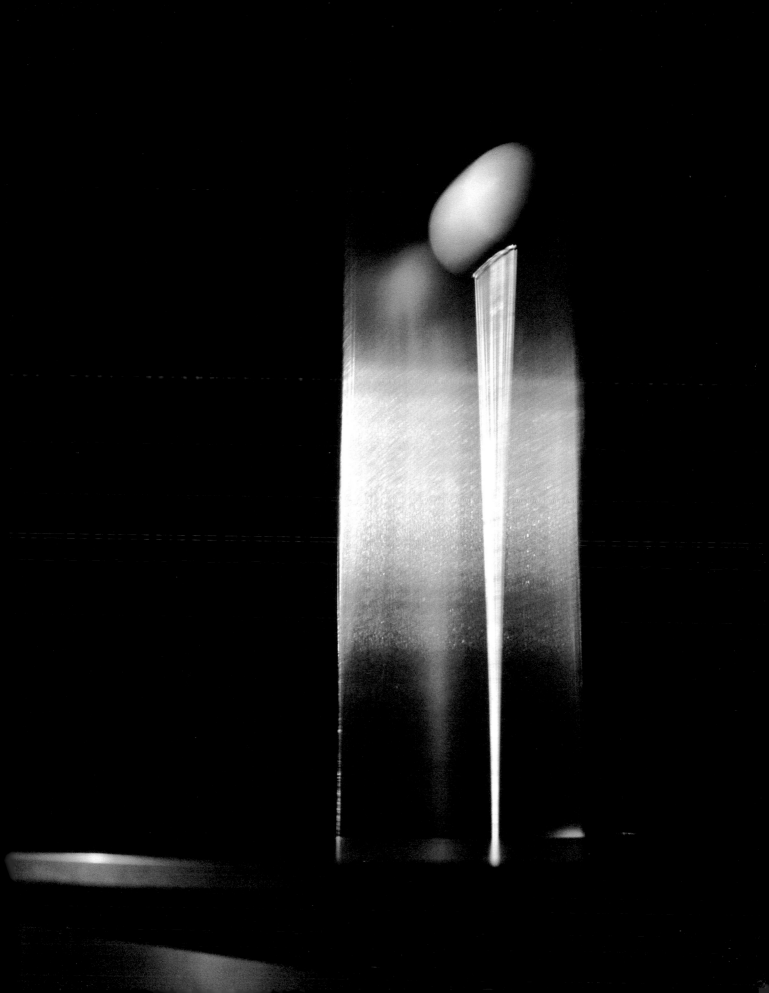

Li Yuan-chia *Untitled Folding Scroll,* 1963

John Latham Four Noits (*One-Second Drawings*), 1975

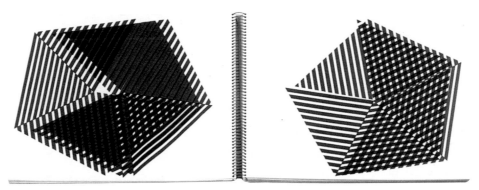

Dieter Roth *Gesammelte Werke, Band 4/Buch 5*
(Collected Works, volume 4/book 5), 1961

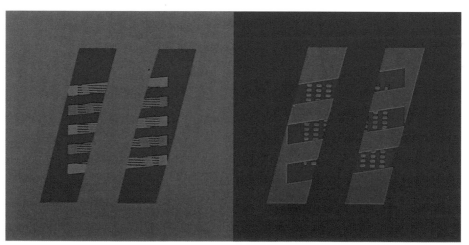

Dieter Roth *Gesammelte Werke, Band 1/Kinderbuch*
(Collected Works, volume 1/Children's book), 1958

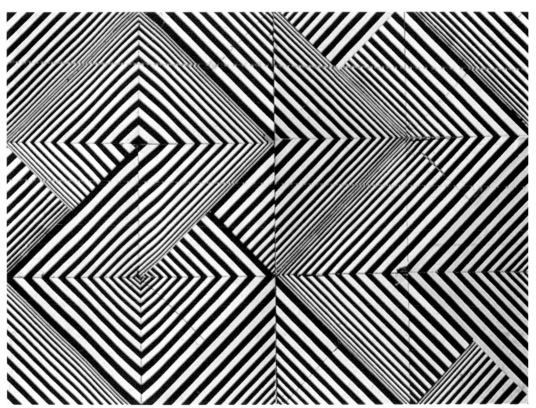

Dieter Roth *Untitled,* 1958–1959

Dieter Roth *Dreh-Rasterbild – Scheibe nr. 2* (Gridded Rotary Frame – Disc no. 2), 1960

Dieter Roth *Kugelbild nr. 4/4* (Ball Painting no. 4/4), 1962

CHRONOLOGY

This chronology sets out to sketch a map of the kinetic (in the expanded sense accorded to the term in *Force Fields*), of the individuals who were its practitioners and of its principle landmarks. The time-scale adopted here (1910–1975) effectively takes in all of the events directly associated with the production of the works on show in the exhibition. In preparing this, the extensive existing bibliography has been taken account, as well as original editions, catalogues and documents from the period. The information has been structured by country, without this implying the imposition of any kind of hierarchy: Italy, France, Germany, Great Britain, other European countries, the United States, Latin America, Japan and finally Spain. References for the various experimental films have also been included.

1910 The *Manifesto of Futurist Painters* was published in Milan, written by Umberto Boccioni, Carlo D. Carrà, Luigi Russolo, Giacomo Balla and Gino Severini; it advocated the rejection of all forms of imitation and the need to show universal dynamism and dynamic sensation in painting. For the Futurist painters movement and light destroyed the materiality of bodies.

• From 1910 to 1913, Naum Gabo (born Naum Borisovich Pevsner) studied technology in Munich, and read widely in medicine, engineering, philosophy and art history. He travelled through France and Italy.

1912 Publication on 11 April of the *Technical Manifesto of Futurist Sculpture*, by Umberto Boccioni, in which he put into words the principles he had developed in his pictorial and sculptural work: the synthesis between matter and movement that represents the energy principle. He affirmed the possibility of incorporating a small motor in a sculptural composition which might need a special rhythmic movement to increase or take forward the arrested movement of a sculptural whole.

1913 Publication of the *Rayonist Manifesto* by Michel Larionov, Natalia Gontcharova and other artists (Bogomasov, Zdanevitch, Ivan Larionov, Le Dantu, Viatcheslav, Levkievsky, Romanovitch, Obolensky, Fabry and Chevtchenko), which defined the object in terms of the light reflected from it, or the accumulated light it emits. These artists brought coherence to the movement known as Rayonism, which began in 1909, and grew out of Michel Larionov's interest in the reflection of light from objects, with the emphasis on the relationship between movement and light, the representation of objects and their surrounding space, the study of the set of invisible rays emitted by an object and how they are intercepted by another. According to Larionov, the form created by the painter appears in the space produced by the limits of the objects.

1914 Appearance of F.T. Marinetti's manifesto *Geometric and Mechanical Splendour and Numerical Sensitivity. Futurist Manifesto*, written in Milan on 18 March. The text evokes a new form of expression in language, in which geometry, linguistic punctuation marks, and mathematical symbols take centre-stage in a machinist future.

• Naum Pevsner moved to Norway, a neutral territory during the First World War. There he became an artist and took the name Gabo to distinguish himself from his brother Antoine Pevsner.

• At the outbreak of the First World War, Georges Vantongerloo moved from Belgium to Holland, where he began to develop his ideas on space. However, he would soon abandon painting and sculpture to express his ideas in writing.

1915 Publication of the manifesto *Futurist Reconstruction of the Universe* signed by Balla and Fortunato Depero (Milan, 11 March) and illustrated with six works, among which were Depero's *Complesso plastico colorato motorumorista di equivalenza* (Motorumorist Coloured Plastic Set of Equivalence) and Balla's *Complesso plastico colorato di frastuono danza allegria* (Coloured Plastic Set of Noise Dance Joy). The manifesto proclaims the abolition of genres and the move towards the total work of art; the reconstruction of the universe involves the inclusion of the non-visible, sound and movement.

• Michel Larionov added a fan to a picture frame to give a more natural movement to the scene taking place in it.

• Kasimir Malevich's *0,10* exhibition in Petrograd. At this time, he published the Suprematist manifesto *From Cubism to Suprematism*, together with the poet Vladimir Maiakovski, in which they described flowing and cosmic rhythms; the importance of movement and universal energy; the idea of dynamics; of the plastic elements; the supremacy of pure sensation in the plastic arts displayed through the tension and movement between background, shapes and colours — preferably using simple geometric figures which are not ordered in space in a straight line, but obliquely. Investigation into the functional structures of images.

• Publication of the book *Het nieuwe wereldbeeld* (The New Image of the World) by the mathematician and mystic Mathieu Hubert Joseph Schoenmakers (Holland, 1875–1944), whose writings influenced members of De Stijl, especially Piet Mondrian and Vantongerloo. He propounded a global vision of the universe through geometric principles and symbols: the circle is made up of an origin, in the centre, and of energy in the radii; the circumference is movement, the boundary between matter and energy.

• From 1915 to 1917, Gabo produced a series of heads and torsos which he described as 'stereometric'. He used mathematical models in which volumes are constructed by means of algebraic equations — "the converse of practical stereometry" — such as those of the German mathematician Brill.

1916 Manifesto entitled *Futurist Science (Anti-German – Adventurous – Capricious – Segirophobe – Blinded by the Unknown)* written by Bruno Corra, A. Ginanni, R. Chiti, Settimelli, M. Carli, Oscar Mara, and Nannetti on 15 June. The authors supported the idea of art and science being related fields moving towards the 'new'. They also showed an interest in invisible energies and in occultism.
 • Schoenmakers published *Beginselen der beeldende wiskunde* (Principles of Plastic Mathematics).

1917 The De Stijl group was created, with members including Theo Van Doesburg, Mondrian, Vantongerloo (in exile in Holland), Van der Leck, Huszar and Wils. The first manifesto of the group was published the same year as the first edition of their *De Stijl* magazine. Vantongerloo worked on the magazine from 1917 to 1920.
 • Vantongerloo wrote *Réflexions* (Reflections) but this would not be published until the following year (with additions in later years). He made his spherical constructions, which the artist did not consider to be sculptures, as they did not refer to nature but to spatial studies. His knowledge of space at that time was limited to three-dimensional Euclidean geometry, leaving him unsatisfied because of his interest in the relationship between volumes.
 • Gabo returned to Russia along with his brothers Antoine and Alexei to support the Revolution.
 • László Moholy-Nagy was one of the founders of the MA group together with Lajos Kassak, who edited its publication of the same name.
 • D'Arcy Wentworth Thompson published *On Growth and Form,* on the growth and multiplication of organisms from symmetrical and geometrical forms.

Walther Ruttmann still from the film *Opus II,* 1921-1925

Naum Gabo *Kinetic Construction,* 1920

1918 Aleksandr Rodchenko began producing abstract compositions based on different light qualities.
 • At the end of the war, Vantongerloo returned to Brussels where he refused to participate in the Salons des Beaux-Arts. His studies on space extended to studying the universe. From 1918 to 1920, his *Réflexions* were published in the *De Stijl* magazine. It consisted of texts on subjects such as art and science: 'La création, le visible, la substance' (Creation, the Visible, Substance), 'Le tout, la force, le point' (The Whole, Force, the Point), 'De l'invisible' (On the Invisible), 'La science, l'homme de science, le vrai' (Science, the Man of Science, the Real).
 • From 1918 to 1921, Hans Richter worked with Viking Eggeling. At first, they sought to integrate notions of time and movement into painting, but they would soon turn their investigations towards cinema.

1919 Moholy-Nagy left Hungary and moved to Vienna, a city with little interest for him, as he was increasingly pulled towards the technological advances generated by German industry.
 • Walther Ruttmann made his *Opus I* which, according to its creator, opened up a totally new art genre in which motifs and harmonies combined and clashed. It was his first 'absolute film'.

1920 On 5 August, Gabo and Pevsner's *Realistic Manifesto* was published, in which they used the term 'kinetic rhythms': "We proclaim that for the present-day perceptions, the most important elements of art are kinetic rhythms."
 • Gabo produced his *Kinetic Construction,* based on his thoughts about movement in the *Realistic Manifesto.* The work was a steel sculpture with a motor in its base, making it vibrate rhythmically. Gabo had been using elemental stereometry in his plastic investigations since 1919. He had been using plastic during this time, which interested him not only because of its modernity but because of the way it modulated light: reflecting, refracting and transmitting it. He used both opaque and clear plastics and also shiny metals. Using these materials, he discovered an infinite source of forms, structures and rhythms.
 • Moholy-Nagy went to live in Berlin; Vantongerloo left Belgium and moved to Menton in the South of France for some years.
 • Marcel Duchamp produced with Man Ray the work *Rotative plaques-verres (optique de*

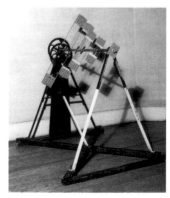

Marcel Duchamp *Rotative plaques-verre (optique de précision),* 1920

précision) (Rotary Glass Plates [Precision Optics]). This consisted of five painted glass plates that rotated around a metallic axis, themselves forming a single axis and drawing continuous concentric circles when set in motion.

• Lucio Fontana began his studies at the Accademia di Belle Arti di Brera, in Milan.

1921 Moholy-Nagy made his 'transparent' pictures, the result of his interest in painting with light directly in space. He painted transparencies which produced a similar effect to when coloured lights were projected on to a screen and superimposed by other coloured lights. During the year, his work was totally free of any elements referring to nature. In October, he published *Aufruf zur elementaren Kunst – An die Künstler der Welt* (Manifesto for Elementary Art – To the World's Artists) in the magazine *De Stijl*, together with Hans Arp, Raoul Hausmann and Ivan Puni.

• In January, Vantongerloo showed his series entitled *Construction colorée dans la sphère* (Coloured Construction in the Sphere) at the *Exposition International d'art moderne* (International Exhibition of Modern Art) in Geneva.

• Fontana returned to Argentina, breaking off his studies.

• Richter made abstract films entitled *Rhythmus* (Rhythm): rhythm is a primitive sensation and is supreme in all cinematographic expression. Of *Rhythmus 21* (1921-1924) and *Rhythmus 23* (1923-1925) he

Hans Richter still from the film *Rhythmus 21,* 1921-1924

wrote: "I consider film to be a part of modern art, above all else a visual art. There are some problems and some sensations which are completely characteristic of painting and others which belong exclusively to films. But there are also problems where the two fields coincide and even join one another. Taking the rectangular shape of the screen as given in relation to time and time only (as form was previously), the same principles of the dynamism of contrasted similarity can be used here. These led me to a new sensation: rhythm, the basic and fundamental sensation of all cinematographic expression. In short, we must break with the stupid prejudice that assumes that the problems of art in our time can only be solved through working with oils or bronze."

Oskar Fischinger still from the film *Wachs Experimente,* 1921-1927

• From 1921 to 1927, Oskar Fischinger produced several abstract experimental films involving cut-out silhouettes, coloured liquids, etc. His films responded to perfect backing music which aimed to make the abstract images more comprehensible through a simultaneous auditory experience.

1922 Gabo moved to Berlin, working as one of the organisers of an extensive official exhibition on Russian art at the Diemen gallery. He was to remain in the city for ten years, creating a series of works in the form of hypothetical towers, monuments and fountains.

• The Russian artists El Lissitzky and Ilya Ehrenburg moved to Berlin, where they met Gabo. They made contact with Moholy-Nagy, who knew of Mondrian and De Stijl's neo-plasticist work through Van Doesburg. At the time, many artists and intellectuals came together in the city and discussed painting and the function of art: Alexander Archipenko, Tristan Tzara, Arp, Vantongerloo, Joseph Peters, Walter Gropius, the producer Eggeling and his co-worker Richter, together with Kurt Schwitters, Raoul Hausmann, George Grosz and others. Out of these discussions came the Constructivist Congress in Weimar.

• From 29 to 31 May, Moholy-Nagy participated in the Erster Internationaler Kongress für Fortschrittliche Künstler (First International Congress of Progressive Artists) in Düsseldorf, as representative of the magazine *MA*, for which he had been a correspondent since 21 April. In the July edition of *De Stijl* he published the article 'Produktion-Reproduktion', in which he developed a theoretical idea that would lead him to the photogram technique.

• First of Moholy-Nagy's solo exhibitions at Der Sturm gallery, showing his constructions in metal, wood and glass. After visiting the exhibition, Gropius was to offer him the directorship of the Bauhaus metal workshop.

• In December, the magazine *Der Sturm* published Moholy-Nagy and Alfred Kemeny's manifesto 'Dynamisch-konstruktives Kraftsystem' (Dynamic-Constructive Energy System), in which the 'kinetic' term was also used. Constructivism meant the activation of space in the middle of a dynamic-constructive system of forces (theory of forces in extension). Moholy-Nagy developed the idea and initial plan for the *Licht-Raum Modulator* (Light-Space Modulator).

• In São Paulo the *Semana de Arte Moderno* (Modern Art Week) took place, which consisted of exhibitions, poetry sessions, concerts and lectures organised by the Brazilian Modernist Group, and included artists, poets and musicians. Participating were, among others, Anita Malfatti, Alberto di Cavalcanti, Tarsila do Amaral and the composer Heitor Villa-Lobos. This was a key event in highlighting the modernity of Brazil, and developed from an idea of the poet Oswaldo de Andrade.

1923 On 22 May, the magazine *Jizn Iskousstva* (The Life of Art) in Petrograd published the declaration *Soupretitchskoc Zerkalo* (The Suprematist Mirror) by Malevich.
• In March, Moholy-Nagy published *Light – A Medium of Plastic Expression* in *Broom*, the American magazine edited in Berlin. In this he described his experiences in light and colour resulting from his sculptural and photographic work. The same month, he was hired to teach at the Bauhaus in Weimar, where he was to run the metal workshop until 1928. The photograms he made at the Bauhaus show evidence of the investigations he had described in *Modulator*.
• Marcel Duchamp made his *Disques avec spirales* (Discs with Spirals), an initial approximation to the optical discs, or *Rotoreliefs*, which would appear in motion in the film *Anémic Cinéma* in 1926, alternating with other discs inscribed with *calembours* (puns or word-plays).

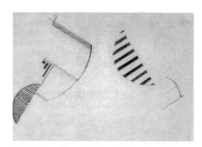

Viking Eggeling still from the film *Symphonie diagonale,* 1923-1924

• Henri Chomette developed a concept of film in which all ideological elements were eliminated, as was narration and representation. He made two films: *Jeux de reflets et de la vitesse* (Games of Reflections and of Speed; 1923 to 1925) and *Cinq minutes de cinéma pur* (Five Minutes of Pure Cinema; 1925).
• Eggeling made the film *Symphonie diagonale* (Diagonal Symphony); (1923-1924), which Erna Niemeyer-Soupault worked on, helping to produce the more than six thousand drawings it needed.

1924 Vantongerloo published *L'Art et son Avenir* (Art and its Future) in Antwerp. This brought together his ideas on the evolution of sculpture; the physics of colour and mathematics; the art of the new and old; and his existential reflections. The latter were strongly influenced by the mathematical-plastic concepts developed by the philosopher Schoenmakers.
• Constantin Brancusi created his series *Le Commencement du Monde* (The Beginning of the World), based on the form of an egg.

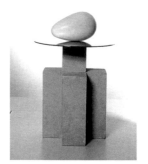

Brancusi *Le commencement du monde,* 1924

• Duchamp made his *Projet pour Rotative demi-sphère* (Project for Rotary Demi-Sphere). A version of this project was reproduced in July 1924 in issue 18 of the magazine *391*, edited by Francis Picabia; another was published on the cover of *The Little Review* in spring 1925 (no. 1, vol. 11); a different version became the book cover for *L'aventure Dada (1916-1922)* by Georges Hugnet (the pseudonym of Tzara), published by the *Galerie de l'Institut* to coincide with the exhibition in 1957: *Exposition Rétrospective Dada, 1916-1922* (Dada: Retrospective Exhibition).
• Oswaldo de Andrade published his *Pau-Brasil manifesto.*
• Fernand Léger made the film *Le ballet mécanique* (Mechanical Ballet) with Dudley Murphy. It affirmed the primacy of rhythmic structure.

1925 Moholy-Nagy's book *Malerei Photographie Film* (Painting Photography Film), was published in the *Bauhausbücher* series, conceived by Walter Gropius and himself and launched in 1924.
• Duchamp made his second motorised machine, *Rotative demi-sphère (optique de précision)* (Rotary Demi-Sphere [Precision Optics]), a demi-sphere with white spirals painted on a black background, around which revolved a disc with a play on words engraved on it: "*Rrose Sélavy et moi esquivons les ecchymoses des esquimaux aux mots exquis*" (Rrose Sélavy and I avoid the Eskimos' bruises with exquisite words.) – in the final version he substituted '*estimons*' (esteem) for '*esquivons*'. When set in motion, the relationship between the eccentric circles

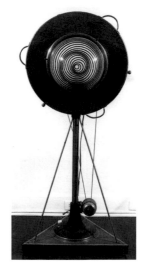

Marcel Duchamp, *Rotative demi-sphère (optique de précision),* 1925 Photo Man Ray

produces a deeply hypnotic effect. That same year, he started making *Stéréogramme d'un film anaglyphe* (Stereogram of an Analglyphic Film), along with Man Ray (who gave it the date of 1920). It was destroyed during its creation. The work, a stereoscopic film based on *Rotative Demi-Sphère*, aimed to achieve an animated relief image by filming simultaneously with two cameras, one loaded with green monochrome film and the other with red. The two films, when projected simultaneously and with the two images slightly out of sync, restored the optical impression provided by the machine.

• From 1925 to 1926, Duchamp made the 7-minute-long film *Anémic Cinéma* in collaboration with Man Ray and Marc Allegret. The film is made up of alternate sequences of 10 optical discs and 9 discs with plays on words inscribed on them, so that the sentences intermingle with the circles. To do this, he used 5 *Disques avec inscriptions de calembours* (Discs with Inscribed Word-plays) produced in 1926.

• At the UFA Palast in Berlin was the first public showing of the film *Symphonie Diagonale* by Eggeling. This was alongside Hirschfeld-Mack's *Reflektorische Farbenspiele* (Reflective Colour Games); Léger and Murphy's *Ballet Mécanique* (under the title *Images mobiles*); *Opus I, II and IV* by Ruttmann; and *Entr'acte* by René Clair.

1926 First exhibition by Moholy-Nagy at the Bauhaus, which had been based in Dessau since 1925. He created transparent compositions with industrial materials. Until 1930, he was to abandon painting and work in photography and cinema, whilst elaborating theoretical proposals.

1927 In Hanover, the magazine *i10* was set up, edited by Arthur Müller-Lehning, together with Moholy-Nagy (who would be in charge of the photography and cinema sections), J.J.P. Oud and Willem Pijper.

1928 Moholy-Nagy left the Bauhaus and moved back to Berlin.

• Vantongerloo went to live in Paris where he continued his work on the function of lines, planes and volumes, reaching the conclusion that solid bodies are not limited by their volumes, but that they are energies. The same year, he made models for the airport and the Scheldt river bridge in Antwerp, which would be shown in November 1930 in the *Exposition Aéronautique et l'Art* (Aeronautics and Art Exhibition) at the Musée des Arts Décoratifs in Paris.

• Fontana returned to Milan where he enrolled in the fifth year at the Accademia di Brera, studying under the sculptor Adolfo Wildt.

• De Andrade published his *Anthropophagite Manifesto* which, like his previous *Pau-Brasil Poesia*, articulated a way to transform European modernity from a Brazilian perspective.

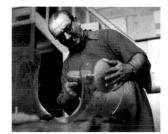

Georges Vantongerloo in his studio
Photo Ernst Scheidegger

1929 Between 1929 and 1931, Gabo produced his biggest architectural project, his entry for the international contest for the construction of the Palace of Soviets.

• Alexander Calder held his first exhibition in Paris at the Galerie Billiet: *Sculptures, bois et fils de fer d'Alexander Calder* (Sculptures, Wood and Wires by Alexander Calder.)

• Len Lye made his first film *Tusalava*, with organic forms referring to motifs used by the Australian aborigines and Samoans.

1930 Gropius, Herbert Bayer and Moholy-Nagy organised for *Deutscher Werkbund* the German contribution to the exhibition *XXème Salon des Artistes décorateurs* (Xxth Salon of Decorative Artists) at the Grand Palais in Paris. Moholy-Nagy presented *Lichtrequisit einer elektrischen Bühne* (Light Prop for an Electrical Stage), or the *Licht-Raum-Modulator*, which he had made in 1929 and 1930. Activated by a motor in its base, it contained coloured bulbs controlled by a coil, which emitted perpetually metamorphosing multicoloured light. Moholy-Nagy published an article of the same name as the piece in the magazine *Die Form* (no. 11-12). In it he explained that the Modulator was a device to demonstrate kinetic and light phenomena, allowing us to see the new possibilities in optical and kinetic creation. Out of this work would emerge the film *Lichtspiel schwarz-weiss-grau* (Light-play: Black-White-Grey), conceived as the first part of a film on light, which retained the visual effect produced by the sculpture. The complete project would be reproduced in no. 24 of the Hungarian magazine *Munka* in 1932.

• In the late twenties and early thirties, Gabo introduced movement through dynamic curves, replacing the more static arcs of his earlier work. His representation of the sphere was a way of demonstrating the expansion of the universe.

• The mathematical operation became the subject matter in the work of Vantongerloo. Algebraic lines, previously invisible or represented by dotted lines, now took centre stage.

• Calder visited Mondrian at his workshop in Paris. While looking at his paintings, he suggested to Mondrian that "it could be real fun to make all those triangles move." After that, he produced his first moving sculptures: "It was basically as a direct result of [that visit] and the sight of all those coloured rectangles spread out on the wall, that my first abstract work was based on the idea of interstellar relations. Since then I have done variations on the subject, but one way or another, I have always returned to it."

• Bruno Munari created his first three-dimensional mobiles he called 'Macchine inutili' (Useless Machines). These were constructed from a fixed dimension, the sphere, and silk thread set in motion by the slightest puff of air.

• Publication of Art Concret (Concrete Art) manifesto by Van Doesburg; a reference point for the Concrete Art Movement, CAM.

• In the thirties, Len Lye employed a new technique in his film-making: without a camera and involving painting and manipulating a film strip. Colour Box was one of the first films in which he used this technique. In these works, called Films in Motion, the use of synchronised music aimed to stimulate a response from the spectator. Lye also began producing Shadowgraphs, photograms in which he placed different elements in front of undeveloped photographic paper, and then exposed them to light. The result was white images on a black background. With these works he developed a technique first used in the 1920s by Man Ray and Lee Miller.

• In September, Jackson Pollock moved to New York and visited the studio of Thomas Wilfred, whose kinetic machines would be crucial in the development of Pollock's work. Wilfred made colour kinetic projections, which he called 'lumia', of programmed compositions, which he had been working on since 1926. Over the next few years, Pollock got to know the films of Fischinger and James Whitney.

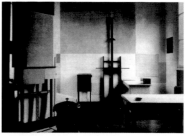

Mondrian's studio in Paris, 26 rue du Départ

Thomas Wilfred from Unfolding, Opus 127, 1941

Alexander Calder exhibiton at the Galerie Percier, Paris, 1931
Photo Marc Vaux

1931 Moholy-Nagy published 'Fényjáték-film' (Light Exhibition Film) in no. 12 of the magazine Korunk, where he explained the possibilities of light creation offered by the Modulator and shown in the film. It included a script for a light exhibition film.

• On 15 February, the Abstraction-Création group was created – after the failure of its predecessors Cercle et Carré (Circle and Square) and Art Concret (Concrete Art) – being an initiative of several artists: Van Doesburg (who died the same year), Hans Arp, Albert Gleizes, Vantongerloo and Jean Hélion; Mondrian and his disciples; Michael Seuphor, Jean Gorin, Marlow Moss and the followers of Van Doesburg; as well as Russian and Polish Constructivists such as Henri Strazewski, Pevsner and Gabo. Calder kept in touch with the group's debates on mathematics and science. A magazine sharing the group's name was published, of which five issues would appear between 1932 and 1936. Various exhibitions and conferences took place at the headquarters of this association at 14 Avenue Wagram, Paris.

• Calder's first exhibition of his abstract works at the Galerie Percier in Paris, Volumes – Vecteurs – Densités – Dessins – Portraits (Volumes – Vectors – Densities – Drawings – Portraits). He announced that he was able to mount the exhibition thanks to his friends in the Abstraction-Création group. He created his first mobiles activated solely by air. Through the winter of 1931 and the following year, he started to incorporate mechanical movement into his abstract works.

1932 Gabo left Berlin and moved to Paris, where he played an active part in the Abstraction-Création group.

• Moholy-Nagy participated for the first time in an exhibition of the Abstraction-Création group, and then joined the organisation; he participated regularly in the group's exhibitions until 1936.

• Calder had an exhibition at the Galerie Vignon (Marie Cuttoli's gallery) in Paris. Duchamp suggested he name his objects *Mobiles,* and put on the invitation a drawing of '*l'objet à moteur*' (Motorised Object) and the printed words '*Calder, Ses Mobiles*' (Calder, His Mobiles.) According to Calder, all the members of Abstraction-Création visited his exhibition. They invited Brancusi to join them in contributing money to bring out an edition of the magazine and to send an attached photo. Brancusi sent a photograph but no money.

• Wols (still known as Alfred Otto Wolfgang Schulze) studied ethnology at Frankfurt am Main. Interested in the architecture of Mies van der Rohe, he considered entering the Bauhaus by taking a vocational training exam. He finally decided against this, and Moholy-Nagy recommended that he move to Paris. There he would work as a photographer and come into contact with Amédée Ozenfant, Léger, Arp and Nelly Van Doesburg.

• Leandre Cristòfol began to work in what he described as 'non-figuration' (in contrast with the idea of figuration which he never abandoned.)

1933 Calder travelled to Spain at the invitation of Ramón Gómez de la Serna. He showed his *Cirque* (Circus) at the Universidad de Madrid and with the Amics de l'Art Nou ADLAN (Friends of New Art) in Barcelona.

• Fontana participated in the V Milan Triennale, where he presented two new sculptures, as part of a collaboration with the architects Luigi Figini, Gino Pollini and the BBPR group.

• Wols made trips around France and Spain. However, from this year on he would have problems with the authorities in Spain and in occupied France, as he had refused to perform compulsory services for the Reich.

• In September and October, Cristòfol had an exhibition at the Casino Independent de Lleida, in which 9 works were shown, including one abstract work entitled *Cosa lírica (De l'aire a l'aire)* (Lyrical Thing [From Air to Air]). In the catalogue Cristòfol wrote: "Part of the works exhibited (the recent ones) have as their main significance a total rectification of my previous work. [...]. (All my current) works are spontaneous, whose language I seek in a mutual osmosis between reality and surreality. They are created under intense spiritual conditions but concretised in basically real forms, and are arranged in an illogical manner in accordance with my inner self, in order to achieve total expression."

• During the thirties, Catalan artists and intellectuals such as J.V. Foix, Sebastià Gasch, Lluís Montanyà, Josep Carbonell and M.A. Cassanyes (who made up the ADLAN group) worked on experimental work, influenced by Miró and Dalí.

Invitation for **Calder**'s exhibition at the Galerie Vignon, Paris, 1932

Marcel Duchamp *Rotoreliefs (disques optiques)*, 1935

1934 After emigrating to Holland, Moholy-Nagy held an exhibition at the Stedelijk Museum in Amsterdam, at which he showed paintings and scenographic projects. That year he met Brancusi and Mondrian.

• Gaston Bachelard published his book *Le Nouveau Esprit Scientifique* (The New Scientific Spirit), which would influence many artists, among them Duchamp and Jesús Rafael Soto.

• Henri Focillon's *La Vie des Formes* (The Life of Forms) was published in Paris.

1935 Moholy-Nagy went into exile in London, where he contacted the Circle group, which included Ben Nicholson, Gabo, Henry Moore and Barbara Hepworth. He produced three-dimensional paintings which he named *Space Modulators*, using materials such as troilite and silverite.

- Gabo exhibited his work at the Jeu de Paume in Paris and the London Gallery.
- Calder made his first outdoor sculpture.
- Duchamp produced 6 lithographed cardboard discs called *Rotoreliefs (disques optiques)* (Rotoreliefs [Optical Discs]). There were different versions of these.
- Fontana's solo exhibition at the Galleria il Milione, of his abstract works from the previous year, was his first exhibition of abstract sculpture in Italy. In March he wrote the manifesto for the *First Collective Exhibition of Italian Abstract Art* with Bobliardi, De Amicis, D'Errico, Ghiringhelli, Licini, Melotti, Reggiani, Soldati and Veronesi. However, Fontana did not take up his abstract investigations again until 1947.

1936 Gabo went to live in London to prepare his exhibition *Abstract and Concrete*.
- Moholy-Nagy perfected his idea for spatial modulators, and started to write his essay *Licht Architecture* (Light Architecture).
- Calder created his *Visual Preludes*, with moving circles and spirals, which formed sets for Martha Graham's new dance shows *Four Movement* and *Horizons* in New York.
- In May, Cristòfol participated in the exhibition *Logicofobista* (Logicophobist), organised by the ADLAN at Galerias Catalonia in Barcelona.

1937 Exhibition at the London Gallery of Moholy-Nagy's kinetic sculptures, spatial modulators, photograms, paintings and drawings. Thanks to Gropius, on 22 August he took charge of the New Bauhaus in Chicago, which was sponsored by the Association of Arts and Industries. In December, he presented the first exhibition there with works by Gabo, Mondrian, Henry Moore, himself and others. Before the end of the year the institution had shut down.

James and John Whitney still from the *Film Exercise 4,* 1942-1944

- Gabo introduced a new material into his sculptures, Plexiglas or methacrylate, an acrylic plastic, with the help of Dr John Sisson of ICI. Gabo published, in collaboration with the painter Ben Nicholson and the architect Leslie Martin, the book *Circle: International Survey of Constructive Art*.
- Calder did his first *Stabile*: *Whale*. On February-March he had the exhibition *Calder: Stabiles and Mobiles* at the Pierre Matisse Gallery in New York.
- Fontana went to Paris, where he met Brancusi, Miró and Tzara.
- Henri Michaux's first exhibition at the Galerie Pierre in Paris took place this year, according to his own biography; other sources give the date as the following year.
- For the first time, Alfred Otto Wolfgang Schulze signed a telegram with the name of 'Wols'. From then on he would use this as his pseudonym.

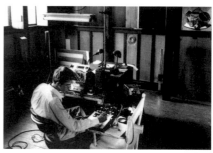

James Whitney in his studio at Pasadena, 1942

1938 Moholy-Nagy published *The New Vision. Fundamentals of Design, Painting, Sculpture, Architecture*, which corresponded to the second American edition of *Von Material zu Architektur* (From Painting to Architecture) which appeared in 1929 as the last book in the Bauhaus series. In this he outlined his pedagogical programme.
- Duchamp produced variations based on the spiral motif *Disque Optique nº 3* (Optical Disc No. 3), *Disque Optique nº 6* and *Disque Optique nº 10*, which had appeared in *Anémic Cinéma*.
- From 1938 to 1939, Michaux was in charge of the magazine *Hermés*.
- Wols worked as a successful professional photographer in Paris and was in contact with surrealist artists and intellectuals, particularly Max Ernst and Alberto Giacometti.

1939 At the beginning of the year, Moholy-Nagy opened his own school on East Ontario Street, Chicago, with the same teachers as were at the New Bauhaus. A compulsory subject was the 'light laboratory'.
- Gabo, Ben Nicholson and Barbara Hepworth moved to work in St. Ives, Cornwall.
- Following France's entry into World War II on 3 September, Wols was interned in various parts of the

country. During this period he did drawings and watercolours. His problems with alcohol dated from this time.

• Gego (Gertrud Goldschmidt) left Germany for Venezuela, where she was to settle.

• From 1939, the brothers John and James Whitney made abstract films in California. In these they worked on the metamorphosis of geometrical forms in a rhythmic order derived from compositional principles developed in new and unknown music. In *Film Exercises*, a joint work, they made sound synthetically with an infra-sound instrument they themselves had created. The film soundtrack was presented exclusively by optical methods and after the film had been developed the soundtrack became acoustically perceptible. The instrument consisted of a series of pendulums, each one making the others vibrate manually. Later, both John and James Whitney would work with computers.

• In his early films, James Whitney explored the formal possibilities of permutation calculations, following the model applied to music by Arnold Schoenberg.

1940 Throughout the decade, Gabo continued to use mathematical models for his works (*Linear Constructions in Space*). He also resumed his painting, a medium which he had hardly used since 1914.

• Moholy-Nagy participated in exhibitions organised by the American Abstract Artists group. He also featured in shows at the Museum of Non-Objective Painting, on the invitation of Peggy Guggenheim, who had been collecting his work since 1929.

• Fontana returned to Argentina, where he devoted most of his time to teaching.

• In the forties, Lye moved to New York, where he was to work with several artists and film-makers.

1941 Moholy-Nagy achieved transparent structures by moulding Plexiglas.

• The Czech artist Zdnek Pesánek published the book *Kinetismus*.

1942 German troops invaded southern France. Wols and his wife tried to flee to the United States but their visas arrived too late and they missed the last boat from Marseilles. In the attempt Wols lost a great deal of his work. His surviving works were exhibited at the Betty Parsons Gallery in New York. Henri-Pierre Roché, with whom Wols was to strike up a strong friendship, was to buy several drawings and watercolours from him.

Wols in Dieulefit, 1944

1943 The first appearance of Calder's *Constellations*; the name came out of several discussions with the critic James Johnson, Sweeney and Duchamp, who paid homage to Miró and his similarly named *gouaches* from between 1940 and 1941.

• Wols's alcohol problems increased. He read in depth the writings of Poe, Artaud, Lautréamont, Sartre, Faulkner and Lao-Tse.

• Publication of Gaston Bachelard's book *L'Air et les Songes. Essai sur l'immagination du mouvement* (Air and Dreams. Essay on the Imagination of Movement). It was the first book by this author that Yves Klein read, later in 1958; of it he stated: "I must say that it was a revelation to me; after that I never once felt lonely again!"

1944 Moholy-Nagy began writing *Abstract of an Artist* in Chicago (published in 1946), a review of his artistic career. The text is divided into sections: 'Apparent Chaos', in which he explained the process of line control and simplification and the study processes in Cubist and Futurist works; 'Organisation of the Picture Plane'; 'The Influence of Machine Technology'; 'The Function of the Artist'; 'Objective Standards'; 'Colleagues'; 'Sculptures and Mobiles'; 'Synthetic Materials'; 'Painting with Light', where he alluded to the use of bubbles and other imperfections in the plastics which "might produce a kinetic play of light", something that would be explored years later by Liliane Lijn; and 'Moulding Plastics'.

• Denise René opened her gallery in Paris, which would become a focal point for the promotion of optic and kinetic artists. The inaugural exhibition was on Victor Vasarely.

• The magazine *Arturo* was launched in Buenos Aires, signalling the beginning of the avant-garde movements in Argentina.

1945 From this year on, Vantongerloo introduced into his work various elements meant to evoke the immaterial, thus continuing his search for the expression of the invisible. He incorporated shiny threads, sometimes standing out due to their colours, and used Plexiglas for its transparency. The result was reflected lights and colours, generating a new interior space which was partially transformed into colour or became colour itself (*Champs magnétiques* [Magnetic Fields], 1951). Vantongerloo stayed in Paris, as did Mondrian and Van Doesburg.

• From 1945 to 1954, the street named Brera in Milan was transformed into a creative centre where a large number of artists lived; there Umberto Eco came into contact with the Italian artistic avant garde, including Fontana as well as younger artists such as Piero Manzoni.

• René Drouin visited Wols, and exhibited his watercolours at his gallery in Paris, in December, with little success. Prior to this, the *Art Concret* exhibition had been held at the gallery with works from Mondrian, Pevsner, Van Doesburg and others. Wols moved to Paris where he once again tried to obtain a visa for the United States, and established a close friendship with Jean-Paul Sartre.

• In October, Sartre founded the review *Les Temps Modernes* in Paris.

• Maurice Merleau-Ponty published *La phénoménologie de la perception* (The Phenomenology of Perception.)

• The art historian and critic Mário Pedrosa returned to Brazil after being in exile during the Vargas dictatorship. In subsequent years he would play a key role in the Brazilian artistic scene, as both critic and exhibition organiser.

1946 Moholy-Nagy completed his *Abstract of an Artist*. It was published in 1947 as *Vision in Motion*.

• Together with Arthur Siegel, Moholy-Nagy created the symposium 'New Vision in Photography'. He died later this year.

• Gabo left Britain to live in the United States.

• Calder's exhibition *Mobiles, Stabiles, Constellations* opened at the Galerie Louis Carré in Paris, in June. Sartre wrote the catalogue preface.

• Wols created a large number of oils during this period, with materials provided by the gallerist René Drouin.

• Pedrosa created the plastic arts section of the *Correio da Manhá* in Rio de Janeiro.

Marcel Duchamp in one of his films in collaboration with Hans Richter, *Dadascope*, 1956-1961

• The editor Gonzalo Losada, with Jorge Romero, Jorge Larco and Fontana, founded the Academia Altamira in Buenos Aires, where Fontana taught sculpture. The same year, Sérgio Camargo studied at the academy with Fontana and Pettoruti.

• The *Manifiesto blanco* (White Manifesto) was published in Buenos Aires, written by Fontana's students at the Academia Altamira. Although it expressed the ideas of the artist, his name did not appear on the document, which was signed by Bernardo Arias, Pablo Arias, Enrique Benito, César Bernal, Rodolfo Burgos, Horacio Cazenueve, Luis Coll, Marcos Fridman, Alfredo Hansen and Jorge Rocamonte.

1947 Gabo went to live in Woodbury, Connecticut, with his family.

• Fontana returned to Milan in April, where he developed the concept of Spatialism and began intensive collaboration with architects.

• The *Primo manifesto dello spazialismo* (First Spatialist Manifesto) was written around May, after Fontana had returned from Argentina, and signed by Fontana, Beniamino Joppolo, Giorgio Kaisserlian and Milena Milani.

• On 23 May, Wols's exhibition opened at the Galerie René Drouin; he showed forty oil paintings. His work did not gain public acclaim. Wols's health deteriorated. He participated in the exhibitions *Réalités Nouvelles* (New Realities) and *L'Imaginaire* (The Imaginary) at the Palais de Luxembourg, and met Jean Paulhan and Georges Mathieu, with whom he remained friends.

• The Galeria Domus opens in São Paulo; the first space in the city devoted to modern art.

• Pedrosa travelled to Europe as correspondent for *Correio da Manhá*.

• From 1947 to 1949, Lygia Clark studied with Roberto Burle Marx and Zélia Salgado in Rio de Janeiro.

• Hélio Oiticica moved with his family from Brazil to the States, and studied in Washington.

1948 Duchamp, Ernst, Léger and Calder participated in Richter's film *Dreams That Money Can Buy*, produced by the gallery Art of This Century in New York. One scene is dedicated to Calder's mobiles.

• *Secondo manifesto dello spazialismo* (Second Spatialist Manifesto) by Gianni Dova, Fontana, Joppolo, Kaisserlian and Antonino Tullier. The manifesto had been preceded in February by an unsigned pamphlet titled *Spazialismo* (Spatialism) distributed by the Galleria del Naviglio in Milan.

• Fontana participated in the XXIV Venice Biennale.

• In December, the *Movimento Arte Concreta* (Concrete Art Movement) was founded by Bruno Munari, Atanasio Soldati, Gianni Monnet and Gillo Dorfles. This was a reaction against post-war neo-realist art and promoted an art of logic and mathematical precision, which also possessed a spiritual dimension. The artists adopted geometrical abstraction as their stylistic definition. The works of Van Doesburg and Arp were central influences on the group, as was Van Doesburg's manifesto *Art Concret* (1930). The first exhibition was held, the same month, of *Movimento Arte Concreta* (MAC), at the bookshop Salto in Milan, with works by Dorazio, Dorfles, Fontana, Munari, Soldati and others.

• During the year, Wols had several exhibitions in Paris, at the Galerie des Deux Îles, the Galerie de Montparnasse, and the show *H.W.P.S.M.T.B* at the Galerie Colette Allendy. Sartre helped to support him financially.

• Exhibition of Michaux's drawings at the Galerie René Drouin in Paris.

• An exhibition of Argentine abstract artists with works by, among others, Maldonado, Kosice and Prati, was shown at the Salon Réalités Nouvelles in Paris.

• Camargo made his first trip to Europe. He took courses in philosophy at the Sorbonne, studied with Gaston Bachelard, and came into contact with Brancusi, Arp and Vantongerloo.

• The Museu de Arte Moderna (MAM) was set up in Rio de Janeiro, founded by Paulo Bittencourt and with Raymundo Castro Maya as president. The Galería do IBEU (Brazil-USA Institute) organised an exhibition of work by Calder, sponsored by MAM. The introduction to the catalogue was written by Sartre. The show then went to the MASP in São Paulo, coinciding with Calder's visit to Brazil. Pedrosa gave a lecture on Calder's work at the city's MES gallery.

• In Ashiya in Japan, a group of artists came together on 29 April Ashiyashi Bijutsu Kyôkai (Artistic Association of the City of Ashiya), with a grant from the city. The association, led by Jiro Yoshihara, held annual exhibitions organised through a public competition. Atsuko Tanaka presented her works in spite of an initial refuge by the committe. Out of these displays evolved the Gutai group, which continued to show its work in this way.

• Pablo Palazuelo exhibited six works in a joint exhibition at the Galerie Denise René in Paris.

Alexander Calder working in the scenography of *Nucléa*, 1952

1949 Fontana created his first Spatial Environment, *Ambiente Spaziale con forme spaziali de illuminazione a luce nera* (Spatial Environment with Spatial Forms Illuminated by Black Light) also named *Ambiente nero* (Black Environment). The exhibition, at the Galleria del Naviglio in Milan, opened on 5 February. The same year he produced his first *Buchi*, canvases with holes.

• Yves Klein composed his *Symphonie Monoton – Silence* (Monotone Symphony – Silence), consisting of one continuous tone.

• André Bloc edited the magazine *Art Aujourd'hui* (Art Today) in Paris, the first publication devoted to concrete art. Out of this publication was created Groupe Espace (Space Group) in 1951, whose members included Vasarely, Herbin and Magnelli.

• René Drouin held an exhibition of the work of Wols at the Galleria Il Milione in Milan, without the knowledge of the artist. Wols had exhibitions at various galleries in Paris and the Perspective Gallery in New York. Pierre Loeb hired him for two months, providing him with a certain financial stability.

• The Museum für Gegenwartskunst in Zürich held an exhibition of the work of Pevsner, Vantongerloo and Max Bill.

• Mira Schendel arrived in Brazil from Italy.

• Pedrosa wrote his thesis on Gestalt, *Da naturaleza afetiva da forma na obra de arte* (On the Emotional Nature of Form in Works of Art) for the Facultade Nacional de Arquitetura in Rio de Janeiro. The same year he published his book *Arte Necessidade Vital* (The Vital Necessity of Art).

• In March, the exhibition *Do Figurativismo ao Abstracionismo* (From Figurativism to Abstractionism) was held at the MAM in São Paulo. The artists were selected with the participation of the galleries René Drouin and Denise René; works by Vantongerloo and Calder were among those included.

1950 Vantongerloo's painting became an explosion of lines, suggesting the complexity of matter in continual vibration.

Jesús Rafael Soto, *Métamorphose*, 1954

• On 31 March, Fontana gave the lecture *Precisione sul movimento spaziale* (Precision on the Spatial Movement) at the Galleria del Naviglio. He participated in the XXV Venice Biennale.

• Publication on 2 April of the manifesto *Proposta di un regolamento del movimento spaziale* (Proposal for a regulation of the Spatial Movement), also named *Terzo manifesto dello spazialismo* (Third Spatialist Manifesto); signed by Carlo Cardazzo, Roberto Crippa, Fontana, Giampiero Giani, Joppolo and Milani.

• Calder's exhibition *Mobiles et Stabiles* at the Galerie Maeght in Paris was attended by Pol Bury, on whom it had a formative effect: "One July day (1950), I pushed open the door of the Galerie Maeght, not knowing that that action would change the face of the world, at least my face and my world. [...] My fascination was indescribable. It went against nature. How can one describe a draught of air, here the essential component of a retinal mystery? It was without doubt an indescribable event."

• Soto moved to Paris where, due to the lectures he attended at the Atelier d'Art Abstrait, he was able to study in more depth the work of Klee, Albers, Malevich and particularly Mondrian. There he met his compatriots who formed the group Los Disidentes (The Dissidents), including Alejandro Otero and Narciso Debourg, and also Arden Quin and members of Grupo Madí.

• Lygia Clark travelled to Paris to study painting with Léger, Szènes and Dobrinsky.

• Wols's exhibition at the Iolas Gallery in New York was organised through René Drouin.

• Oiticica returned to Rio de Janeiro after two years in Washington D.C.

• Mira Schendel's first solo exhibition was held in the Auditorium of *Correio do Povo* in Porto Alegre.

• Palazuelo went to live in Paris, where he remained until 1963.

1951 Guido le Noci, later the main dealer in Spatialism and later Nouveau Réalisme (New Realism), organised an exhibition on abstraction in Italian art at the Galleria Bompiani named *Mostra storica dell'astrattismo italiano* (Historical Exhibition on Italian Abstractionism.)

• IX Milan Triennale, to which Fontana contributed his suspended neon arabesque *Spatial Environment* and *Manifesto tecnico dello spazialismo* (Technical Spatialist Manifesto), subtitled *Noi continuamo l'evoluzione del mezzo dell'arte* (We Continue the Evolution of the means of art).

• *Quarto manifesto dell'arte spaziale* (Fourth Manifesto of Spatial Art) was published by the Galleria il Naviglio in Milan in November, written by Antonio Ambrosini, Adolfo Carozzi, Crippa, Mario de Luigi, Diva, Fontana, Virgilio Guidi, Joppolo, Milani, Berto Morucchio, Cesare Peverelli and Vinicio Vianello.

• Dieter Roth set up the magazine *Spirale*, a part of the absolute abstraction movement. It represented a certain continuity with *Abstrakt-Konkrete* which appeared in Zurich from 1944 to 1945.

• dom sylvester houédard started his studies at the University San Anselmo in Rome. Three years later he published his thesis on freedom in Sartre.

• Lancelot Law Whyte published *Aspects of Form*, an anthology of texts by scientists and art historians, including Ernst Gombrich, Rudolph Arnheim and Joseph Needham.

• Li Yuan-chia, a Chinese refugee in Taiwan since 1949, met Hsiao Chin and Ho Kan, also in exile, with whom he studied.

• Soto began his investigations on the notions of 'repetition', 'progression' and 'vibration', and began to use

geometry in his works. He investigated the codifying of plastic language, based on the example of serial and dodecaphonic music.

• From 20 October to 23 December, São Paulo held its first Biennial, where abstract-geometric trends took centre stage. The event introduced a wide spectrum of European art into the Latin American field. Standing out among the twenty international representations were those of France (Léger, Picasso, André Grommaire, André Masson, Séraphine, Georges Rouault and Francois Villon), the United States (Lyonel Feininger, Willem De Kooning, Pollock, Mark Rothko, Mark Tobey, Calder and Jacques Lipchitz), Italy (Afro, Bartolini, Renato Birolli, Corrado Cagli, Carlo Carrà, Massimo Campligi, Filippo De Pisis, Alberto Magnelli, Renato Guttuso, Giorgio Morandi and Emilio Vedova) and Britain (Graham Sutherland and Ben Nicholson). Among others, Brazil was represented by Mavignier, Abraham Palatnik and Ivan Serpa. Also participating were Schendel and Fontana. The prize for sculpture was won by Max Bill. Pedrosa wrote an article in Rio de Janeiro's *Tribuna da Imprensa* in October, highlighting the contribution from the Brazilian Palatnik, who received a special mention for his plastic chromatic dynamism: kinechromatic kinetic sculpture. Palatnik developed the light form by technical and optical means, which enabled him to experiment with colorimetry and the virtuality of artificial light.

Baj, Fontana, Manzoni, Crippa and **Messens,** 1962 Photo Carlo Cisventi

• In the city of Osaka, the Democratic Artistic Association (DAA) was created. Its members did not recognise the established exhibition system operating by means of a public competition. The DAA was one of the post-war Japanese groups to introduce avant-garde attitudes to the country's art scene.

• In February, for the *III Yomiuri Independent Exhibition*, works from the European and American avantgarde were shown, including works by Pollock. Also taking place was the *Exhibition of Contemporary French Painting* at the May exhibition, making a big impact on Japanese artists.

• Palazuelo's interest in matter led him to become interested in alchemy. Influenced by Claude d'Yge, he studied philosophical, scientific and mystical systems including biology, cosmology, pre-Socratic and oriental philosophy, and Gnostic thought.

Atsuko Tanaka *Untitled,* preparatory drawing for *Bell Piece,* 1955

1952 Gabo obtained US nationality. While he was in the country he established strong friendships with many artists, among them Duchamp.

• XXVI Venice Biennale. The Grand Prize in Sculpture went to Alexander Calder's *Triple Gong,* 1951. There was a special De Stijl exhibition.

• *Arte Mobile* (Mobile Art) exhibition at the Galleria Annunziata, Milan. This was the precursor to *Le Mouvement* exhibition in Paris in 1955.

• Appearance on 6 May of the sixth and last of the Spatialism manifestos, *Manifesto del movimento spaziale per la televisione* (Manifesto of the Spatialist Movement for Television), signed by Antonio Ambrosino, Burri, Roberto Crippa, Mario de Luigi, Bruno De Toffoli, Enrico Donati, Gianni Dova, Fontana, Giancarozzi (Giancarlo Carozzi), Virgilio Guidi, Joppolo, Guido La Regina, Milani, Berto Morucchio, Cesare Peverelli, Tancredi and Vinicio Vianello.

• In Paris, Lygia Clark had an exhibition of her first abstract paintings at the Galerie de l'Institut Endoplastique in June and July, organised by Jamil Hamoudi. When it finished, she returned to Brazil and exhibited her paintings in Rio de Janeiro at the Ministry of Education (MEC) building.

• Carlos Raúl Villanueva designed the arts integration project for the Ciudad Universitaria de Caracas (University of Caracas Campus), in which Calder, Soto, Pevsner, Vasarely, Arp, Léger, Otero and others participated.

• The first edition of the magazine *Noigandres* was published in São Paulo by the poets Haroldo de Campos, Augusto de Campos and Decio Pignatari. In it was coined the term 'concrete poetry'.

• In November, the group *Gendai Bijutsu Kondankai* (Round Table on Current Art, or Group of Friends of

Contemporary Art), also called Genbi, was formed in the Japanese region of Kansai. It involved Jiro Yoshihara, Shigero Ueki, Kokuta Suda, Shin Nakamura, Takao Yamazaki and others, and was a meeting-point for abstract artists and people from sectors such as floral creation and design, etc. For the next two years, they would hold exhibitions. Tanaka showed her *Beru*, a work consisting of small bells which, at the press of a button, rang one after another throughout the rooms of the exhibition. The last sound was produced in the place where she was. As Tanaka put it herself, she wanted to make her presence felt. Again, on this occasion the authorities objected to her work being displayed, but Yoshihara finally managed to have it included.

Dieter Roth *Kinder-Buch,* 1954

1953 Works by Gabo and Calder were exhibited at the Wadsworth Atheneum in Hartford, Connecticut.
• Soto exhibited at the Salon des Réalités Nouvelles in Paris, where he showed a series of five paintings. He read in Moholy-Nagy's *Vision in Motion,* and started to use Plexiglas and superimposition: he created his first kinetic structures, which produced optical vibration effects through the juxtaposition of planes with alternating vertical and horizontal lines.
• In New York, Robert Smithson met writers and artists: Paul Goodman, Meyer Levin, Hugh Selby, Alan Brillant, Charles Haseloff, Franz Kline, several of them from the Black Mountain College.
• Camargo returned to Brazil after his stay in Paris.
• Gego moved to Tarma, Venezuela.
• Schendel went to live in São Paulo, after her isolation in Porto Alegre.
• II São Paulo Bienal opened on 12 December and continued until 26 February 1954. For Brazil the participants included Palatnik, Mary Viera, Lygia Clark, Serpa, Amílcar de Castro and Burle Marx. Standing out among the 33 international displays were France (Picasso, Braque, Juan Gris, Duchamp, Roger de la Fresnaye, Léger, Villon, Sonia and Robert Delaunay, Gleizes, Picabia, Brancusi and other artists), Holland

Gutai group members: front row (from left to right) Yoshida, Mizuguchi, Kanayama, Sumi, Shibata; standing up (from left to right) Tsuruko, Tanaka, Motonaga, Yoshihara, Shiraga, Shimamoto and Sato. Photograph taken on the occasion of the II Gutai open-air exhibition, 1956 Photo Yawazuki Tsuruko

(a review of De Stijl and a special room devoted to Mondrian), the United States (a special room devoted to Calder, de Kooning and Robert Motherwell), Germany (Klee – with his own special room – Bercke and Fassbender), Austria (a room devoted to Oskar Kokoshka), Belgium (a special room on James Ensor), Argentina (Tomás Maldonado, Miguel Ocampo), Britain (a room devoted to Henry Moore), Italy (Birolli, Vedova and other artists, together with a review of Futurism), Norway (a room devoted to Edvard Munch). There was also a room showing 51 of Picasso's works. Alexander Calder was awarded the Biennial Prize and Mira Schendel participated.
• Cristòfol made his *Ralentís* series, in which real movement was sensed through metallic structures of diverse origins in continuous movement.
• Palazuelo did the first of his works around his geometrical conception called 'transgeometry', in which the 'constructivists' created order. He formalized what he himself called 'his idea': "a plastic interpretation of the interval ever-alive rhythms of matter, which he would develop with complete consistency until the present."

1954 XXVII Venice Biennale: the artists representing Brazil were chosen by Pedrosa, W. Pfeiffer and Antonio Bento, and included Lygia Clark, – who had started working on her *Composiçoes* (Compositions) –, Serpa and others.
• Michaux exhibited his ink paintings at the Galerie René Drouin, presenting his experiences in improvisation, energy and movement.
• Takis arrived in France from Greece, settling in Paris at the beginning of the year.
• Soto met Jean Tinguely as a result of the latter's exhibition at the Galerie Arnaud, Paris.
• Roth carried out experiments in Op Art (screen, complementary contrast, reflected/deflected light.) The same year he produced his first book with holes for children, of which two different versions would be printed in 1957, as would also be the case with his 1956 'picture book'. They used variable mobile elements so that

the spectator was included in the process of producing the picture, changing geometric forms into kaleido-scopic structures.

• In October, John Latham staged an event at Hill House Gallery, Church Crookham, England, marking the beginning of his cosmology, named in his later texts as *Io54 (Idiom of 1954)*; at the invitation of his friends the ethologist Anita Kohsen and the head astronomer at the London University Observatory, Clive Gregory, he painted a mural with black paint from a spray gun, his first *Process sculpture*. The work fashioned a new inter-pretation of nature and origin: the unalterable timelessness of being and the variability of our experience. Out of this experience, Koshen and Gregory founded the 'Institute for Study of Mental Images' (ISMI), with the aim of developing a psy-cho-physical cosmology. Latham would become an honorary found-ing member. Koshen and Gregory published the results of their stud-ies in 1959 in the book *The O-Structure*, and from 1960 to 1964 in 41 editions of the publication *Cosmos*.

• Camargo visited China.

• Oiticica studied at MAM in Rio de Janeiro with Serpa. He started to write his thoughts on art and his work in his diary.

• On 30 June, the first exhibition by Grupo Frente was opened at the Galería do IBEU (Institute of Brazil-United States) in Rio, which included works by Aluísio Carvão, Serpa, Lygia Clark and Lygia Pape.

• Schendel's first solo exhibition was held at the MAM in São Paulo.

• In July, formation of the Gutai Bijutsu Kyotai (Gutai Artistic Association) in the city of Ashiya in Japan, headed by Jiro Yoshihara and consisting of 17 mostly young artists. Most participated in the exhibition *Avant-Garde Art by Young Artists* sponsored by the newspaper *Shinko*. The name Gutai was provided by the philosopher Shimamoto, the brother of a group member, and means 'concrete' or 'mate-rialisation'. According to Yoshihara, the name was con-ceived for the magazine but later applied to the group: "We give this word the sense of trying to capture visu-ally and directly the inner hopes of men by means of mat-ter. That is, that the spirit, freed from the norms from which it could not escape until now, tries to obtain in a concrete form that which is formed through chaos." (Jiro Yoshihara, 'On the Art of Gutai' in *Notizie*, Turin, April 1959).

Exhibition *Le Mouvement*, Galerie Denise René, Paris, 1955

Soto with *Spirale*, one of his works presented at the exhibition *Le Mouvement*, at the Galerie Denise René, Paris, 1955

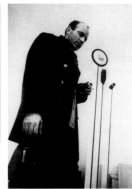

Takis with some of his *Signals*

1955 From 6 to 30 April, the exhibition *Le Mouvement* was held at Galerie Denise René, Paris, organised by Pontus Hulten. It included works by Iaacov Agam, Bury, Calder, Duchamp, Egill Jacobsen, Soto, Tinguely and Vasarely. The display was divided into three sections: one historical, including works by Duchamp and Calder; a section for Vasarely's paintings on double-thickness glass; and a third section of works by other artists. The presence of Duchamp's *Rotoreliefs* and *Nude Descending a Staircase,* was seen as an acknowledgment of his seminal role for the other artists. The choice of artists aimed to include those who had gone beyond the static Constructivism of Mondrian. Agam showed transformable paintings; Bury, his *Mobile Plans or Multiplans*; Calder, new versions of *Stabiles* and *Mobiles*; Tinguely, his first motorised relief-sculptures; and Soto, reliefs with repeated geometric elements. The catalogue included an offprint publishing Vasarely's *Yellow Manifesto*; there were also two texts by Pontus Hulten, *Mouvement-Temps ou les quatre dimensions de la plastique cinétique* (Movement-Time or the Four Dimensions of Kinetic Plastics) and *Petit memento des arts cinétiques* (Small Memorandum on the Kinetic Arts); and by Roger Bordier, *L'oeuvre transformable* (The Transformable Work) and *Cinéma*.

• Soto produced *Spirale*, a Plexiglas relief inspired by Marcel Duchamp's *Rotative demi-sphere*. After seeing this work, Soto decided "to make the image move without a motor".

• Between 1955 and 1959, Takis made the series of sculptures, *Signaux* (Signals); in the early sixties the same name was to be adopted by the Signals art centre in London and its publication. In 1955 he met Klein and Tinguely; the latter, along with Giacometti, as a result of Calder's exhibition at the Galerie Rive Droite.

• Klein submitted an orange monochrome for exhibition at the Salon des Realités Nouvelles, which was rejected. He had a solo exhibition at the Club des Solitaires, where he showed various coloured monochromes.

• Bernard Réquichot's first solo exhibition at the Galerie Lucien Durand in Paris. He started to experiment with collage, using pieces of cloth, and also made his first boxes of bones and earth, his *Reliquaires* (Reliquaries). The first traces of spirals appeared, which would become a recurring feature in his work.

• First *Documenta*, an international exhibition of contemporary art, in Kassel, Germany. The Galerie Denise René participated in the exhibition *Art du XXème Siècle* (Art of the 20th Century), with works by Albers, Calder, Léger and Vasarely, and others.

• Calder retrospective at the Museo de Bellas Artes in Caracas, organised by Villanueva. The catalogue preface was written by Alejo Carpentier. Later, in 1960, the museum would acquire *The City*, a large *stabile* with a small mobile in the centre.

• On 3 July, Haroldo de Campos published 'A obra de arte aberta' (An Open Work of Art) in the *Diario da Manhá* in São Paulo. In this essay he analysed the poetic work of Mallarmé, Joyce, Cummings and Pound. "In order to objectify that which in a wilfully 'drastic' proposition, in the pragmatic-utilitarian sense adopted by Poundian theory, could be defined as the vectorial field of poetic art in our time (whose conjunction of resulting lines of force, some predictable and others not, may emerge as the creative labour demands), it would suffice to highlight as key the works of Mallarmé (*Un Coup de Dés*), Joyce, Pound and Cummings."

• On 14 July, Grupo Frente's second exhibition opened at MAM in Rio de Janeiro, including works by Lygia Clark and Hélio Oiticica (the same exhibition was to be shown the following year at the Itatiaia Country Club). Pedrosa wrote the text for the catalogue. Clark made her first *Superfícies moduladas* (Modulated Surfaces), which were displayed along with her *Maquetas para interior* (Models for the Inside). Meetings took place almost daily at the homes of Clark and Pedrosa, attended by artists and critics such as Ferreira Gullar, Lygia Pape and Serpa.

• III São Paulo Bienal, in which Clark participated (with *Superfícies moduladas*) with Schendel.

• Publication of Merleau-Ponty's book *Les aventures de la dialectique* (Adventures of the Dialectic).

• Launch on 1 January of the review *Gutai*, which was to be published regularly in both Japanese and English until its fourteenth edition in October 1965. The review featured descriptions of ephemeral artworks and performances, and would enable the group's activities to become more widely known. The critic Michel Tapié was to become familiar with the group through this review, as would the artist Allan Kaprow.

• In agreement with Jiro Yoshihara, Shozo Shimamoto invited the members of Zero Kai to join the Gutai group. From then on, Akira Kanayama, Kazuo Shiraga, Atsuko Tanaka and Saburo Murakami participated in the works and activities of the group.

• In March, the first exhibition by all the Gutai group members coincided with the VII Yomiuri Independent Exhibition. Tanaka participated along with the other artists.

• In July, the Gutai group staged its first show: *Manatsu no taiyo ni idomu modan ato yagai jikken ten* (Experimental Open-air Exhibition of Modern Art in a Challenge to the Midsummer Sun). It took place in an extensive pine forest near the Ashiya sea. Tanaka exhibited a piece consisting of roughly 10 square metres of artificial pink silk, raised 20 cm off the ground. The fabric gleamed like metal, reflecting the sun's rays. Another work, entitled *River of Men's Paradise*, was made of 17 two-metre x 30 cm planks of cryptomeria (Japanese cedar), extending from big pillars erected in the centre of the area and descending towards the north-west. As a result of the exhibition the group was joined by Sadamasa Motonaga, Fujiko Shiraga, Yasuo Sumi, Yozo Ukita and Toshiko Kinoshita; but deserted by Yutaka Fumai, Hideo Yoshihara and Sadami Azuma.

• In the autumn, Gutai had its first exhibition in Tokyo, in the Ohara exhibition rooms, where many paintings were shown. Saburo Murakami did a performance which consisted of him leaping through large pieces of treated paper, ripping them apart. Tanaka presented her small bell piece with retouches; she also presented a piece with touched-up rectangles producing the appearance of a large yellow fabric on an 18 m wall; and a work which captured the rustle of wind by means of an electric fan.

• Joaquim Llucià went to Paris for the first time, allowing him to discover the work of Picasso and Klee.

1956 First of Calder's exhibitions in Italy: at the Galleria dell'Obelisco in Rome and the Galleria il Naviglio in Milan.

• Appearance of the manifesto *Per la scoperta di una zona immagini* (For the Discovery of an Image Zone), signed by Camilo Corvi-Mora, Manzoni, Ettore Sordini and Giuseppe Zecca in Milan. A second undated version of the manifesto was probably signed in spring 1957.

• Michaux started to take mescaline voluntarily (the first artistic experiences with mescaline date back to 1954). In January, he presented the first of his drawings created under its effects, entitled *Expression d'un trouble* (Expression of a Turmoil), with a text describing the circumstances under which they were made: *Misérable Miracle*.

• Tinguely met Klein, who showed his *Propositions Monochromes* at the Galerie Colette Allendy in Paris; Pierre Restany wrote the text for the catalogue.

• One-man exhibition by Soto at the Galerie Denise René, where he displayed his first 'kinetic structure', a distanced superimposition of spirals in Plexiglas, with the time element introduced by the movement of the spectator to and from the piece. In August, he too participated with Tinguely and Klein among others in the Festival d'Art de l'Avant-garde, organised by Michel Ragon at Le Corbusier's Unité d'Habitation in Marseilles, where he came across the work of Klein.

Atsuko Tanaka works presented at the II Gutai open-air exhibition, Ashiya, 1956

• Vasarely published his *De l'invention à la Re création* (From Invention to Re-creation): "We do not interpret the term kinetic forms as meaning giving movement to pictures or objects at any price. We are expressing a broad concept of form with movement as its vehicle."

• Gyorgy Kepes published his book *The New Landscape in Art and Science*.

• Roth made his *Ideograms*, which would be published in 1959.

• Nam June Paik arrived in Germany after finishing his studies in music, art and history at the University of Tokyo.

• Gego tested on paper the conversion of planes into volumes using lines. She began her three-dimensional investigations, which she would pursue over the following years, and moved to Caracas.

Yves Klein and **Lucio Fontana** opening of the exhibition *Yves, le monochrome* at the Galerie Rive Droite, Paris, October 11, 1960 Photo Orazio Bacci

• In September, the first exhibition and publication of a manifesto by Grupo Rectángulo took place in Chile. Until 1960, it would produce works of a Constructivist type, then evolving into an 'optical' type. Later, Grupo Forma o Espacio would emerge.

• Third exhibition in March of Grupo Frente at the Itatiaia Country Club in Resende, Brazil, with participation from Oiticica, Pape, Clark, Serpa, et al. In June the group's fourth and final exhibition before it broke up took place at the Companhia Siderúrgica Nacional (National Iron and Steel Company) in Volta Redonda.

• The group of painters Ton Fan was founded in Taiwan by Li Yuan-chia, Hsiao Chin, Ho Kan, Yan Hsia, Wu Hao, Chen Tao-ming, Hsiao Ming-hsien and Ouyang Wen-yuan. All its members had been students of Li Chung-sheng, who had studied in Japan and knew about both modern European art and traditional Chinese painting; he had a decisive influence on the young artists, emphasising the importance of co-ordination between hand, eye and mind.

• The press agency *Asahi* promoted the International Exhibition of Current Art in Japan, where Japanese artists saw for the first time works by Fontana, Fautrier, Dubuffet, Guiseppe Capogrossi, and Karel Appel, and was an encouragment ot them.

• In April, the Gutai group held an open-air exhibition that lasted just one day. It was an initiative of *Life* magazine, and took place on the banks of the river Muko at the ruins of an oil depot complex which had been bombed during the war. Nobody who was not involved in the show was allowed to enter, as the aim was to take photographs to be published later in the magazine.

• The press agency *Shinko* sponsored a Gutai group room at the *Independent Exhibition*. Murakami presented a wooden box with a watch inside, and the work by Kazuo Shiraga involved making a hole in a piece of red wood with a chisel to embed a lens in it.

• *Second Open-Air Exhibition* by the Gutai group, again in the pine forest by the Ashiya sea, in which Tanaka

presented seven very big figures, roughly 4 m high and 3.6 m long, with red neon lights inside switching on and off on a regular basis; according to Yoshihara they looked like blood vessels. The *II Gutai Exhibition* in October featured a profile of each artist's experimental work, such as Tanaka's electric dress and Murakami's torn paper.

• Jiro Yoshihara wrote the manifesto *Gutai bijutsu sengen* for Gutai which was published in December in the 12th edition of *Geijutsu Shincho 7*.

1957 Opening on 2 January of the exhibition *Yves Klein: Proposte Monochrome, Epoca Blu* (Yves Klein: Monochrome Propositions, Blue Period) at the Galleria Apollinaire in Milan, directed by Le Noci. It was Klein's first exhibition in Italy in which he displayed blue monochromes (one of them was acquired by Fontana). Manzoni went to the exhibition and met Klein.

• Manzoni created his first *Achromes*, colourless paintings made from canvas soaked in white clay, inspired by Klein's monochromes.

• Publication in May of the manifesto *L'arte non è vera creazione* (Art is Not Real Creation) by Manzoni, Ettore Sordini and Angelo Verga; in June, the three artists joined the Movimento Arte Nucleare (Nuclear Art Movement) which distributed the manifesto.

• Manifesto *Per una pittura organica* (For an Organic Painting) signed in Milan in June by Guido Basi, Mario Colucci, Manzoni, Sordini and Verga. It was published on wrapping paper in Italian and French, and distributed by the Movimento Arte Nucleare.

Tinguely, Klein, Runhau, Brô, Iris Clert and **Soto**, Galerie Iris Clert, Paris, May 1959

• The *Manifesto di Albisola Marina* was signed on 15 August by Biasi, Colucci, Manzoni, Sordini and Verga.

• In September, members of the Gruppo Nucleare Internazionale made public their manifesto *Contro lo stilo* (Against Style), signed by the following: Arman, Enrico Baj, Franco Bemporad, Gianni Bertini, Stanley Chapmans, Jacques Colonne, Colucci, Sergio d'Angelo, Enrico de Miceli, Reinhout D'Haese, Wout Hoeber, Fritz Hundertwasser, Klein, Theodore Koenig, Manzoni, Nando, Joseph Noiret, Arnaldo Pomodoro, Giò Pomodoro, Restany, Antonio Saura, Sordini, Serge Vandercam and Verga. It was published on a cardboard pamphlet in Italian, French, English and German.

• Bachelard published his book *La Poétique de l'Espace* (The Poetics of Space), in which he explained the poetic and artistic image as being the autonomous creation of an automatic imagination. The book had a big impact on many artists, especially Klein.

• Klein presented his first *Immatériel* at the Galerie Colette Allendy, Paris, a completely empty room that signified "the presence of pictorial sensitivity in the raw material state".

• Soto refused to exhibit at the Salon des Réalités Nouvelles on discovering that it had rejected a monochrome work by Klein, whom he had yet to meet personally. In June, he showed his *Estructuras cinéticas* (Kinetic Structures) at the Museo de Bellas Artes in Caracas.

• François Morellet worked on an element of simple geometry which randomly spreads out or alternates in a painting to establish an active relationship between the spectator and the work.

• The Zero group was formed by Heinz Mack and Otto Piene, later joined by Günther Uecker. The gallery owner Alfred Schmela helped them by organising exhibitions at his gallery in Düsseldorf, enabling them to become known outside their local circle. Mack and Piene also organised regular exhibitions at their Düsseldorf studio. During the group's first night-time exhibition in April, they made contact with the philosopher and sociologist Arnold Gehlen. The group looked to distance themselves from the traditional art forms, trying to establish a 'starting point' from which to formulate new artistic conceptions. The group abandoned concrete forms and shapes in order to work on the effects of light and colour, using media as unconventional as balloons and coloured gases. It would publish a magazine of the same name, of which three editions would appear. The movement evolved between 1957 and 1961, extending to the international level, and brought together a large number of artists without any clear aesthetic link, such as Klein, Fontana, Tinguely, Mack, Piene, Uecker, Arman, Christo, Soto, Hans Haacke, Gerhard Von Graevenitz, Roth, Graubner, Hiltmann and Salentin.

• In late May, Klein presented *Yves. Propositions monochromes* at the Schmela gallery in Düsseldorf after the

end of his exhibition at the Galerie Iris Clert in Paris. The exhibition particularly impressed Piene and Mack.

• Piene produced his Raster (Screen) paintings, with titles such as *Solœil* (Sun-eye).

• The magazine *Spirale*, edited in Berne, published an article on Vantongerloo; one of the magazine editors was Dieter Roth.

• De Campos published in Rio de Janeiro *Da fenomenologia da composiçao à matemática da composiçao* (From the Phenomenology of the Composition to the Mathematics of the Composition). In this he expressed the position of the concrete poets from São Paulo, provoking a response from Ferreira Gullar, Oliveira Bastos and Reynaldo Jardim, which was published in the Sunday supplement of *Jornal do Brasil* and entitled 'Concrete Poetry: Intuitive Experience'. This Rio group believed the São Paulo standpoint was a linguistic formalisation deriving from erroneous science. This difference would cause the rupture in 1959 of the neo-concrete movement founded in Rio.

• IV São Paulo Bienal, 22 September -31 December. Lygia Clark won the Acquisition Prize. Li Yuan-chia was invited to participate with Ton Fan; Oiticica also took part.

• A Jackson Pollock retrospective was organised by The Museum of Modern Art, New York, under the guidance of Frank O'Hara. It was subsequently shown at Rome's Galleria d'Arte Nazionale, and in Basel, Amsterdam, Hamburg, Berlin, London and Paris.

• Oiticica started his *Metaesquemas* series, with which he would continue until 1958, defined by the artist as "an obsessive dissection of space". It was not until 1972 that Oiticica would apply this name to the series.

• Gego began developing her system of parallel lines in drawings, sculptures and environmental sculptures.

• In April, the III Gutai Exhibition took place. Held the following month was *Gutai Art Using the Stage*, a selection of performance works by the group. Tanaka presented various works: in one of them she repeatedly ripped the dress she was wearing; in another, she appeared on stage in an electric dress, which incorporated different-coloured, -shaped and -sized light bulbs. Based on the dress, she made drawings of small circles joined by lines, following the electrical distribution design of the fluorescent tubes and coloured bulbs used for the piece. *The New York Times* published an extensive report on the show which attracted the attention of many people, particularly abroad. As proof of this, Jiro Yoshihara's visit to the States the following year aroused great interest, especially among artists and musicians.

• In September, Michel Tapié arrived in Japan accompanied by George Mathieu and Toshimitsu Imai. In Osaka he visited members of Gutai, whom he already knew about through Hisao Domoto, who had shown him their review. He gave several talks during his stay in the country, in Tokyo and Osaka, and wrote articles for magazines and newspapers. In October, he organised the *International Exhibition of Contemporary Art* at the Bridgestone Museum in Tokyo, which featured works by the Gutai group and by Yoshihara, Shiraga and Shimamoto. Tapié's meeting with Gutai marked the disappearance of the performance and experimental work of his early period, and his move towards painting.

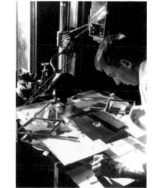

James Whitney in his studio

• In December, *The Informal Adventure* was shown at the Daimaru Hall in Osaka, with works by Yoshihara, Shiraga, Shimamoto and Tanaka.

• Cristòfol made the series *Planimetries*: collages of abstract forms on sacking. Their compositions created a rhythmic movement that became increasingly musical over time, to the detriment of geometry.

• James Whitney made the film *Yantra*, in which circular and spherical designs linked to mystical oriental traditions proliferated.

• From 1957 to 1959, Jordan Belson worked with the composer Henry Jacobs to create the *Vortex Concerts* held at the Morrision planetarium in San Francisco. In these, electronic music was combined with projections of moving abstract visual elements. In his later films, Belson would work on the direct manipulation of pure light in real time.

1958 Fontana began his *Tagli* (Cuts) series with monochrome canvases.

• At the XXIX Venice Biennale, a room was devoted to Fontana's work.

• Gianni Colombo made his first monochrome relief 'in ovatta', which was shown next year in an exhibition at the Galleria Azimut in Milan, jointly organised by the artist and Anceschi, Boriani, Castellani, De Vecchi, and Manzoni.

• Michaux's solo exhibition at the Galleria dell'Ariete in Milan. According to Michaux, his autobiography does not go beyond this year.

• Opening on 28 April of the Yves Klein exhibition *Le Vide* (The Void), also entitled *La Spécialisation de la sensibilité à l'état de matière première en sensibilité picturale stabilisé* (The Specialisation of Sensitivity to the Raw Material State in Stabilised Pictorial Sensitivity) at the Galerie Iris Clert in Paris.

• In May, the first collaboration between Klein and Tinguely: a pictorial-kinetic project submitted to the Salon des Nouveaux Réalistes, which rejected it. In response, the artists organised a counter-exhibition, with a catalogue text by Restany.

• In July, Tinguely exhibited *Mes étoiles, Concert pour sept peintures* (My Stars, Concert for Seven Paintings) at the Galerie Iris Clert: seven paintings with a large variety of sounds produced by percussion instruments. The spectator could adjust the sound effects.

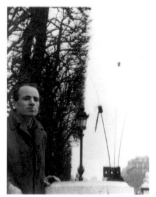

• Opening on 17 November of the joint Klein and Tinguely exhibition *Vitesse pure et stabilité monochromne* (Pure Speed and Monochrome Stability) at the Galerie Iris Clert. The invitation was a blue disc. Six of the eight works exhibited were IKB (International Klein Blue) discs activated by rotary motors turning at variable speeds of between 450 and 2,500 rotations per minute. They also displayed two machines called *Excavatrice d'espace* (Space Excavator) and *Perforateur monochrome* (Monochrome Drill), turning at between 450 and 2,500 rotations per minute.

• In November, Mack met Klein and Tinguely in Paris, while they were preparing joint works for the exhibition at the Galerie Iris Clert. Mack's visit to Tinguely's studio in Impasse Ronsin made a big impression on him. He compared the experience with his visit to the Brancusi's workshop nearby.

Takis with *Signal*, Paris, 1956

• François Morellet produced the first *trame* (mesh), *4 doubles trames traits minces 0°-22,5°-45°-67,5°-90°*, a network of superimposed parallel lines that create a homogeneous image over the whole surface, coinciding with the fabric plane. This principle would allow for a wide diversity of results depending on the variations made: more or fewer number of lines, thinner or thicker ones.

• In November, Julio Le Parc moved to Paris from Buenos Aires, after getting a grant from the Service Cultural Français. He wanted to find out first hand about the artistic events taking place, rather than rely on the garbled versions that reached Argentina.

• Takis studied the possibilities of movement in sculpture from the standpoint of his interest in radars as receptors for magnetic signals. Magnetic fields would become the basis of his work.

Piero Manzoni with one of his *Achromes*, 1959

• Piene organised the exhibition of monochrome painting *Das Rote Bild* (The Red Picture) at his Düsseldorf studio. He included works by 45 artists, including himself, Zero group co-founder Mack, Matthieu and Klein, in the seventh of a series of night-time exhibitions held at his studio. The exhibition catalogue was the first volume of *Zero* magazine, and included texts by Klein, Mack and Piene.

• The second issue of *Zero* was published the same year, with texts by Adolf Zillmann and Piene. In his text, Piene emphasised the primacy of light (and colour) as the first condition for visibility. In his view the informal movement, which centred on Pollock's action painting and the mysticism of Wols, meant the renunciation of something he believed essential: the purity of light and colour.

• In 1958-1959, Daniel Spoerri founded *Éditions MAT* (*Multiplication d'Art Transformable*), in order to reproduce artworks at accessible prices and counter the idea of original and unique art. The first 1959-1960 edition consisted of multiple works by 9 different artists: a variant of Duchamp's old *Rotoreliefs*; a *Ponctuation* (Punctuation) by Bury; and pieces by Agam, Albers, Mack, Roth, Soto, Tinguely and Vasarely.

• Latham introduced into his work spray-paint with assemblages of everyday objects, mainly books, with which he tried to give priority to the concept of process, involving the observer in a social and scientific system.

• Smithson travelled through Mexico and the United States, where he mixed with writers and poets from the *beat* generation, including Allan Ginsberg and Jack Kerouac.

• Soto was commissioned by Carlos Raúl de Villanueva to produce the mural design for the Venezuelan Pavilion at the Universal Exhibition in Brussels. Tinguely helped him by making a machine to mark out lines. Soto met Klein through Tinguely just after the opening of the exhibition *Le Vide* at the Galerie Iris Clert. He abandoned Plexiglas and began to conceive works made of suspended strips of metal.

• Lygia Clark began her *Espaços Modulados* (Modulated Spaces), in which space itself is modulated, and her *Ovo* (Cosmic Egg) , in which the egg is not oval but circular, reminding us of time and the creation of man.

• Gego taught sculpture for two years at the Escuela de Artes Plásticas y Aplicadas Cristóbal Rojas and at the Escuela de Arquitectura y Urbanismo at the Universidad de Caracas, where she would continue working until 1967.

• Tapié and the Gutai group organised the exhibition *International Art from a New Informal and Gutai Era,* in which were shown works by a total of 57 European and American artists, including Fontana, Klein, Pollock and Tàpies; and Japanese artists including members of Gutai.

• In October, Gutai exhibited at the Martha Jackson Gallery in New York.

• Llucià travelled to Paris and Brussels, where he was able to visit the Universal Exhibition and see works by Malevich, who became an essential reference point for him and his work.

1959 Manzoni broke with Gruppo Nucleare; his relationship with Vicenzo Agnetti and Enrico Castellani strengthened. In April, he produced his first *Linee* (Lines). The same month, as a result of his exhibition at the Galerie De'Pasthoorn in The Hague, he met Henk Peeters who put him in touch with the *Zero* group.

Gruppo T: (from left to right) **Colombo, Anceschi, Varisco, Boriani, de Vecci**

• Castellani and Manzoni started up the magazine *Azimuth,* with Agnetti strongly linked to the project from the beginning. It aimed to counter-act *Il Gesto,* the publication of Gruppo Nucleare. The first issue, co-ordinated by its two founders, included texts by Agnetti, Bruno Alfieri, Balla, Gillo Dorfles, Albino Galvano, Carl Laszlo and Yoshiaki Tono, and reproduced works by Klein, Jasper Johns and Robert Rauschenberg. In November, the shop basement at no. 12 Via Clerici was turned into a gallery of the same name, opening to the pub-lic on 4 December with the presentation of Manzoni's *12 Linee* (12 Lines).

• In April, exhibition by the Gutai group at the Galleria Civica d'Arte Moderna in Turin.

• Founding in Milan of Gruppo T, also known as *Miriorama,* which involved Giovanni Anceschi, Davide Boriani, Colombo, De Vecchi and Grazia Varisco (the latter joined the group in 1960).

Iris Clert, Jean Tinguely and **Marcel Duchamp** at Tinguely's exhibition in the Galerie Iris Clert, Paris, 1959

• In the winter, Gruppo N was founded in Padua, initially with ten members; by 1969 this was reduced to Alberto Biasi, Ennio Chiggio, Giovanni Antonio Costa, Edoardo Landi and Manfredo Massironi, who experi-mented with technology and image reduction. From winter 1959 to spring 1960, Massironi, Landi and Biasi par-ticipated in various collective exhibitions at the Galleria Azimut in Milan.

• Yves Klein gave two lectures at the Sorbonne: *L'Évolution de l'art vers l'immatériel* (The Evolution of Art Towards the Immaterial) on 3 May; and *L'Architecture de l'air* (The Architecture of Air) on 5 June, in which he outlined his project to create an *Académie de la Sensibilité* (Academy of Sensitivity). He also sold the first of his *Zones de sensibilité immatériel picturale* (Zones of Immaterial Pictorial Sensitivity).

• Tinguely produced his *Méta-matics* series, exhibited at the Galerie Iris Clert in July. He showed *Méta-matic no. 17* at the first Paris Biennale, which opened on 2 October (Klein also presented a 'monochrome' , and Dufrêne, Hains, and Villeglé were represented). Tingueley's *Méta-matic no. 17* was acquired by the Moderna Museet in Stockholm in 1965, using the profits from the drawings done for *Méta-Moritz (Méta-matic n° 8),* which already belonged to its collection.

• Le Parc carried out visual investigations of surface, working on sequences and progressions. He made contact with, among others, Denise René, Vantongerloo and Morellet; also Vasarely, with whom differences would soon

emerge, since Le Parc criticised the attitude of artists who used a free choice of forms and their positioning.

• Exhibition of mescaline watercolours and drawings by Michaux at the Galerie Daniel Cordier. Michaux wrote the preface text: "I start only ... ".

• Iris Clert and Alain Jouffroy presented three magnetic sculptures by Takis at the Maison des Beaux-Arts in Paris.

• Roland Barthes published his essay *Zero pour littérature* (Zero for Literature; 1954-1959).

• Opening on 30 January of Tinguely's exhibition *Concert no. 2* at the Galerie Schmela, Düsseldorf. Daniel Spoerri, Haio Bode and Klaus Bremer recited *Tinguely hat Zwei Katzen* (Tinguely Has Two Cats), *Elementar-Bausteine der Materie* (Elementary Components of Matter) and *Die Apparate von Jean Tinguely* (The Apparatus of Jean Tinguely). On 14 March he flew over the city and scattered copies of his pamphlet 'For static'. This year Tinguely and Klein were given the job of decorating part of the Gelsenkirchen music hall. As result of their stay in Germany, they established a greater contact with Mack, Piene and Uecker.

• In January, Klein's lecture in Düsseldorf to coincide with Tinguely's exhibition entitled *La collaboration entre artistes créateurs* (Collaboration between Creative Artists) referred to Heindel's prophecy: "We will all become aerial men, we will know the upward force of attraction, towards the void and towards everything."

• As the year progressed, the Zero group consolidated itself as an international movement, co-operating in exhibitions with Galleria Azimut and holding exhibitions in Antwerp and Wiesbaden. The exhibition at the Hessenhuis in Antwerp was entitled *Vision in Motion – Motion in Vision*, in a clear reference to Moholy-Nagy's book, and was organised by the artists themselves; participating were Bury, Soto, Tinguely, Klein, Mack, Piene, Uecker, Roth, Spoerri, Mari and Munari. The Wiesbaden exhibition, *Dynamo 1*, was held at the Galerie Boukes and organised by Mack and Piene; with participation from Bury, Holweck, Mack, Mavignier, Oehm, Piene, Roth, Soto, Spoerri, Tinguely and Klein.

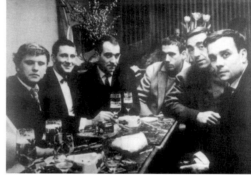

Mack, **Piene**, **Tinguely**, **Spoerri**, **Bury** and **Klein**, at the exhibition *Vision in Motion*, Hessenhuis, Antwerp, 1959 Photo Wilp

• In May, Roth made his kinetic sculptures, kinetic paintings (puzzles) and paintings with geometric stamps.

• In July, Manzoni travelled to Düsseldorf, establishing a crucial link between Zero International and Milan. At the last minute, Mack and Piene invited Manzoni to participate in the *Dynamo* exhibition opening that month at the Galerie Boukes in Wiesbaden. Manzoni also used images of works by the two artists in the magazine *Azimuth*.

• Launch in May of the magazine *nota*, devoted to experimental poetry and art. In the same year, the second and third edition appeared, the latter devoted to concrete poetry. Gerhard Von Graevenitz was one of the founders, along with Jürgen Morschel.

• Von Graevenitz began his white structures, in which he expanded on the geometrical and optical treatment of movement.

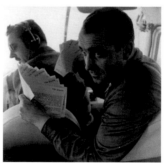

Tinguely flying over Düsseldorf on March 14, 1959, to drop his manifesto *Für Statik* Photo Charles Wilp

Lecture of **Jean Tinguely** *Art, machines and motion, a lecture by Tinguely* at the ICA, London, November 12, 1959 Photo Ida Kar

• On 12 November Tinguely gave a talk at the ICA in London: *Art, Machines and Motion, a Lecture by Tinguely*. He remained motionless and silent on the platform while the audience listened to two soundtracks played simultaneously. In the first, Tinguely explained his theory of stability for the modern machinist movement in terrible English; in the second, an angry English voice constantly corrected and interrupted him.

• Gustav Metzger formulated the foundations for his theory and practice of auto-destructive art in his text of the same name, in which destruction is conceived as a social and aesthetic phenomenon.

• Li Yuan-chia invented the *Point,* painting a small black dot on white cloth.

• Pursuing his interest in incorporating the observer in the visual system of art, Latham found film to be the ideal medium to include the spectator in his structured perception.

• In the late fifties, Lye started making *Tangible Motion Sculptures* in New York, where he regularly exhibited at the Howard Wise Gallery.

• Gego travelled to the United States where she stayed for a year. She produced the sculpture *Sphere*, now in the collection of The Museum of Modern Art, New York. It would form part of the travelling exhibition *The Responsive Eye* in 1965.

• On 22 March, the *Manifesto Neoconcreto* was published in the *Jornal do Brasil*, signed by Ferreira Gullar, in collaboration with Franz Weissmann, Amilcar de Castro, Lygia Clark, Lygia Pape, Reynaldo Jardim and Theo Spanudis. This represented a break by the Brazilian artists with the concrete movement. On the same day, the first exhibition of Neoconcrete Art was opened at the MAM in Rio de Janeiro, in which these artists and others participated.

• In September, the MAM in Rio de Janeiro presented an exhibition of Calder's mobiles.

• *Exposición de Arte Neoconcreta* at Belvedere da Sé in Salvador (Brazil); among the artists participating were Oiticica and Clark.

• Oiticica made the transition from painting to three-dimensional space with his 'monochromatic' works that were a foretaste of *Relevos Espaciais* (Spatial Reliefs) and *Bilaterais* (Bilaterals). The year was very significant in terms of his work: he himself would later declare that there was no reason at all to take his pre-1959 work seriously.

• Clark produced her *Contra-Relevos* (Counter-Reliefs) and *Casulos* (Cocoons), at the same time announcing the "death of the plane" and integrating her work into the architectural field. She participated in the exhibition

Heinz Mack Diagram of Art History

Brasilianischer Künstler (Brazilian Artists) at the Haus der Kunst in Munich. The following year, Gullar published his *Diálogo sobre não-objeto* (Dialogue on the Non-object), in the Sunday supplement of Rio de Janeiro's *Jornal do Brasil,* taking *Casulos* as a reference point.

• V São Paulo Bienal included a retrospective exhibition of Torres García and confirmed Tachism as a tendency. Fontana's *Tagli* were shown along with works by Oiticica, Clark and Eusebio Sempere.

• One of the Neo-Concreto group members, Lygia Pape, created the *Livro da Criação* (Book of Creation), a concrete-kinetic book that reformulated the myth of creation by means of geometric metaphors.

• In May, the exhibition *Arte Nuova* (New Art) took place at Arte Figurative in Turin, and included works by eight Gutai artists, one being Tanaka.

• The Spanish artist Francisco Sobrino settled in Paris.

1960 In Paris on 20 March, Vantongerloo wrote *Aurore boréale* (The Northern Lights) in which he described his experience of seeing them in Sweden and Norway in February; an experience that roused him to wonder and intense reflection.

• Between 4 January and 1 February, the exhibition *La Nuova Concezione Artistica* (The New Artistic Concept) took place at the Galleria Azimut in Milan, with participation from Kilian Breier, Castellani, Holweck, Klein, Mack, Manzoni and Almir Mavignier. The show brought together works on the objective dimension of visual experimentation. A folder catalogue was published, with reproductions of the artists' works. The second edition of *Azimuth* magazine appeared in January, devoted to the exhibition, with texts by Castellani, Udo Kultermann, Manzoni and Piene.

• Gruppo N opened its gallery Studio N in Padua with an exhibition by group members. Later exhibitions would be held on Burri, Fontana and Pollock; as well as experimental music and other performances.

• Opening on 15 January of the first exhibition by Gruppo T, *Miriorama 1*, at the Galleria Pater in Milan, whose

Grande ogetto pneumatico (Big Pneumatic Object) and *Pittura in fiumo* (Painting in Smoke) were shown. On the walls hung photographs of works by Boccioni, Calder, Klee and Manzoni, accompanied by notes from the artists. To coincide with the event, the group signed its first manifesto: "Each aspect of reality: colour, form, light, geometrical space or astronomical time, is a different aspect of the space-time relationship, or better still a different way of perceiving the relationship between space and time. We thus consider reality to be a continuous development of the varied phenomena; from the moment that reality understood in these terms takes the place of a fixed and unchanging reality in the conscience of man (or merely in his intuition), we are recognising a tendency in art to express reality in terms of change. Thus, considering art to be a reality consisting of the same elements that make up the reality surrounding us, it is necessary for art be constantly changing. In saying this we are not rejecting the validity of means such as colour, form, light, etc. But we give the work a new dimension, placing it in the real situation in which we acknowledge it within reality, that is, in continual change, which is the effect of this reciprocal relationship." By 1962, the group had organised twelve *Miriorama* exhibitions in various places.

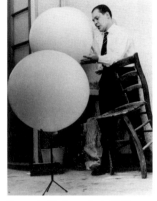

Manzoni with *Corpo d'aria*, 1960
Photo Orazio Bacci

• Manzoni made his first *Scultura nello spazio* (Sculpture in Space), a sphere held up by a rotating blast of air produced by a mechanical system; he used the same system to create *Corpi d'aria de luce assoluta* (Air Bodies of Absolute Light) which consisted of spheroids activated by a blast of air to swirl around at high speed, forming a virtual mass. He presented *Corpi d'aria* and, at the Galleria Azimut on the 19 July, *Consumazione dinamica dell'arte dal pubblico, divorare l'arte* (The Consumption of Dynamic Art by the Art-Devouring Public). He continued to explore *Achromes,* making them from absorbent cotton, expanded polystyrene, cloth or cotton treated with cobalt chloride, which changes colour according to environmental conditions.

• Takis toyed with the idea of working with Klein, as had been suggested by the latter: "It was he who suggested that we work together. He liked my *Signals* a lot, but thought I should do something more realist, using colour, blue, red, yellow... Then he brought me three small square and diamond-shaped boards. My *Signals* were poles with pieces of metal on the ends which made them move to and fro. Klein wanted to replace the metal with the boards. We tried it once... They looked like Christmas trees. It was horribly ornamental. Klein admitted that it had been a failure. But there was another reason making joint work impossible: The Monochrome was a totalitarian project and that is something to which I am opposed."

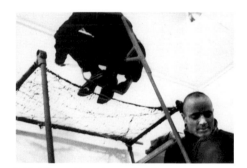

Takis *L'Impossible, un homme dans l'espace,*
Galerie Iris Clert, Paris, 1960 Photo Hans Haake

• In Paris, Takis frequently visited the writers Sinclair Beiles and Brion Gysin and the *beat* poets Gregory Corso, William Burroughs and Allen Ginsberg, who were to dedicate numerous poems to him. On the occasion of the Takis exhibition *L'Impossible, un homme dans l'espace* (The Impossible, a Man in Space) at the Galerie Iris Clert, Sinclair Beiles read his *Magnetic Manifesto* which began "I am a sculpture... " and jumped into the air, where the force from a magnet he wore around his waist held him suspended for an instant.

• Creation in July of Groupe de Recherche d'Art Visuel (Visual Arts Research Group) or GRAV (previously named Centre de Recherche d'Art Visuel-CRAV, formed from the Motus collective). This was made up of the Argentine artists Horacio García Rossi and Le Parc, Spain's Francisco Sobrino, and France's François Morellet, Joel Stein and Yvaral (Jean-Pierre Vasarely). Its founding charter was published.

• Founding of the Nouveax Réalistes group, with a manifesto signed by Restany, Arman, Dufrêne, Hains, Klein, Raysse, Spoerri, Tinguely and Villeglé. They would later be joined by Christo, Deschamps and Niki de Saint Phalle. The first exhibition under the group's name took place at the Galleria Apollinaire in Milan in April-May, organised by Restany and showing Arman, Dufrêne, Hains, Klein, Tinguely and Villeglé.

• Le Parc made his first mobiles, wooden reliefs with progressive rotational levels and adjustable light boxes. He experimented with different uses of light: projections, moving light rays, reflections from translucent mobiles and installations with radiant light.

• *III Festival d'Art de l'Avant-garde* in Paris: Klein circulated a unique edition of the magazine *Dimanche, le journal d'un seul jour* (Sunday, the one-day newspaper) in which he expressed his ideas on the 'Theatre of the Void', alongside other texts; on the cover he reproduced *Saute dans le vide* (Leap into the Void) with the title *Le peintre de l'espace se jette dans le vide* (The Painter of Space Leaps into the Void). Also participating were Bury, Soto, Roth (with kinetic pictures and projections of films on to moving mirrors), Yaacov Agam, Mack, Frank Malina, Piene and Tinguely.

• Vasarely visited Morellet's workshop.

Gerhard von Graevenitz Photo Benjamin Katz

• David Medalla travelled to Europe from the Philippines and presented his first performances in Paris at the Raymond Duncan Academy. He met many artists and writers, among them Bachelard, Braque, Reinhardt, Ernst, Magritte, Arp, Richter, Klein, Takis, Tinguely, Fontana, Lourdes Castro, Meret Oppenheim, Man Ray and Giacometti.

• Publication of the book *L'Oeil et l'esprit* (The Eye and the Spirit) by Maurice Merleau-Ponty: space, light and vision were redefined as the starting point of spatialism.

• Controversial argument sparked off between Klein and Matthias Goeritz, who had just published *L'art prière contre l'art merde* (Prayer Art Against Shit Art), a manifesto that called for emotional and mystical experience to be invested in art, and rejected monochromicity as seeking the annihilation of the individual, thus denying authorship.

• The exhibition *Monochrome Malerei* (Monochrome Painting), organised by Udo Kultermann at the Städtisches Museum in Leverkusen, ran from 18 March to 8 May. Participating artists from a variety of countries included Castellani, Fontana, Klein, Lo Savio, Mack, Manzoni, Morellet, Piene, Rothko and Tàpies.

• Appearance of the fourth edition of the magazine *nota*, with a manifesto, 'Dynamo', by Piene and Mack; articles by Mack, Klein, Tinguely, Spoerri and Agam; a manifesto by Spoerri on MAT publications, and other texts by Bury, Duchamp and Soto; a text by Roth; a text on Vasarely and Manzoni; and a theoretical piece from Max Bense on concrete poetry; Zero's works and kinetic works. *nota* also organised experimental activities at the Städtische Galerie in Münich, with the participation of personalities from different cultural fields. Reproductions of the latest works by Von Graevenitz were planned for the fifth edition, but these did not get published.

• In September, the Galerie nota was opened in Münich by Gerhard Von Graevenitz and his friend Jürgen Morschel. Von Graevenitz set out the programme of exhibitions: 1. Piene 2. Mack 3. Morellet 4. Mavignier.

• On 9 October, Piene displayed his *Lichtballett* (Light Ballet) (1959) at his studio, as part of the 9th night-time exhibition, followed by three other pieces from the same work, *Licht und Jazz. Ensemble* (Light and Jazz: Ensemble). These were: *Archaische Lichtballett* (Archaic Light Ballet) on 10 October, in which Piene created mobile light projections in a dark room with lanterns and printed screens; *Chromatische Lichtballett* (Chromatic Light Ballet), a choreography with lights operated by different people, using jazz and morse code sounds, on 13 October; and finally, on 15 October, *Vollelektronische Lichtballett* (All Electronic Light Ballet) which experimentally substituted lights for actors.

• Influences from the work of the German artist Karl Otto Götz began to show in Nam June Paik's work. Götz was a lecturer at the Akademie in Düsseldorf between 1959 and 1979, and developed theories about the creation of kinetic images with the help of electronic television images.

• *Movens,* a multi-authored book, was published in Wiesbaden: it included the first chronology of kinetic art.

• Roth saw an exhibition in Basel of the works of Tinguely (whom he met in the same city in August, along with Emmett Williams) whose self-destructive machines made a big impression. Roth would thus rethink his artistic activity and abandon his Constructivist work. He claimed that this was his first conscious change of direction.

• The exhibition *Kinetische Kunst* (Kinetic Art) was presented at the Kunstgewerbemuseum in Zurich. Agam, Albers, Bury, Calder, Duchamp, Gerstner, Mack, Roth, Soto, Tinguely, Vasarely and others participated.

• On 8 June, the exhibition *Konkrete Kunst. 50 Jahre Entwickwung.* (Concrete Art. 50 Years of Evolution) opened at the Helmhaus in Zurich. This was organised by Max Bill and included works by 116 artists, among them Mondrian, Albers, Moholy-Nagy, Smith, Morellet, Schoeffer, Balla, Munari, Dorazio, Magnelli, Lygia Clark, Oiticica, Agam, Mack, Piene, Soto, Tomasello, Uecker and Vasarely.

• *Manifesto contro niente per l'esposizione internazionale di niente* (Manifesto Against Nothingness for the

International Exhibition of Nothingness) signed in Basel by Bazon Brock, Castellani, Carl László, Mack, Manzoni, Onorio, Piene and Herbert Schuldt to coincide with the *L'esposizione internazionale di niente* (International Exhibition of Nothingness).

• John Latham had his first solo exhibition outside Britain at the Galerie Schmela in Düsseldorf.

• In March, Gustav Metzger published his *Manifesto of Auto-Destructive Art* in London. In June, he gave his first exhibition of auto-destructive art, pouring acid on to nylon in Kings Lynn, Norfolk.

• Liliane Lijn began to experiment with plastics and fire.

• Robert Smithson met Sol LeWitt, and rented him his loft in Montgomery Street, New York; Smithson did a series of works on paper, which were phantasmagorias and cosmologies.

• On 17 March, Tinguely's work *Hommage à New York* (Homage to New York), the first self-destructive machine, went on display in the gardens of the New York MoMA. After 30 minutes of violent animation, the enormous machine had completely destroyed itself.

• In Brazil, Oiticica made his 'Nuclei', in which colour was transformed into a bodily sensation, and which entailed a reformulation of his work to incorporate audience participation. He also produced *Penetrávei-PN1* (Penetrable-PN1), the first of his penetrable works. His essay 'Colour, Time and Structure' was published in the Sunday supplement of *Jornal do Brasil*: in it he rejected the two-dimensional plane as an aid to representation, and defended its structural transformation into the colour-time duality.

• Lygia Clark participated in the inaugural exhibition of the Galería Bonino in Rio de Janeiro, together with 23 other artists. At the same gallery in October she exhibited her *Bichos* (Animals), which were structured from joined-up aluminium plates to be adjusted by the spectator. She took part in the exhibition *Contribução da Mulher às Artes Plásticas* (Woman's Contribution to the Plastic Arts) in Rio de Janeiro, presented by Pedrosa. She also exhibited at the Venice Biennale, and taught fine arts at the Instituto Nacional de Educaçao dos Surdos (National Institute of Education for Deaf People).

• On 21 November, *II Exposição de Arte Neoconcreta* was held at the MEC in Rio de Janeiro, with participants including Oiticica and Clark.

• From the beginning of the sixties, Camargo and Schendel kept up a close friendship. During the decade, Mario Schenberg, Mário Pedrosa and Theon Spanudis wrote essays in Schendel's catalogues.

• Soto won the National Prize of Venezuela for one of his *Vibraciones* (Vibrations) shown at the Museo de Bellas Artes in Caracas. MAT published the multiple work *Spirale*, which Soto had shown in the exhibition *Le Mouvement* at the Galerie Denise René.

• In Caracas the exhibition entitled *Los Espacios Vivientes* (Living Spaces) took place, and was seen as a provocation against kinetic art on the Venezuelan scene.

• Gutai and Michel Tapié jointly organised the International Festival of the Void at the Takashimaya hall in Osaka, featuring a total of thirty international artists. The presence of Saura from Spain was notable.

• Throughout the sixties, new members joined Gutai from a new generation of artists oriented towards the production of non-organic forms using industrial materials, such as plastic; they also worked on optical and kinetic art.

• Cristòfol began the *Volumetries* series, in which volume was achieved through the rhythmic suggestion of the metallic structural elements making up the work.

• Joaquim Llucià stayed in Sweden for three months, where he became interested in Scandinavian design and began to use materials unknown until then, including different-coloured aluminium paper which he would employ in his collage work.

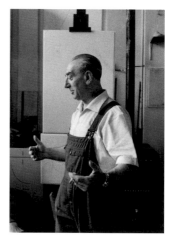

Vantongerloo in his studio Photo Ernst Scheidegger

1961 Vantongerloo wrote an 'intimate biography' in Paris, in which he explained his researches, impulses and reactions.

• Gruppo T made their first exhibition at the Galleria La Salita in Rome, called *Miriorama 10*, opened on 14 April, with an introduction by Fontana. By now Grazia Varisco had joined the group.

• In March, Castellani and Manzoni co-ordinated the publication of 100 copies of the 'Azimuth' box, a compendium of the magazine editions from 1959 to 1960 with the catalogues of the exhibitions held at the gallery of the same name.

• In August, Umberto Eco published 'L'informale come opera aperta' (The Informal as an Open Work) in no. 4 of *Il Verri*. Within the framework of a critical reflection on informal experience, Eco introduced the notion of the "poetry of the open work" as a cultural trend in contemporary art that did not refer to how problems are solved, but to how they arise. The open work is the field of the infinitely possible in a world faced with the vagueness of a message; it alludes to the prolongation of the aesthetic subject given that its ambiguity stimulates the spectator actively to intervene in its interpretation. The attribution of meaning to the open work is a hypothesis bringing together aesthetic perception and the critical act, always from the intentionality of the creative act.

• Hsiao Chin went to live in Milan and founded the group Il Punto with the painter Antonio Calderara and the Japanese sculptor Kengiro Azuma. He would invite artists from the Ton Fan group to come to Italy. Later, Spanish, French and Dutch artists would join them, with Fontana and Manzoni remaining in contact with the group.

• Exhibition *Gruppo 0+0* at the Galleria La Salita in Rome in June, with Klein, Lo Savio, Mack, Piene and Uecker.

• Opening in March of the exhibition *Continuité et avantgarde au Japon* (Continuity and Avant Garde in Japan) at the International Centre of Aesthetic Research in Turin, with works by ten Gutai members, including Tanaka, Yoshihara, Shimamoto, Shiraga and Murakami.

• II Paris Biennale, with a large variety of trends. Piene participated in one of the sections. During the biennial, GRAV distributed their pamphlet *Assez de mystifications* (Enough Mystifications).

• Exhibition *Groupe de recherche d'art visuel* at the Galerie Denise René, Paris, with works by Horacio García-Rossi, Le Parc, Morellet, Francisco Sobrino, Joël Stein, and Yraval.

• The Galerie Denise René showed the exhibition *Art Abstrait Constructif International* (International Abstract Constructive Art), with works by Agam, Albers, Kosice, Le Parc, Lissitzky, Malevitch, Moholy-Nagy, Mondrian, Morellet and others.

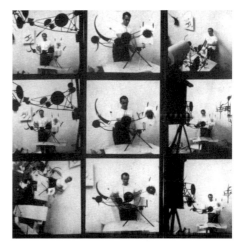

Images of Tinguely published in *Zero* magazine, no. 3, 1961

• From 17 May to 10 June, the exhibition *À 40° au-dessus de Dada* (40° Above Dada) took place at the Galerie J in Paris, organised by Restany. It was the second exhibition by the group Nouveaux Réalistes, with works from Arman, César, Dufrêne, Hains, Klein, Rotella, Saint-Phalle, Spoerri, Tinguely and Villeglé. Manzoni travelled to Paris to see the exhibition and to meet Arman and Tinguely; he introduced himself to Klein, saying: "You are the monochrome blue and I am the monochrome white, we must work together." However, no collaboration ever took place.

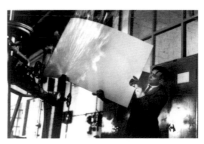

Yves Klein working on his *Fire Paintings*, 1961

• In October, Klein, Hains and Raysse declared the group Nouveaux Réalistes disbanded as a result of differences that had arisen over their second manifesto, written by Restany immediately after the May-June exhibition, in which he declared the group to be the descendants of Dada.

• Bernard Réquichot's first solo exhibition at the Galerie Daniel de Cordier, for which the artist wrote seven letters in illegible 'false handwriting': *Letter of Insults, Letter to Art Followers, Letter of Conclusion for a Philosophy of Art*, etc. Two days before its 4 December opening, he committed suicide.

• Camargo went to live in Paris, where he studied the sociology of art under Pierre Francastel at the École Pratique des Hautes Études, and started to produce his monochromatic reliefs.

• The Piene exhibition at the Galerie nota opened on 24 March; in the same gallery was a show devoted to Mack, starting on 14 April. The next exhibition was billed as 'concrete works' by Morellet and opened on 9 May, followed by an exhibition devoted to Mavignier.

• Gunther Uecker joined the Zero group.

• In July, the third and last number of the magazine *Zero* appeared, including texts from Piene, Mack, Klein, Tinguely; Uecker showed some of his works, with a brief essay on his canon; also featured were texts by Castellani, Manzoni, Ira Moldow, Marc Adrian and Arnulf Rainer, and an invention by Tinguely and Spoerri. To coincide with

this, a Zero party was held at the Galerie Schmela in Düsseldorf.

• Klein exhibited his first *Fire Paintings* at the Museum Haus Lange in Krefeld. The same museum held the *MAT* exhibition, with works by Soto, Spoerri, Mack and others.

• In November, the Dutch artists Henk Peters, Jan Schoohoven and Herman de Vries founded the group and magazine *Nul*, following the example of the Zero group and *Azimuth*.

• Exhibition *Bewogen Beweging* at the Stedelijk Museum in Amsterdam and the Louisiana Museum in Copenhagen; *Rörelse Konsten* at the Moderna Museet in Stockholm. These constituted a pioneering look at the new optical and kinetic trends, organised by Pontus Hulten, William Sandberg, Spoerri and Tinguely. Participants included Agam, Bury, Colombo, Carlos Cruz-Díez, Duchamp, Jacobsen, Le Parc, Mack, Metzger, Morellet, Piene, Roth (who designed the poster), Soto, Spoerri, Takis, Tinguely, Tomasello, Vasarely, Gruppo N from Padua – Alberto Biasi, Ennio Chiggio, Toni Costa, Edoardo Lando and Manfredo Massironi – and Gruppo T from Milan. In 1960, after talking to Sandberg (then director of the Stedelijk, who in 1938 had organised the exhibition *Art abstrait* with Nelly Van Doesburg), Spoerri was given the responsibility of organising the kinetic art exhibition at the Stedelijk, with 'kinetic' being understood to include works that move or can be moved by the spectator, that is, which require their participation. Tinguely's friend Pontus Hulten

Poster of the exhibition *Bewogen Beweging*, Stedelijk Museum, designed by **Dieter Roth**, Amsterdam, 1961

(then director of the Moderna Museet in Stockholm) provided ideas on the choice of artists and works. Hulten had previously worked on the exhibition *Le Mouvement* at the Galerie Denise René. From the collaboration between them came out the exhibition: Hulten produced the catalogue, Spoerri took charge of the organisation of the exhibition and Sanberg came up with the title. In the show held in Copenhagen, Tinguely presented *Étude pour une fin du monde* (Study for an End of the World), and Hains suggested spectators should wear distorting glasses during their visit.

• On 3 July, Metzger performed the *South Bank Demonstration* in London in which, wearing a gas mask, he threw acid on to white, black and red nylon fabrics as an allusion to Suprematism.

• Creation of New Tendency: an international grouping of artists interested in active spectator participation (in physical terms) and visual activation. They would

Opening of the *MAT* exhibition at the Museum Haus Lange, Krefeld, 1961: **Mack**, **Soto** and **Wember**

hold exhibitions every two years until 1965. The first New Tendency took place between August and September at the Galerie Suvremene Umjetnosti, Zagreb. It was organised by Matko Maestrovic, Bozo Bek and Radoslar Putar, and brought together works by Colombo, Von Graevenitz, Le Parc, Manzoni, Morellet and Piene, together with Gestner, Mack, Dorazio, Castellani, Stein, Uecker, Equipo 57 and others.

• In April, Lye showed his *Tangible Motion Sculptures* at MoMA in New York.

• Liliane Lijn moved to New York, where she lived until 1963, and started working with plastics and experimenting with fire and acids.

• During November, Takis showed his *Telemagnetic Sculptures* at the gallery of Alexandre Iolas in New York, based on a musical poem by Brion Gysin. The same year, his autobiography *Estafilades* was published. During one of his trips to New York he met Duchamp through Nicolas Calas.

• In April, *III Exposición de Arte Neoconcreta* at the MAM in São Paulo included works by Lygia Clark and Hélio Oiticica. It would be the last of the group's exhibitions, as it split up before the show had ended.

• Oiticica presented the project *Projeto Cães de Caça* (Project Hunting Dogs) at the MAM in Rio de Janeiro: an environmental project made with five *Penetráveis* (Penetrables). Pedrosa wrote the accompanying text, featured alongside 'Buried Poem' by Gullar and 'Integral Text' by Reynaldo Jardim. On 16 February, Oiticica wrote *Aspiro ao Grande Laberinto* (I Aspire to the Great Labyrinth), in which he explained the definitive end of the picture. He referred to Mondrian, who prophesied the mission of the non-objective artist at a very early stage, and the fragmentation of pictorial space in artists such as Wols (an idea already indicated by the very term 'informal').

• VI São Paulo Bienal, with Pedrosa as director general. Here Lygia Clark presented her *Bichos*, with which she won the National Prize for Sculpture.

- Soto exhibited his kinetic-informalist works at the Museo de Bellas Artes in Caracas. At the same museum, Gego held an exhibition of her drawings and sculptures.
- Nam June Paik began developing audience participation in his work.

1962 In March, Umberto Eco's *Opera aperta. Forma e indeterminazione nelle poetiche contemporanee* (Open Work. Form and Uncertainty in Contemporary Poetry) was published in Milan. This compilation of theoretical essays emerged from the report 'The Question of Open Work' presented at the 12th International Congress of Philosophy in 1958. It raised the idea of 'productive disorder' corresponding to the 'breakdown of a traditional order', which western man identified with the objective structure of the world, and argued that scientific progress had neutralised the values of objectification, and artists had accepted this situation and were aiming to give it shape.

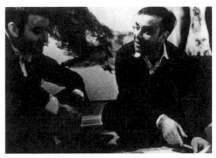

Yves Klein and **Otto Piene**, 1962 Photo Manfred Tischer

- The exhibition *Arte programmata: arte cinetica, opere moltiplicate, opera aperta* (Programmed Art: Kinetic Art, Multiplied Works, Open Work), was organised by Bruno Munari and Giorgio Soavi at the Olivetti exhibition rooms, Milan, in May; a catalogue was compiled, with texts by Munari and Eco, and published by Negozio Olivetti. Participating were members of GRAV, Gruppo N, Gruppo T, Enzo Mari and Munari. Eco wrote the introduction to the catalogue, in which he coined the term 'arte programmata' (programmed art) to describe the artistic production of works conceived to stimulate the perceptive activity of the spectator by means of light effects, an imbalance between different chromatic surfaces or matter, and mechanisms that physically move the object. He gave one of the first definitions of kinetic art, calling it a "form of plastic art in which the movement of forms, colours and planes is the means to obtain a changing whole". By 1963, the exhibition had already been shown at the Royal College of Art in London; at the Smithsonian Institute in Washington; the Lob-Student Center in New York, and the Olivetti gallery in Düsseldorf. In the latter, the catalogue included only Italian artists.

GRAV, Groupe de Recherche d'Art Visuel, 1962

- Takis had an exhibition at the Galleria Schwartz in Milan; the accompanying catalogue included various texts: Brion Gysin's poem *Musique de mots magnétiques pour les sculptures de Takis* (Music with Magnetic Words for the Sculptures of Takis); a poem by William Burroughs dedicated to the artist whose *Télélumières* he described as "The cold mineral and blue music of the thinking metal". (These were pieces using cathode tubes functioning upside down in order to produce a bluish light.)
- The Galleria Civica d'Arte Moderna in Turin held the exhibition *Struttura e Stile* (Structure and Style) from June to August, in which were exhibited works by Yoshihara, Tanaka, Motonaga and Mukai.
- Lygia Clark exhibited at the XXXI Venice Biennale.
- In November, Manzoni wrote the text *Alcuni realizzazioni, alcuni esperimenti, alcuni progetti* (Some Productions, Some Experiments, Some Projects), in which he reviewed his artistic career.
- Li Yuan-chia arrived in Italy at the end of the year, on the invitation of Hsiao Chin in Milan. He would subsequently go to live in Bologna where Dino Gavina would offer him a studio in his San Lazzaro furniture factory. There the artist would produce his many painted books and paintings based on the "dot on monochrome surfaces" theme.
- From April to May, Tanaka and Shuji Mukai participated in the exhibition *Structures répétitives* (Repetitive Structures) at the Galerie Stadler in París.
- The Italian film-maker Gualterio Jacopetti invited Klein to participate in the film *Mondo cane*. In the film exhibition Klein felt he was being ridiculed and subjected to great contempt because of the portrait that the film shows of him. He died in June.
- In the catalogue for the GRAV exhibition at the Maison des Beaux-Arts in Paris, the manifesto *Transformer l'actuelle situation de l'art plastique* (Transforming the Current Situation in Plastic Arts), written on 25

October the previous year, was published. The catalogue also included *Propositions générales du GRAV* (General Propositions of GRAV), with fragments written by each artist. The members of GRAV organised visits and meetings with members of Gruppo N from Padua and Gruppo T from Milan, and also with artists working on the same themes, such as Enzo Mari and Von Graevenitz.

• The Städtisches Museum Leverkusen presented a retrospective exhibition of Fontana, organised by Udo Kultermann.

• The Stedelijk Museum in Amsterdam presented the exhibition *Tentoonstelling Nul*. The term 'Nul' described the concept 'zero' and at the same time 'nothing'. Organised by W. Sandberg in conjunction with Henk Peters from the Nul group, it included work from different European artistic tendencies based on the monochrome. Among the artists who participated were: Arman, Aubertin, Bury, Castellani, Dorazio, Fontana, Haacke, Manzoni, Lo Savio and Soto; Mack, Piene and Uecker exhibited a joint installation based on Piene's *Lichtballett*: *Espace Lumineux* (Lit Space).

Soto's room *Tentoonstelling Nul* exhibition at the Stedelijk Museum, Amsterdam, 1962

• The exhibition *Dilaby* at the Stedelijk Museum, featuring works made with waste materials or 'objets trouvés' (found objects), included pieces by Tinguely and Spoerri.

• Gustave Metzger gave a talk on auto-destructive art at Ealing School of Art in London, which he illustrated with slides from the Gutai group.

• Various essays by houédard: on poetry and language in Burroughs and Allen Ginsberg; on auto-destructive art; and on the concrete poetry of De Melo and Castro. During these years houédard created visual poems with typewriter typography: his *Typestracts*.

Sérgio Camargo's studio in Paris

• Liliane Lijn used a hypodermic syringe to form drops of acrylic polymer in a block of clear acrylic; she investigated invisibility based on the refraction of materials.

• John Latham worked in New York, following his visit there the previous year.

• Mira Schendel began her *Embroideries* series: semi-geometrical designs with 'ecoline' on rice paper, and produced oil or tempera paintings which incorporated sand and other texturally varied materials.

• Gego integrated one of her works into architectural space for the first time: a structure in the inner courtyard of the Banco Industrial building in Caracas.

• Establishment of Pinacoteca Gutai in Nakanoshima, Osaka, as a permanent exhibition centre. A programme of exhibitions was planned featuring members of the group and international artists, such as Fontana.

• In Barcelona, first exhibition on 17 March by Ciclo d'Art d'Avui, a group of artists connected with the Cercle Artístic Sant Lluc, including Joaquim Llucià. The group produced a publication of the same name, of which eight issues were printed.

1963 The film library at Monte Olimpino in Como began to make experimental films on a variety of subjects. Its most immediate historical reference point was Fernand Léger's *Ballet Mécanique*. The project was performed by Munari and Marcello Piccardo.

• At the III Paris Biennale, GRAV presented the first of their *Labyrinthe* (Labyrinth) works, a collective project that increased visual stimulation and the active participation of the spectator. The catalogue *L'Instabilité – Le Labyrinthe* (Instability – The Labyrinth) included the manifesto *Assez de mystifications II* (Enough Mystifications II), signed by GRAV in October. The same month, the group presented *A instabilidade* (Instability) at the Museu de Arte Moderna in Rio de Janeiro.

• Camargo received the Prize for Sculpture at the Paris Biennale. He presented his show *Transition Exhibition*

at the Galerie Ravenstein in Brussels. The catalogue included a text by Karl Ringstrom on his wooden reliefs.

• Le Parc began to create environments in the middle of mazes, mobiles to be penetrated, etc. He worked on creating adjustable and interactive objects and became interested in different levels of participation such as in/voluntary, ludic, and active.

• Fontana's solo exhibition at the Galerie Iris Clert in Paris.

• In Paris, David Medalla had the opportunity to see Camargo's white wooden reliefs and the works of other Brazilian artists: Clark, Schendel and Oiticica. It was through Camargo, that Paul Keeler, Guy Brett and Medalla met Clark and Oiticica.

• On one of his first trips to Paris, Medalla saw for the first time Takis's 'telemagnetic' sculpture, Soto's 'vibration' paintings and Klein's *anthropometries*, which made a big impression on him. Keeler organised the exhibition *Soundings I* at the Ashmolean Museum in Oxford, which included pieces by Soto, Takis and Pol Bury.

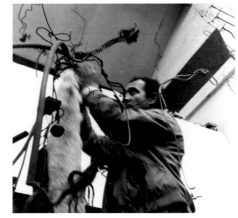

Tinguely at work Photo Vera Spoerri

• Hans Haacke began making *Kondensations-Würfel* (Condensation Cube; 1963-1965), a cube of transparent Plexiglas with light and water; it was part of a series of works on water condensation in transparent geometrical structures.

• David Medalla's first exhibition in Britain, organised by Paul Keeler, in which he showed drawings and paintings. From 1963 to 1967 Medalla made kinetic or 'biokinetics' works, and described himself as a 'Hylozoist' ("One who believes that matter is alive", according to the definition of the Greek pre-Socratic philosophers). During these years he produced, among other works, *The Bubble Machines* (1963),

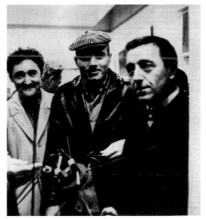

Soto, **Takis** and **Bury** in Paris, 1963
Photo Marion Valentine

David Medalla with *Bubble Machine*, 1963

Sand Machine (1964) and *Mud Machine* (1964-1967), which deal with the physical relationships in nature in an elemental way. The *Bubble Machines* were models that transformed matter into energy, and dealt with problems that had been tackled by sculptors such as Arp, Gabo and Brancusi. In his unpublished writings, *Biokinetics: a Memoir on Motion* (1967), Medalla claimed that Brancusi was dealing with the idea of dematerialization within the boundaries of the sculptural and static object, as with his *Le Commencement du Monde* (The Beginning of the World). He felt that in his use of plastics Gabo destroyed the traditional idea of mass in sculpture; in his work "the experience of sculptural space becomes synonymous with the experience of continuous depth". His *Cloud Canyons* were boxes built in accordance with the proportions of his own body, which re-examined the correlation between the elementary forces in the work and the body of the spectator in a way similar to that which Moholy-Nagy had announced forty years earlier.

• Writings by houédard on international spatial, concrete and typographical poetry. He presented his first project of 28 kinetic poems.

• Second *New Tendency* exhibition in Zagreb, from 1 August to 15 September. Artists included Castellani, Cruz-Díez, Dorazio, Le Parc, Morellet, Stein, Tomasello, Uecker and Gruppo N. Coinciding with the exhibition, there was a discussion on the composition of the *New Tendency*, with the Neo-Dada and Tachist tendencies being excluded.

• Takis exhibition at the Alexandre Iolas Gallery in New York during October and November, entitled *Telesculptures, Telephota, Telemagnets*.

• Robert Smithson abandoned painting and began to work with plastics, and to "develop structures based on a spatial concern for the elements of the material themselves".

• Oiticica started his *Bólides* (Bolides) series, involving manipulable structures classified in accordance with the categories of materials and in numerical order: the first was '*Bolide B1*'. In his text *Bolides* on 29 October, he called them 'transobjects'.
• Lygia Clark had a solo exhibition at the Louis Alexander Gallery in New York and, in May, at the MAM in Rio de Janeiro.
• VII São Paulo Bienal, with a whole room devoted to Clark.
• From 1963 to 1964, Nam June Paik lived in Japan, devoting his energy to experimentation with colour television. He started to develop works with Degausser's ring-shaped electromagnets that technicians used to destroy electrostatic charges in television screens; with these he could manipulate images.

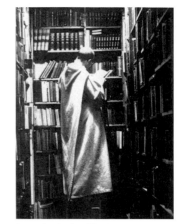

dom sylvester houédard

1964 XXXII Venice Biennale, with a number of kinetic artists present: Bury, Le Parc, Soto, Gruppo N from Padua, and Gruppo T from Milan. Soto won the David Bright Prize for painting.
• At Villa la Malcontenta, during the opening week of the Venice Biennale, Paul Keeler organised an exhibition on kinetic art. He included works by Takis (*Blue Lamp, Ballet Magnétique*), Medalla (*Machine for Making Patterns in Loose Sand* and *Bubble Machine*), Lijn (*Poem Machine*) and Marcello Salvadori (*Eclipses*).
• Camargo began working at the Soldani workshop in Massa, Italy. He would continue to travel regularly to Italy to do so.
• The exhibition *Nouvelle Tendance* (New Tendency) was held at the Musée des Arts Décoratifs, Palais du Louvre, Paris. Colombo presented the first habitable environment using artificial light and was given the task of producing a 'pulsating' 25 m² surface for the exhibition entrance.
• Exhibition at Musée d'Arrais in Paris: *L'Aujourd'hui de demain* (The Today of Tomorrow), with participation from Camargo, Clark, Cruz-Díez, Soto, Vasarely and others.
• From 15 December to 28 February, the Galerie Denise René in Paris showed the exhibition *Mouvement 2*, a commemorative display celebrating the ten years since the previous exhibition devoted to kinetic art. The number of participating artists increased: Agam, Josef Albers, Anuszkiewickz, Ernst Benkert, Martha Boto, Camargo, Calder,

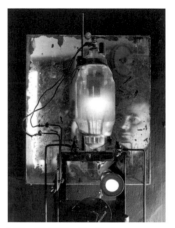

Takis with *Télélumière*, Paris, 1963–1964

Clark, Toni Costa, Cruz-Díez, Hugo Demarco, Equipo 57 (Duarte, Serrano and Ybarrola), Lillian Florsheim, Günther Fruhtrunk, Charles Gerstner, Alviani Getulio, Horacio García-Rossi, Von Graevenitz, Lily Greenham, Francis R. Hewitt, Harry Kramer, Bernard Lassus, Le Parc, Richard Lohse, Mack, Enzo Mari, Edwin Mieczkowski, Morellet, Richard Mortensen, Giora Novac, Eric Olson, Palatnik, Yvan Piceli, Uli Pohl, Keith Potts, George Rickey, Michel Seuphor, Nicholas Schoffer, Ed Sommer, Soto, Sobrino, Joel Stein, Paul Talman, Tinguely, Tomasello, Uecker, Gregorio Vardanega, Vasarely, Antonio Virduzzo, Yvaral and Walter Zehringer. The catalogue preface was by Jean Cassou.
• *Documenta III* in Kassel. Calder presented five *stabiles*. In the *Licht und Bewegung* (Light and Movement) section were present GRAV (García Rossi, Le Parc, Morellet, Sobrino, Stein and Yvaral), Yaacov Agam, Hermann Goepfert, Günther Haese, Harry Kramer, Schöffer, Soto and Tinguely. Piene, Mack and Uecker exhibited as the Zero group, showing a joint collective work, *Lichtraum* (Light Room): a light room whose elements had been produced between 1960 and 1964, and which stood out due to the intensity of light and variety of movements. Later, the show was displayed in Brussels, Baden-Baden, Düsseldorf and Paris.
• Lygia Clark travelled for several months in Europe, coinciding with her solo exhibition at the Studium Generale Technische Hochschüle in Stuttgart, organised by Max Bense in February. In Paris, she frequently met up with Soto and the Camargo family.
• Paul Keeler organised the exhibition *Structures Vivantes: Mobiles/Images* (Living Structures: Mobiles/Images) at the Redfern Gallery, London, which was the first exhibition in Britain to present kinetic and optical art. Medalla displayed his *Bubble Machine* and *Smoke Machine*.
• Creation of *Signals, Centre for Advanced Creative Study* in London, to programme exhibitions, activities

and publications, with a special interest in the new technological and scientific developments. Its name was inspired by Takis's series of sculptures. The founders of the centre were Keeler (director), Guy Brett, Medalla, Christopher Walker, Metzger and Marcelo Salvadori; Frank Popper was one of the patrons. *Signals*, the news bulletin of the Centre for Advanced Creative Study was published from August 1964, with Medalla as editor. It would have 10 issues printed in volume I (nos. 3-4, double) and 2 issues in volume II. The last issue was published in January-March 1966. There were several numbers dedicated to a single artist's work: Takis (no. 3), Camargo (no. 5), Salvadori (no. 6), Clark (no. 7), Cruz-Díez (no. 9), Soto (no. 10) and Otero (no. 2, vol. II).

• Soto displayed his work in Britain in an exhibition organised by Keeler at the Lamda Theatre foyer in London at the beginning of the year. It was held in connection with the Royal Shakespeare Company's production of Peter Brook's *theatre of cruelty*.

• From July to August, the exhibition *Tomorrow Today: Second Pilot Show* ran at the Signals Gallery in London, featuring international kinetic artists: Takis,

Sérgio Camargo, **Guy Brett**, **Paul Keeler**, **David Medalla** and **Gustav Metzger** preparing the distribution of *Signals* magazine, London, 1964

Salvadori, Camargo, Cruz-Díez, Medalla, Soto, Malina, Harry Kramer, Aubertin, Gyula Kosice, Clark, Lijn, Keith Potts, Bob Lens, Cruxent, Paul James, Antonio Asis, Ray Staakman, Haacke, Klein, Vasarely, Calder, Lye, Tinguely, Mack, Uecker, Bury, Arman and Henk Peeters. This was an international exhibition on the history and development of kinetic art from its beginnings to the present day, and was held at the Centre for Advanced Creative Study, with Keeler as organiser and Popper as chief advisor. The catalogue was designed by Medalla.

• From 30 September to 27 October, the *Festival of South American Kinetic Art* was held at the Signals Gallery. Participants included Camargo, Soto, Piza, Palatnik, Otero, Kosice, Le Parc, Asis, Navarro Viera, Vigas, Sobrino, Manaure, Vardanega, Boto, Cruz-Díez and Tomasello.

• On 20 November the Signals showroom in Wigmore Street, London, opened with a retrospective exhibition of Takis's work. The exhibits

Hoenich operating the mirror reflector of his *Sun paintings*

ranged from his early 'archaic' bronze works to his late telemagnetic sculptures, *télélumières* and *téléphoto*. This same year he went to live in England where he would stay until the end of the sixties. Camargo also presented his first solo exhibition in Europe at the Signals showroom, which opened on 29 December.

• *Constellation* exhibition at the Signals showroom, with a double homage to Manzoni and Klein. Participation by Takis, Cruz-Díez, Salvadori, Tinguely, Camargo, Medalla, Von Graevenitz, Hoenich, Norbert Kricke, Chillida, Link and Piene.

• Talk by P.K. Hoenich, lecturer at the Faculty of Architecture of the Technion-Israel Institute of Technology in Haifa, organised by Guy Brett at the Signals showroom on 8 September. In 1962 Hoenich's *Robot Art. The Hopeful Monster* was published. In it he described his constructions as 'robot-art': metal and glass reflectors that use solar light and the rotations of the earth in order to create perpetually changing paintings; and projections on the walls of dark rooms. His latest experiments used spectrums created with sunlight and the movement of water.

• dom sylvester houédard became a member of the IKPF, International Kinetic Poetry Foundation. He began his unfinished project, an anthology on concrete, on which Nanni Balestrini would also later work.

• Lijn began to work with prisms after experiencing the strong impact of colour caused by the splitting of light in a prism.

• The exhibition *Movement* took place at the Hanover Gallery in London, and *Art in Motion* at the Royal College of Art, also in London.

• Smithson began to write, and to create sculptures with mirrors attached to walls, which were "rooted in glass structures".

• Oiticica started to frequent the Escola de Samba da Mangueira in Rio de Janeiro, which played a key role in his work in terms of the breaking down of social barriers, and the relationship between collective and individual work. Soon after, he produced his first *Parangolés* or 'anti-environmental art', essential to his development of structure-colour in space and in which spectator participation is of great importance. Oiticica explained the concept 'Parangolé' as "not being a new order of manifested colour in space, but a new form in which other orders would appear". In November, he wrote *Fundamentals for the Definition of Parangolé*.

• Schendel began work on her series *Monotipias* (Monotypes): from 1964 to 1966 she made two thousand drawings on very fine rice paper. The monotype technique consisted of spreading paper over a flat surface covered with ink and marking it from behind with an instrument. Her drawings may be grouped in numerous series, among which stand out her '*desenhos lineares*', minimal interventions with lines of different intensities, and those which included letters, words or sentences. She became interested in psychoanalysis and psychology, and especially the theories of Jung. She also participated in the II Bienal de Arte Americano (II Biennial of American Art) in Argentina.

• The exhibition *Intuiciones y Realizaciones Formales* (Formal Intuitions and Realizations) was shown at the Centro de Artes Visuales of the Instituto Torcuato di Tella in Buenos Aires from August to September. Yoshihara, Tanaka, Shiraga and Mukai participated.

1965 May saw the opening at Fontana's studio at 23 Corso Monforte, Milan, of the *Zero Avantgarde* exhibition, in which works by thirty artists were presented, including Fontana, Bonalumi, Castellani, Manzoni, Bury, Haacke, Mack, Piene, Soto and Uecker. The exhibition would be shown in other cities.

• Michaux rejected the French *Grand Prix National des Lettres*. The eighth edition of the magazine *Cahiers de l'Herne,* edited by Raymond Bellour, was dedicated to him.

• At the IV Paris Biennale, between September and November, GRAV presented an active participation room for the spectator to play in.

• Takis began producing *Sculptures musicales* (Musical Sculptures), which made sound by means of magnetic attraction and *Sculptures musicales lumineuses* (Musical Light Sculptures) which, following the same system, introduce bulbs activated according to the rythm.

• In June, a Von Graevenitz exhibition took place at the (op) Art Galerie in Esslingen, Germany.

• In the catalogue *Editions MAT Collection 65*, 24 works by different artists were included, Bury among them.

• At the beginning of the year, 37 international artists from the Zero movement were invited to join in the project *Zero op Zee* (Zero in the Sea) in Scheveningen harbour in Holland, on the initiative of Leo Verboon and Albert Vogel. The artists would have three weeks in April the following year to produce works that incorporated the wind, the sea, space and light. However, the project was not carried out due to lack of funds. Haacke would later develop the proposal he had submitted on Coney Island beach in 1968.

• Second showing of the exhibition *Nul, Negentienhonderd Vijfen Zestig* (Zero, Nineteen Seventy-Five) at the Stedelijk Museum in Amsterdam, organised by Sandberg. It was on the different trends in optic and monochrome art, and involved Arman, Bury, Castellani, Colombo, Dorazo, Fontana, Haacke, Yayoi Kusama, Manzoni, Murakami, Soto, Tanaka, the Zero group and Gutai group. Yoshihara attended the setting-up of Gutai's special room.

• The exhibition *Licht Und Bewegung = Lumière et Mouvement = Luce e Movimiento = Light and Movement: Kinetische Kunst* was shown at the Kunsthalle in Berne, Palais des Beaux-Arts in Brussels; the Kunsthalle in Baden-Baden and the Kunsthalle in Düsseldorf. The tour came to an end in 1966. Participants included: Agam, Berlewi, Boto, Bury, Calder, Clark, Cruz-Díez, Duchamp, Von Graevenitz, Haacke, Kowalski, Le Parc, Mack, Man Ray, Morellet, Piene, Schöffer, Soto, Takis, Tinguely, Uecker, Vasarely, GRAV, the Zero group and Equipo 57; and the exhibition brought together different manifestations of the art of movement and light. Just before the Kunsthalle in Baden-Baden decided to organise the exhibition, signs of a rupture had emerged. As the show in Brussels had an expanded Op Art section, the director of the centre, Dietrich Malhow, was sent a letter by Tinguely, Takis, Soto, Agam and Bury dated 2 November 1965 in which they stated: "With the hope of avoiding any confusion between our works and those of the so-called 'Optic' school – very different – we especially insist that respect is given to the Berne section, based entirely, as its title would suggest, on the notion of real movement.

[...] We would press you, if you exhibit in Baden works of a so-called 'optic' nature, not to allow them to fig-ure in the same exhibition as ours. If this were not to happen – and in order to avoid an amalgam of works that would harm us greatly – we would be obliged to withdraw our works". With this declaration they clearly differentiated themselves from the positions of Vasarely, in particular. The response from the Kunsthalle on 10 November was "The exhibition will be held in the spirit you desire: the will be no Optic at Baden-Baden!". The preface to the catalogue presented at the Staatliche Kunsthalle in Baden-Baden, 1965-1966, stated: "Besides the title *Light and Movement,* is the concept 'kinetic art', which we frequently see in galleries in its abbrevi-ated form 'kinetic'. However, with the present works we are not dealing with scientific reflections, although several artists use these extensively. On the contrary, we are speaking about an artistic metamorphosis of sci-ence through movement and technique; technique, the practical side to science, turns science into pure aes-thetic phenomena (which enables us to see how much of a metamorphosis modern aesthetics can go through)."

• Founding of the Artist Placement Group (APG) by John Latham, Barbara Steveni, Jeffrey Shaw, Barry Flanagan, David Hall, Stuart Brisley and Ian Macdonald Monro. It aimed to produce collaborations between artists and different social groups. The founding of the group was linked to Latham's 'Time-base' theory, accord-ing to which all art forms are a process undefined by their temporality. In the history of the group there are three internal phases: firstly, from 1966 to 1972, centred on the artist; secondly, from 1973 to the early eight-ies, the development of a concept of interactive work with a social strategy; and thirdly, from 1979 to 1989, based on a concept of the group as a dynamic structure developed by people acting as individuals questioning the adequacy of Latham's 'Time-base'. The creation of the APG coincided with Latham starting to give classes at St Martin's School of Art, something he would do until 1967. Many of the APG members were students.

• Paul Keeler and the Camargo family organised Lygia Clark's first solo exhibition in Europe at the Signals showroom in London from 27 May to 3 July.

• At the same London centre *Soundings Two,* an exhibition of international modern art, was held from 22 July to 22 September. Gabo's 1957 linear construction *Suspended* was presented; participating artists were Albers, Arp, Asis, Brancusi, Pol Bury, Calder, Antonio Calderara, Camargo, Chillida, Clark, Cruz-Díez, Da Costa, Debourg, Duchamp, Gabo, Goeritz, González, Von Graevenitz, Guzmán, Herbin, Kandinsky, Klee, Klein, Leger, Li Yuan-Chia (abstract reliefs), Lijn (a rotating cone and an Echolight in the form of a large methcrylate disc), Lissitzky, Malevich, Medalla, Moholy-Nagy, Mondrian, Moore, Louise Nevelson,, Nicholson, Oiticica (a glass *Bolide*), Otero, Rossini Pérez, Picasso, Piza, Schendel (a suite of abstract drawings), Schwitters, Soto and Takis. Some works were for sale.

• Soto has an exhibition at the Signals showroom between 28 October and 24 December, where he shows two of his repetition-reliefs, among other works.

Soto's exhibition at *Signals*, London, 1965

• The ninth edition of *Signals* newsbulletin, August-September-October, published the article 'The Role of Modern Physics in the Present Development of Human Thinking' by Professor Werner Heisenberg, director of the Max Planck Institute of Physics and Astrophysics (the concluding chapter to his book *Physics and Philosophy: The Revolution in Modern Science*). Heisenberg had sent a letter to Medalla praising his demonstration of the poetic interactions between the technology devel-oped by human beings and natural phenomena.

• Gyorgy Kepes published his book *The Nature and Art of Motion.*

• In February, the exhibition *The Responsive Eye* took place at the Museum of Modern Art, New York. It was organised by William C. Seitz, and travelled to Saint-Louis, Seattle, Pasadena and Baltimore. The artists were: Agam, Albers, Max Bill, Castellani, Carlos Cruz-Díez, Gego (presenting her work *Sphere* part of the museum collection), Von Graevenitz, Ellsworth Kelly, Alexander Liberman, Louis, Mack, Morellet, Kenneth Noland, Larry Poons, Ad Reinhardt, Bridget Riley, Soto (who dropped out in order to distance himself from the opti-

cal trend and Vasarely), Frank Stella, Tomasello, Uecker, Vasarely, etc. The exhibition was structured in six blocks: 1) 'The Colour Image': Kelly, Morris, Louis and Noland; 2) 'Invisible Painting': Ad Reinhardt; 3) 'Optical Paintings': Anuszkiewicz and Larry Poons; 4) 'Black and White': Vasarely and Riley; 5) 'Moire Pattern': Michael Kidner; and 6) 'Reliefs and Constructions': Le Parc. An explicit distinction was made between Op Art and kinetic art, with regards to the distinction between 'virtual movement' and 'real movement'. The exhibition touched upon two-dimensional works, mainly painting, playing on optical effects and the way they were perceived. A very critical response to the exhibition was made by Thomas B. Hess in *Art News* ('You Can Hang It in the Hall', April 1965), Rosalind Krauss and Lucy Lippard ('New York Letter' in *Art International*, March 1965), and Barbara Rose ('Beyond Vertigo: Optical Art at the Modern', *Artforum*, April 1965).

• Other noteworthy exhibitions held at various institutions during the year were: in February and March, *Kinetic and Optical Art Today*, at the Albright Knox Art Gallery and Buffalo Fine Arts Academy, with Bury, Le Parc, Len Lye, Morellet, Equipo 57, Piene, Soto, Takis and Tinguely, etc.; *Art and Mouvement. Op Art and Kinetic Art*, at the Museum of Tel-Aviv, including Pol Bury, Albers, Calder, Camargo, Clark, Morellet, Soto, Equipo 57, Von Graevenitz, P.K. Hoenich, Le Parc, Tinguely and Vasarely.

• Robert Smithson showed mirror pieces in the American Express Pavilion of the Universal Exhibition in New York.

• VIII São Paulo Bienal, in which Schendel and Oiticica participated. A special prize went to Tinguely, Grand Prizes to Burri and Vasarely. Camargo represented Brazil.

• Mira Schendel exhibited her *Monotipias* (Monotypes) at the Buchholz Gallery in Lisbon, and made her *Bombas* (Bombs) series. Brett and Keeler, encouraged by Camargo, saw her work at the VIII São Paulo Bienal, and urged Medalla to see it too; they showed it in *Soundings Two*.

• Hélio Oiticica participated in the exhibition *Opinião 65* (Opinion 65) at the MAM in Rio de Janeiro, showing his *Parangolés* in public for the first time.

• Exhibition *Georges Vantongerloo 1886-1965* at the Museo Nacional de Bellas Artes in Buenos Aires. Ignacio Pirovano wrote the introductory text. Many articles referring to the artist's work had already appeared in various Argentine publications in the early fifties, some pointing out Vantongerloo's influence on young Argentine artists.

• Second Biennial Exhibition of American Art, in Córdoba, Argentina: Mira Schendel represented Brazil. Soto won the main prize.

• Nam June Paik made *Magnet TV*, consisting of the manipulation of an image broadcast on television by means of a magnet.

• Tanaka left the Gutai group.

1966 XXXIII Venice Biennale. Le Parc's 1965 installation *Cerchi suddivisi* (Subdivided Circles) was presented in the Giardini, and won a Grand Prize for Painting. Lucio Fontana presented his *Tagli* in a room specially designed by the architect Carlo Scarpa, winning him too a Grand Prize for Painting. Soto presented his *Mur panoramique vibrant* (Vibrating Panoramic Wall).

• Disbanding of Gruppo T and Gruppo N.

• On 19 April, GRAV organised a day of artistic demonstrations in the streets of Paris.

• Retrospective exhibition on the work of Gabo at the Tate Gallery in London, one of the most important on his works before his death in 1977.

• Keeler and Anthony de Kerdrel organised the exhibition *3+1* at the Signals showroom, which included works by Li Yuan-chia, Hsiao Chin, Ho Kan and Pia Pizzo. Li Yuan-chia went to London and Medalla commissioned him to create a big relief mural incorporating points especially for the exhibition.

• Exhibition *In Motion: An Arts Council Exhibition of Kinetic Art* at the Bear Lane Gallery in Oxford, organised by Brett. Among the participants were Clark, Medalla and Von Graevenitz.

• In August, while still a lecturer at St Martin's School of Art, Latham carried out his performance *Still and Chew*, in which participants (artists, students, critics) were invited to chew and then spit into a bottle of acid pages from the Clement Greenberg book *Art and Culture*, which Latham had taken from the St Martin's library. It was a protest against the dominant aesthetic, a reaction against the concept of modernity developed by Greenberg.

• In London in September, the Destruction in Art Symposium, DIAS, took place, organised by Metzger. This

was an international event which encompassed different disciplines and brought together a hundred artists and poets who, without going so far as to form a movement, shared an attitude towards the use of destruction as a creative element in art. Latham participated with his Skoob Tower Ceremony. From 1964 to 1968, Latham carried out public burnings of his sculptures of books.

• Liliane Lijn moved to live in London after having lived in Greece. She participated in the exhibition *White and White* at the Kunsthalle in Bern, wheres she displayed the first piece from her series *Liquid Reflections*, which showed her interest in astronomy and physical particles and explored the properties of light and balance. She did her first series of *Liquid Reflections* in this and the following year, in which she made plays of light on condensed drops inside discs of Plexiglas on which transparent balls rolled freely. The second series would be produced in 1968, when she reviewed the design of *Liquid Reflections*.

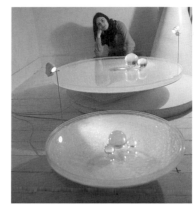

• Schendel started work on the series *Droguinhas* (Little Nothings) and *Trezinhos* (Little Trains). In *Droguinhas* rice paper was rolled and knotted together, forming nets and balls; the *Trezinhos* were sheets of the same rice paper strung together. She had a solo exhibition at the Signals showroom in London, in which she showed works from both her series and her drawings. (The same works were shown at the Museu de Arte Moderna in Rio de Janeiro with a catalogue introduction by Haroldo de Campos). As a result of the exhibition she met Li Yuanchia, with whom she would keep in touch. She also took advantage of her visit for the London exhibition and travelled around Europe, the first time she had done so since her arrival in Brazil. She went to Zurich and Milan, where she met

Liliane Lijn with *Liquid Reflections*

Umberto Eco; in Lisbon she exhibited at the Galeria Buchloz; in Stuttgart, Haroldo de Campos introduced her to Max Bense, and his wife Elisabeth Walther, also a lecturer at the same university. They would remain friends until the mid-seventies.

• *Kunst Licht Kunst* (Art Light Art) exhibition at the Stedelijk Van AbbeMuseum in Eindhoven from 25 September to 4 December 1966, organised by Leering and Popper; later it was shown in Boston and London. Prominent among the artists were Agam, Appel, Boto, Calos, Colombo, Flavin, Fontana, Von Graevenitz, Kosice, Man Ray, Moholy-Nagy, Munari, Palatnik, Raysse, Schöffer, Takis, Equipo 57, GRAV, Gruppo T and the Zero group (with works using artificial light as the main means of expression and the relationships between light and the environment.)

• The exhibition *Directions in Kinetic Sculpture*, organised by Peter Selz at the University Art Museum in Berkeley, University of California, was shown there in May, and at the Santa Barbara Museum of Art from June to July. Among the participating artists were Fletcher Benton, Davide Boriani, Robert Breer, Bury, Colombo, Von Graevenitz, Haacke, Harry Kramer, Len Lye, Mack, Charles Mattox, George Rickey, Takis and Tinguely. Rickey wrote the catalogue text.

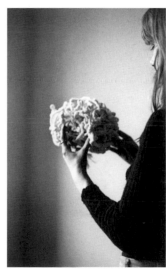

• Fontana's solo exhibition at the Walker Art Center in Minneapolis and at The University of Texas Art Museum in Austin, organised by Jan van der Marck.

Mira Schendel *Droguinha*, 1966

• Series of performances by Piene, along with Aldo Tambellini, at the Black Gate in New York, called *The Proliferation of the Sun*. These also involved Hans and Linda Haacke, Peter Campus and Paolo Icaro. The German version was called *Die Sonne kommt näher* (The Sun Comes Nearer).

• Gego stayed in Los Angeles, where she worked on a series of lithographs at the Tamarind Lithography Workshop.

• *Opinião 66* exhibition at the Museu de Arte Moderna in Rio de Janeiro. It included works by Lygia Clark; Oiticica displayed his project *Apropriação: Sala de Bilhar* (Appropriation: Billiard Room).

• I Salvador Bienal, Brazil, with a special section devoted to Lygia Clark, in which an extensive range of her work was brought together.

• James Whitney made *Lapis*, an experimental film which he called 'space/time mandala', in which the vision of the forms generated by the closed eye contributed to very elaborate designs.

1967 The Zero group disbanded.

• Gianni Colombo created his environment *Spazio Elastico* (Elastic Space).

• Soto made his first *Pénétrable*, to coincide with his solo exhibition at the Galerie Denise René in May: "The *Pénétrable* is the materialisation of the idea that fed my thoughts on the state of total plenitude of the universe, which is full of relationships. This is the revelation of sensitive space, eternally completed by the purest structural values, such as energy, time and movement. The experience of the spectator who participates..."

• At the Musée d'Art Moderne de la Ville, Paris, the exhibition *Lumière et mouvement: Art cinétique à Paris* (Light and Movement: Kinetic Art in Paris) (May-August), was organised by Frank Popper. Participating were Bury, Camargo, GRAV (presenting *Parcours à volume variable* [Journey of a Variable Volume]), Kosice, Le Parc, Lijn, Morellet, Soto (showing *Grand mur vibrant* [Large Vibrating Wall]) which incorporated vibrating artificial light), Takis, Tinguely and other artists. Lijn also participated in the show *Science Fiction* at the Kunsthalle in Bern.

Gianni Colombo with a relief of *Spazio elastico,* 1967

• Show by Schendel at the Studiengalerie Uni-Stuttgart/Technische Hochschule in Stuttgart, at the invitation of Max Bense, who wrote a text on her drawings for the catalogue. Coinciding with the exhibition, the artist published a text on her work, accompanied by a concrete-poem written by Haroldo de Campos in 1966.

• In January, David Medalla founded the Exploding Galaxy, "a kinetic confluence of transmedia explorers". The period 1967 to 1976 was a participatory one in the work of Medalla, which focused on the relationship with other people and the interaction between nature, culture, art and society. The kinetic model of growth, change and randomness were transferred to the social field. *Participation-Production* works allowed for an infinite number of contributions from an infinite number of people.

• dom sylvester houédard became a member of the Exploding Galaxy.

• Nicholas Logsdail invited Li Yuan-chia, whom he met through Medalla, to have the solo exhibition *Cosmic Point* at the Lisson Gallery, London. Li's characteristic small square catalogues first appeared here.

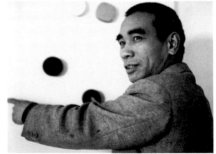

Li Yuan-chia with *Magnetic cosmic points,* at the solo exhibition *Cosmic Point* at the Lisson Gallery, London, 1967

• Launch of the magazine *Robho*, which would continue to be published until 1971.

• Frank Popper published *La Naissance de l'art cinétique* (The Birth of Kinetic Art), in which he analysed movement in the plastic arts from 1860 until 1967. He looked at movement from three perspectives: the relationship between movement in the plastic arts and movement in other arts; the relationship between physical, mental and biological movement and movement in the arts in general; and lastly real movement in the plastic arts. The book was a re-working of his thesis *L'image en mouvement dans les arts plastiques depuis 1860* (The Moving Image in the Plastic Arts since 1860).

• P.K. Hoenich wrote 'Kinetic Art with Sunlight: Reflections on Developments in Art Needed Today', which would be published the following year in the magazine *Leonardo*. He argued that art techniques and works should incorporate and reflect the tendencies of spiritual and scientific development of their era. His work used solar rays and the rotation of the earth, as well as wind energy, which was introduced in some cases as an additional driving force. He described two techniques in his work: *Robot-Picture* is a mobile and changing system to project sunlight, which is repeated each year; the artist could control the technique perfectly and determine in advance the programme for the whole year. *Robot-Painter* is also a mobile and changing system of projecting sunlight, but one which may not be repeated; using this system, the artist cannot predict the works that are to be made, but can determine the style of the works by selecting the forms and movement of the reflected elements.

• During the summer and until October, the exhibition *Kinetica* at the Museum aus der 20 Jahre in Vienna was open to the public. Among the participants were Camargo, Clark, Colombo, Duchamp, Von Graevenitz, Le Parc, Morellet, Soto, Tinguely and Uecker.

• The exhibition *Light and Motion* was shown at the Worcester Art Museum in Massachusetts; and *Light, Motion, Space* at the Minneapolis Walker Art Center.

- Hans Haacke had a one-man exhibition in the Hayden Gallery at the Massachusetts Institute of Technology (MIT) in Cambridge, participated in the exhibition *Miscellaneous Notions of Kinetic Sculpture*, also at the Hayden Gallery.
- Haacke created his *Skyline* from tethered helium balloons in Central Park, New York, in June. Also participating were Richard Hogle, Gilles Larrain, Preston McClanahan and John van Saun: the director was Willoughby Sharp.
- Sol LeWitt wrote his first manifesto 'Paragraphs on Conceptual Art', published by the magazine *Artforum*.
- Robert Smithson produced *Strata*, a series of works in crystal and mirror which referred to the stratification and superimposition of "civilised scrap, as well as the way crystals grow".
- Gego exhibited at the Biblioteca Luis Arango in Bogotá and the Galería Conkright in Caracas. In her work she investigated the curvatures in planes forming parallel lines.
- Exhibition *Art et Mouvement* at the Musée d'Art Contemporain in Montreal from May to October, with works by Albers, Calder, Equipo 57, Le Parc, Mack, Mondrian, Morellet, Soto, Takis and Tinguely et al. A text by Denys Chevalier was published in the catalogue.
- IX São Paulo Bienal; Gianni Colombo was one of the participants.
- Exhibition *Nova objetividade brasileira* (New Brazilian Objectivity) at the Museo de Arte Moderna in Rio de Janeiro, organised by Frederico de Morais. Oiticica had his anthology of texts 'General Outline of New Objectivity' published in the exhibition catalogue, in which 'New Objectivity' was defined as a typical feature of Brazilian avant-garde art at the time, whose main features were: a general Constructivist will; the tendency for the object to reject and exceed the framework of the easel painting; spectator involvement; taking positions on political, social and ethical problems; a tendency towards collective art; and the resurgence of the anti-art question. A manifesto was written, signed by Lygia Clark, Raimundo Colares, Antonio Dias, Ruben Gerchmann, Solange Escosteguy, Pedro Geraldo Escosteguy, Renato Languin, Ana Maria Maiolino, Sami Mattar, Frederico Morais, Mauricio Nogueira Lima, Hélio Oiticica, Lygia Pape, Glauco Rodrigues, Carlos Augusto Vergara and Carlos Zilio.
- In April, the Gutai group organised the exhibition *Art of the Spatial Age* in Hanshin Park in Nishinomiya. Among others, Jiro Yoshihara, Michio Yoshihara and Toshio Yoshida exhibited kinetic works.

1968 XXXIV Venice Biennale opened despite protests from students proclaiming 'No alla cultura opportunista' (No to Opportunist Art). Many artists withdrew their works in solidarity. Nicolas Schöffer won the Grand Prize in Sculpture; Gianni Colombo the First Prize in Painting for his work *Spazio Elastico*. Special exhibition *Linea della ricerca: dall'informale alle nuove strutture* (Line of Investigation: from the Informal to the New Structures), with works by Calder, Duchamp, Fontana – who presented *Ambiente spaziale, nero* –, Malevich, Soto and others. Special exhibition *Stimolazione percettiva, Analisi del Vedere* (Perceptive Stimulation, Analysis of Watching), with works by Soto, Le Parc, Albers, Man Ray, Munari, Bill, Fontana, et al. Schendel and Clark represented Brazil, together with Farnese de Andrade, Anna Letycia and Mary Vieria, as selected by Jayme Mauricio. Schendel showed twelve *Objetos gráficos* (Graphic Objects): rice paper drawings, in general handwritten, in printed or painted letters, were grouped together, pressed between two acrylic boards and hung by a nylon thread so they could be seen from both sides.
- The Galleria dell'Obelisco in Rome organised the exhibition *2001. Opere de arte nello spirito del film della Metro Goldwyn Mayer* 2001 Odissea nello Spazio *di Stanley Kubrick* (Works of Art in the Spirit of the Metro Goldwyn Mayer film Stanley Kubrick's *2001 Space Odyssey*) in December. This involved a total of 58 artists, including Balla, Bury, Calder, Camargo, Castellani, Colombo, Dorazio, Duchamp, Fontana, Le Parc, Manzoni, Munari, García Rossi, Sobrino, Soto and Varisco.
- From May to June, the Maison de la Culture in Grenoble showed *Cinétisme, Spectacle, Environnement*, organised by Popper. Participants included Agam, Bury, Colombo, Cruz-Díez, GRAV, Kowalski, Le Parc, Morellet, Soto, Tomasello and Vasarely.
- On 15 November, the GRAV group split, owing to dissent among its members and doubts about its efficacy under the circumstances of the time. A collective note was signed, but texts were signed separately.
- *Documenta IV* opened in Kassel amid a storm of debate and argument about the political events that were taking place. Participating artists included Bury, Takis, Fontana – who presented his *Ambiente spaziale,*

bianco –, Manzoni, Von Graevenitz and Kosice, in an exhibition with a great diversity of artistic tendencies and attitudes. Enzo Mari and Le Parc signed a document stating that since institutions sanctified and mystified art with the aim of selling it, they chose to withdraw their works from *Documenta* as a symbolic gesture of collective conscience-raising.

• Piene created his first television production for Westdeutscher Rundfunk in Cologne. The performance at his studio included *Lichtballett*, objects and actors. The same year, he was offered work sponsored by CAVS (Center for Advanced Visual Studies at MIT).

• The Museum am Ostwall in Dortmund shows the exhibition *Participation: À la Recherche d'un Nouveau Spectateur:* (Participation: In Search of a New Spectator) *Groupe De Recherche d'Art Visuel.*

• Mira Schendel visited the philosopher Jean Gebser who was lecturing in Berne, with whom she would establish an intense dialogue. They remained in touch until Gebser's death in 1973.

• Liliane Lijn began to write *Crossing Map*, which would be published in 1982, in which she expressed her interest in solid state and quantum physics and Zen Buddhism.

• Li Yuan-chia, increasingly interested in manipulable and participatory structures, invented the mobile magnetic point. He had his second solo exhibition at the Lisson Gallery in London, *Cosmic Multiples*, where he showed his piece *Cosmagnetic Multiple*, a metal panel with four magnetic points of different colours: red, white, black and gold.

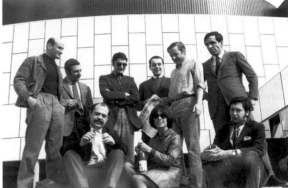

Cinétisme, Spectacle, Environnement exhibition, Maison de la Culture, Grenoble, 1968: standing up (from left to right) **de Vecchi**, **Boriani**, **Colombo**, **Massironi**, **F. Morellet**, **Mari**; seated (from left to right) **Sobrino**, **D. Morellet** and **Le Parc**

• Guy Brett published *Kinetic Art. The Language of Movement*, which was divided into two parts. The first, *A New Space*, re-examined the representation of real space in painting and sculpture (art) and the propositions and experiments with regards to movement (anti-art), and reviewed the history of movement in art. In the second part, *A Living Structure*, he analysed the work of various contemporary artists according to particular themes. *The Elements, Real Forces*: Takis, Tinguely, Medalla, Schendel, Camargo, Lijn, Bury, Colombo and Le Parc. *The spectator*: Clark and Oiticica. *The surface*: Soto, Graevenitz, Debourg, Cruz-Díez and Agam. *Light*: Morellet and Flavin.

• The artist and engineer Frank Malina founded the magazine *Leonardo*, published by the MIT Press, as a platform for artists to write about their work from a multidisciplinary point of view.

• On 28 November, MoMA in New York opened its exhibition *The Machine as Seen at the End of the Mechanical Age*, organised by Pontus Hulten, which would extend until 9 February 1969. Later it

Li Yuan-chia *Cosmagnetic Points*

would be shown at the University of St Thomas, Houston (March 25 – May 18, 1969), and at the San Francisco Museum of Art (June 23 – August 24, 1969). Takis sent a letter to the director of MoMA expressing his desire not to have his work *Télésculpture* shown in the context of the exhibition. The work, made seven years earlier, was the property of the museum, and MoMA replied that it did not need Takis's approval for it to be exhibited. Takis removed his sculpture to the museum gardens, which he considered to be neutral territory. In February 1969, a group made up of the artists Takis, Hans Haacke, Wen-Ying Tsai, Carl Andre, Len Lye and Dennis Oppenheim, and the critics Willoughby Sharp and Nicolas Calas, wrote *Thirteen Points*, which they sent to Bates Lowry, director of the museum.

• Parallel to this exhibition, the association Experiments in Art and Technology – E.A.T. (a non-profit-making association founded in 1967 by Billy Klüver and Rauschenberg to promote joint creative work between artists and technicians) and MoMA organised a competition for collaborations between artists and engineers.

The entries were exhibited in the show *Some More Beginnings* at the Brooklyn Museum, New York, and some were included in the catalogue produced by MoMA for the exhibition *The Machine as Seen at the End of the Mechanical Age*.

• As a result of the controversies that surrounded the exhibition *The Machine as Seen at the End of the Mechanical Age*, a group of artists including Takis created the Art Workers Coalition (AWC), to defend artists against institutions and to improve the relations between the two groups.

• During a visit to New York, Keeler had shown photos of Medalla's *Bubble Machines* to Duchamp, who then made the multiple *Medallic Object*. This was a silver medal with forms resembling soap bubbles, which Duchamp photographed in the palm of his hand surrounded by cigarette smoke.

• Takis received a grant from the Center for Advanced Visual Studies, MIT, which enabled him to work with scientists. At the end of the year, his exhibition *The Evidence of the Unseen*, which brought together the works he had done while he was at MIT, was held at the Center. Later, at the beginning of 1969, he would exhibit his works at the Howard Wise Gallery in New York, including his *Long Magnetic Wall (McNamara Line)*, a peace-protest work against North-American intervention in Vietnam. The same year he made *Sculpture hydromagnétique* (Hydromagnetic Sculpture), along with two scientists from MIT who had won Nobel prizes for their research on the response of water to magnetic attraction. In Higham Bay in October, together with the MIT lecturer Ain Sonin, Takis performed the show *Sea Oscillation Hydrodynamics*, which used the movement of the sea to create electricity. Using the same principle, he created *The Perpetual Moving Bicycle Wheel of Marcel Duchamp* as a homage to this artist. He had already dedicated to him his *Jeu d'échecs: Hommage à Marcel Duchamp* (Game of Chess: Homage to Marcel Duchamp) in 1962.

Lygia Clark, *Máscara abismo, 1967*

• Agnes Denes made her site-specific *Rice/Tree/Burial*, a private ritual in Sullivan County, New York, which addressed environmental and human issues.

• Robert Smithson made *Nonsite*, with the aim of resolving "the organic and the crystalline, in a dialectic of site and nonsite". He travelled to Europe where he participated in *Prospect 68* at the Kunsthalle in Düsseldorf, and *Minimal Art* at the Gemeentemuseum in The Hague. He also had his essay 'A Sedimentation of the Mind: Earth Projects' published in *Artforum*.

• On 4 March, Oiticica wrote his essays *Tropicália* (a concept which had important repercussions for 'tropicalism', a popular Brazilian music movement) and *Aparecimiento do supra-sensorial na arte brasileira* (Emergence of the Supra-Sensorial in Brazilian Art), which cited Lygia Clark's *Máscaras sensoriais* (Sensorial Masks).

• From the last quarter of this year until mid-1974, the Centro de Cálculo at the Universidad de Madrid organised seminars led by Florentino Briones and Ernesto García Camarero. Standing out among the wide-ranging courses in music, architecture and linguistics, were those on the *Generación Automática de Formas Plásticas* (Automatic Generation of Plastic Forms). The centre published a bulletin, which brought together information on the regular meetings between artists working with computers.

1969 VI Paris Biennale at the Musée d'art moderne de la Ville, Paris, 2 October-2 November, in which numerous representations were shown of collaborations by groups such as the Computer Technical Group from Japan and Experiments in Art and Technology (E.A.T.) from the United States. *Environnements* and theatrical performances were presented during the biennial. Among the artists selected to represent France was Pol Bury.

• Tinguely wrote his *Vive Calder* (Long Live Calder), which was reproduced in the catalogue *Calder* for the artist's solo exhibition at the Fondation Maeght in Saint-Paul de Vence. Afterwards, in an interview for Belgian television, Tinguely admitted "The discovery of Alexander Calder, or 'syndical', as he was called, opened a door for me to enter…"

• *Prospect 69* exhibition held at the Kunsthalle in Düsseldorf, organised by K. Fischer and H. Streelow, and involving the galleries Fischer (Düsseldorf), Sonnabend (Paris), L'Attico, Sperone, Lambert (Italy), Dwan (the United States), among others. The artists shown included Becker, Beuys, Boetti, Buren, Byars, Darboven, Dibbets, Haacke, Heizer, Kounellis, LeWitt, Long, Oppenheim, Penone, Ruthenbeck, Ryman and Smithson. The catalogue featured interviews with Barry, Huebler, Kosuth and Weiner.

• Exhibition *Wenn Attitüden Form werden. Konzepte, Prozesse, Situationen, Information* (When Attitudes Become Form. Concepts, Processes, Situations, Information) at the Kunsthalle in Bern, 22 March-27 April, organised by Harald Szeemann and Charles Harrison. This travelled to the Museum Haus Lange in Krefeld and the Institute of Contemporary Art in London. Among the 69 selected artists were Haacke, Medalla, Smithson and LeWitt.

• Li Yuan-chia had her last exhibition at the Lisson Gallery, *The Golden Moon Show*, an installation with three distinct environments: *Man on the Moon=Men in the Stars, Life Station* and *Universe=one*.

• Sol LeWitt published *Sentences on Conceptual Art*.

• From 1969 to 1970, Agnes Denes made *A Human Argument*, a pyramid-shaped reticule aiming to provide a calculation of truth and lies. The pyramid was a recurring motif in her work, used as a symbol of the distorted perfection of organic forms.

• A solo exhibition by Oiticica at the Whitechapel Gallery in London, organised by Guy Brett (Oiticica would later call it the *Whitechapel Experience*). From 1969 to 1970, Oiticica lived in Britain as resident artist at Sussex University in Brighton.

• X São Paulo Bienal. Schendel exhibited her installation *Ondas Paradas de probabilidade* (Still Waves of Probability) – the work would be shown again in the room especially devoted to her at the 1994 Biennial. She continued to deal with the theme of transparency in works such as *Toquinhos, Discos* and *Transformáveis*.

• Boycott of the São Paulo Bienal by a group of artists and intellectuals as a protest against the cultural repression meted out by the Brazilian military regime. In the field of visual arts this meant the closure they had ordered of the Bienal of Bahia (3 works were

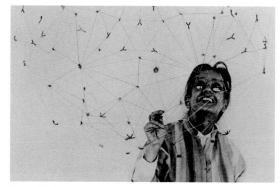

Gego with *Reticulárea* Photo Ricardo Goldman

burned and 16 confiscated) and the Salon de Arte Moderna in Belo Horizonte, on the pretext that they exhibited 'subversive' and 'immoral' works, and the fact that Brazil's entry for the VI Paris Biennale was cancelled on the orders of the Cultural Department of the Brazilian Foreign Office. Among the Brazilian artists who protested against this by withdrawing their works from the São Paulo Bienal were Lygia Clark, Oiticica, Camargo, Rubens Gerchman and Antonio Dias. Some of the international artists who supported the ban were Hans Haacke, Morellet, Daniel Buren, Bury, Takis, Le Parc, Kowalski, Tilson and Marta Minujin. Mário Pedrosa defended the protest and was forced into exile in Santiago de Chile, where he worked as director of the Museo de Solidaridad. Later he would move to Paris.

• Gego began her *Reticuláreas*. The name came from the critic Roberto Guevara: 'retícula' (reticule) described a fabric in the form of a net; 'retícula-área' was an area of nets, freed from the previous schema of parallel lines. She presented *Reticulárea Ambiental* at the Galeria Nacional de Bellas Artes in Caracas. From 1971 she worked on his *Reticuláreas cuadradas* (Square Reticulareas). Her *Nubes* (Clouds) were environmental nets.

• First International Tactile Sculpture Symposium in California, in which Lygia Clark, Hélio Oiticica and Mathias Goeritz participated.

• In the spring the 'Seminar on the automatic generation of plastic forms' took place at the Centro de Cálculo of the Universidad de Madrid. This brought together painters, architects, mathematicians, experimental poets and art theorists. An exhibition, *Formas ordenables* (Orderable Forms) was held to display the works produced (June-July 1969), and a monograph was published on *Ordenadores en el arte. Generación automática de formas plásticas* (Computers in Art. Automatic Generation of Plastic Forms). There was a clear interest in early works (Mondrian, *Equipo 57*) that were regarded as forerunners. The exhibition *Formas computables* (Computable Forms) followed later.

1970 In Milan, Agnetti and Colombo made the video-film *Vobulation et bioéloquence Neg*: "In this work, the basic pattern (the perimeter of the frame) is transmitted to the cinemascope guided by a *vobulateur* (an electronic instrument which enables television messages to be deformed), thereby achieving dimensional commutations for the pattern through very slow, slow, fast and extra-fast voyages" (Colombo). "Speech or other sounds are negatively completed with the NEG (an instrument that detects pauses), so that the operation on the auditory threshold has silence as its reference point" (Agnelli).

• At the Städtisches Museum in Leverkusen Takis showed his *Double ligne parallèle* (Double Parallel Line), which paid homage to Gabo's 1920 piece *Kinetic Construction*.

• From 22 September to 22 November the exhibition *Kinetics* ran at the Hayward Gallery in London. Works by Bury, Calder, Morellet, Schöffer, Takis and other artists were shown, with texts by K. Popper, T. Crosby and J. Benthall.

• John Latham continued his investigations into perception with his *One-Second Drawings*, which he showed for the first time in an exhibition at the Lisson Gallery.

• Agnes Denes began work on her series *Isometric Systems in Isotropic Space*, developing in her *Map Projections* mathematical forms projected on to a fluid space so that a globe is distorted in different ways. She also worked on her *Human Dust* series. She was interested in showing in her work universal concepts such as time, change, truth, distortion, paradox or probability. She initially worked with paint but soon expanded into other media, enabling her to incorporate the natural and physical sciences from the point of view of mathematics and geometry, combining philosophy, science and mathematics.

• Exhibition of Gego drawings at the Graphics Gallery in San Francisco.

• Oiticica moved to New York after receiving a grant from the Guggenheim Foundation, which enabled him to flee the repressive regime in Brazil. He would not return until 1978. During his stay in New York, he wrote a large number of texts and maintained contact with Brazil through his 'Héliotapes'. His many projects were documented in his letters, drawings, photographs and films; his work tended towards 'programmes in process'. At his exhibition *Informations* at MoMA, he presented *Ninhos* (Nests).

• Soto created a series of *Pénetrables* from nylon, wood and rope, in which the spectator was invited to enter spaces and perceive the sensation of dematerialization.

• Mira Schendel went back to work on her *Monotipias* series.

• To coincide with the International Exhibition of Osaka, Gutai presented its Gutai Festival of Art, a range of performances. On this occasion the participants were artists whose work was linked to kinetic art, Op art and technological art, which had been key trends since 1965.

• After the seminar held the previous year at the Centro de Cálculo of the Universidad de Madrid on the automatic generation of plastic forms, more theoretical sessions were held and *El ordenador y la creatividad. Arquitectura-Pintura* (The Computer and Creativity. Architecture-Painting) was published. The results from the course were shown in the exhibition *Generación automática de las Formas Plásticas* (Automatic Generation Of Plastic Forms).

1971 Films by artists were shown at the *Festival of the Two Worlds* in Spoleto, Italy, including works by James Coleman, Yves Klein and Robert Smithson.

• The exhibition *Pioneers of Participation Art* was organised by Rupert Legge and Mark Powell-Jones at the Museum of Modern Art in Oxford. Participants included Lygia Clark, David Medalla and Li Yuan-chia.

• From 1971 to 1973, Robert Smithson became increasingly interested in working with industry and in the possibilities for art in the reclamation of land; he wrote to many mining companies which he would then visit, doing drawings and making proposals for art projects to reclaim the land exploited by mines. The mining industry rejected most of his proposals. The artist wrote controversial declarations in which he protested against what he saw as the art establishment.

• Gordon Matta-Clark was invited to participate in the São Paulo Bienal, organised by Jorge Glugsberg. However, he refused to attend as a protest against repression by the Brazilian military government. On 19 May he wrote a letter announcing his refusal and urging other artists to follow suit. From this emerged the idea of organising an alternative exhibition in Chile to denounce the social and political conditions in South

America. In autumn that year he travelled to Chile with Jeffrey Law and Carol Goodden. The director of the Museo de Bellas Artes in Santiago, Nemesio Antúnez, offered to let him to produce a work in the building, which was being renovated the time.

• Gego made *Reticuláreas* from square-shaped modules with various manually-applied solutions in their joints.

• Exhibition of Mira Schendel's sketchbooks at the Museo de Arte Contemporanea in São Paulo. She participated in the II Biennial Exhibition in India, producing the series *Fórmicas*, drawings on resinated sheets of paper applied to a plywood backing.

1972 Hans Haacke's one-man exhibition at the Galleria Françoise Lambert in Milan, which opened on 2 January, was his first exhibition in Italy.

• In October, Lygia Clark was invited to run a course in Gestural Communication at the Université de la Sorbonne in Paris, where she would experience working with very large groups of pupils. She would continue with this kind of activity over the next few years until she returned to Brazil in 1976, where she worked on her own.

• Controversy arose in the magazine *Flash Art* as a result of an exhibition in which Sol LeWitt displayed superimposed fabrics. The M Gallery in Bochum, which represented Morellet in Germany, took a full-page advert in *Flash Art* which asked: "Which work from what European artist in the sphere of modern concrete art will be taken next for Sol LeWitt to copy for his newest work, to be propagated with much publicity as his own innovation?". The page included representations of the works of three artists which, according to gallery, LeWitt had copied, alongside his own works: Schoonoven, *Zeichnung*, 1962/LeWitt, *Drawings*, 1969; Holweck, *Paper Relief*, 1958/LeWitt, *Paper Rice*, 1972; and Morellet, *Grillages*, 1958/LeWitt, *Arcs, Grids and Circles*, 1972. The controversy continued over three editions of the magazine. LeWitt's response, published in no. 41 in June 1973, defended the works as his own innovations.

• As his contribution to *Documenta V*, Robert Smithson presented a declaration of protest.

• In August, Li Yuan-chia opened to the public the LYC Museum and Art Gallery in Cumbria, in the north of England. From 1972 to 1982, the centre would be show the work of over 300 artists, such as Liliane Lijn, Mira Schendel, Soto, Takis and artists in residence, and publishing catalogues and books.

• Matta-Clark started producing his 'cut drawings', which he would work on until 1976. He also started his 'tree drawings' or 'energy trees' which he would continue with the following year; these drawings would evolve into more abstract forms, his arrows.

• Gego's studies in geometry pushed her to experiment with double surfaces for her *Reticuláreas* and with tubular surfaces for her *Troncos* (Trunks). She also worked on hanging spherical surfaces.

• Mira Schendel resumed work on her *Toquinhos* concept, this time using white or black paper with small squares of tinted Japanese paper with letters, numbers or graphic symbols on them. Due to an initiative by Mario Schemberg, she exhibited at the Galería Ralph Camargo in São Paulo.

1973 Piene published *More Sky*, in which he affirmed: "The potential of a kinetic set of conditions (versus a 'kinetic object') is to create a large-scale environment that abandons the pretty-perspective Renaissance viewer-object relationship and provides an experience that is analogous to an experience of the universe."

• In the autumn, Matta-Clark travelled to Italy with Carol Goodden. In November he produced his project *Intraforma* in a warehouse on the outskirts of Milan (without the necessary permits). He travelled to Genoa where he met Paulo Minetti from the Galleria Forma, who offered to let him work in a house about to be demolished. The results of this were the works *Roof Top Atrium* and *Datum Cut*. Later, he would have the exhibition *A W-hole House* at the same gallery.

• Hélio Oiticica created the 'quasi-cinema' concept, involving the use of a series of slides.

• In Venezuela, the Museo de Arte contemporaneo in Caracas and the Museo de Arte Moderno Jesús Soto in Ciudad Bolívar were founded.

• Gego's solo exhibition at the Art Gallery of the Brazilian-American Institute in Washington D.C.

1974 Otto Piene became the director of CAVS at MIT, replacing Gyorgy Kepes; he held this post until 1993. He planned to change the centre's name to Solart Center, a pun implying both a centre for social arts and a centre for solar art, but eventually dropped the idea.

• Sérgio Camargo returned to Brazil, having lived and worked in Europe since 1961.

1975 To coincide with the Paris Biennale, Matta-Clark made *Conical Intersect* in Les Halles, right at the time of the urban transformation of Paris with the Beaubourg project, and before the building was finished. In this project he continued to deal with circular forms in space cutting through the fabric of the building's interior. Afterwards he travelled to Italy, where he would exhibit several times at the Galleria Salvatore Ala in Milan.

• David Medalla developed his performance-based work, which he continues with today.

• Mira Schendel met the philosopher Hermann Schmitz during a visit to the University of Kiel in Germany, and became interested in the idea of phenomenology based on the corporal nature concept. Her enthusiasm for his studies led her to revisit him during later trips to Europe in 1976 and 1977.

• In April, the exhibition *Le Mouvement: París avril 1955* was held at the Galerie Denise René in New York. This was a commemorative display celebrating the 20th anniversary of *Le Mouvement*, with works by Agam, Bury, Calder, Duchamp, Jacobsen, Soto, Tinguely and Vasarely. A commemorative catalogue was published with a facsimile of the 1955 edition, including the relevant texts by Denise René herself, Roger Bordieu, Pontus Hulten, Jean-Jaques Lebel, Agam, Dore Ashton, Pol Bury, Sartre and others.

ANTHOLOGY

CONTENTS

NAUM GABO and ANTOINE PEVSNER **The Realistic Manifesto**

The realisation of our perceptions of the world in the forms of space and time is the only aim of our
pictorial and plastic art.
In them we do not measure our works with the yardstick of beauty, we do not weigh them with
pounds of tenderness and sentiments.
The plumb-line in our hand, eyes as precise as a ruler, in a spirit as taut as a compass ... we construct
our work as the universe constructs its own, as the engineer constructs his bridges, as the mathemati-
cian his formula of the orbits.
We know that everything has its own essential image; chair, table, lamp, telephone, book, house, man
... they are all entire worlds with their own rhythms, their own orbits.
That is why we in creating things take away from them the labels of their owners ... all accidental and
local, leaving only the reality of the constant rhythm of the forces in them.
1. Thence in painting we renounce colour as a pictorial element, colour is the idealised optical surface
of objects; an exterior and superficial impression of them; colour is accidental and it has nothing in
common with the innermost essence of a thing.
We affirm that the tone of a substance, i.e. its light-absorbing material body is its only pictorial reality.
2. We renounce in a line, its descriptive value: in real life there are no descriptive lines, description is
an accidental trace of a man on things, it is not bound up with the essential life and constant
structure of the body. Descriptiveness is an element of graphic illustration and decoration.
We affirm the line only as a direction of the static forces and their rhythm in objects.
3. We renounce volume as a pictorial and plastic form of space; one cannot measure space in volumes
as one cannot measure liquid in yards; look at our space ... what is it if not one continuous depth?
We affirm depth as the only pictorial and plastic form of space.
4. We renounce in sculpture, the mass as a sculptural element.
It is known to every engineer that the static forces of a solid body and its material strength do not
depend on the quantity of the mass ... for example a rail, a T-beam etc.
But you sculptors of all shades and directions, you still adhere to the age-old prejudice that you cannot
free the volume of mass. Here (in this exhibition) we take four planes and we construct with them the
same volume as of four tons of mass.
Thus we bring back to sculpture the line as a direction and in it we affirm a depth as the one form of
space.
5. We renounce the thousand-year-old delusion in art that held the static rhythms as the only
elements of the plastic and pictorial arts.
We affirm in these arts a new element, the kinetic rhythms as the basic forms of our perception of
real time.

Manifesto written on the occasion of the artists' joint open-air exhibition. Tverskoy Boulevard, Moscow, August 5, 1920.
Original translation and publication: *Gabo*. London: Lund Humphries, 1957 (introduction by Herbert Read).
Reprinted in *Naum Gabo. Sixty Years of constructivism*. London: Tate Gallery, 1987 (exhibition catalogue).

LÁSZLÓ MOHOLY-NAGY and ALFRED KEMENY **Dynamic-Constructive Energy-System**

Vital construction is the embodiment of life and the principle of all human and cosmic development. Transposed into art it now means the activation of space by dynamic-constructive systems of energy, i.e. the inter-construction of energies actually opposed in physical space, and their construction into space, which likewise functions as energy (tension).

Construction as an organizational principle of human striving has led, in latter-day art, from technology to a static form that has degenerated into either technological naturalism or formal simplifications that vegetate in a confinement to horizontals, verticals, and diagonals. The best example was an open, eccentric (centrifugal) construction, which did indicate the tensions of space and forms, but without resolving them.

We must therefore replace the *static* principle of *classical art* with the *dynamic* principle of universal life. In practice: instead of static *material*-construction (relationships of material and form), we have to organize dynamic construction (vital constructivity, energy relationships), in which the material functions solely as a conveyor of energy.

Carried further, the dynamic single-construction leads to the DYNAMIC-CONSTRUCTIVE ENERGY-SYSTEM, with the beholder, hitherto receptive in his contemplation of art-works, undergoing a greater heightening of his powers than ever before and actually becoming an active factor in the play of forces.

The problems of this system of energy involve the problem of pendent sculpture and of the film as projected spatial movement. The initial projects of a dynamic-constructive energy-system are limited to experimental and demonstrational devices for testing the connections between matter, energy, and space. Next comes the use of the experimental results in the creation of art-works in freer motion (freer of machine and technological motion).

Translated from the German by Joachim Neugroschel. Originally published by Galerie der Sturm, Berlin, 1922.

Reprinted in Richard Kostelawetz (ed.). *Documentary Monographs in Modern Art*. London: Penguin, 1971.

LÁSZLÓ MOHOLY-NAGY **Abstract of an Artist**

Sculptures and mobiles. I made sculptures from wood, glass, plated metal and other materials,
I also started working on a light play machine, a spatial kaleidoscope that kept me occupied for years.
It was a mobile structure driven by an electrical motor. In the experiment I tried to synthesize simple
elements based on a constant superposition of their movements. For this reason, most of the mobile
forms were built using transparent materials such as plastics, glass, wire mesh, lattice and perforated
metal sheets. The co-ordination of these mobile elements brought results of great visual richness.
For nearly ten years, I planned and fought for the mobile to be made, and thought I had familiarised
myself with all its potential outcomes. 'I knew off by heart' what its effects would be. But when my
Light Utensil was set in motion for the first time at a small garage in 1930, I felt like the wizard's
apprentice. Its co-ordinated movements and the articulations of the light-and-shade sequences were
so surprising I almost started believing in magic. I learned a lot from the mobile which helped
towards my later paintings, photographs and films, and with regards to my architectural work and
industrial design. The mobile had been designed mainly to see transparencies in action, but I was
surprised to find that the shadows thrown on the transparent and perforated screens produced new
visual effects, a kind of ever-changing fusion. Also unexpected were the reflections of the mobile
plastic forms on the shiny nickel and chrome surfaces. These surfaces, although in fact opaque,
looked like transparent sheets when set in motion. Furthermore, some transparent wire mesh flags
that had been put between a few differently-shaped floor and ceiling planes displayed irregular and
powerfully illusory movement.
Given that I had devoted a lot of time to the work, I found it depressing that for most people the
beauty of the mobile and its emotional penetration were not apparent. Hardly anybody was able to
perceive the technical ingenuity of the experiment or its promising future. I was luckier with the film,
Light Play: Black, White, Grey, which I made with the mobile in 1930. On that occasion I tried to turn
its movements into photographic 'light' values.

Synthetic materials. At the same time as making sculptures with metal and glass, I turned towards
the new industrial materials. I began to paint on aluminium, very smooth non-ferrous alloys, and on
thermoplastics. If I hadn't been scared that maybe the latter wouldn't stand the test of time, I would
never have painted on canvas again.
By working with these materials – coloured plastics, opaque or transparent – I made discoveries that
would contribute to the changing of my pictorial technique. This had inevitable repercussions on my
thoughts regarding the problems of light.
[...]
The Painting with Light. Although plastics are new and hardly-tested materials, I felt that I should
work with them, despite the danger of merely achieving pretty effects. It may take us decades to really
understand them and be able to develop a proper technique for their handling. Even the technical
problems of painting on these materials have yet to be resolved.
[...]

The work has still only just started and the possibilities of combinations and discoveries, such as the use of imperfections and bubbles in the plastics, might lead to even more surprising results. It could come up with kinetic light plays.

I often use to think that my first transparent paintings were static phases of such light plays. In order to accentuate the kinetic nature of the paintings, I often repeated their central motifs in a somewhat smaller size or in a distorted way on the same surface. It struck me that through such repetition I was achieving a new dynamic type of harmonious organisation, similar to the classical compositional forms that I had very eagerly studied. [...]

Moulding the plastic. The last step was the distortion of the plane itself. Thermoplastics can be easily shaped by applying heat. One day it occurred to me that when I painted on flat plastic sheets, I was not taking advantage of this essential property of the material. Thus, I heated, bent and twisted a transparent sheet after having painted on it. By treating it in this way, I obtained complex concave and convex forms, a composition of rich curves creating a constantly changing relationship between the painted and engraved transparent planes and the background. This gave rise to a new kind of 'related' distortion. The folds and curves provided the plastic with greater structural resistance against breaking. At the same time, the curves produced reflections. These could form part of the light composition itself. They could scarcely be called painting or sculpture, but the difficulty in finding a suitable name for these forms should not be considered as something negative. In the last twenty-five years, I have been fascinated by phenomena that does not appear named anywhere. For this reason I am not really bothered about the name that could be given to this unknown version of a type of sculpture-painting. For me they were 'spatial effects'. The distorted forms of my 'modulators' produced spatial effects not only through the curved surfaces entering and leaving, but also by means of the lines that flowed to all the cardinal points, deriving from the thickness of the sheets themselves. From their edges came spatial curves that when combined with wires of the same thickness as the edges could fuse together in a full row of spatial cells. They partly consisted of transparent plastics with highlighted edges, and partly of wires and 'walls' of air which were 'more transparent' than transparency itself. These experiments may be seen as relating to the spatial quality of the furniture constructed with bent tubes. I liked those tubular structures and had a lot of ideas about their use in other structural and architectural experiments. I tried to achieve similar effects with paint on canvas. There, the free 'movement' of colour, to-and-fro, led to a new kind of spatial perception. This clearly went against the renaissance method of producing illusory space by means of the illusionary relationships between volumes. Thus, my experiments seemed to fit with the general trends among contemporary painters. Many of us have abandoned the old canons and obsolete conventions in favour of a new articulation of space, aiming to intuitively define and most suitably satisfy the specific need of our time: a moving vision.

Chicago, 1944

Reprinted in *Moholy-Nagy*. Valencia: IVAM, 1991 (exhibition catalogue).

ROBERT LEBEL **Marcel Duchamp's passage from the 'Retinal' to the 'Optical'**

If we look back at his early works, we notice at once that Marcel Duchamp was fascinated by 'movement' almost from the start, when he was still a very gifted 'retinal' painter. At the end of 1911, his *Coffee Mill* was already the representation of a machine viewed during the grinding operation, with the handle on top seen simultaneously in different positions as it revolved. In January 1912, the *Nude Descending a Staircase* was the study of a figure in motion, showed also in the successive positions of its descent. It was meant to be a criticism of 'static' Cubism which prevailed at that moment in Paris and this is why it was rejected from the Salon des Indépendants of 1912. When, a year later, it created a scandal at the New York Armory Show, Duchamp had already begun his sequence of moves towards his final withdrawal from aesthetics.

The word 'retinal' was used by him almost as an equivalent of 'painterly'. Of course for most painters, this was and still is a highly desirable quality but for Duchamp it soon turned into an offence. When he produced 'retinal' painting, concerned chiefly with impressions, colours and taste, he felt more or less guilty of some unhealthy enticement performed upon the innocent 'gazer'.

Therefore, from 1913 onward, he concentrated on a 'dry rendering' of 'straight perspective and geometrical design' which he used for the preparatory studies for the *Large Glass* and also for the *Glass* itself, but this method did not lead him directly in the direction of 'optics'. When he renounced the 'retinal', he was attracted by the painting of 'ideas'. His *Large Glass* was based on a 'catalogue' of ideas, many of which were collected in his *Green Box* of 1934. He was not 'retinal' any more but he was not 'optical' yet. This made him rather 'intellectual'. His work had a 'meaning' but so difficult to grasp that it could even be considered 'esoteric'. Exceptionally, one of his first *Readymades*: the *Bicycle Wheel*, set up in 1913 for the sake of seeing a wheel turning, was 'pure motion' already, although it was not until 1920 that he went another step further and started his experiments of motorized motion. For all these experiments, he used a single subtitle: *Precision Optics*, which explains the kind of result he was seeking. It had to meet the eye only but there was still an 'idea' behind: the introduction in art of *time* through the fourth dimension.

Two motorized optical devices were built by him, one with Man Ray in 1920: *Rotary Glass Plates* and one in 1925: *Rotary Demisphere*. In a letter to Jacques Doucet, who owned this second machine and wished to exhibit it, Duchamp replied that he would rather not and he added: "I would also regret it if one saw in this globe any other thing than optics".

He then produced on the same basis some 'Discs', either inscribed with puns or merely 'optical', showing revolving spirals. They alternate in his short film of 1926, *Anaemic Cinema*, which is not devoid of erotic suggestions.

This was all. Duchamp had completed his 'passage' from the 'retinal' to the 'optical'. It was a personal venture and there was no need for him to repeat it.

He seemed to have lost interest in this kind of experiment but many years later, in 1955, when Denise René organized in her Paris gallery the first exhibition of *Le Mouvement*, Duchamp, surprisingly enough, asked me to visit it with him. I could see that he was keenly concerned and, taking advantage of his talkative mood, I asked him some questions about his conception of 'motion' and 'optics'. I have tried here to recall and summarize our conversation.

Le Mouvement/Movement. Paris; New York; Düsseldorf: Galerie Denise René, 1955.

GEORGES VANTONGERLOO To Perceive

The five senses at the disposal of man allow him to perceive a certain number of facts that we have qualified as objects. This very, very limited number seems comparatively non-existent among the facts, or manifestations, of creation (if indeed one can speak of a comparison).

But for man, considered independently, these five senses are sufficient for him to live his kind of life. Fish, birds, insects, and we could say even plants, behave differently, having other needs for survival. But apart from these five senses, man possesses a more or less developed sensibility (as sight is more or less good); a brain allowing him to reflect; imagination (generally a little wild and fanciful); and the ability to observe and deduce. Thus he can see the invisible or, if you like, take a sounding of the incommensurable. In reality man, like all created things, is a mechanism capable of picking up waves. The difficulty lies in interpreting the sensations received. The variety and richness of these experiences go on to infinity, and can often contain simple facts which nevertheless escape our five senses. Often it is our sensibility which must draw us out of this impasse. This is what one calls having an illuminating idea.

An experience can affect us long after it has taken place, even years after, unless it escapes us. But the event has taken place, and our brain or our sensibility only becomes aware of it later. What one usually calls evolution must fall into this category. Evolution in such a case would be an accumulation of information received.

I have myself made several investigations which I will describe. I made an object in plastic material; *No. 210, Six couleurs dans l'espace*, 1949. This is a curved form on which are placed six colours at a distance from one another. At first I could not measure the distances which separated the colours. In order to be able to do so with an object so shaped, it was necessary to discover a relative system of reference. I hooked the object on a wire and let it revolve. At whatever speed the object rotated, I could always see it as recognisable, and although in movement it was not changed in form. This meant that its speed synchronised with that of my vision. But if my vision was limited to a split-second, like a camera, it would no longer see the object as it previously appeared to me, and the result would no longer have any resemblance to the known object, for it would have changed its geometric forms. I possess a very characteristic photograph of this effect. I showed it at the Congress of the Golden Section in Milan in 1951.

But do not think that these results will always be identical. The universe contains innumerable phenomena which could equally well be cited. The refraction of light, for example. An object changes geometrical forms as *its* speed changes in relation to that of the observer (speed of the eye organism, mechanical device, photo). But it can also undergo physical changes. *No. 210* seen through the eye of the camera, while rotating, registers multiple geometric positions giving an astonishing image.

But the work *No. 214* (1950) titled *Cocon chrysalide, embryonnaire*, in plastic material and of circular form, retains its object-form for the naked eye while rotating. But in the photograph it will take on a physical aspect, radiographic in type. It is the refraction which dominates. I showed this to the Milan Congress in 1951.

I have also made other observations. An example is *No. 228, Segment d'espace*, 1953, in plastic material on which dots of colour are painted, giving by refraction various coloured forms. One can look at this object from any side and it will always remain the same; that is to say, only the position will vary. But seen through the camera's eye it can reveal unknown aspects, and certain shots show unsuspected

forms and colours. One could even say that in making this object I wanted to incorporate this indefinable quality, but doubtless man's sight does not allow him to perceive this, and he needs another instrument that can develop what is denied to the human eye. I always find my work deceptive at the moment of finishing it, but later, often a long time afterwards, I notice that I have put in what I intended without knowing it. The photograph of this work was an encouragement to me, for I had so much wanted to obtain a result that I couldn't see in the object. Yet I must have put it there since the photograph showed it to me. The incommensurable well deserves its name. It is, of course, only thus so long as it isn't under conditions which render it commensurable and even visible. Under certain conditions infinity is finite.

I have had a more or less analogous experience with *No. 240, Elément indéterminé*, 1955. But there the object in itself and in the photograph is totally absent. You would imagine that I had wanted to make something indeterminate. But to speak of determining the indeterminate and subjecting that to man's limited vision, is like speaking of the energy of the atom to someone who hasn't seen the result of it. Here I think that time plays its role. Time, as an absolute value, does not exist. The fact is that when we believe we see something as existing, this thing, before being transformed into another state, corresponds to the speed of our senses. That is to say, its position at a given moment is maintained long enough to allow our senses to perceive it, or register its presence. Time therefore has a varying duration between more or less NT. [Ed: NT is the scientific indication for indefinite time.] It is like space, finite and infinite at once. Basically, we observe a segment or movement of time, a segment or measure of space. Through our senses we are unable to perceive the infinite, for our senses are themselves limited. This does not affect the existence of the infinite, and we are subject to it. Being ourselves part of creation, the infinite, we would not be able to live without the infinite. We are within it, as in the air, like fish in the water. All this is one and the same thing, but from different aspects. Well then, *No. 240* is truly indeterminate. It is in perpetual transformation. The forms and the colours are variable: they have a mobility, and that without them being touched or agitated. They move calmly of themselves. They allow us to see, too, that the infinite is visible and hence finite, at least to man's vision. If the speed of the infinite is synchronised with the speed of vision, we see the infinite as finite. Let us imagine: an unknown, invisible factor is born, lives, endures for a time and dies. Throughout the whole duration of the time it lives, it is visible. Time is spectacular.

Light–time–space.
Light reveals itself by the surface on which it falls.
The time limit is the limited and varying duration of synchronised speeds; that of the perceived object in relation to that of the senses allowing perception.
The space limit is an extension, perceived or perceivable through the speed of our senses.
Time, light, and speed.

Light reveals itself by the surface on which it falls, and in the same way, it reveals the surface. The speed (energy) of the illuminated object, in accordance with the speed of our vision, reveals time to us. On either side of the speed of these illuminated bodies, our vision is unable to perceive the bodies or the light. Nor can it experience the duration of time. It is the duration of this perceptible state that gives us the sensation of time. If this state changes its speed, it re-enters the infinite. For a blind

person objects and space reveal themselves through the tactile sense, and duration through the sense of hearing.

By convention, man registers time by the clock, space by three dimensions. This is very practical and does not offend his senses. But man is well aware that creation is not concerned with such conventions. He is obliged to admit electricity, Hertzian waves, radar, and the atom, although he is lost in the infinitely small and great, in infinite and finite, where time escapes him and he can only recognise what his watch shows him. To accept only those things which are perceptible by our senses is to expose ourselves to a lie. Confronted with the incommensurable, man is handicapped, and has recourse to a god. But he cannot be satisfied by ignorance, and so he must interpret creation. Beautiful though they may be, fables, hymns and commemorations are only illusions.

Man's possibilities of perception are increased by optical instruments and techniques, such as radiography, detectors and a thousand others. He has realised that his five senses are limited. One must say, too, that change is perpetual, that the infinite is in action, and that the finite which our senses perceive is subject to infinitesimal transformations which escape us. We often need instruments to give us information, though happily we have our sensibility. Today we know that the earth has existed for millions of years. It is easy to imagine that it did not always look the same as today, since everything is in the process of transformation. Things are transformed physically and chemically, through action and reaction. The fluxes of nature take part. Legends and fables about it have only a literary value. Through discernment and deduction, through the subtlety of the sensibility, and through science, man is able to approach the inconceivable. The earth with its atmosphere is moving round the sun in an unknown matter, doubtless composed of gas and microbes. This matter no longer has the same characteristics as the atmosphere that surrounds the earth, yet the earth is revolving; in a vacuum? This is inconceivable! The sun's rays would then be non-existent, and simply the effect of a chemical or physical cause, electromagnetic. As the universe is infinite it must have infinite, non-identical zones: atmospheric zones of density. Light would not then be a ray of the sun but could be due to refraction: could be an effect of a cause. The state of one thing can change into that of another with different characteristics. It is therefore possible that the earth is moving in a milieu where its apparent weight, as we know it, is no longer the same, and forces the earth to describe an orbit on the ellipse from which it cannot deviate. This is as necessary to it as air to man. It is inevitable. Creation always has its reasons. The physical chemistry of the universe has its imponderables. Is it not beautiful? This really is engendered creation.

1957

Reprinted in Anthony Hill. *Discours in Art Theory and Aesthetics*. London: Faber and Faber, 1968.

GEORGES VANTONGERLOO **The Incommensurable**

Everything that man perceives, he perceives through his five senses. Thus he turns everything into his own image and according to his own needs. His gods possess bodies and are subject to moods; we address them as if they were our kind. No wonder, therefore, that in art the subject has always been a representation of the life of man: his religion, his environment, his plants, the sun, rain, storms, all natural phenomena – what one used to call: interpretation of matter. Consequently, everything was in three dimensions, or what was termed: in space. In that way everything was kept objective, even when one wanted to express such ideas as Creation. God is truly eternal; Creation has neither beginning nor end, the whole is incommensurable, and yet man has always resorted to three dimensions. Now, what we think we perceive is in fact only an illusion and in a perpetual state of transformation. We do not know the basic causes – the different atmospheric layers, radiations, actions and reactions, refractions and all other factors which make us see as real what is in fact nothing but a consequence: a rainbow, a mirage, an aurora borealis, etc. We produce an explanation and it satisfies us; yes, but why? Because we live and think in three dimensions. In practice, so long as we are dealing with social conventions, it proves to be very useful; however, as soon as we want to express ourselves in the language of Creation, dimensions disappear. Art, and I'm not talking about the image, is perceived through our sensitivity. It is not the subject that affects us, the subject is nothing but a parasite, a pretext that allows the artist to give an external existence to his emotion, to what he feels as incommensurable. A work of art of geometrical forms can be as beautiful as a naturalistic work of art. I am not referring to those works of art which are geometrical and nothing else, as their value is no greater than certain naturalistic works of art.

If you ask me: Does a language exist that would allow us to express the incommensurable? My answer is: yes, Infinity, but one needs to understand Infinity, and not just imitate the created things, or make them look geometrical, as some poor souls do, thinking this is enough to convince us they are modern. It is not by using our brain that we can approach art as we can approach God or the incommensurable. It is through our sensitivity, and that has no dimensions!

Creation is rich and never repeats itself. It contains every possibility. It can produce a magnificent brightness, such as the aurora borealis, which is not in fact light. It is a radiation which does not dazzle you and yet is of an enchanting brilliance. It is a refraction of electrons in the magnetic field. O! the incommensurable is never the same; if it were, it would be commensurable. All the phenomena of Creation show us its eternal infinity, the *novae*. And the secret of the sun?

Space no longer has dimensions. It is no longer our terrestrial space, it is the universe. And the beauty of all that can be expressed by means of art. Science also is aware of this. It, too, tries to approach the problem through the incommensurable. And it is always our sensitivity that keeps us in step. It is not a method, it is a state of mind; it is an art. And life is the same. There is little that we can understand but much, or everything, to be felt. Art is not a one-way street. There is the art of the Mayas, of China, Japan, Negro art, Egyptian art, Greek art, Impressionism, and the so-called abstract art, etc.; they all are manifestations of *Art*, they all are ways of expression. They are always concerned with man and his three dimensions, but there is also the sensitivity which reveals art, and there is the universe. It, too, is beautiful. And as the universe is incommensurable, what we need is an expression that would have neither end nor beginning; and this too exists.

Paris 1961

Georges Vantongerloo. London: Marlborough New London Gallery, November 1962.

WOLS Aphorisms

The universe is One
it manifests itself
in an infinite number
of relative phenomena
partly accessible to our senses
(in their relativity)
only through the things
do we sense the One
*

The great all manifests itself
in a number of endless circles-
all details move in circles,
water proves this,
the world exists through rhythms
*

[...] The universe is a great organism,
a living unity where beats the pulse
of divine power.[...]
*

Had the world been
lucky enough
not to exist
existence could
have existed
*

Sound seems to us to move along
at the rate of about 1 km per 3 seconds
it never stops on its way
into the endless unknown space
only it ceases to be perceivable
the same is true, though their speeds are different
of light waves,
of radio waves,
of human lives,
of thoughts,
of minerals,
of all things
this is how we see the eternity of life
and the immensity without end
we know not whether it all starts over again
and if it does
it is of no importance
*

It is probable that God
prefers flies to people.
The Arthropoda are technically superior
to man
the day a butterfly was beautiful
it fulfilled its task
it is doubtful that man
will ever reach the level of the wasp
*

We set down our little earthbound tales
on little slips of paper
*

At Cassis the stones, the fish
the rocks seen through a magnifying glass,
the salt of the sea, and the sky
made me forget that man is important,
they urged me to turn my back
on the chaos of human affairs
they showed me eternity
in the little waves of the harbor
which are always the same without being the
same.
Nothing can be explained, all we know is the
appearances.
All loves lead to one love, and
beyond all personal loves
there is the nameless love,
the great mystery,
the Absolute,
X
Tao
God
the cosmos
the Holy Ghost
the One
the Infinite.
The Abstract that permeates all things
is ungraspable.
In every moment
in every thing
eternity is present

Dieulefit, 1944

Werner Haftmann (ed.). *Wols. Watercolours, drawings, writings*. New York, undated.

WHITE MANIFESTO

[...] The artistic era of colours and paralytic forms is coming to an end. Man is becoming more and more insensible to stock images with no signs of vitality. The old, immobile images do not satisfy the appetites of the new man formed in the need for action, in constant contact with mechanics, which imposes on him a constant dynamism. The aesthetic of organic movement replaces the worn-out aesthetic of fixed forms.

Invoking this mutation which has taken place in the nature of man, in the psychic and moral changes, and in all human relationships and activities, *we are abandoning the practice of known forms of art and embarking on the development of an art based on the unity of time and space.*

The new art takes its elements from nature.

Existence, nature, and matter are a perfect unity. They develop in time and space.

Change is the essential condition of existence.

Movement, the property of evolving and developing, is the basic condition of matter. This exists in movement and in no other way. Its development is eternal. Colour and sound are found in nature connected to matter.

Matter, colour, and sound in movement are the phenomena whose simultaneous development makes up the new art.

Colour in volume developing in space, taking on successive forms. Sound produced by as yet unknown devices. Musical instruments do not respond to the need for great sonorities and do not produce the required sensations of amplitude.

The construction of voluminous forms in mutation by means of a plastic, malleable substance. Arranged in space, they act in synchronic form, making up dynamic images.

Thus we exalt nature in all its meaning.

Matter in movement manifests its total and eternal existence, developing in time and in space, adopting as it mutates different states of existence.

We conceive man in his re-encounter with nature, in his need to link himself to nature in order to take up once again the exercise of its original values. We postulate a complete comprehension of the primary values of existence, which is why we restore to art the solid values of nature.

We present the substance not the superfluities. We do not represent man, the other animals, or other forms. They are only manifestations of nature and will mutate over time, change and disappear according to the succession of phenomena. Their physical and psychic conditions are subject to matter and its evolution. We turn our attention to matter and its evolution, the generative sources of existence.

We take the energy specific to matter, its need to exist and develop.

We postulate an art free of all aesthetic artifice. We practise what man has in him that is natural, true. We reject the aesthetic falsities invented by speculative art.

We place ourselves close to nature, closer than art has ever been in its history. [...]

Bernardo Arias, Horacio Cazeneuve, Marcos Fridman, Pablo Arias, Rodolfo Burgos, Enrique Benito, César Bernae, Luis Coll, Alfredo Hansen, Jorge Rocamonte
1946

Reprinted in Germano Celant (ed.). *The Italian Metamorphosis, 1943–1968*. New York: Solomon R. Guggenheim Museum, 1995 (exhibition catalogue).

SECOND SPATIALIST MANIFESTO

The work of art is destroyed by time.

When, in the final pyre of the universe, time and space also cease to exist, no memory will remain of the monuments erected by man, even though not a single hair from his head will have been lost.

But we do not wish to abolish the art of the past or to stop life: we want the painting to come out from its frame and the sculpture from its bell jar. A minute's airy expression of art is the same as if it had lasted a millennium, in eternity.

To this end, using the resources of modern technology, we shall make appear in the sky:

artificial forms,

rainbows of wonder,

luminous writings.

If, at first, the artist, shut up in his tower, represented himself and his amazement and saw the landscape only through the panes of glass and later, descending from his castles and into the cities, knocking down walls and mixing with other men, he saw the trees and objects from up close, today we, the spatial artists, have fled our cities, broken our shells, our physical crust, and seen ourselves from above, photographing the Earth from flying rockets.

By this we do not mean to glorify the primacy of our minds over this earth; rather, we wish to recover our true face, our true image, a transformation anxiously awaited by all creation.

The spirit casts its light, in the freedom that has been granted us.

Lucio Fontana, Gianni Dova, Beniamino Joppolo, Giorgio Kaisserlian, Antonino Tullier
Milan, 18 March 1948

Reprinted in Germano Celant (ed.). *The Italian Metamorphosis, 1943–1968*. New York: Solomon R. Guggenheim Museum, 1995 (exhibition catalogue).

TOMMASO TRINI The last interview given by Fontana

Selections from a conversation with Lucio Fontana recorded by Tommaso Trini on July 19, 1968, one and a half months before his death. (...)

You see, unfortunately I am an explorer. Today the young are going through a period of both crisis and evolution. We on the other hand lived during a period of fruitful exploration, because we had behind us some considerable artists. You must be aware of De Chirico, Sironi, Campigli and Morandi who brought new life to painting. My experiments took a new direction with the Spatial Manifesto of 1946 in which I said, 'We carry forward the evolution of art through the medium'. That summarises it in a formula. It would have been enough to leave it at that, because to say 'through the medium' is to say that today art can be made with plastic or light. It was just the feeling that art was no longer to be thought of in terms of brushes and painting and restricted to canvases and frescoes. It was a warning that art had changed direction and dimension. I mean dimension in the sense of profundity.
Of course the Manifesto is now probably out of date, but it still retains some relevance. We said, 'We will use television to transmit forms through space'. I think that that is still valid, because television remains an unsophisticated medium. (...) So, if any of my discoveries are important, the 'hole' is. By 'hole' I meant going outside the limitations of a picture frame and being free in one's conception of art. A formula like: 1+1=2. I did not make holes in order to wreck the picture. On the contrary, I made holes in order to find something else... I can talk about it today, because they were basically my ideas. They never understood. They used to say that I ripped up canvases, destroyed things and wanted to break the rules. But that's not true. Look at Pollock... I have argued with a few Americans. Once an American in Venice said to me, 'You're the spatialist but you don't understand about spaces. Who are you anyway?' Later he got to know me but did not understand anything. He found out that I am Fontana and am a spatialist. 'But how can you understand space? We've got Arizona. There's space for you...' So I said to him, 'Look, if it comes to that, I come from South America and we have the Pampas which is twice the size of Arizona. I am not interested in the kind of space you are talking about. Mine is a different dimension.' The 'hole' is this dimension. I say dimension because I cannot think what other word to use. I make a hole in the canvas in order to leave behind me the old pictorial formulae, the painting and the traditional view of art, and I escape symbolically, but also materially, from the prison of the flat surface. As for Pollock, and Pollock got there *after* the spatialists – I say the spatialists and not just me, because Crippa had done his works with threads, and the works he did in 1950 are very important – Pollock, then, threw paint on to the canvas. He was looking for a new dimension of space, but all he could produce was Post-Impressionism, because he threw paint *onto* the canvas, although he wanted to go *beyond* the canvas. Klein is the one who understands the problem of space with his *blue* dimension. He is really abstract, one of the young artists who have done something important, like Manzoni with 'line'. In spite of all that the Americans are doing today they still haven't caught up with Manzoni. Manzoni's 'line' is still way ahead of them. That's how it is. They will understand it in a hundred years' time. So, the 'hole' is free space and is way in advance of Pollock. (...) Back in 1949, the black spatial environment – you were talking of environments – I exhibited it on its own, without sculpture. But today young artists have it easy, don't they? But in those days a man who made holes was despised, he was an idiot, a madman. But today things have changed. I don't claim to have invented anything. I admit that the Futurists prompted me – time, space, etc. (...) The 'ceilings' too were sculptures full of light, but they were not light itself. Now they say, 'He's the one who did the electric light'. But why? When I called it 'spatial concept', why do they have to say that it's an electric light? Of others they say that they invent or renew. But about me, that I

did the electric light or the holes. I never understand why. And especially when I used the precise terms, 'spatial concept'. It was an object and really I anticipated objects. They were objects, no longer pictures. These things have now achieved a perfect form, but that form is also decadent. Manzoni's 'line' as concept or as social motivation of art has not yet been reached by anybody, because it is infinity. These are things that we come to slowly, turning back sometimes, as I did. Because I have taken some enormous steps backwards in order to reconsider my position. I went through periods of decadence on my way from 'holes' to 'slashes'. It's not that I have improved, because 'holes' and 'slashes' are the same thing. (...)

In art the revolution is social and not just visual. It is a revolution in thought. The evolution of art is something internal, something philosophical and is not a visual phenomenon. That is the relevance of the Futurists and the Cubists... Manzoni's 'line' is a matter of pure philosophy. Even Le Parc's game in which light destroys form is valid because the man in the street discovers that art is no longer done on wall and canvas. This way people begin to think and decide whether in the future art will have a *raison d'être* or whether it will have finished its usefulness. Art is a creation of man and not a material fact like eating and sleeping. It is a creation which at a given moment can come to an end or be super-seded by other sciences. Art is only thought in evolution and if human thought should evolve into such dimensions that art becomes in time superficial, then that is the end of art... Art may become so superficial that it will be, if not repudiated, at least overtaken. (...) I also did the Manifesto on televi-sion. I wanted to have an exhibition simultaneously in New York, Milan, Berlin, the whole world over, to transmit forms. They didn't let me do it. We got together a group of spatialists.

We wanted to transmit simultaneously all over the world a statement, some kind of gesture, to demon-strate that the whole world was simultaneously aware of a single thought. Television did not understand, they rejected our idea. Only the Manifesto remains. (...) Will there always be artists? But of course, there will always be the unemployed. Let's not be romantic... In 500 years' time people will not talk of art, they will talk of other problems and art will be like going to see a curiosity like the two rocks put together by the first caveman. What were they up to? Why did they cover walls with pictures? Today man is on earth and these are all things that man has done while on earth, but do you think man will have time to produce art while travelling through the universe? He will only have time to travel through space and discover marvellous things, things so beautiful that things here will seem worthless. Today's young people too are still tied to the earth. Man must free himself completely from the earth, only then will the direction that he will take in the future become clear. Today we are still too firmly glued to the earth. And since I believe in man's intelligence – it is the only thing in which I believe, more so than in God, for me God is man's intelligence – I am convinced that the man of the future will have a completely new world.

Studio International, London, November 1972, pp. 164–165.

YVES KLEIN **My Position in the Battle between Line and Colour**

The art of painting consists, in my opinion, of restoring matter to its primordial state. An ordinary picture, as it is generally conceived, seems to me like the window of a prison, where the lines, contours, forms and composition are determined by the bars. The way I see it, lines embody our mortal state, our emotional life, our power of reasoning and even our spirituality. They are our psychological boundaries, our history, our education and skeleton, our flaws and wishes, our powers and our stratagems.

Colour, on the other hand is more natural and human, it bathes in cosmic sensitivity. Pictorial sensitivity, unlike what line would tend to make us believe, is not filled with hidden nooks and crannies. It is like the moisture in the air; colour is nothing but sensitivity turned into matter, matter in its primordial state. I can no longer approve of a 'legible' picture, my eyes are not made to read a picture, but rather to see it. Painting is COLOUR, and van Gogh exclaimed: 'I want to be liberated from I don't know what prison.' I think he subconsciously suffered from seeing colour cut up by line and its consequences. Colours are the real dwellers in space, whereas lines merely travel through space and streak it. They streak the infinite, while colour is. Through colour I feel a total identification with space; I am truly free!

During my second Parisian exhibit at Colette Allendy's in 1956, I displayed a selection of PROPOSITIONS in varied colours and sizes. What I expected from the public was this 'moment of truth' of which Pierre Restany spoke in his text for my exhibit. In feeling free to remove this impure external encumbrance and to achieve that degree of contemplation where art becomes full and pure sensibility. Unfortunately, it became obvious from reactions to this display that many observers, caught in their habitual way of seeing, were far more receptive to the relationship of the PROPOSITIONS to each other and re-created the elements of a decorative and architectural multicoloured design.

After this, I was moved to continue my research one step further and to show, this time in Milan in the Gallery Apollinaire, an exhibit dedicated to what I dared to call my 'blue period' (in fact, I had been concentrating on the search for the most perfect expression of blue for more than a year). This exhibit consisted of ten blue pictures, dark ultramarine, all of them exactly alike in tone, value, proportion, and size. The impassioned controversy following this exhibit and the deep emotion among open-minded persons who were ready to escape the stifling effects of well-known representations and deep-rooted rules showed me the importance of the phenomenon.

Although I live in the midst of errors, naivetes, and Utopias, I am happy to be dealing with a problem that is so much of our time. One must — and this is not an exaggeration — keep in mind that we are living in the atomic age, where everything material and physical could disappear from one day to another, to be replaced by nothing but the ultimate abstraction imaginable. For me there exists a sensitive artistic colour material that is intangible. Thus I have pondered whether even colour, in its physical aspect, has also become finally for me a limit and a hindrance to my effort to create perceptible pictorial states.

In order to reach Delacroix's 'indefinissable,' the very essence of painting, I have embarked on the 'specialization' of space, which is my ultimate way of treating colour. It is no longer a matter of seeing colour but of perceiving it.

My recent work with colour has led me progressively and unwillingly to search for the realization of matter with some assistance (of the observer, of the translator), and I have decided to end the battle. My paintings are now invisible and these I would like to show in my next Parisian exhibit at Iris Clert's, in a clear and positive manner.

Paris, April 16, 1958

Reprinted in *Zero aus Deutschland 1957 bis 1966. Und heute.* Ostfildern-Ruit: Hatje Cantz Verlag, 2000 (exhibition catalogue).

YVES KLEIN

"The specialisation of sensitivity in the primary material state into stabilised pictorial sensitivity."
Pneumatic era (Many details will be omitted because they would be too numerous.)

The object of this attempt is to create, establish and present to the public a sense-based pictorial state within the limits of an exhibition of ordinary paintings. In other words, the creation of an ambience, an invisible pictorial climate, in the spirit of what Delacroix called in painting the 'undefinable', to which he often referred in his journal as being the very essence of the painting. This invisible pictorial state in the gallery space has to be present and endowed with an autonomous life to the extent that it has to be literally what, to date, has best been offered as a definition of painting in general: 'radiance'.

Invisible and intangible, this immaterialization of the painting has to act, if the creative operation is to succeed, upon the exhibition visitors' sense-based vehicles or bodies, with far more effectiveness than the physical, ordinary and representative paintings, which, in the case that they are obviously good paintings, are also endowed with this particular pictorial essence, with this affective presence – in a word, with sensitivity, but transmitted by the suggestion of all physical appearance.

3000 invitations have been sent, 300 of which within Paris itself. We have also decided to add a sort of bonus entrance ticket, clearly indicating that without this special little card, the entrance price will be 1500 francs per person.

This manoeuvre is necessary because although all the pictorial sensitivity that I am exhibiting is for sale, either in pieces or in bulk, visitors endowed with a body or their own vehicle of sensitivity will be able, in spite of me – and try as I may with all my strength to keep the whole exhibition in place, consciously or not – to deprive me of some degree of intensity through impregnation. And that, above all, has to be paid for. After all, 1500 francs is really not expensive.

Then we decided on the stage devices and the exhibition's material presentation (in terms of additional advertising: two large posters were planned at Saint-Germain-des-Prés Square for only five days, blue letters in relief against a white background, with text; Iris Clert's gallery, 3 rue des Beaux-Arts, Yves le Monochrome, from 28 April to 5 May. We have announced the exhibition by a small ordinary insert in *Arts* and in *Combat*, for Paris, and in *Arts* for America).

The Iris Clert gallery is very small – twenty square meters – with its front window and door on the street. We will close the street entrance and have the public come round by the building's entrance hallway, in which there is a small door into the back of the gallery. From outside in the street, it will be impossible to see anything but blue, because I will paint the windows in the blue of last year's blue era. On and around the building's entrance door, through which the public will have access to the galley through the hallway, I will place a monumental blue-cloth canopy, still in the same tone of dark ultramarine.

On either side of the entrance, beneath the canopy, Republican Guards in full presidential regalia will be posted on the evening of the opening. (This is required by the official character I want to give the exhibition and also because the true principle of the republic, if it were applied, appeals to me, although I find it incomplete in its present form.)

We will receive the public in the approximately thirty-five-square-meter hallway, where a blue cocktail will be served (made by La Coupole bar in Montparnasse, with gin, Cointreau, and methylene blue). Once in the hallway, the visitors will see on the left-hand wall a large blue tapestry which will mask the small access door into the gallery.

We have also planned for a private security service to deal with the 3000 guests, made up of four men ready for anything. This is all the more both urgent and necessary, given that I am expecting acts of vandalism.

These men are trained fighters, and will receive strict orders to observe the greatest courtesy toward the public so long as people are behaving decently and not conducting themselves too disagreeably. Two of these 'bodyguards', as it were, will be placed at the entrance to the building on the street, along with the Republican Guard, in order to inspect the invitation cards, and the other two at the entrance into the gallery, in the hallway, on the sides of the tapestry, and will usher the public into the gallery in groups of no more than ten persons at any one time. I myself will be standing inside and will ask people not to linger more than two or three minutes at the most, in order to enable everyone to get in.

Gallery stage devices. On the one hand, in order to specialise the ambience of this gallery, its pictorial sensitivity in the state of raw material, in a particular individual and autonomous stabilised pictorial climate, I have to paint the wall white, in order to cleanse it of the impregnation's of numerous previous exhibitions. By painting them white, I hope not only to purify the site, but also and above all, through this action and this gesture, to make it momentarily into my work-space and creation-space – in a word, my studio.

If, by putting one of more coats of paint on the gallery walls, using my usual technique, conscious of my act and enthused by the principle of my demonstration, as if working on a large painting, giving it all I've got and all the good will possible, with pure white lithopone, ground into my special varnish, made out of alcohol, acetone, vinylic resin (which does not kill the pure pigment in affixing it on the support), spread with a ripolin lacquer roller, I will have attained my goal.

By not playing the house painter, in other words, by abandoning myself to my craftsmanship, my painterly gesture, which is free and perhaps slightly deformed by my sensual nature, I think that the pictorial space I had previously managed to stabilise in front of and around my monochrome paintings will be, from then on, well established in the gallery space. My presence in action during the execution in the given space of the gallery will create the climate and radiant pictorial ambience which customarily reigns in the studio of any artist endowed with real power; an abstract yet truly sense-oriented density will be brought to life by and for itself in the space.

To this end, nothing must inhibit the view within the gallery, which, on the other hand, must not be too deliberately naked. Thus, there is to be no furniture, though we will leave the window built into the back wall, on the left, which I will paint white like all the rest, except for the metal mounts; I will leave the street-window table-cupboard as is, and will paint the wooden parts white, always in the same way, and will cover it over with white cloth.

The glass of the window and the condemned door onto the street will be painted white on the inside like everything else. Everything will be white to receive the pictorial climate of the sensitivity of the immaterialized blue. I will not paint the ceiling or the floor: I will leave the new gray-black carpet on the ground, which Iris had laid several days ago.

To make it extremely clear that I have abandoned material and physical blue, waste and coagulated blood, stemming from primary material, sensibility of space, I would like to obtain permission from the Prefecture of the Seine and the French electricity utilities company, to illuminate the obelisk at the Place de la Concorde in blue. In such a way that by placing blue frames on the already-installed spotlights, it will be possible to illuminate the obelisk while leaving the base in shadow. Thereby

giving all the mystique of high Antiquity to the monument, I will at the same time provide a solution to sculpture's eternal problem: that of 'the plinth'. Indeed, lit up in this way, the obelisk will hover, immutable and static, in a monumental movement of the affective imagination, in the space above the entire Place de la Concorde, above the prehistoric gas street lamps, in the night – like an immense vertical stroke, unpunctuated by exclamation.

Thus the tangible and visible blue will be on the outside, in the street; the inside will be the immaterialization of the blue, the coloured space which is not seen, but in which one is immersed.

At first, there is nothing; then, there is a profound nothing, then a blue deepness.

Wednesday 23 May, at 11 pm, the Prefecture having authorised illuminating the obelisk in blue the day of my opening, Iris Clert and I had an appointment with technicians from the French electrical utilities company at the Place de la Concorde. When we arrived, even from far away, we were carried away with enthusiasm by this extraordinary vision of such rare and exceptional quality. The hieroglyph-covered surfaces became a pictorial matter of profound and mysterious, unheard-of and stunning richness. [...]

At 8 pm, I go to the Coupole to pick up the 'blue cocktail', which has been specially prepared for the occasion.

At 8:45 pm, I get to the gallery for last-minute preparations. At 9 pm, the Republican Guards arrive in dress uniform.

I immediately offer them a ceremonial blue cocktail before they take up position beneath the entrance-way canopy, standing at attention.

The almost simultaneous arrival of the four men from the private security firm. I give each of them their instructions, they repeat them, and already the first visitors begin to arrive...

9:30 pm, everything is jam-packed, the corridor is full, the gallery as well, outside is a growing crowd, who find it far from easy to get in.

At 9:45 pm, it is madness. The crowd is so dense that it is impossible to move anywhere. I stand inside the gallery itself. Every three minutes, I repeatedly shout out to the people crowding into the gallery in every greater numbers (the security guards are unable to contain them and control their comings and goings): "Ladies and gentlemen, please be so good as not to stay too long in the gallery so as to allow the other visitors who are waiting outside to come inside."

[...]

At 10 pm, the police arrive in force (three vans full) by the Rue de Seine. The firemen too arrive in full force – with even the hook-and-ladder truck – by the Rue Bonaparte, but they are only able to get past the crowd in the Rue des Beaux-Arts by going down as far the Claude Bernard Gallery...

At 10:10 pm, between 2500 and 3000 people are in the streets, and the police, coming from the Rue de Seine, and the firemen, coming from the Rue Bonaparte, attempt to push the crowd back toward the quays along the Seine. While a patrol shows up at the entrance demanding explanations (some people, furious at having been charged an entrance fee of 1500 francs only to have seen nothing whatsoever inside, had filed a complaint). My security guards inform them laconically and firmly that, 'We have our own personal security service here, and have no need of your services'. Legally unable to enter, the patrol withdraws.

At 10:20 pm, a representative of the Order of Saint-Sebastian arrives in full regalia (cocked hat and cape emblazoned with a red Maltese cross). A lot of painters being in the space at one time, Camille Bryen cries out: 'In short, this is an exhibition of painters here!' [...]

At 10:50 pm, the blue cocktail having run out, someone runs over to the Coupole to get more.
Two attractive Japanese women in extraordinary kimonos arrive.
At 11 pm, the crowd which had been dispersed outside by the police and the firemen returns in small exasperated groups. Inside, things are still teeming.
At 12:30 pm, we close up and head for the Coupole.
At the Coupole, we have a large table for forty persons, in the back.
At 1 am, my voice trembling with exhaustion, I give my revolutionary speech.
At 1:15 am, Iris faints. [...]

The human experience is of such considerable magnitude as to almost defy description. Certain visitors are unable to enter – as if an invisible wall were inhibiting them. One day, a visitor yelled to me from the doorway: "I will come back when this void has been filled..." I reply that when it has been filled, he will no longer be able to enter!
Often people spend hours inside without saying a word, some shudder and other start to cry.

Preparations for the exhibition, 28 April 1958
At Iris Clert's, 3 rue des Beaux-Arts, in Paris

Reprinted in *Yves Klein*. Paris: Centre Georges Pompidou, 1983 (exhibition catalogue).

For an organic painting

We want to organise disintegration. In a disintegrated world, we want to be able to discover and reveal to ourselves the inner structures. We want to establish these presences unequivocally.

Beyond all surface hedonism, all impression, all memory, we disintegrate phenomena and acts in order to find their innermost impulses, to separate the essential from the gratuitous and monodize it with absolute precision, so as to highlight each in its most authentic seed.

The painting is our space of freedom, in which we continuously reinvent painting, in continuous search of our primary images.

Piero Manzoni, Guido Biasi, Mario Colucci, Ettore Sordini, Angelo Verga
Milan, June 1957.

Reprinted in Germano Celant (ed.) *The Italian Metamorphosis, 1943–1968.* New York: Solomon R. Guggenheim Museum, 1995 (exhibition catalogue).

PIERO MANZONI Free Dimension

New conditions and problems imply different methods and standards and the necessity of finding original solutions. One cannot leave the ground just by running and jumping: one needs wings. Changes are not sufficient; the transformations must be total.

This is why I do not understand painters who, whilst declaring themselves receptive to contemporary problems, still stand in front of a canvas as if it were a surface needing to be filled in with colours and forms, in a more or less personalized and conventional style. They draw a line, step back, stare complacently at their work with their head to one side, closing one eye. They approach it once again, draw another line, apply another stroke. This exercise continues until the canvas is covered: the painting is complete. A surface with limitless possibilities has been reduced to a sort of receptacle in which inauthentic colours, artificial expressions, press against each other. Why not empty the receptacle, liberate this surface? Why not try to make the limitless sense of total space, of a pure and absolute light, appear instead?

To suggest, to express, to represent: these are not problems today. I wrote about this some years ago; whether or not a painting is a representation of an object, of a fact, of an idea, or of a dynamic phenomenon, it is uniquely valuable in itself. It does not have to say anything, it only has to be.

Two matched colours, or two tones of the same colour are already an alien element in the concept of a single, limitless, totally dynamic surface. Infinity is strictly monochromatic, or better still, colourless. Strictly speaking, does not a monochrome, in the absence of all rapport between colours, eventually become colourless?

The artistic problematic which has recourse to composition, to form, is deprived of all value; in total space, form, colour and dimensions have no sense. Here, the artist has achieved total freedom: pure matter is transformed into pure energy. Blue on blue or white on white to compose or to express oneself, both obstacles of space, and subjective reactions cease to exist; the entire artistic problematic is surpassed.

This is why I cannot understand artists of today who scrupulously fix the limits in which they place forms and colours, according to a rigorous balance. Why worry about the position of a line in space? Why determine this space? Why limit it? The composition of forms, their position in space, spatial depth, are all problems that do not concern us. A line can only be drawn, however long, to the infinite; beyond all problems of composition or of dimensions. There are no dimensions in total space. Furthermore, the questions concerning colour, chromatic relations (even if this only involves nuances) are shown to be useless. We can only open out a single colour or present a continuous and uninterrupted surface (excluding all interference of the superfluous, all possibility of interpretation). It is not a question of painting the contrary of everything. My intention is to present a completely white surface (or better still, an absolutely colourless or neutral one) beyond all pictorial phenomena, all intervention alien to the sense of the surface. A white surface which is neither a polar landscape, nor an evocative or beautiful subject, nor even a sensation, a symbol or anything else: but a white surface which is nothing other than a colourless surface, or even a surface which quite simply 'is'. Being (the total being which is pure Becoming).

This undefined surface, uniquely living, which in the material contingency of the work cannot be infinite, can on the other hand be multiplied to the infinite, without the solution of continuity.

This appears more clearly in the Lines; in this case, no doubt remains. The line develops in length uniquely, to the infinite. Its only dimension is time. It goes without saying that a line is neither a horizon nor a symbol and its value is not linked to the fact that it is more or less beautiful, but rather to the fact that it is a line, that it exists, like a work which counts for what it is and not for its beauty or for what it evokes. But in this case the surface only retains its value as a vehicle. The same is true of the Bodies of Air (pneumatic sculptures) that one can let down or fill at leisure (from nothingness to the infinite); they are absolutely undefined spheres, because all intervention destined to give them a form (even formlessness) is illegitimate and illogical.

There is no question of forming, articulating; one cannot have recourse to complicated, parascientific solutions, to graphic compositions, to ethnographic fantasies, etc. Each discipline possesses in itself elements of solution. Expression, imagination, abstraction, are they not in themselves empty inventions? There is nothing to explain: there is only to be, to live.

Azimuth, no. 2, Milan 1960. Reprinted in *Piero Manzoni*. London: Serpentine Gallery, 1998.

PIERO MANZONI **Immediate Projects**

Since 1959 the roster of the fabrics of white light that I call Achromes have been stitched in sewing machines (in 1957 and 1958 the fabric was impregnated with kaolin and glue). I am now planning to produce large forms by making use of plastic fabrics. In 1959 I prepared a series of forty-five Air Bodies having maximum diameters of eighty centimetres, and now, if the purchaser so desires, he may also buy My Breath, as well as its covering fin rubber and its base, which are kept in a special case. In this way it may be kept in its covering.

I am working now on a series of Air Bodies that will have diameters of approximately two and a half metres and that can be set up in parks or gardens. Through the use of a small device, these objects will pulsate slowly as if breathing, but not in a synchronized fashion. (I prepared the first experimental samples in 1959, but with coverings of a smaller size. And making use of the same principle, I have also planned a pulsating pneumatic wall that can be used architecturally.) In the same park or garden I will plant a small forest of pneumatic cylinders resembling stalks (four to seven metres high), which will vibrate in the wind.

I am also preparing, still for the same park, a sculpture that will perform autonomous movements. This mechanical animal will draw its nourishment from nature (solar energy); at night it will pause and contract into itself, while during the day it will move about slowly, emit sounds, and project antennae that will absorb energy and act as warning signals against obstacles.

I am developing in addition a new series of Absolute Bodies Of Light. (The 'absolute bodies' I have created up to now are plastic spheroids with a diameter of forty centimetres; they remain immobile, suspended in space by a jet of compressed air, and by changing the direction of the jet they can be made to whirl until they achieve a virtual volume: an 'absolute body of light'.)

Absolute Bodies Of Light can be made in any dimension (I am planning a big one now for a particular architectural project), but at the moment I am working on a series of very small Absolute Bodies Of Light which will be kept in action by a tiny independent motor that will require no special installation.

Recently I signed and left My Fingerprints on several eggs (the public had direct contact with these works by swallowing an entire exhibition of them in seventy minutes). But I am continuing to distribute eggs consecrated with my fingerprints. This year I was able to draw A Line 7,200 METRES LONG. (The first series of lines, begun in the spring of 1959, had a maximum length of 33.63 metres.) This is the first of a series of exceptionally long Lines of which I will leave one sample in each of the principal cities of the world. (Each Line, when it is completed, will be vacuum-packed in a special stainless-steel case that will be hermetically sealed.) The series will be completed only when the sum of the lengths of the lines is equal to the circumference of the earth.

1961

Reprinted in *Zero aus Deutschland 1957 bis 1966. Und heute.* Ostfildern-Ruit: Hatje Cantz Verlag, 2000 (exhibition catalogue).

JEAN TINGUELY **Static, static, static!**
Conference at the Institute of Contemporary Arts (ICA) of London, 12 November 1959

Static, static, static! Be static! Be static! Movement is static! Movement is static! Movement is static because it is the only immutable thing – the only certainty, the only unchangeable. The only certainty is that movement, change and metamorphosis exist. That is why movement is static. So-called immobile objects exist only in movement. Immobile, certain and permanent things, ideas, works and beliefs change, transform and disintegrate. Immobile objects are snapshots of a movement whose existence we refuse to accept, because we ourselves are only an instant in the great movement. Movement is the only static, final, permanent and certain thing. Static means transformation. Let us be static together with movement. Move statically! Be static! Be movement! Believe in movement's static quality. Believe in change. Do not hold anything fast. Change! Do not pinpoint anything! Everything about us is movement. Everything around us changes. Believe in movement's static quality. Be static!

The constant of movement, of disintegration, of change and of construction is static. Be constant! Get used to seeing things, ideas and works in their state of ceaseless change. You will live longer. Be permanent by being static! Be part of movement! Only in movement do we find the true essence of things. Today we can no longer believe in permanent laws, defined religions, durable architecture or eternal kingdoms. Immutability does not exist. All is movement. All is static. We are afraid of movement because it stands for decomposition – because we see our disintegration in movement. Continuous static movement marches on! It cannot be stopped. We are fooling ourselves if we close our eyes and refuse to recognize the change. Actually, decomposition begins only when we try to prevent it. Decomposition does not exist! Decomposition does not exist! Decomposition is a state envisaged only by us because we do not want it to exist, and because we dread it.

There is no death! Death exists only for those who cannot accept evolution. Everything changes. Death is a transition from movement to movement. Death is static. Death is movement. Death is static. Death is movement.

Be yourself by growing above yourself. Don't stand in your own way. Let us change with, and not against, movement. Then we shall be static and shall not decompose. Then there will be neither good nor evil, neither beauty nor unsightliness, neither truth nor falsehood. Conceptions are fixations. If we stand still, we block our own path, and we are confronted with our own controversies.

Let us contradict ourselves because we change. Let us be good and evil, true and false, beautiful and loathsome. We are all of these anyway. Let us admit it by accepting movement. Let us be static! Be static!

We are all still very much annoyed by out-of-date notions of time. Please, would you throw away your watches! At least, toss aside the minutes and hours.

Obviously, we all realize that we are not everlasting. Our fear of death has inspired the creation of beautiful works of art. And this was a fine thing, too. We would so much like to own, think or be something static, eternal and permanent. However, our only eternal possession will be change.

To attempt to hold fast an instant is doubtful.

To bind an emotion is unthinkable.

To petrify love is impossible.

It is beautiful to be transitory.

How lovely it is not to have to live for ever.

Luckily, there is nothing good and nothing evil.

Live in time, with time – and as soon as time has sickened away, against it. Do not try to retain it. Do not build dams to restrain it. Water can be stored. It flows through your fingers. But time you cannot hold back. Time is movement and cannot be checked.

Time passes us and rushes on, and we remain behind, old and crumbled. But we are rejuvenated again and again by static and continuous movement. Let us be transformed! Let us be static! Let us be against stagnation and for static!

Reprinted in Pontus Hulten. *Jean Tinguely*. Paris: Centre Georges Pompidou, 1998 (exhibition catalogue).

JEAN TINGUELY Tinguely talks about Tinguely

I am a movement artist. I started by doing painting, but I got stuck, I found myself at a dead-end. The whole history of art and the School of Fine Arts had handicapped me, and so I began painting with a handicap. I got hung up in paintings, on paintings. All I was able to end up doing in paintings was to wait for them to get worn out. I was never able to find the end. And so I decided to reintroduce movement into them. I started with constructivist elements, with Russian supremacist painter Malevitch's vocabulary; with Kandinsky's, Arp's and a few other artists' vocabulary. I reused their component parts and put them to movement. In that way I tried to get away from their imperative, their strength – and from Mondrian's strength as well. I began using movement simply in order to produce a recreation, to recreate or redo a painting in such a way that it become infinite, that it continuously find new compositions, thanks to physical and mechanical movements which I set behind the work. I then slowly began to notice that the movement was a possibility for expression in itself, with which it would be possible to do things plastically different from what had been done previously. I knew what had been done previously. I met artists like Pevsner – Antoine Pevsner as a very old man, all knitted up. Well, actually, he was wearing a knitted outfit because when he was welding, he was always very cold, so he wore these knitted vests – it was marvellous. Antoine Pevsner – one of the artists, who with Gabo, had signed the Russian constructivist manifesto – told me, when I met him with Daniel Spoerri, that movement was nothing, that it didn't work, that they had tried everything in vain. That really cracked me up because I felt that deep down, his whole generation had nostalgia for movement, and that the only big winner amongst them was Alexander Calder.

Calder, with his mobiles, had found a direct and potent means of expression. He had worked a quarter century before me, and had succeeded in producing a self-evident and altogether extraordinary work, full of joy and a certain humour. So that gave me confidence. Let's say that my discovery of Alexander Calder, alleged to be a unionist, swung open a door that I was able to move through.

Well, I headed in that direction and discovered the wonderful possibilities of movement. And that is the point of departure of, amongst other things, my self-destructive works, such as *Hommage à New York* (Homage to New York), an ephemeral work, fleeting like a falling star, and above all intended to be irrecuperable by museums. It was not supposed to be 'museified'. It had to pass by, be dreamed

about, talked about, and that's all – the next day there was to be nothing left. Everything went back to the garbage. It possessed a certain complicated sophistication, which led to its destroying itself. It was a machine that committed suicide. It was a very nice idea, if I do say so myself. That was in 1960 in New York. I was supported by guys like the dadaist Richard Heulsenbeck. I have always been in contact with Dada, because I had been into Dada-Duchamp, Dada-Ernst – Max Ernst, Marcel Duchamp. The dadaists liked me and took an interest in my work. With hindsight, I am able to understand my extensive interest in Dada, because when I gave up geometrical-abstract painting and set its geometric elements into motion in order to go still further, I was quickly referred to as a dadaist. I myself had a very good impression of Dada, because I knew the marvellous things the dadaists had done, at exactly the same time as – and in parallel with – Stravinsky during the war, and that was incredible.

I also share Dada's deep-seated suspiciousness with regard to power. We don't like authority, we don't like power. It is a characteristic of dadaists, and of the Fluxus group as well, and which you also find in the attitude of the second-generation New York artists, such as Rauschenberg and Jasper Johns, who suddenly shattered conventions. There is a movement of revolt everywhere, and in my opinion art is an obvious, utter and complete form of revolt. It is a political attitude that does not require founding a political party. There is no question of taking power; when one is against power, one cannot very well take it. We are against all types of force which come together and crystallise into an authority which oppresses other people. This is obviously not just a characteristic of my work alone, but is far more general; it is a basic political attitude. There is a clear intention, more than ever necessary today, to oppose all forms of force emanating from a directive and centralising political power. In this same sense, we are automatically anti-nationalist, not necessarily anti-patriotic, but anti-nationalist, inasmuch as it is necessary to fight against the agglomeration of political forces in any country what-soever.

From a broadcast on Belgian radio-television's French-language service, presented by Jean-Pierre Van Tieghem, 13 December 1982.

Reprinted in Pontus Hulten. *Jean Tinguely*. Paris: Centre Georges Pompidou, 1998 (exhibition catalogue).

Programme Thought Up in 1961 by Takis and Sinclair Beiles

Subject 1. What is the structure of a thought? How does it change its structure? How is a thought transformed into light and sound and chemical reactions? What is the relation of thoughts to numbers since thoughts have definite geometrical shapes? *(Thoughts are things. An electromagnetic configuration is a definite thing.)*

Subject 2. History is composed of thoughts – therefore one can ask the question. *What is the structure of History?* What is its electromagnetic configuration? How does it change its structure?

Subject 3. What living organisms behave like thoughts? How are they similar to thoughts? For example, viruses, bacteria, simple sea animals, highly organised insects such as flies. If one can think in terms of a thought (with structure) of which a certain species partakes, then what is the structure of this thought? How does it change? How is it related to other thoughts which determine the forms of other species?

Subject 4. What environments and conditions are favourable for closer collaboration between thoughts *(we posit the existence of thought configurations which do not depend on the existence of Man for their existence)* and human bodies, and how can a closer collaboration be achieved today?

Subject 5. What is the anatomy and physiology of the sixth sense? What can be done to encourage its development and use? Precisely how is the sixth sense a radio phenomenon? What is communicated? It must be a kind of language which we partly know unconsciously. *Discover this language.*

Subject 6. How does muscle work? Is it possible to make artificial muscles which work by artificially photosynthesised sugar? If so, one may have to use a machine which runs on air, sunlight, water, magnetism.

Subject 7. Since language is a means of travelling through thought-structures, a means of bringing closer collaboration between things *(modifying them, opening up new points of life for them)* and thoughts, languages must be constructed devoid of those words which do not lead to things but only to more words.

From *Signals*, vol. 1, no. 3-4, London, October-November 1964.

WILLIAM BURROUGHS **Takis**

is working with and expressing in his sculpture thought forms of metal – Silent flowers twist in mineral pollenization – And you hear metal think as you watch disquieting free floating forms move and click through invisible turnstiles – Cold blue mineral music of thinking metal – You can hear metal think in the electromagnetic fields of Takis sculpture:

Walked out in your brain – Free floating forms moving flesh – Wind through the cables – Cold mineral music moved the spine hatching blue twilight where time stops drifting in slate houses – Sculpture thought forms leave a wake as you watch the disquieting ventriloquist dummies click through invisible turnstiles the heavy thinking metal – Takis is working with locks and motors – You can hear weather maps arranging The American Dawn Of Terminal Blue Twilight – Time out in flesh memories and wan light – He came to Blue Junction in his sculpture – Thought forms composite being – Think as you watch the disquieting assassins wait skid-row street boys caught in data and thinking metal – Blue heavy silent streets in your brain – You can hear metal caught in the turn for position – Free floating move and click in the long slot – Cold mineral music of The Silent People – Blue twilight where Time in a vast knife fell – High Note tinkling through his sculpture in a heavy blue mist as you watch the disquieting Insect People click through invisible turnstiles the white hot thinking metal – Heavy the judge and many light years away.

This text was prepared by folding the opening paragraph down the middle and passing it through some texts I had written on a planet of heavy blue metal.

From *Signals*, vol. 1, no. 3-4, London, October-November 1964.

We have entered a shock zone. A phenomenon of crowds; but tiny, and infinitely stormy.

Eyes shut, we have interior visions.

Thousands and thousands of effulgent microscopic points, dazzling diamonds, flashes of microbes.

Palaces with countless turrets, which careen through the air under unknown pressure. Arabesques, festoons. Fairgrounds. Extremism in the blinding light which pierces your nerves; extremism in the colours that eat into you, assail you with their brutal, even harmful associations.

A trembling in the images. Coming and going.

An exhilarating perspective.

(When one opens one's eyes, the surrounding objects one sees sometimes seem to swarm on the spot, no longer at a precise and permanent distance. They show a more interesting aspect, as if hazed over with the dew of various dots of colour.)

Interior images more brilliant more numerous more colourful more agitated more lacy more

We have become sensitive to very, very fine (sanguine? cellular? molecular?) variations, to minute fluctuations (in consciousness? in kinaesthesia?), which, in order to better observe, we are perhaps busy visualising simultaneously. But we have lost our footing. We have lost consciousness of footholds, of our members and organs, of the regions of our body, which has ceased to matter, fluid in the midst of fluids. We have lost our home. We have become eccentric, decentered from the self.

At the same time as the universe changed, we too entered a second state; visions and fluidity, inverse and obverse of the same room.

The moorings had to be cast off which bound us to the comfortable initial state where we were, on which we relied; we had to lose those excellent localisation's, which kept infinity outside the ramparts.

In our troubled head, a surprising 'all at once' is perceived.

We are in something like the turbulence of the air and the dust of a closed room, hitherto apparently motionless, but which a beam of sunlight, passing through a hole in a worn shutter, has unmasked in its mad and incessant agitation, going nowhere, and yet which knows no rest, nor has any sense.

Caught up in an infinite turbulence

This turbulence is OUR now.

In the dome of an enlarged interior void, there is an extreme acceleration, a soaring acceleration of passing images, passing ideas, passing desires, passing impulses. We are cut to bits by this passing. Dragged along by this passing, unhappy and weary of this passing. This passing drives us mad. This passing leaves us sometimes giddy and somnolent. Mostly, we are scratched and agitated by this passing.

Passing

Agitated, AGITATED, AGITATED.

Agitated
AGITATED
AGITATED

Time passes in these new passages, a quick time, an avid time, an unusual time, a time in very short moments in Indian file, mad, shooting, hurling along.

We have become sensitive to very, very small units of time. Sensitive to everything minute, to little 'whatever they are', which pass in abundance.

Sensitive because insensitive.

If, having become particularly sensitive, instead of tuning in on the A of the diapason, we have grasped every last one of the four-hundred thirty-five double vibrations, of which it is the condensed beam, it would mean great sensitivity – but we would cease to hear the A. We would have lost it. Thus I feel thousands of minute entities, in which I recognise nothing, except perhaps that the whole is the most usual, most daily, most common thing I encounter – and perhaps the one most mine.

Gone the stream of transitions, of the phrase, meditation, reverie.

No more streams, only isolated drops which together made up streams, discourses, mass, continuity.

Acceleration.

Repetition.

Accentuation. Impression comes to truly conform to its name as imprint, impressed within us, tenacious, adhesive, irremovable, exces-sively 'permanent'.

Accelerating, repetitive, accentuating, thought-interrupting mescaline, overturning every reverie.

Demonstrative of the discontinuous.

Discontinuous feelings.

Discontinuous movements.

Discontinuous élan's.

Discontinuous reflections.

Binary rhythm. Immense scansion.

As if everything were smashed, smashable halfway through.

As if everything were in unison with an alternate current,

of an oscillating bell,

of a short-wave train.

Even the most usually united, the most easy-flowing has to yield to the law of interruption,

and will stop ten times, twenty times, fifty times. [...]

Discontinuity
Clear Ideas
passing
like
comets
Everything
subjected
to the law
of intermittence

Henri Michaux. 'Les effets de la mescaline' (in *L'infini turbulent*)

© Mercure de France 1964 (an abstract of this chapter)

HENRI MICHAUX

[...] Space that is teeming, a space of gestation, of transformation, of multi-plication, whose swarming, even if only an illusion, would give a better idea than our ordinary vision of what the Cosmos is like. A quick, a unique means (though people who are homesick for infinity find it more or less in all drugs) of entering into communication with corporeal infinity.

This stellar interior is so amazing, its motions so accelerated, that it is not recognized as such. Cellular autoscopy, or beyond the cellular where energies are discerned better than particles, and where the images released by an overactive mind are instantly superposed as on a screen.

In this crumblejumble, directed more by the waves than by spherules, there reigns at moments a no less unbearable and infinite rectilinearity.

The symmetry (more mechanical than mental, arranged for the most part without rhyme or reason and wildly repetitive) might well be derived from the waves, the attention following their interminable chain, and jumping to the right and to the left of an imaginary line. Undulation is a model of symmetry, but, since there are a hundred others in the body and in the mind, this explanation may be discarded.

The repetition (also creating symmetries) is far more curious. No question, naturally, of figures being repeated only three of four times. In mescaline there is no repetition under a hundred, and what is more, the last one is only provisional, only until one is conscious of it, then immediately it goes on repeating itself two, three, four hundred times.

Strange multiplication (this entire universe is born by means of spasmodic gestation).

discontinous growth

progressions corresponding probably to quanta

The successive generations of a body, the successive multiplications of a figure (geometric or natural) are accomplished by means of successive discharges, with a complete halt between each one, or after each series, then starting up again almost immediately, and the whole thing at so incredible a speed as to be at times almost instantaneous. Generally each phase is clearly visible, clean cut, startling: speed and increment by quanta of energy.

No matter what happens in this space, you have plenty of time to view the spectacle. With your new time, with your minutes made up of three million instants, you will never be in a hurry, with your attention superdivided you will never be outdistanced. [...]

1956

Henri Michaux. Extract from *Misérable Miracle*. Translated by Louise Varèse. San Francisco: City Light Books, 1963.

OCTAVIO PAZ **Henri Michaux**

Henri Michaux has published three books in recent years dealing with his experience with mescaline.* He has also confronted us with a disturbing series of sketches – most of them in black and white, and a few in colour – executed shortly after each of his experiences. His prose, his poems, and his sketches are intimately related, for each medium of expression reinforces and illuminates the others. The sketches are not simply illustrations of the texts. Michaux's painting has never been a mere adjunct to his poetry: the two are at once autonomous and complementary worlds. In the case of the 'mescaline experience', lines and words form a whole almost impossible to break down into its component elements. Forms, ideas, and sensations intertwine as though they were a single, dizzyingly proliferating entity. In a certain sense the sketches, far from being *illustrations* of the written word, are a sort of *commentary*. The rhythm and the movement of the lines are mindful of a kind of curious musical notation, except that we are confronted not with a method of recording sounds but with vortexes, gashes, interweavings of being. Incisions in the bark of time, halfway between the ideograph and the magical sign, characters and forms 'more palpable than legible', these sketches are a criticism of poetic and pictorial writing, that is to say, a step beyond the sign and the image, something transcending words and lines.

Painting and poetry are languages that Michaux has used to try to express something that is truly inexpressible. A poet first, he began to paint when he realized that this new medium might enable him to say what he had found it impossible to say in his poetry. But is it a question of expression? Perhaps Michaux has never tried to express anything. All his efforts have been directed at reaching that zone, by definition indescribable and incommunicable, in which meanings disappear. A centre at once completely empty and completely full, a total vacuum and a total plenitude. The sign and the signified – the distance between the object and the conscience that contemplates it – melt away in the face of the overwhelming presence, the only thing that really exists. Michaux's œuvre – his poems, his real and imaginary travels, his painting – is an expedition winding its way toward some of our infinities – the most secret, the most fearful, and at times the most derisive ones – in a never-ending search for the other infinite.

Michaux travels via his languages: lines, words, colours, silences, rhythms. And he does not hesitate to break the back of a word, the way a horseman does not hesitate to wind his mount. In order to arrive: where? At that nowhere that is here, there, and everywhere. Language as a vehicle, but also language as a knife and a miner's lamp. Language as cautery and as bandage, language as fog and a siren amid the fog. A pick striking rock and a spark in the blackness. Words once again become tools, prolongations of the hand, of the eye, of thought. A nonartistic language. Slashing, cutting words, reduced to their most immediate and most forthright function: clearing a path. Their utility is paradoxical, however, since they are not employed to foster communication, but rather pressed into the service of the incommunicable. The extraordinary tension of Michaux's language stems from the fact that it is an undoubtedly effective tool, but its sole use is to bare something that is completely ineffective by its very nature: the state of nonknowledge that is beyond knowledge, the thought that no longer thinks because it has been united with itself, total transparency, a motionless whirlwind.

* *Misérable Miracle* (1956); *L'infinie turbulent* (1957); and *Paix dans les brisements* (1959). In *Les lettres nouvelles* (num. 35), there appeared a brief text of Michaux's on hallucinogenic mushrooms: 'La Psicocybine (Expérience autocritique)'. See on this latter subject the book by Roger Heim and Gordon Wasson, *Les champignons hallucinogènes du Mexique* (1958).

Misérable miracle opens with this phrase: "This is an exploration. Through the word, the sign, the sketch. Mescaline is what is explored." When I had read the last page, I asked myself whether the result of the experiment had not been precisely the opposite: the poet Michaux explored by mescaline. An exploration or an encounter? The latter, most probably. A physical encounter with the drug, with the earthquake, with the cataclysm of being, shaken to its very foundations by its inner enemy – an enemy that is one with our own intimate being, an enemy that is indistinguishable and inseparable from ourselves. An encounter with mescaline: an encounter with our own selves, with the known-unknown. The double that wears our own face as its mask. The face that is gradually obliterated and transformed into an immense mocking grimace. The devil. The clown. This thing that I am not. This thing that I am. A martyrisible apparition. And when my own face reappears, there is nobody there. I too have left myself. Space, space, pure vibration. A great gift of the gods, mescaline is a window through which we look out upon endless distances where nothing ever meets our eye but our own gaze. There is no *I*: there is space, vibration, perpetual animation. Battles, terrors, elation, panic, delight: is it Michaux or mescaline? It was all already there in Michaux, in his previous books. Mescaline was a *confirmation*. Mescaline: a testimony. The poet saw his inner space in outer space. The shift from the inside to the outside – an outside that is interiority itself, the heart of reality. A horrible, ineffable spectacle. Michaux can say: I left my life behind to catch a glimpse of life.
It all begins with a vibration. An imperceptible movement that accelerates minute by minute. Wind, a long screeching whistle, a lashing hurricane, a torrent of faces, forms, lines. Everything falling, rushing forward, ascending, disappearing, reappearing. A dizzying evaporation and condensation. Bubbles, more bubbles, pebbles, little stones. Rocky cliffs of gas. Lines that cross, rivers meeting, endless bifurcations, meanders, deltas, deserts that walk, deserts that fly. Disintegrations, agglutinations, fragmentations, reconstitutions. Shattered words, the copulation of syllables, the fornication of meanings. Destruction of language. Mescaline reigns through silence – and it screams, screams without a mouth, and we fall into its silence! A return to vibrations, a plunge into undulations. Repetitions: mescaline is an 'infinity-machine'. Heterogeneity, a continuous eruption of fragments, particles, pieces. Furious series. Nothing is fixed. Avalanches, the kingdom of uncountable numbers, accursed proliferation. Gangrenous space, cancerous time. Is there no center? Battered by the gale of mescaline, sucked up by the abstract whirlwind, the modern Westerner finds absolutely nothing to hold on to. He has forgotten the names, God is no longer called God. The Aztec or the Tarahumara had only to pronounce the name, and immediately the presence would descend, in all its infinite manifestations. Unity and plurality for the ancients. For us who lack gods: Pullulation and Time. We have lost the names. All we have left is 'causes and effects, antecedents and consequences'. Space teeming with trivialities. Heterogeneity is repetition, an amorphous mass. Misérable miracle. Michaux's first encounter with mescaline ends with the discovery of an 'infinity-machine'.
The endless production of colours, rhythms, and forms turns out in the end to be an awesome, absurd flood of cheap trinkets. We are millionaires with vast hoards of fairground junk. The second series of experiments *(L'infini turbulent)* provoked unexpected reactions and visions. Subject to continuous physiological discharges and a pitiless psychic tension. Being split apart. The exploration of mescaline, like a great fire or an earthquake, was devastating; all that remained intact was the essential, that which, being infinitely weak, is infinitely strong. What name can we give this faculty? Is it in fact a faculty, a power, or is it an absence of power, the total helplessness of man? I am inclined to believe it is the latter. This helplessness is our strength. At the last moment, when there is nothing left in us – when self is lost, when identity is lost – a fusion takes place, a fusion with

something alien to us that nonetheless is ours, the only thing that is truly ours. The empty pit, the hole that we are fills to overflowing, and becomes a wellspring once again. When the drought is most severe, water gushes forth. Perhaps there is a point where the being of man and the being of the universe meet. Apart from this, nothing positive: a hole, an abyss, a turbulent infinite. A forsaken-ness, alienation, but not insanity. Madmen are imprisoned within their madness, which is an ontological error, so to speak: taking the part for the whole. Equidistant from sanity and insanity, the vision Michaux describes is total: contemplation of the demoniacal and the divine – there is no way around these words – as an indivisible reality, as the ultimate reality. Of man or of the universe? I do not know. Perhaps of the man-universe. Man penetrated, conquered by the universe.

The demoniacal stage of the experiment was above all the revelation of a transhuman eroticism – and therefore infinitely perverted. A psychic rape, an insidious opening and extending and exhibiting of the most secret parts of being. Not at all sexual. An infinitely sensual universe, from which the human body and the human face had disappeared. Not the 'triumph of matter' or that of the flesh, but the vision of the reverse side of the spirit. An abstract lasciviousness: 'Dissolution – an apt word that I understood instantly. Delight in deliquescence.' Temptation, in the literal sense of the word, as all the mystics (Christian, Buddhist, Arab) have reported. I nonetheless confess that I do not under-stand this passage at all. Perhaps the cause of Michaux's sense of repulsion was not so much the contact with Eros as the vision of the confusion of the cosmos, that is to say, the revelation of pure chaos. The visible entrails, the reverse side of presence, chaos is the primordial stuff, the original disorder, and also the universal womb. I felt a similar sensation, though a much less intense one, in the great summer of India, during my first visit in 1952. Once I had fallen into that panting maw, the universe seemed to me to be an immense, multiple fornication. I suddenly had a glimpse of the meaning of the architecture of Konarak and erotic asceticism. The vision of chaos is a sort of ritual bath, a regeneration through immersion in the original fountain, a return to the 'life before'. Primitive tribes, the early Greeks, the Chinese, Taoists, and other peoples have had no fear of this awesome contact. The Western attitude is unwholesome. It is moral. Morality, the great isolator, the great separator, divides man in half. To return to the unity of the vision is to reconcile body, soul, and the world. At the end of the experiment, Michaux recalls a fragment of a Tantric poem:

Inaccessible to impregnations,
Enjoying all joys,
Touching everything like the wind,
Everything penetrating it like ether,
The ever-pure yogi
Bathes in the ever-flowing river.
He enjoys all joys and nothing defiles him.

The divine vision – inseparable from the demoniacal vision, since both are revelations of *unity* – began with 'the appearance of the gods'. Thousands, hundreds of thousands, one after the other, in an endless file, an infinity of august countenances, a horizon of beneficent presences. Amazement and gratitude. But before that: surges of whiteness. Whiteness everywhere, sonorous, resplendent. And light, seas of light. Afterwards, the divine images disappeared though the tranquil, delightful

cascade of being did not cease. Admiration: "I cling to the divine perfection of the continuation of Being through time, a continuation that is so beautiful – so beautiful that I lose consciousness – so beautiful that, as the Mahabharata says, the gods themselves grow jealous and come to admire it." Trust, faith (in what? simply faith), the sensation of being carried along by perfection that flows ceaselessly (and yet does not flow), ever identical with itself. An instant is born, ascends, opens out, disappears, just as another instant is born and ascends. One felicity after another. An inexpressible feeling of abandon and security. The vision of the gods is followed by nonvision: we are at the very heart of time. This journey is a return: a letting go, an unlearning, a travelling homeward to birth. On reading these pages of Michaux, I remembered a pre-Columbian object that the painter Paalen showed me some years ago: a block of quartz with the image of the old and wrinkled god Tlaloc engraved on it. He went over to a window and held it up to the light:

Touched by light
The quartz is suddenly a cascade.
The infant god floats on the waters.

Nonvision: outside of actuality, history, purposes, calculations, hate, love, 'beyond resolution and want of resolution, *beyond preferences*', the poet journeys back to a perpetual birth and listens to 'the endless poem, without rhymes, without music, without words, that the Universe ceaselessly recites'. The experience is participation in an infinite that is measure and rhythm. The words *water, music, light, great open space*, echoing and re-echoing, inevitably come to our lips. The self disappears, but no other self appears to occupy the empty space it has left. No god but rather the divine. No faith but rather the primordial feeling that sustains all faith, all hope. No face but rather faceless being, the being that is all faces. Peace in the crater of the volcano, the reconciliation of man – what remains of man – with total presence.
On embarking on his experiment Michaux wrote: 'I propose to explore the mediocre human condition.' The second part of this sentence – a sentence which applies, I might add, to Michaux's entire Îuvre and to that of any great artist – turned out to be strikingly false. The exploration showed that man is not a mediocre creature. A part of oneself – a part walled in, obscured from the very beginning of the beginning — is open to the infinite. The so-called human condition is a point of intersection with other forces. Perhaps our condition is not merely human.

Octavio Paz. *Alternating Current*. New York: Viking Press, 1973.

Dialogue: JESÚS RAFAEL SOTO & GUY BRETT

J. R. S.: [...]By means of the endless repetition of the square, the square itself disappears and produces pure movement. Before I began to use superimposition in 1952, I was touched by the idea of serialism in music. I worked with small dots of familiar colours, again the least descriptive, so that one's attention is directed on the relationships between them. I organised the intervals precisely. Separating colours, calculating the distance between them, produces a vibration – as in the work of the Impressionists, Seurat, the Fauvés. The problems of abstract painting, you see, are problems of pure dynamism; the simplified-organic shapes of an artist like Arp belong essentially to figuration. For two years I worked on the idea of superimposition, using sheets of plexiglass. It was in the last of these, using three planes and the form of the spiral, that the movement was free-est, most realised. The whole process had been one of trying gradually to *detach* the elements. After I'd worked with plexiglass for a little while I got tired of it, and there followed a rather baroque period. I became more interested in the *material* of the work.

G. B.: Yes, the informality of these paintings is surprising after the strict, step-by-step progress of the early works. It is as if you suddenly became conscious of what your actual contemporaries were doing. *L'art informel* was at its height in Paris then, wasn't it?

J. R. S.: Yes, it's true; I wanted to test the relationships between my researches and the researches of painters around me, to be associated with them. It was certainly an experience. At that time I also made very free and complex 'sculptures' from wire. Wanting to liberate the elements still further, I began looking for a way to combine illusionary optical movement with *real* movement.

G. B.: And this, of course, brings us to your recent work. I think that here the superimposition ceases completely to look like a device; it becomes sensually inseparable from the visible change that appears to take place in the elements.

J. R. S.: Yes, what has always interested me has been the *transformation* of elements, the *dematerialisation* of solid matter. To some extent this has always interested artists, but I wanted to incorporate the *process of transformation* in the work itself. Thus, as you watch, the pure line is transformed by optical illusion into the pure *vibration*, the *material* into *energy*. Of course it all depends on the elements one uses and the way one uses them, but the transformations can always be different, and really I leave it alone to behave as it likes. But I do use elements which seem to be the purest and most unadorned, because I want this transformation to take place in perfect *equilibrium*.

G. B.: It's interesting that you should use the word 'equilibrium', for the quality of the movement in your works has always struck me as being confident, lucid, ordered – like the waves of the sea rising and falling evenly. Do you see it like that?

J. R. S.: Not exactly. In my case, at bottom, it's a *repetition*. I no longer see waves but the pure repetition behind the waves – blue, grey, green. But what happens when you see the work is that you discover Nature in it. One invents nothing in the plastic arts; all one does is *demonstrate* the existence of things. The artist discovers possibilities. But although it's a question of discovering, of demonstrating, it's also a question of doing it at the right moment. It's no good setting out with the intention of inventing something, some 'new reality'. One is placed at a certain point in an historical evolution. I am very conscious of this 'historical process' in which I am placed, and my ambition is to develop this process from the stage at which I found it. [...]

G. B.: I think people still find it difficult to believe that abstract art has its basis in life, that it is as much a personal necessity as any other form. A lot of people seem to think it's a sort of set of rules you can distribute like a book. For this reason, most optical painting seems to me to have a great deal of surface drama, but no real density.

J. R. S.: Yes. ... For the bad optical artists it is a system, artificial and stylised, which they just take up one day and exploit. Maybe tomorrow they will be exploiting something else. Stylisation is the great enemy of creation – it's a sign that the traveller has turned his back on the unknown and settled down. For me, optical painting is not a system, but a record of day-to-day plastic discoveries, and a means of expressing what I feel – nothing more complicated than that. As you say, it is also a need.

G. B.: I'd like just to come back to what you said earlier about your first desire being to make the works of Mondrian move. It reminds me of a story about a visit Calder made to Mondrian's studio when he first came to Paris – a decisive visit, which gave him what he called 'the necessary shock'. He found Mondrian's studio like a spatial version of one of his mobiles, with rectangles of primary colour carefully placed on the white walls. Calder suggested to Mondrian that all these coloured elements might be made to *move*

J. R. S. (laughing): I didn't know that; it's very gratifying, because it corresponds to my own work. I wanted to do the same sort of thing. Of course Calder never did anything of that kind because he is a sculptor, interested in objects moving in space, which I am not as I explained earlier. My works keep their distance – the vibration is not felt as something tangible, as something that involves the body; it's purely optical, without physical substance. The elements I use, I use solely to realise an abstract world of pure relations, which has a different existence from the world of things. My aim is to free the material until it becomes as free as music – although here I mean music not in the sense of melody, but in the sense of pure relations. For me, the first artist who began to see things in this way was Turner. Turner made a conscious move away from figuration. You can say that there was already a feeling for abstract relations among primitive peoples, but for them a naturalistic art was not technically feasible. For Turner it was, but he rejected it. I see him as altogether more remarkable than the Impressionists and post-Impressionists, who were still attached to figuration. In fact after Turner one can move directly to pure abstraction, to Kandinsky for example.

G. B.: Yes, I think that modern art's gradual discovery of the *spiritual* power of relationships, which have no material existence but are something generated by the interaction of elements, corresponds exactly with modern science's discovery of the *physical* power of relationships between material elements. Both art and science have been able to reveal these new forces, which simply take no notice of the old barriers that man used to erect between one part of his world and another.

J. R. S.: Yes. I use anonymous elements to emphasise the purity and sufficiency of the rhythm that may be revealed between them. In representational painting the surrealists approached the same problem in a different way. You remember that old passage from Lautréamont the surrealists liked so much – about the sewing-machine and umbrella meeting upon an operating-table. Separately these things are nothing, but together something very strange happens. This is the sense in which I understand the 'immaterial' – a whole world of new meaning and possibility revealed by the combination of simple, neutral elements. Coming from the material, it has immaterial existence, freedom, purity and precision.

Paris, rue de Turenne, April 1965

From *Signals*, vol. 1, no. 10, London, November-December 1965.

JESÚS RAFAEL SOTO

'My works are classical, without confusion or mystification. I work with very simple elements.
These elements in themselves are unimportant. A piece of wire, a few lines – what are they?
What are important are the relationships *(les relations)* which they bring into being.
A piece of wire against a moiré background becomes broken up. Its form is 'dematerialized'.
It undergoes a transformation, a metamorphosis. You cannot say which is wire and which is ground.
I hang yellow rods in front of the same background, and black spots appear on the yellow. Where has the colour come from?
This has to do with reality, with perception. We are forced to question our perceptions, which seem so reliable. When Duchamp set a two-dimensional disc spinning and it looked solid, he was doing the same thing. He made us question our perceptions.
The Impressionists, Cézanne, the Cubists and Mondrian broke up form into light and colour.
They liberated these elements.
I am not interested in connections *(les rapports)* between things, but only in their relationships *(relations)*. I am not interested in the connection of one colour with another or one line with another.
Relationships are more than connections.
There need be no logical connection between the elements in my work. Two themes in a Bach fugue have no logical connection. The work is essentially a relationship. Not between two elements in the picture but between the principle which governs the picture – for example, the dematerialization – and a general law of the universe which conditions everything. You may call these relationships chance relationships: they cannot be foreseen. They happen by chance, by the laws of chance. It may seem strange to talk of laws of chance, but chance occurrences do not come about independently of laws. It is just that the laws are very hard to discover. That is why we call them laws of chance. It is my aim to discover these laws.'

'Statements by Kinetic Artists', *Studio International*, London, February 1967.

GROUPE DE RECHERCHE D'ART VISUEL
Transforming the current situation of plastic art

The Groupe de Recherche d'Art Visuel invites you to demystify the artistic phenomenon, to pool your activities so as to clarify the situation, and to set up new ground rules for appraisal. The Groupe de Recherche d'Art Visuel is made up of painters who are committing their activities to ongoing research and the visual production of primary basic data aimed at freeing plastic art from tradition.
The Groupe de Recherche d'Art Visuel thinks it is helpful to offer its viewpoint, even though this viewpoint is not definitive and calls for subsequent analysis and other comparisons.

General Propositions of the 'Group for Research in the Visual Arts' (1961)
Relationship of the artist with society
This relationship is presently based upon:
The unique and isolated artist
The cult of the personality
The myth of creation
The overestimation of aesthetic and anti-aesthetic conceptions
Elaboration for the elite
The production of unique works of art
The dependence of art on the marketplace

Propositions to transform this relationship:
To strip the conception and the realization of works of art of all mystification and to reduce them to simple human activity
To seek new means of public contact with the works produced
To eliminate the category 'Work of Art' and its myths
To develop new appreciations
To create reproducible works
To seek new categories of realization beyond painting and sculpture
To liberate the public from the inhibitions and warping of appreciation produced by traditional aestheticism, by creating a new social-artistic situation

Relationship of the work to the eye
This relationship is presently based upon:
The eye considered as an intermediary
Extra-visual attractions (subjective or rational)
The dependence of the eye on a cultural and aesthetic level

Propositions to transform this relationship:
To totally eliminate the intrinsic values of the stable and recognizable form be it:
Form idealizing nature (classic art)
Form representing nature (naturalistic art)
Form synthesizing nature (cubist art)
Geometrizing form (constructivist art)

Rationalized form (concrete art)

Free form (informal art, tachism, etc.)

To eliminate the arbitrary relationships between forms (relationships of dimension, placement, colour, meanings, depths, etc.)

To displace the habitual function of the eye (taking cognizance through form and its relationships) toward a new visual situation based on peripheral vision and instability

To create an appreciation-time based on the relation of the eye and the work transforming the usual quality of time

Traditional plastic values

These values are presently based on the work which is:

unique

stable

definitive

subjective

obedient to aesthetic or anti-aesthetic laws

Propositions to transform these values:

To limit the work to a strictly visual situation

To establish a more precise relationship between the work and the human eye

Anonymity and homogeneity of form and relationships between forms

To stress visual instability and perception time

To search for a nondefinitive work which at the same time is exact, precise, and desired

To direct interest toward new variable visual situations based on constant results of the eye-art rapport

To state the existence of indeterminate phenomena in the structure and visual reality of the work, and from there to conceive of new possibilities which will open up a new field of investigation

1961

Translated from French by Davida Fineman.

Jack Burnham. *Beyond Modern Sculpture*. London: Allen Lane the Penguin Press, 1968.

UMBERTO ECO **Programmed Art**

Contemporary art is generally recognized by two categories of artists: on the one hand those who devote themselves to the search for new forms, faithful to an almost Pythagorean ideal of mathematical harmony. They, in order to achieve poetry, pass through geometry, Euclidean or not. On the other hand those who have realized the richness of chance and disorder, certainly not unaware of the re-evaluation – made by scientific disciplines – of random processes. They have accepted every suggestion which comes freely from the material, squirting tubes of colour onto clean canvases, cutting, beating, piercing and burning cloth, wood and metals, mounting and hanging fragments of actual objects, which have been broken and re-embodied.

In both cases an attempt was made to refuse the idea that society achieved about 'beautiful forms', in order to propose other ways of creating new possibilities of giving form to reality; on the one hand, discovering the poetic possibilities of geometric forms; on the other, discovering the formal possibilities of the informal, thus trying to give a form, a new form to what was generally considered to be 'disorder'.

Thus, while following such different paths, the two streams of artists really pursued the same aim to enlarge the patterns of perception and enjoyment. Naturally, in relation to social situation, their position was different: the 'mystics' upholding self-contained and measured form actually integrated the forms of their invention within an industrial society which was accepted without reservation; while the anarchists who wanted to disintegrate form really protested against an established order which they could not accept. But does such a dichotomy hold? or perhaps, the first category – passing from the abstract painting to the most concrete form of the fork or the beater – integrated the art of their time within a social context, and introduced new relationships between form and function in a democratic way; and the second category, withdrawn and disdainful, produced in the last analysis the type of artists yearned for by the society which they were apparently protesting against?

These are problems which, aside from individual challenges, should be left to a historical judgement. But it is indeed true that both sides seek the liberation of man from acquired formal habits.

And consequently, the breakdown of perceptual schema. If perceptual habits encouraged one to appreciate a form as something fixed, then it was necessary to invent forms which never allowed one's attention to rest, forms always appearing different from themselves. Thus, while the informals were elaborating a way of obtaining 'motion' of a two-dimensional plane of canvas, embodying a dialectic of signs capable of leading the eye to an ever renewed inspection, the inventors of mathematical forms were trying to find ways of three-dimensional 'motion', constructing non-moving structures which, seen from a certain perspective, looked like moving or 'kinetic' structures.

In this way, while the former constructed works which were 'open' in the sense that they displaced constellations of elements in many relationships, the latter were creating works which were not only 'open' but directly 'in motion'.

But an object that moves, moves either according to certain fixed schemes determined by a motor (and then is reduced to a mechanical pretext which quickly exhausts its possibilities of improvisation) or moves due to natural forces, unpredictable by themselves, or vaguely predictable in relation to the dynamic possibilities of the object, as a structure determined by physical laws. And here once again the old dichotomy: either mathematical rule, or chance.

But is it really true that mathematical rule excludes chance? In effect, there are in nature phenomena which happen by chance whose behaviour is predictable on the basis of statistical rules, which, as a matter of fact, measure with a sufficient margin of security the disposition of random events. Hence, in the vicissitudes of chance one can a posteriori distinguish a kind of programme, such as those which exist for winning at roulette. Would it not be possible, therefore, to delineate, with the linear purity of a mathematical programme, 'fields of events' where random processes can happen? Thus we would have a singular dialectic between chance and programme, between mathematics and accident, between planned conceptions and free acceptance of what will occur, anyway might occur, given that basically it will occur directly following precise, predisposed formative patterns, which do not negate spontaneity, but rather enlarge its boundaries and possible directions.

Thus we can speak of 'programmed' art, and admire the kinetic sculptures that a man of a coming future will install in his house, in place of the old prints or the modern masterpieces reproduced. And if someone should observe that this is not painting, nor even sculpture, it should be of no concern. One could start a contest to find a new name, but let us not be frightened by a question of names.

Then there is one final problem: it is not painting, it is not sculpture, but at least is it art? Mind you, one does not ask that it be 'fine art', but only if an operation of that kind re-enters somehow into the world of art. It is always very dangerous to establish a definition of art and then see afterwards what belongs and what does not. The cautious person makes an historical and sociological analysis of what a certain civilization or epoch considers as art, and then proceeds to make a definition, which includes whatever phenomenon is discovered. Nevertheless, for the moment one could say 'within the limits of the 20th century a formative practice was affirmed which gave first place to mobile objects, according to a dialectic of planning and causality [check original Italian for whether this should be causality or casuality: original translation has casuality, but sense suggests causality, and the word casuality does not feature in current English dictionaries], which the public, or a part of the public 'consumed' as art, employing these objects as a concrete stimulus for considerations of a formal nature, for imaginative satisfaction, and – often – for epistemological reflections'. One ought to add that within the limits of this civilization aesthetic pleasure was no longer – or at least not always – derived from the vision of complete and completed objects, but rather from the image of organisms in the process of indefinite completion; and the quality of a work did not consist in being an expression of a law whose basis remained immutable and intangible, but in a kind of 'propositional function' according to which it continually attempted the adventure of mutability, following determinate lines of orientation.

The future critic who will elaborate such a definition – and on the basis of which will proceed to redimensionalize the notion of form and of art used in his time – will not be at all surprised at this. He will find it proper that the men of the 20th century derived pleasure from the sight, not of one form but of many forms co-present and simultaneous, and that this fact did not at all signify to a new dynamics of perception which the new technological and social conditions allowed.

This critic will remember with a smile how common were the quarrels in the homes of that epoch, between the mother and her son, the former insisting that she did not understand how it could be possible to read and listen to the radio at the same time, and the latter finding this completely natural, because by now he was educated to a kind of perceptual gymnastics which allowed him to understand

and appreciate side by side two 'Gestalt', aptly balancing his attention (but the mother, since the beginning a stranger to this education, continued to suspect him of trickery).

He will remember, our critic, how the men of former centuries were always so anxious to 'look where you put your feet', afraid to stumble, concentrating their attention on what was in front of them, except when clinging to the mechanisms of habit – otherwise they would fall into the puddles, like Thales intent on the stars. He will remember how the 20th century driver, instead, had learned to give his attention to two orders of form in motion, that of the ribbon of road in front of him, and that behind him, reflected in the rear-view mirror; and that, when there was another mirror on the left of the car, the driver was capable of perceiving the road behind him following a second perspective axis, thus co-ordinating three perspective forces, and at the same time enjoying the view, and the hum of the motor responding to the pressure he applied to the accelerator, even following a mathematical calculation with an eye continually on the speedometer, without ever losing view completely of the other orders of form in motion.

Will this descendant of ours lament the loss of that capacity that former men had to concentrate on a single object and to enjoy it down to its most minute fibres, with an eye both affectionate and exclusive? This is a possibility that cannot be denied. What the critic should realize is that art in the 20th century was attempting to propose to man the vision of more forms simultaneously and in continuous becoming, because this was the condition to which he was submitted, to which even more he submitted his sensibility.

How many dawns and dusks did Titov and Glenn see in a trip of a few hours? It is not true that forms approved by tradition are the best because they reflect the stability of natural cycles. The stability of the solar system is valid as a point of reference for a man who is at a standstill on the planet while the planet moves. But what of a man who moves like the planet in the opposite direction, at a faster speed? All his modes of thinking, of perceiving, of reflexive functioning would change. And it would be much better if the geometrists of form, the planners of iron dust, the architects of re-embodied spheres, the lyricists of little electric toys that move coloured ribbons, net surfaces, lights, plate glass, tassels and cylinders, had accustomed him to consider that forms are not something immobile that wait to be seen, but also something 'becoming' while we watch them.

Is this to say perhaps that these are didactic constructions for astronauts or sons of astronauts? Columbus disembarked in America with something like ten galley slaves and the ways of thinking for the Western man was changed. For all, even for those who would never abandon their villages.

But even before the world really got larger, the artists had already tried the ways of 'dolce prospettiva'. We don't really know it is so, but it has always been art which has first modified our mode of thinking, of seeing, of feeling, even long before, sometimes 100 years before, one could understand why.

Arte programmata: arte cinetica, opere multiplicate, opera aperta. Milan: exhibition galleries of Olivetti, 1962. [Programmed art: kinetic art, multiple works, open works]

GIANNI COLOMBO **The Elastic Space**

An accessible cubic container, divided within into volumes of space virtually circumscribed by stretched lines of elastic material treated with fluorescent paint and lit by ultraviolet bulbs: inside this structure, driven by four electric motors, occur rhythmical horizontal and vertical tensions, which constantly deform it in an irregular manner, following progressive combinations. The volumes of space also have cubic form and are equal to each other, so they belong coherently with the shape of the environment which contains them; the visitor can pass from one space into another and can observe from inside each the adjacent spaces. In this attempt to bring the integration of methods of visual communication to ever-new aesthetic effects, the dimension of the 'space-environment' represents the place where the interests of our types of plasticity converge. In this sense, 'environment' can be defined as a plastic realisation, which comes to fruition in a state of habitability.

The environment devised for this exhibit aims to demonstrate the state of habitability in a space conditioned by kinetic action. I have chosen an accessible cubic container as the display ground because it represents one of the habitable forms most familiar to us, in which take place permutations of forms and dimensions: the most unusual habitable conditions for us.

The visitor will find himself inside a geometrically organised space which is subjected to continuous dimensional osmosis, in which different kinetic events, overlapping, interweaving and expanding in all directions, tend to eliminate a centre of attention determined by observation, and to suggest a rhythmic, multi-visual situation.

This experiment propses to embody a visual object which, free from interpretations analogous with pre-existing reality and from choices derived from the subjective world of the creator, is presented as a primarily optical visual communication (a visual communication based on signs to be interpreted without passing through a semantic phase). More precisely, it is a programmed cine-visual construction in which the programming aims to be completely legible to the spectator in terms of the combinability of elements which are themselves limitedly differentiated. In other words, it could also be defined as an experimental construction through which to discern reliefs of the optical and psychological behaviour of its creator, who brings about the variables according to his own physical and psychological reactions, which will in part auto-determine the image he himself perceives, open to associations of possible spatial-dynamic relationships.

Projects, 1964–1967, catalogue of the exhibition at the Galleria L'Attico, Rome, and Galleria Schwartz, Milan, 1968.
Reprinted in *Gianni Colombo*. Tokyo: Sogetsu Art Museum, 1999 (exhibition catalogue).

LUCIO FONTANA

Painting and sculpture no longer respond to the sensibility of today's man.

Contemporary sensibility continually conforms to the demands created by the manifestations of a civilization which renews itself.

Science, the notions of the rapid and of the changeable, demand of man a more intense way of perceiving the flux of time.

This new mode of perceiving reality no longer finds painting and sculpture the most appropriate ways to express itself most concretely and directly.

We must, out of the necessity of total communication, arrive at an art based on the unity of time and space.

In the light of these premises, the works of the members of Group T can be seen as the result of research aiming to use time, along with space, as a plastic medium. This is the feature common to the canvases of fluid possibility of Giovanni Anceschi, to the magnetic surfaces of Davide Boriani, to the pulsating surfaces of Gianni Colombo, to the vibrating surfaces of Gabriele Devecchi, and to the variable linear constructions of Grazia Varisco.

These works, which are outside the usual classifications and which are realised with materials and by methods offered by the discoveries of our actual present civilization, propose an art which in its variety is continually immersed in the present, an art which refutes the self-proclaimed and outworn absoluteness of the image as embodiment of relativity; which abandons evocation by the concrete; which destroys form and rediscovers it in organic movement. The machine is recognised as a means capable of producing sequences of images, and exclusively as a means; it is used as a positive necessity of enquiry and communication, not to exalt it naively, nor to make it an object of negative irony. The artists of Group T do not want to stop at the edge of a world which it is necessary to confront and recognise as valid.

Introduction to the exhibition *Miriorama 10* by Gruppo T, Galleria La Salita, Rome 1961.

POL BURY **Time Dilated**

Between the immobile and mobility, a certain quality of slowness reveals to us a field of 'actions' in which the eye is no longer able to trace an object's journeys.

Given a globe travelling from A to B, the memory we shall retain of its point of departure will be a function of the slowness with which it achieves its journey. Our eye, our memory have lost the memory of A. Only the quality of slowness allows it to obliterate its own tracks, to be an eraser of memory, to make us forget its past.

The journey from A to B, perceived in terms of speed, is less a voyage than a confusion which can become so great that A and B approach close enough to each other to become indistinguishable. But perceived in terms of slowness A is no longer necessarily the point of departure towards B. One no longer knows whether the globe is going from A to B, or whether A is the point of arrival, or even whether the globe, in its periplus, has any connection any longer with any putative A or B whatsoever. Thus, we can see that slowness not only multiplies duration but also permits the eye following the globe to escape from its own observer's imagination and let itself be led by the imagination of the travelling globe itself. The imagined voyage becomes imaginative.

Journeys avoid 'programmization' in the degree that they are endowed with a quality of slowness; they finally achieve a real or fictional liberty, a liberty acting on its own account and for its own pleasure. Speed limits space, slowness multiplies it. The liberty thus manifested can also be observed in the contrary force which the globe opposes to its own displacement: an opposition whose intention is to keep reminding us of the constant battle it is required to wage against the forces of weightiness.

At this point we enter the realm of the dynamics of slowness. Travelling rapidly from A to B, the globe tends to make us forget momentarily the facts of weight and gravity, to forget even its own volume, but a slow motion re-establishes it for us in its struggle of opposition, as it finds in itself the strength necessary to conquer its own weight. The globe's volume then assumes its full significance; it is real, it registers the limits of its possibilities, of its ambitions, it is a volume which has made its choice. In slowness, the globe's density discovers its full potentialities.

Let us add a little complexity to the preceding data. If we add to the area of activities of our first globe a second globe of a different volume, animated by a different degree of slowness, then our first findings are multiplied by the second series of findings; yet other findings ensue as a result of this multiplication.

Two slownesses gently grazing each other even go so far as to rub against each other. We dare henceforward speak of such activity no longer in terms of geometry, but almost in the language of the boudoir.

In such an atmosphere, caresses are born, are renewed, multiply. Only linked slownesses have the capacity to create, keep alive and re-create these foreseen and unforeseen contacts, these tentatively gentle strokings.

The hand, the breast, other volumes proceeding from A to B, from C to D? No voyage is so indecisive, so precise. But a slowness plus a slowness do not equal a quickness: on the contrary, they become intensified, they transmit to each other their acquired slowness, adding to each other in order to measure themselves, in terms of mechanics, by a subtraction.

Two globes on the scale of slowness: it is air, fire, earth and water which bear the weight of their measure.

Le Mouvement/Movement. Paris; New York; Düsseldorf: Galerie Denise René, 1955.

EUGENE IONESCO **Pol Bury**

All around us, people who forget everything are telling us that the universe is just like that, that it is like it is, like it was made, like it was made once and for all, that it is stable, that we are secure. They also say that people are all friends, that people smile at you, that people are polite, that conventions are well respected, and are set once and for all. Even artists, even poets will tell you: there is the sky above us, here is the earth, here the moon, here the sea, here the hills, here the forests, here the cities, here the society. Sure there have been earthquakes, but now that's all over with, be reassured, for here is the perfect order, and here are its pillars, we're leaning up against them, they're solid as rock, they'll be standing for all eternity... But then along comes Pol Bury and awakens us, demystifies our tranquillity and shows us that is just not how it is. Society is not established, the columns on which the sky is founded, on which the universe is founded, on which certitude is founded, are not solidly shored up at all, and the earth itself is giving way. It is a world of threat. Or rather, the world itself is danger and threat. At any moment, everything can change.

Look carefully at how it stirs, how it sags, listen how it creaks, how it groans, how it moans. Listen carefully. Look carefully how it moves – not a lot, ever so slightly; it scarcely moves at all and then stops, then moves again. In Giacometti's work, the world has been stripped of its flesh, its substance; existence is marked by the sign of precariousness. Creation is evanescence, mere smoke ready to disappear into nothingness at any moment. In Brancusi's work, particular forms cancel one another out to make way for form, for the tangible – though real – figure of the idea, more real than reality. With Giacometti, on the other hand, the very idea of the real is negated to the same extent that reality is manifested. In the work of all other painters and sculptors, there are colours – these colours here, those forms there, this reality here – as if given once and for all, as if permanent or eternal. In Giacometti's work, it is a case of fear tinged with stupefaction and astonishment that what is still is. In Brancusi's work, abolished realities yielded to the Idea – to God.

For Pol Bury, there is an immediate anguish stemming from the fundamental intuition that anything might jump out at you at any moment; that one is never sure of anything. When you enter a forest, the trees may grab you in their leafy arms and squeeze the breath out of you; not only can the stones of the mountains bury you at any moment, but the sky and the earth and the ocean roar as if the whole world were a threatening beast, as if this threatening beast were itself threatened by other threatening beasts; as if the bank tellers, who answer you and smile politely, were capable at any moment, instead of cashing your check, of turning into sharks, crocodiles, enormous viper heads – as if the check itself were in fact only a viper's tongue or a flame in hiding.

At any moment, anything can happen behind apparent reality. The world can split into two pieces, three pieces, four pieces, and the stars explode. But, for the time being, there is only the murmuring of danger, making ready for catastrophe.

If therefore, in Giacometti's work, the world was in the throws of very slowly going up in transparent smoke; and if Brancusi had discovered the foundations – some of the foundations – of the universe, lying beyond the pulverised forms, beyond the particular forms, for Pol Bury, the immediate world exists, the world of immediate data possesses an oppressive, heavy reality. And if indeed it does possess reality, if it is self evident, it is the danger itself which provides this evidence and this reality. For the time being, everything is still holding, the collapse is forestalled, but only for the time being, for the time being...

Pol Bury. New York: Lefèbre Gallery, 1966.

OTTO PIENE

What is a painting?
A painting is a field of forces, the arena where its author's impulses all come together, there to be transformed, re-formed into a movement of colour. Energies which the painter has received out of the fullness of the Universe are now directed into channels opened to the spirit of the onlooker.

What is colour?
Colour is the articulation of light. And what is Light? Light is the sphere of everything that lives, the element in which the trialogue of painter, painting and spectator must take place; it is caught and intensified into a continuous vibration which contains all three.

What is vibration?
Vibration is the activity of the nuance, which outlaws contrast, shames tragedy and dismisses drama. It is the vehicle of the frequencies, the life-blood of colour and the pulse of light. Vibration is pure emotion and pure energy, that which gives the picture its radiance.

What is pure energy?
The undisturbed continuum, never-ending, unquenchable, the stuff of life.

What are they all, painting, colour, light, vibration and pure energy?
Life. And the free spirit.

1959

Reprinted in *Zero aus Deutschland 1957 bis 1966. Und heute*. Ostfildern-Ruit: Hatje Cantz Verlag, 2000 (exhibition catalogue).

GERHARD VON GRAEVENITZ Statement

my kinetic objects are visual objects.

the elements are simple.

the organization is not hierarchic (no composition).

the movement is not linear (no beginning, no end).

the objects are structures: networks of connections of elements or simple processes.

because the organization is open – as it has been developed in the theory of games – there is playfulness involved.

the relation of my objects to reality is not that of copies, but rather of models, i.e., I try to make the objects so simple, so logical that they take on the character of models.

my round objects with discs work according to a relatively simple principle. The discs are fixed at a point on the periphery, on axes which turn at random, sometimes clockwise, sometimes counter-clockwise, and are moved by an electric motor.

as all discs move, the network changes continuously and therefore the path of each disc seems to be relatively complex, while the movement of the total circle cannot be seen.

The number of the possible situations is so great that a repetition is very improbable.

Munich, December 1965

Peter Selz. *Directories in Kinetic Sculpture*. Berkeley: University Art Museum, University of California Press, 1966.

GERHARD VON GRAEVENITZ Statement

my kinetic objects developed out of white reliefs, divided into convex and/or concave hemispheres.

in this [project] I was primarily interested in the method of arrangement. from the initial hierarchical order (progress, course) there developed strictly non-hierarchical homogeneous structures (based on the principle of chance). correspondingly my interest turned more and more to instability and change caused by the effects of light. the white reliefs react to external conditions, because neither colour nor other factors distracts from them. the kinetic objects cause the changes themselves, and here the restriction to white has the function of laying the strongest possible emphasis on the movement.

1974

Reprinted in *Gerhard von Graevenitz*. Oterloo: Rijkmuseum Kröller-Muller, 1984 (exhibition catalogue).

GERHARD VON GRAEVENITZ **Kinetic Art: Challenge and Play**

if one claims that changes in art also express the shifting roles of art and the artist in society, then there have been many changes in our century.

the invention of abstract art removed the pressure on the artist to act as the intermediary for the message. propaganda had also meanwhile found more effective means. art had liberated itself.

yet how can one now justify the subjective decision to create a work of art? intuition and inner need hardly suffice.

an artist's work has become more and more a form of research, in which one thing develops from, and is justified by, others. on the other hand, the subjective decision has been reduced to the minimum (at its most extreme, to a choice of ready-mades. In the place of form there are elements, which are no longer arbitrarily ordered, but function within systems, according to rules. a viewer is no longer a receiver of messages, but has become a participant in a game.

my work lies between challenge and game. i am mostly interested in systems in the domain of visual reality. i do not use centuries-old traditional materials and techniques, but new, everyday ones. my objects can be reproduced. with the application of real movement comes too the elimination of aspirations to eternity and constancy. in the unpredictability of movement lies a challenge to play.

who'll play with me?

September 1975

Reprinted in *Gerhard von Graevenitz*. Oterloo: Rijkmuseum Kröller-Muller, 1984 (exhibition catalogue).

LEN LYE **Making 'Particles in Space'**

Just the other day I was experimenting with some abstract jiggling shapes in a film I was making. The shapes were vibrating dots and dashes which swirled, pulsed, squiggled, and darted about on the screen in a repetitive way. I hadn't the foggiest idea what they were all about and simply called them particles of energy in space; but what kind of particles and what kind of energy the Lord only knew. I had spent over four weeks trying to get my particles to work to my absolute satisfaction, and had at last succeeded. But I just couldn't kid myself – after about fifteen seconds, they're trying to find the right sort of music to go with their kinetic qualities. At last I found an absolutely identical twin for my particles in the way an African drummer attacked his notes to knock out a most cryptic, simple, tubby, and marvellously repetitive rhythm. It sat right in with my own cryptic, simple, repetitive 'particle' action on screen. But, like the film, the drum music soon got monotonous when I listened to it on its own. I then came up with the following explanation:
In the first place the drum music was conceived for dance, and simple repetitive dance at that, during which action one could derive stimulation from the vital progression of the sound rhythm for hours on end. Now, just as the music required literal bodily action to enable one to retain its bodily sensory appeal, so the action of my film imagery required some counterpart action which, in this case, was expressed in the kinetic nature of the drum rhythm. Watching the film images jiggling and darting to music took the place of dancing, and gave me a vicarious experience on an 'old brain' or sensory level of aesthetic emotion.

'The films of Len Lye', *Film Library Quarterly*, vol. 14, nos. 3–4, New York 1981.

WILLIAM WEES **James Whitney**

[...]

James Whitney began making films for the inner eye by using equivalents of the light-dots of closed-eye vision and the abstract geometric forms of hallucinations. Although his early collaborations with his brother, John, culminating in *Five Film Exercises* (1943–1945), seem to have been devoted entirely to exploring spatial-temporal relationships between simple abstract shapes, his own independently made films venture into a much richer terrain of imagery and ideas. All of Whitney's subsequent work was influenced by his interest in 'Ramana Maharshi, Jungian psychology, alchemy, yoga, Tao, quantum physics, Krishnamurti and consciousness expansion', but those interests expressed themselves differently in different films. For that reason, and because Whitney has attracted less critical attention than any of the other filmmakers in this book, all of his films will be included in the following discussion, though greater emphasis will fall on the films that mark significant stages in Whitney'' development as a film artist. Taken together, Whitney's films reveal – beneath their differences in imagery and technique – a single-minded dedication to uniting 'cosmic happenings and inner psychic happenings', as Whitney says of his first major film, *Yantra*.

Preceding that film, however, was a short, *Yantra Study* (1949), based on a series of mandala paintings done by Whitney in the late 1940s. Though extremely simple structurally (static shots of the paintings are linked by dissolves), the film is quite rich visually. The mandalas are composed of rapidly sketched lines, rough brush strokes, and dribbles of paint in the abstract expressionist style of Jackson Pollock. Under Whitney's guiding hand, however, they reproduce the circles, rectangles, and other geometric structures of the mandala-yantra tradition. Whitney's painterly interest in color, texture, and formal design is clearly evident in the mandalas of *Yantra Study*, but one can also sense in them the effort to give archetypal form to patches of light and dark that are like the flecks of light and streaks of color in closed-eye vision.

Whitney's next step was to translate those perceptions into 'dot-patterns' (as he called them), which became the basis of his two best-known films, *Yantra* (1957) and *Lapis* (1966). He specifically equated his 'dot-patterns' with the breaking up of forms as he perceived them in meditation and with "a quality which in India is called the *Akasha*, or ether, a subtle element before creation like the *Breath of Brahma*, the substance that permeates the universe before it begins to break down into the more finite world." In *Yantra* the swirling masses of colored dots coalesce into lines, waves, fountains, comets, and many circular and spherical designs. Although Whitney's comments on the film explicitly link its imagery to mandalas and other visual expressions of Eastern mystical traditions, it is not necessary to be familiar with those esoteric subjects to appreciate Whitney's accomplishment. That is not only because Whitney uses shapes, rhythms, and formal structures made familiar by modern abstract art but also because equivalents of the films' 'dot-patterns' occur in everyone's inner perceptions – though rarely so beautifully distilled from the visual 'noise' and mental distractions that usually hide them.

The traditional function of yantras is to aid meditation. By concentrating all attention on the patterns of the yantra, the meditator eliminates extraneous perceptions, thoughts, and feelings in order to achieve something like a mental-perceptual unity with the design itself. The pattern, as Heinrich

Zimmer puts it, 'becomes reproduced by the worshipper's visualizing power'. Or, as I argued earlier in this chapter, the yantra may help the meditator recognize patterns that are already present in the visual system but remain unnoticed until the steady stream of external stimuli is cut off by techniques of meditation or by other physiological and psychological conditions that cause hallucinations. Whitney's *Yantra* not only displays some of the archetypal patterns perceived under those conditions but reproduces the mind's process of creating or discovering them.

In *Lapis*, which Whitney calls a 'space/time mandala', the 'dot-patterns' of closed-eye vision form even more elaborate designs. The film begins with masses of grayish beige grains drifting around the edges of an empty white field. Slowly the grains draw together in a revolving mandala of exceedingly intricate geometrical patterns. A close-up reveals the patterns to be made of pulsating dots of colored light that seem to follow their own independent trajectories yet constantly move into and out of elegant geometrical formations. They suggest galaxies (or subatomic particles) engaged in a stately cosmic dance.

Although Whitney's description of the film draws upon the language of physics and meditation – "a totally balanced opposition of stasis and flow, holding the paradox symbolically through wave and particle, pointing to a still center of emptiness" – the terminology Siegel applies to hallucinations works equally well: "lattice-tunnel arrangements ... moving in explosive or rotational configurations". More speculatively, one might describe the film as a vast metaphor of neural activity in the visual system of the brain. Its sequences of crystallizing and dissolving mandalas are like spacial-temporal maps of brain cells firing during the process of meditation. [...] These approximations of the elusive and delicate patterns of light perceived in closed-eye vision would not be exploited fully, however, until Whitney made *Dwija*. [...]

Completed in 1976, *Dwija* ('twice-born' in Sanskrit) is based on eight drawings of a mandala-like jar or alchemical vessel. Like the paintings in *Yantra Study*, the images of the vessel in *Dwija* emerge from mingled lines, shapes, textures and colors. In this case, the effect is not due to the style of the original drawings but to Whitney's filmic techniques. Whitney began with a loop of the eight alchemical drawings, which he then solarized, rephotographed, and superimposed in continuously changing combinations. He also hand-processed his footage in order to introduce further subtle variations in hue, texture, brightness, and density. The result is a vivid yet mysteriously insubstantial image of an alchemical vessel dissolving and materializing again and again within a pulsating stream of colored light.

The subtly mutating image of the vessel finally disintegrates into pulsating circles of light, while a ghost-image of the unbroken vessel remains in faint superimposition. After this point there are long passages of nearly pure white light with no intervening images of the vessel, but just when it seems that the vessel has totally dissolved into light, it returns, shimmering like an object seen through water or heat waves. It retains its molten, glowing lines to the film's end, but in the meantime the shape of a descending bird in the design of the vessel is reversed and ascends from the vessel: "The bird escapes leaving the broken shell of the bottle", as Whitney describes it. The bird's ascent would seem to symbolize the soul's rebirth after passing through many trials of fire and light, but it could also stand for the perceptual renewal each viewer can experience through his or her own visual immersion in the film's flowing light. [...]

'Silence and imagelessness' is implied by the title *Wu Ming* [Whitney's next film, 1977] which means 'no name'. Early in the film the Chinese characters for 'No name is the beginning of Heaven and Earth' are vertically superimposed on a sphere of tiny shimmering black and white squares. Formally, this thematic statement (taken from a Taoist text) is represented as a vertical line through a circle, representing the basic organizing concept of the film: the 'binary' relationship of '0' and '1', according to Whitney. Nothingness and oneness, circle and line, make the simplest form of mandala, which reappears in the film as a gleaming shaft of light in front of a fluid oval of dots. Flowing dot patterns and mandalas are major components of the film's imagery, but much of the time (in Whitney's words) 'clear projection light dominates'.

This image of 'imagelessness' is most striking in the concluding five minutes of the film. A large blue circle containing horizontal layers of lighter blue vapors slowly shrinks to a solid black dot in the center of a white field of light. As the dot shrinks, the effects of its afterimage become increasingly prominent: the dot seems to become brighter and the screen darker as negative afterimages are mentally superimposed on the film's positive images. Every eye movement makes the afterimage slide off its source on the screen, producing two dots and two screens continually shifting position. What is 'on the screen', as distinct from what is 'in the eye', becomes increasingly hard to distinguish. When the dot finally disappears into the center of the screen, its afterimage continues to hover and gleam on an ambiguous gray-white plane somewhere between the screen and the viewer's eyes. Meanwhile, concentric gray rings appear at the center and slowly expand to the edges of the screen and disappear, leaving nothing but 'clear projection light' at the film's end. As Whitney describes it, "A very slow collapsing solid black hard-edged circle disappears in a pure white field. ... From this disappearing point, an entirely different kind of energy radiates in expanding wave rings, IN as particle OUT as wave". Light is composed of particles and waves, and it is light's direct impact on the viewer's visual system that produces the powerful final effects of the film. At the end, the film's images are made to seem less important than the 'imagelessness' of pure unobstructed light.

The goal of seeing without images is expressed in the title of Whitney's last film, *Kang Jing Xiang*, which was nearly completed at the time of his death in 1982. The title means 'like an empty mirror', but the film itself is not as 'empty' as its title implies. Instead, it reiterates some of the most striking visual motifs of Whitney's earlier films: solarization, an alchemical vessel containing a butterfly, mandala-circles, and elegant 'dot-patterns'. More intriguing are Whitney's plans for *Li*, a film he did not live to make. It appears that he was hoping to achieve 'imagelessness' by using the 'dot-patterns' of closed-eye vision in a new way.

William Moritz, who worked closely with Whitney in his last years, describes the intentions for Li as follows:

[*Li*] was to have consisted entirely of writhing 'random' dot fields from which the eye (and mind) would create its own transitory patterns and meanings, as Dr. Bela Julesz discusses in *The Foundations of Cyclopean Vision*. 'Li', the Chinese word for 'organic grain pattern' as in wood, stone, etc., symbolized for the Taoists the natural, irregular, a-logical, fluctuating order of things. At times, James also called this *Wu Wei* ('no-resistance'), the Taoist principle of flowing with the rhythms of nature and chance.

Julesz's experiments with computer-generated random dot patterns were designed to help identify the processes used by the visual system to combine binocular data into a single, unified image of the visual world. In the course of his work, Julesz found that perceptions of depth and of simple shapes can be derived from totally random patterns of dots, if the patterns are viewed stereoptically, that is to say, if they are slightly displaced and shown to each eye separately like the pairs of photographs used in old-fashioned stereoscope viewers. The perceived depth and shapes are not, in other words, 'in' the dot patterns, but 'in' the brain's processing of the patterns.

The connection between Julesz's experiments with random dot stereograms and the Taoists' contemplation of 'organic grain patterns' may be rather tenuous, but for Whitney it seems to have reinforced his feeling that 'dot-patterns' can appeal to the basic form-making processes of the human mind. Even more than the shrinking black dot of *Wu Ming*, the 'writhing 'random' dot fields' of *Li* would require audience participation: the viewer's own visual system would have to give form to the film's equivalent of amorphous visual 'noise'. Although the imagery in all of Whitney's films was designed for the mind's eye of the viewer, the 'dot-patterns' of *Li* would have been purely stimuli for each viewer's inner vision.

William C. Wees. Extract from the chapter 'Film for the Inner Eye', *Light Moving in Time: Studies in the Visual Aesthetics of Avant-garde Film*. Berkeley: University of California Press, 1992. © 1992 The Regents of the University of California.

RONALDO BRITO **Order and the Madness of Order**

Reading should be simultaneously methodical and wild, noncontinuous and organizing, agile and insistent, repeated and different. Reading according to a method that operates through oppositions, through ruptures of elements, according to a strict system but one that includes its own opening, its own denial as a system. It is clear that the constructivist tradition in which Sérgio Camargo is included is not that of the rationalists, defenders of a geometrical art, with pure forms. In his works there is system and excess, there is order and the madness of order.

The combinational method used – both the reliefs and the sculptures are the result of the application of this method – would not be, let us say, positivist but dialectical. The work is not presented for viewing as a closed unit to be read and understood within a linear movement of reasoning. On the contrary, its strength lies precisely in the type of complex and tense, rational and spectacular, relationship that it establishes with the observer.

The work is always something different at any time. The inclusion of light – more than this, the radical participation of light within its composition – strictly non-accidental yet uncontrollable, of course, makes it different in relation to the objective conditions of observing and the position of the viewer. The penetration of the light, foreseen by the system, acts in such a manner as to break it, breaking the work as a structure closed within itself. Thus there is the impossibility of the traditional scheme of contemplation – the man standing still in front of the work – and it is necessary to go round it, carefully observing the movements of the light, mentally participating in this game which is carried out within an active and noncontinuous space; the enjoyment is tense, cut short, incessant, with emotional highs and lows.

The discovery of the structure of the combinational format of the work does not eliminate observation. It is always presented with a dual movement that is far from being merely optical: that of the veiling and unveiling of the structure, which makes observation an exercise in which the eye and the mind accompany each other and successively lose their path.

At this point it is possibly clear that Sérgio Camargo's work, with a systematic rigour, progresses in terms of pairs of oppositions, and through a dialectical movement. Systematic/non-systematic, order/madness of order, veiling/unveiling, volume/atmosphere are some of these pairs, around which one may create a proposal for approaching and pertinent reading. Camargo speaks of a type of 'order of straw' to explain his work. It would also be possible to use the old metaphor of the labyrinth, the madness of which lies precisely in the excess of order and method. Anyway, the issue of a coherent reading of these works is precisely connected to equating the method and the asystematic palpitation present within them. To see them as some type of informalism seems to me to be a pure and simple mistake, doubtless the result of an overall and exclusively optical reading. But to think of them as constructive work, based on a concrete system of relationships that, so to speak, might be their very essence – one should note that these sculptures do not really have forms but combined elements – it is necessary to go beyond a certain formalist rationalism that is traditionally connected to western Europe. The importance of art such as that of Sérgio Camargo for our cultural environment may be above all located in two points: firstly, through the closed logic of its process of production, connecting art to an idea of the sequence of intellectual research, with it acting in order to transform a whole policy of seeing art. Against purely visual and nonintellectual consumption, these

works demand a reading that takes art as that which it is: a specific mode of knowledge, parallel to science and philosophy, and as far removed as they are from the discourse of the doxology, so-called common sense. Empirical, mad and unique, art nevertheless does not become confused with the a-critical and irremediably confused common sense, remaining unintelligible – or simply futile – when seen from this point of view.

The second point might be more difficult to demonstrate. This is the linking of Sérgio Camargo's work to the problematics of a Latin-American art. Because its constructivism is not only rationalist, it is also not European. The discovery of his work in Europe, in the sixties – concomitant with the discovery of Soto, Lygia Clark and Hélio Oiticica, among others – was at least partly due to the particular type of logic it pioneereded, no doubt strange in relation to strict European constructivism, and which may be considered, so to speak, as specifically Latin-American; without, obviously, slipping into metaphysics, presenting a Latin-American idea that nevertheless held weight. One may without doubt state that works such as those of Camargo are part of a certain Latin-American constructivism, the yet-to-be-formulated theory of which may be a productive theme for study and debate.

February, 1975

Sérgio Camargo. Rio de Janeiro: Museu de Arte Moderna do Rio de Janeiro, June 1975.

HÉLIO OITICICA **Bolides***

I could characterize my latest works, the *Bolides,* as 'Trans-Objects'. The fact is that the need to give a new structure to colour, to give it 'body', brought me the most unexpected results, one of which was the development of the *Bolides* from opaque to transparent, to a stage where colour not only presents itself in the oil and glue techniques, but in its pigmentary state, contained in the actual *Bolide* structure. There, the glass vessel which contains the colour could be called a pre-fabricated object, since it is ready-made beforehand. What I do, on transforming it into a work, is not simply to make the object 'lyrical', or place it outside the everyday, but incorporate it into an aesthetic idea, making it part of the genesis of the work, it thus assumes a transcendental character, participating in a universal idea without losing its previous structure. Hence the designation 'Trans-Object', to account for the experience. It is valid to compare it with the experience of artists such as Rauschenberg and Jasper Johns, creators of 'combine painting', that is, works where diverse techniques and expressive materials (I take it for granted here that they are used as expression) are combined, some in their objective form of tires, cups, stuffed birds, etc. In these experiments, the arrival at objectification, at the object as it is in the context of a work of art, transported from the 'world of things' to the plane of 'symbolic forms', occurs in a direct and metaphorical way. It is not a matter of incorporating the structure itself, identifying it in the structure of the object, but of transporting it, closed and enigmatic, from its condition of 'thing' to that of 'element of the work'. The work is virtualized by the presence of these elements, rather than the virtuality being previously found in the structure of the object. The work which most approaches an identification with the structure of the object which

participates in it is the work in which Rauschenberg connects a chair which is on the floor to the lower part of a plane which would represent the 'picture', where colour stains develop and, on reaching the chair, continue over it, overflowing the limit of the picture, and incorporating themselves to the structure of the chair. Even here, however, there is an 'a posteriori' incorporation, although the 'choice' of the chair is already a pseudo-identification with its structure; the incorporation of the objects in the other works also functions similarly, but the identification of the structure of the object as a sign within the work prevails there, whereas in the work with the chair to which I referred, it tends to become the backbone of the work, and not only a sign which emmanates from it. What happens, unquestionably, is a 'a posteriori' incorporation, and there remains, even afterwards, the contradiction between the two terms 'structure of the work' and 'structure of the object', as such, even though one is incorporated in the other. In those *Bolides* which I designate as 'Trans-Objects', where the object which I use already exists as such beforehand (for instance a glass vessel(there is no 'virtual juxtaposition' of the elements in the finished work; by choosing the vessel and its implicit structure, the identification of such structure with that of the work had already taken place, it is unknown where one starts and the other ends. Nothing would be more inappropriate here than the word 'chance', as if I had 'found by chance' an object, the vessel, and from that created the work; no! The persistent search for 'that' object already indicated the 'a priori' identification of an idea with the objective form which was later 'found', not by 'chance', or in the 'multiplicity of things' where it was chosen, but sighted without indecision in the world of objects, not as 'one of them which speaks to my creative will', but as the only one possible for the realization of the creative idea, intuited 'a priori' and which, on realizing itself in space and time, identifies its 'a prioristic' structural will with the 'open' structure of the already existing object, open because already predisposed to being captured by the spirit. This experience, in its profound dialectic, already inaugurates, in what I do, in my work, an important position concerning the subject-object problem. Before, the entire objective structure was created by me, and therefore the identification already existed in the moment in which the structures were being born, the subject-object dialogue occurring in a more serene fusion. In the 'Trans-Objects', the dialogue occurs through accentuation of the subject-object opposition. I believe that the problem, put this way, in structures totally 'made' by me, will change vision, dialectics, in its phenomenology. In structures totally made by me, there is a wish to objectify a subjective structural conception, which only realizes itself upon becoming concrete by the 'making of the work'; in the 'Trans-Objects', there is the sudden identification of this subjective conception with the previously existing object as necessary to the structure of the work, which in its condition of object, opposed to the subject, already ceases to be opposed in the moment of identification because, in reality, it already existed implicitly in the idea.

* *Fireballs*

October 29, 1963

From: *Aspiro ao Grande Labirinto*, Ed. Rocco, Rio de Janeiro, 1986.
Reprinted in *Hélio Oiticica*. Rotterdam: Witte de With, center for contemporary art, 1992 (exhibition catalogue).

I no longer have any doubts that the era of the end of the picture has been definitely inaugurated. For me, the dialectics which surrounds the problem of painting evolved, together with the experiences (the works), in the direction of the transformation of the painting-picture into something else (for me the 'non-object'). It is no longer possible to accept development 'inside the picture' the picture already became saturated. Far from being the 'death of painting', this is its salvation, since true death would be the continuation of the picture as such, as the 'support' for 'painting'. How clear it all is now: painting had to launch itself into space, be complete, not in surface, in appearance, but in its profound integrity. I believe that only by starting from these new elements can one carry forward what was begun by the great constructivists of the beginning of the century (Kandinsky, Malevitch, Tatlin, Mondrian, etc.), constructors of the end of the figure and of the picture, and of the beginning of something new, which they achieved not only by being 'geometric', but by striking with greater objectivity at the problem of non-objectivity. I do not deny the importance of Matisse, Picasso, Klee, Pollock, Wols, etc., but they belong to another type of expression, simultaneous with and parallel to the constructivists: they also herald the end of the picture. For me the painting of Pollock already takes place virtually in space. Thus, what is needed is consciousness of the problem, the firm and concrete launching of the development of painting, from this basis, even if it has barely recovered from the destruction of the figure. In truth, the disintegration of the picture is still a continuation of the disintegration of the figure, in search of a non-naturalistic, non-objective art. Practically a year and two months ago I found some words of Mondrian speculating prophetically on the task of the non-objective artist. He said that the non-objective artist who wished for a truly non-naturalistic art should follow through his intentions to the ultimate consequences; he said, too, that the solution would be neither the mural nor applied art, but something expressive, which would be like the 'beauty of life'; something he could not define, because it did not yet exist. He was a prophet of genius.

In our time, the artist who aspires to a non-naturalistic, non-objective art, of great abstraction, will find himself involved with the problem of the picture and will feel, consciously or not, the need for its destruction or its transformation – which deep – down is the same thing – by two different routes. The fragmentation of the pictures' pictorial space is evident in painters such as Wols (the term 'informal' itself indicates it), or Dubuffet ('texturologies' or rather, endless fragmentation as pictorial space transforms itself infinitely towards the minute, the micro-unlimited) or Pollock (there the picture virtually explodes' (transforms itself into the 'acting field' of graphic movement). In the other tendency the same thing occurs, more slowly but more objectively, from Mondrian's prediction of the 'end of the picture' to the experiments of Lygia Clark, and her integration of the frame into the picture: all the consequences of this development of the picture into space begin at this point. In an intermediate position lies Fontana and his pictures cut into slits, grooves of space, in which I see affinities to the grooves in my 'maquettes' and hanging 'non-objects'. The problem is posed. I feel therefore the need to start constructing, firmly, definitively, the basic development of this new type of expression, uncertain because of being new, still floating in indeterminacy, but which sooner or later

must consolidate itself. It is a cosmic necessity, it is in the collective mind; it is up to the artist to make it clear and palpable. I believe that any artist who desires something new and authentic, in this period, aspires to such a thing. The position of the artist will only be possible in an expression which realizes itself in space and in time: the idea unravels, maintaining a parallel dialogue between realization and expression. In the picture, this dialogue occurs through action, because in this way the artist can more easily abstract the limit of the picture; but when this limit no longer exists, the action is already implicit in the genesis, and therefore it will be more appropriate for it to crystallize itself into something constructed. Evidently, this solution is on an equal footing with architecture, because it 'inaugurates its space' (Gullar). Architecture is the sublime sentiment of all eras, it is the vision of a style, it is the synthesis of all the individual aspirations and their highest justification. The problem of painting is resolved by the destruction of the picture, or by its incorporation into space and time. Painting is characterized by colour as its principal element; colour, then, begins to evolve with the problem of structure, in space and in time, no longer imparting fiction to the picture plane: fiction of space and fiction of time. Never has painting so approached life, the 'feeling of life'. It is not the size of a work which determines if it is more 'vital', but its genesis. The problem is not superficial (amplification of the picture to murals), but one of integrating space and time into the genesis of the work. This integration already condemns the picture to disappearance and brings it into three-dimensional space, or, better, transforms it into a 'non-object'.

From: *Aspiro ao Grande Labirinto*, Ed. Rocco, Rio de Janeiro, 1986.
Reprinted in *Hélio Oiticica*. Rotterdam: Witte de With, center for contemporary art, 1992 (exhibition catalogue).

LYGIA CLARK **On the Act**

For the first time I have discovered a new reality which is not within myself, but within the world. I found a *Caminhando* [Walking], an inner itinerary outside of myself. Before, the *Bicho* [Animal] emerged within me, it spurted out like an obsessive explosion – through all my senses. Now, for the first time, with the *Caminhando* – it is the opposite. I perceive the totality of the world as a unique, global rhythm, which extends from Mozart to the gestures of beach football.

Architectural space upsets me. Painting a picture or making a sculpture is so different to living in terms of architecture. Now I am no longer alone. I am sucked in by the others. Such an impressive perception that I feel pulled up from my roots. Unstable in space, it seems like I am coming apart. To live perception, to be perception...

Currently I am almost always sick. I can't swallow anything and my body is abandoning me. Where is the I-*Bicho?* I am becoming an abstract existence. I am drowning in true depths, without any reference points with my work – which looks at me from very far away, from outside myself. 'Did I do that?' Disturbance. Delirium of flight. I am hanging by a thread. My body has left me – 'walking'. Dead? Alive? I am struck by the smells, the tactile sensations, by the heat of the sun, the dreams. A monster emerges from the sea, surrounded by live fish. The sun shines very brightly and suddenly begins to go out. The fish. Dead, on their bellies, white. Then the sun shines again, the fish are alive, the monster disappears into the depths – the fish go with it. I am saved.

Another dream: In the inside, which is the outside, a window and I. Through this window I wish to go outside, which for me is inside. When I wake up, the bedroom window is the one in the dream, the inside I was searching for is the outside. From this dream was born the *Bicho* that I called *O dentro é o fora* [The inside is the outside]. It is a steel structure, elastic and deformable. In the middle of the structure there exists an emptiness. When we manipulate it, this inner emptiness gives the structure completely new aspects. I consider the *O dentro é o fora* to be the result of my research on the *Bicho* (immediately before the *O dentro é o fora* I made a *Bicho* without hinges which I called *O antes é o depois* [The before is the after]).

I often wake up at my bedroom window seeking out the outside space as being the 'inside'. I am afraid of space – but I rebuild myself from it. In my crises it escapes from me. It is as if we were playing – it and me – cat and mouse, loser-winner.

I am the before and the after, I am the future in the present.

I am the inside and the outside, the face and the reverse.

That which touches me in the *O dentro é o fora* sculpture is that it transforms the perception I have of myself, of my body. It modifies me, I am shapeless, elastic, without a determined physiognomy. Its lungs are mine. It is the interiorisation of the cosmos. And at the same time it is my own self crystallised in an object in space. *O dentro é o fora:* A living being open to all transformations. Its inner space is an affective space.

In his dialogue with my work *O dentro é o fora*, the active subject re-encounters his own precarious nature. He also – like the *Bicho* – does not have a static physiognomy which defines him.

He discovers the ephemeral through an opposition to any type of crystallisation. Now the space belongs to the time, continually metamorphosed by action. Subject-object are essentially identified in the act.

Plenitude. I am overflowing with meaning. Each time I breathe the rhythm is natural and flowing. It is united to action. I have become aware of my 'cosmic lung'. I penetrate within the total rhythm of the world. The world is my lung. Is this fusion death? Why does this plenitude have the taste of death? I am so incredibly alive... How can I unite these two poles forever? On several occasions in my life I have discovered the identity of life and death. A discovery which, however, always had a new taste. One night I had the perception that the absolute was this 'full-emptiness', this totality of the interior of the exterior which I am always talking about. The 'full-emptiness' contains all of the potentialities. It is the act which gives meaning to it.

The act of making oneself is time. I ask myself whether the absolute is not the sum of all acts. Could it be this space-time, in which time, walking, is continuously made and remade? This absolute time would be born from it itself.

We are a spatiotemporal totality. In the immanent act we do not perceive of a temporal limit. Past, present and future become mixed. We exist before the afrer – but the after comes before the act. The after is implicit in the act being made. If time lives in the moment of the act, that which comes from the act is incorporated in the perception of absolute time. There is no distance between the past and the present. When we look back, previous past and recent past are fused together.

Maybe this is not clear. But the evidence of the perception that I had is the only thing that matters to me.

Livro-obra. Rio de Janeiro, 1983

Reprinted in *Lygia Clark*. Barcelona: Fundació Antoni Tàpies de Barcelona, 1997 (exhibition catalogue).

HANNI OSSOTT **Gego**

Structural System: Based on the Triangle
Its starting point is the triangle. The linking system for the straight lines, the modules originating from them, the dimensions, thickness, and the material used produce the resulting visual configuration.

The hung and self-supporting environmental Reticlareas, the Spheres and the Trunks, all form part of this system. The Reticlareas were started by Gego in 1969 and continue being made to this day. Their name derived from the art critic Robert Guevara. *Reticle* is the word describing fabric in the form of a net: *Reticle-area*: area of networks. These emerged from the liberation of the pattern of parallel or nearly parallel lines that Gego had worked on since 1956. The drawing of inter-crossing lines forming networks and network planes led to the three-dimensional conception of triangular modules and differently configured network groups. The modulation of its structure is closely linked to the connection systems used: hoops, small rings, small tubes, lines bent into hoops at the ends hooked to each other, aluminium tubes.

The module and the linking system are the foundation for the structural development of the Reticlareas. The *Reticlarea* in the Galer'a de Arte Nacional shows different types of joints and modular configurations. This enables their measurements to be varied and for them to be adapted to space and the environment. Other Reticlareas are more calculated, for example that of *12 bendable triangular modules* and the *Square recticlarea*, made up of seven square meshes which are curved; in these we cannot now find an open and infinitely modulated structure, such as that shown in the environmental Recticlareas, but structures determined rather by the symmetry or repetition of their modules, which, joined together by fixed little tubes, allow the whole structure to be moved. This is the opposite to the environmental Reticlareas, whose movements are brought together, thus making them partially bendable according to the number of lines engraved on the joints. Only those Reticlareas whose lines unite lengthways in a single straight line are bendable.

Gego. Caracas: Museo de Arte Contemporáneo, 1977 (exhibition catalogue).

MARTA TRABA **Gego**

[...] Gego appears strongly linked with nature as tackled by the figurative field. This does not refer to the *image* of nature, as I said before, but its meaning and deep structures. Nevertheless, her empathy towards the natural is so strong that she resists the common practice of dividing art into *representational* and *abstract*. For her, art can only *represent*. Its condition of image confirms this. In her opinion, the separation between figurative and abstract would only create a stupid antagonism. [...]

II Perceptions and experiences seem to be the main work tools for Gego. Potentially, everyone has these, she gently insists. After a long exchange of ideas, she accepts that some may have more opportunities to develop them than others. It is nevertheless logical that her perspective is not fragmented by social injustice. She is not active in the class struggle but in the fight to express oneself with beauty, fairness and harmony. Her perception of the world produces a very detailed record, not of *things*, but rather of the *behaviour* of things. We return to the exercise of *seeing living*. But this excessively detailed inventory of perceptions is later re-worked by Gego, in a kind of permanent meditation, which for us full-time Latin Americans is a really atypical characteristic, having a European nature. Gego believes that man needs to set a time limit for his meditation and creation. The thought on which he meditates, the source of all *correction of meaning* cannot progress in anarchy or a boundless area. There is then in Gego a constant pondering, regarding both perceptions and the reflections made about them. This leads to a sculpture which has an exact density, weight and size, and which does not go beyond itself. However, its growth, as I already explained, is never completely ruled out. [...]

III The formal support of the 'reticlarea' ends up being a perfect poetic unit. It is furthermore clearly an environmental unit. This involves a conception of space which would justify the work being considered as a sculpture. However, nothing is more difficult than to critically characterise Gego's *space*. (If it were not too easy a solution, it would be tempting to define this as *anti-space,* as the spatial conception is permanently disposed due to the will for transparency. This is a constant applicable not only to the 'recticlarea', or the latest marvellous towers where such a will is expressly clear, but to the type of panoply represented by the screens. This creates a false spatial frontier which contradicts the openings and the slides which are at the front and back). [...]

Gego. Caracas: Museo de Arte Contemporáneo, 1977 (exhibition catalogue).

HAROLDO DE CAMPOS **Poem for Mira Schendel**

an art of voids
where the utmost redundance begins to produce original information
an art of words and quasi-words
where the graphic form veils and unveils seals and unseals
sudden semantic values
an art of constellated alphabets
of bee-like letters swarming and solitary
all-pha-bbb-ees
where the digit scatters its avatars
and longs shifting for the ideogram of itself
where digital is driven to become analogical
an art of lines that sink
and stand fronting by a minimal vertigo of space
notwithstanding full of starlight
immeasurable distances
an art where colour may be the name of the colour
and figure the comment on the figure
to let wonder go free again
between sense and sign
a scripictorial art
out of the cosmic dust of words
a semiotic art of icons indexes symbols
which print on the blank of the page
their numinous foam
this is the art of mira schendel

to enter the planetarium where her drawings
like starry patterns hang
and hear the silence like a bird of inwards
on a perch of almost
twittering its absolute haiku

April 1966

Mira Schendel. São Paulo: Museu de Arte Contemporanea da Universidade de São Paulo, November 1990
(exhibition catalogue).

VILÉM FLUSSER **Mira Schendel**

The transfer of interest from process to structure is, no doubt, what distinguishes our century from the nineteenth. No longer are we interested so much in what happens, or how it happens, but in the field where it may happen. We are no longer interested so much in history or in stories, but in the language in which they are told or tell themselves. This can be seen in all our activities, and most of all in art. Our art no longer tells stories. It tells itself, it is about itself, it analyses itself. It is self-analysing structure. The moments of creation and of critical distance coincide in it. And this coincidence is the mark of its authenticity. We can therefore no longer apply traditional classifications to it. Is it painting? Is it music? Is it philosophy? Is it science? Is it theology? These questions become meaningless. It is pure structure in search of its own essence.

Such is Mira Schendel's art. Only more so. Because Mira Schendel's creations are experiments in linguistic structure. They are answers to questions like these: What is language? What is information? What is meaning? How does a letter, or a line, or a word become meaningful? How does it arise from the void of the unutterable, and how does it establish itself as structure? Can the traditional structure of language (the discourse), be amplified? Can it be transformed into new structures, two-dimensional, or three-dimensional, or even n-dimensional structures? And does such an amplification, if possible, give new meaning to the letter, the line, the word? Is it possible to learn to think, not in sentences, but in new structures of language? And what meaning have such thoughts, if any? Mira Schendel's creations are attempts to answer such questions.

This has to do with originality. The quest for new linguistic structures is a quest for original information. Our linguistic structure is tired. It is a field in which most potentialities have already been realized. It tends entropically towards redundancy. It is very difficult to formulate original thoughts within this structure. And this means that our language, such as it is, no longer provides us with the means to utter the tremendous shout of surprise that is the mark of contact with the origin.

Our language, such as it is, is devoid of surprises. It is tedious and all our thoughts within it are devoid of the climate of the sacred. Schendel's art is an attempt to open up language to allow the sacred, the unutterable, to enter it. It is an opening up towards the totally different, which is non-language. Schendel's art is therefore situated at the limit between language and non-language. This is the reason we see in it letters, and words and lines, floating in emptiness of the sacred, trying to inform themselves and each other within the emptiness, and losing themselves in it again. We are present at the origin of structure. We are therefore witnesses to the effort to build a bridge between the realm of what can be said, and the realm of what must be silenced. Schendel's is the anti-Wittgensteinian shout in defiance of the unutterable. It is a prayer.

São Paulo, July 1966

DIETER ROTH

doing something that comes easy
like leaving a page empty
it will gain sufficient meaning
from other pages that have something on them
or from today's overfull environment
which has sufficient activity in colour and expanse
putting something easy on a page
like a couple of lines
so that one line will gain importance from the other
is active in terms of colour and its position to the
eye

1963

Zero aus Deutschland 1957 bis 1966. Und heute. Ostfildern-Ruit: Hatje Cantz Verlag, 2000 (exhibition catalogue).

HANS HAACKE **Statement**

...make something which experiences, reacts to its environment, changes, is non-stable...
...make something indeterminate, which always looks different, the shape of which cannot be predicted precisely...
...make something which cannot 'perform' without the assistance of its environment...
...make something which reacts to light and temperature changes, is subject to air currents and depends, in its functioning, on the forces of gravity...
...make something which the 'spectator' handles, with which he plays and thus animates...
...make something which lives in time and makes the 'spectator' experience time...
...articulate something natural...

Cologne, January 1965

Reprinted in *Hans Haacke*. Barcelona: Fundació Antoni Tàpies, 1995 (exhibition catalogue).

HANS HAACKE **Statement**

In the mind of the public and some artists, the border between art and science has become fluid. The following developments have contributed to this state: scientific terminology has entered the jargon of artists and writers partly because of its precision (an unusual quality in art-talk) and partly because it implies a contemporary mystique. Detached, methodical, and analytical working habits have been adopted. A series of work is being produced like a test series. Some perceptual phenomena have received scientific explanations. Scientists are venturing into art. An increasing number of artists are in need of engineering techniques and devices and therefore collaborate with engineers. There is a general, naive veneration for science, probably based on its spectacular achievements as well as a fascination with its clarity and precision. Beyond that, it simply seems to be 'in' to have something to do with science. These, and a host of other factors, have created a great confusion which is rarely supported by scientists and engineers. It originates, rather, with the public, is propagated by a sensationalist press, and, not the least, derives from the artists themselves.
There is little doubt about the job of the scientist. It is the artists who are not in the fortunate position of being able to state their objectives clearly, nor can they define precisely the field in which they are working. This very weakness (?) contributes to the general confusion in respect of the question of what art has to do with science.
It would certainly make no sense for artists to try to compete with scientists. It is further unlikely that the artist's task is to illustrate the abstract information provided by the scientist's research, notwithstanding the gibberish about the electronic age. The employment of engineering techniques does not establish a scientific art. The artist's application of scientific knowledge is naturally not scientific in itself because it does not intend contributing to the body of knowledge. It is also hardly the artist's job to make the science classroom's demonstrations more stylish.
In view of these negative statements, what is, then, the artist's relation to science? It is the exposure to fundamental ideas of science, even on an amateurish level, that has considerable influence on his thinking. In fact, his being sensitive to all information about his environment (science is part of it) is likely to have a bearing on the ideological foundation of his work.
This, however, is neither surprising nor new. The artists of the past were equally open to the total

body of knowledge of their times. No matter how poorly it was developed, science has always played an important part in it. Also, the use of engineering techniques was familiar to them, particularly to sculptors and architects. Leonardo da Vinci, for example, was outstanding in the wide range of his activities, but he was not the only one in his time. At his side were numerous fellow artists with a similar scope of interests. The very ideal of a Renaissance intellectual was to be a person with a familiarity in all the era's arts and sciences. This did not result in their work being called 'scientific', however. There is no reason for qualifying the work of this generation's artists as scientific either, no matter how technically sophisticated it may be. There exists a fundamental difference of intention. Whatever art is, it is not science.

New York, September 1967

JACK W. BURNHAM **Hans Haacke Wind and Water Sculpture**

QUESTIONS TO THE ARTIST: Most of what follows was taken from a taped dialogue between the writer and Hans Haacke. It was an attempt to ask some probing questions that weren't really answered in the article [not reproduced here].

J. B.: The articles that have appeared in the past year or two concerning the present output of kinetic art have usually cited the more than fifty-year-old history of the movement. Do you think there is any fundamental difference between the kineticism of this generation and past generations?
H. H.: This question might imply that 'kineticists' have more in common than the mere fact that they have made moving things. This, I think, is pretty hard to say, unless you want to confine them in just another of those wonderful didactic straitjackets which are so popular today. What has Duchamp's bicycle wheel to do with Gabo's virtual volume? They are worlds apart, and by the same token you could hardly find principal similarities, let's say, between George Rickey's needles and Tinguely's 'absurd' machines. General attitudes of the first generation can also be detected today, though the work looks very different. So, for example, you might say there are things that could very generally be labelled surrealist; there are other things which continue the approach of Moholy-Nagy etc. If you consider this as fundamental, then there don't seem to be great differences. On the other hand, it seems as though a more acute feeling and understanding of movement is developing, of the nature of movement itself: extremely slow change, speed, rhythm, steady flow and change in time, precise machine-controlled motion, and organic movement feeding on natural forces. Random behaviour is getting a lot of attention, probably more than ever before. The viewer is often an active participant, taking the role of generator. And I believe that in the first half of this century, little thought had been spent on set-ups which react with their environment, like involving air currents, temperature and humidity conditions, light, or even the presence of people. Interest in mechanical or natural feedback systems seems to be more recent. By the way, sensationalist journalism likes to create the impression that spectacular examples of modern technology, soaring rockets, satellites, and so forth, serve as the source of inspiration. This is an image that would be fitting for the Futurists fifty years ago. It was a rather superficial concept of motion, and is very rare among today's 'kinetics'. Another gimmick of this type of journalism is to pretend that the 'kinetic craze' is the top, the latest, the new 'in', space-age art, and that 'stable' sculptors lag behind. This is a basic confusion between the state of information and a particular situation on the art market on one side, and the actual development of things on the other. There are, and I assume there will be, a number of very good

sculptors around who have no use for motion. Take Bob Morris, for example: the immutability of his pieces can only be compared with Egyptian pyramids. The mere fact that an object moves has no value in itself.

J. B.: How about the spinning stainless-steel forms of Len Lye? These seem to be close to what Gabo was doing more than forty-five years ago with his virtual volumes.

H. H.: I don't think so. Gabo was trying to make the appearance of a shape in the same way that a form is created by the blades of a revolving electric fan or a propeller. Lye, except perhaps for some early pieces, is interested in motion sequences –beginnings – temporal climaxes – interruptions – fading effects. He actually programmes to change the type of motion involved. The shape does not seem to interest him primarily.

J. B.: Several times you've spoken of *machines* versus *natural systems*. What do you mean by that?

H. H.: Machines have a different temporal effect on human beings, that is, create a different effect on the nervous system, than nature's timing. Sunrise and sunset, the tides, running water, the movement of clouds, and the glittering reflections on water are only a few examples of natural patterns of time. Man is in tune with this timing: his breathing rhythm, his heartbeat, in short, the functioning of his whole body, and I would guess also the flow of his thoughts, are of a comparable nature. In contrast to this, artificial timing, as experienced daily in all highly industrialized societies, creates nervous tensions and probably contributes a great deal to the illnesses of just these social organizations. Piene's light ballet, involving hundreds of tiny fragments of light, quietly moving across floor, walls, and ceiling of a room, thus also encompassing every person in this room, comes close to the natural quality of time of shifting patterns of sunlight as they filter through the leaves of trees. He seems to be the only one of all light-experimenters who has miraculously arrived at a human time pattern in spite of his use of motor and electronic timing devices. Some of his work gives you a feeling of weightlessness and phenomenal involvement which I admire greatly.

J. B.: Sort of like small boys watching the stars in a field at night?

H. H.: Yes, something like that.

J. B.: Well, a lot of kinetic art, including a few pieces of your own, does involve the use of machinery.

H. H.: Yes, my machines may be prime movers, but they move natural materials such as air and water. Take an artist like Tinguely, whose machine constructions are meant to be disruptive and noisy. There's that incessant clanging and rhythmic banging that ties you up in knots. Or Schoeffer's Cybernetic City at the Jewish Museum – that is one nightmarish city, one city of the future that I'd emigrate from the first chance I had. Don't get me wrong – I admire Tinguely's constructions very much, and he produces a brilliant satire of the stupid type of motion of all the elevated trains, elevators, pneumatic hammers and time-clock buzzers that we are constantly subjected to. It is this capturing of the anti-human time sequence of mechanized life that is one of the main points of his work. It is almost like an exorcism and seems to relieve the visitors at his shows to an extent where they can be amused and laugh, some perhaps with a certain uneasiness. The whole tempo of my work is very different. It is more related to what human beings have known in terms of natural motion. I watched many people during my exhibitions. I was surprised and happy to see them loosening up after handling some of my objects.

J. B.: You've just returned from several months of teaching on the West Coast and I've noticed that one thing that has impressed you, more than the art there, is the range of fountains. How do you feel about the possibilities of fountains used in the future in your water constructions?

H. H.: I envied the people on the West Coast for the tremendous number of fountain commissions, which give them the possibility of investigating unknown ways of dealing with water. Since I began working with liquids, I have been frustrated in not having a chance to do something that is open and

not boxed in. Experiments can hardly be conducted on a primitive level. Expensive equipment and a large space where you don't get into trouble are necessary. There are many things waiting to be explored about the manipulation of the inherent hydrodynamic qualities of water. The hydraulic spectacles of the baroque are fantastic; today, though, we know more about the potential of water and we have more versatile equipment. These new water spectacles would not look like fountains at all. Pressure, surface tension, reflective and prismatic qualities, are, for example, variables with which one can make things that do not resemble the traditional idea of a fountain. Such monumental water 'sculptures' would really be integrated into their environment – buildings, parks, open spaces – in a sense like the baroque Gesamtkunstwerk.

J. B.: I have heard Schoeffer and Piene advocate the same thing: that is, more and better technical training for future kinetic artists. What is your opinion about this?

H. H.: Granted, technical training in the plastic arts is inadequate today, but when has it ever been able to meet the demands of the *avant-garde*? Many of today's 'sculptors' have learned what they know from outside sources, not schools. It makes sense, however, to advocate training in working with new materials like plastics and electronic engineering. Some basic physics and chemistry training would have been handy for me, too. More valuable might be the collaboration with engineers. But let us not kid ourselves: all the technical know-how does not guarantee the outcome of good work; in fact, there is a danger of getting lost in technical gadgetry. A much greater danger, though, would be the build-up of a kinetic academy. I dread the thousands of motor-driven gadgets that might be crowding the schools soon.

J. B.: Several times you have made the point that you want to stick to the most primitive mechanical devices. But isn't using a little mechanics like being a little pregnant? Isn't the impulse there to use successively more sophisticated mechanical devices?

H. H.: Our discussion might sound as if I am anti-machine, anti-technology. I am not. I consider technological means as tools to help me arrive at something that I want. They are not to be worshipped. They are to be used. Let's leave science fiction to Hollywood. The end only justifies the means. In other words, the question is: Can *I do that much more* with the added machinery?

J. B.: I think I fully understand the water pieces, but what about your air projects; if you could design them ideally or for optimal performance, what would they be like?

H. H.: I would want all the machines to disappear and for the sails or balloons or whatever to become completely autonomous.

J. B.: Something affected by outdoor breezes?

H. H.: Not necessarily – but also that.

J. B.: Perhaps air-filled volumes in a room filled with hidden air jets?

H. H.: If the balloons or air 'structures' are balanced properly you need few or no jets at all. Air, no matter where it is, moves. It is highly sensitive and carries light objects.

J. B.: What about the problem of air-filled structures having to be pumped up every few days?

H. H.: They are not stable entities with lasting properties. They are rather systems. They are like pets or bonsai trees that demand care. Incidentally, I suspect that sooner or later, I actually will try something with plants. My idea for a seagull 'sculpture' also fits into this context.

J. B.: How can you be so pro big-city living and yet so attuned to non-urban and natural effects? There is serenity to your things, but also a disquieting precision that looks more Mies than Mies.

H. H.: This precision, for one, is dictated by the nature of the material: standardized acrylic sheets, tubes, spheres. These shapes are technologically determined. At the same time, however, these geometric shapes possess an extremely pristine clarity and absoluteness, ideal forms which, I think, are in tune with the phenomenal nature of my work. The organic happening inside and the geometri-

cally-shaped container enhance each other. Besides that, a more complicated or 'interesting' shape of the container would serve no function, in fact, it would only obscure the internal movement. I believe that a rational, almost positivist approach, sort of matter of fact, can be pushed to a point where it blossoms into something very poetic, weightless, and irrational. Perhaps this helps to account for the seemingly contradictory nature of my work.

J. B.: In a sense you are trying to control a small bit of nature, perhaps just a fragment of the outdoor environment.

H. H.: Not really. I have isolated some natural phenomena – no matter whether they occur outdoors or not – and tried to articulate them as purely as possible, following their own pattern of behaviour. I do not try to control them, unless you think isolation is control.

J. B.: Critics have attacked the tendency of some advocates of kinetic art to parallel important scientific theories with events happening at the same time in motion art. Do you think such parallels are unjustified?

H. H.: I would have to be a scientist who had a definite understanding of these theories to answer this question. Obviously I am not. I am sure of one thing, though: the type of objects and changing relationships we are discussing here is not meant to be an illustration or a model for contemporary scientific theories, be they relevant or not. You don't have to be a scientist to be aware of the fact that there is nothing stable, that the status quo can only be the wishful thinking of bad politicians. Everything, but really everything, is on the move. There is nothing outside of time.

J. B.: Do you conceive of your art as a participation game?

H. H.: A number of things I have made require the participation of the viewer. Otherwise they are dead. I like this physical involvement. It establishes an interdependence between viewer and object. In larger pieces which would not allow handling, I would use photocells to retain this intimate relationship. But, as you know, I have also made things which change independently of the viewer, reacting with their environment.

J. B.: Perhaps what you are trying to reach is the pre-history of art?

H. H.: I don't quite know what you mean by that. Oscar Wilde said something to the effect that life imitates art more than art imitates life. In other words, art is our way of observing reality at any given time. An example: up to the Impressionists, people did not experience light in the way we do now. And since then, our awareness of light has been broadened further.

J. B.: If you could envision an ideal art environment of your own making, what would it be?

H. H.: This is talking about Utopia. It would be of tremendous dimensions.

J. B.: A kind of Philip Johnson glass house with a hermetically sealed weather environment inside?

H. H.: I guess not. I would prefer something unconfined, like the ocean, the desert, Grand Canyon, or even of interstellar proportions.

J. B.: Just a piece of weather 'happening' floating like a cloud in space. Perhaps like the colour areas in a Rothko painting?

H. H.: Probably.

J. B.: I think we already have that; it's called rain, sleet, fog, etc.

H. H.: I did think of signing the rain, the ocean, fog, etc., like Duchamp signed a bottle rack or Yves Klein declared November 27, 1960 as a world-wide 'Théatre du Vide'. But then I hesitate and wonder if isolation, presentation at one limited given area, an estrangement from the normal, is indispensable. It is a very difficult question. It finally boils down to a definition of 'art', and I don't know what this 'Art' is.

Tri-Quarterly Supplement, no. 1, Evanston, Ill: Northwestern University, Spring 1967.

DAVID MEDALLA **New Projects**

David Medalla, the Filipino artist, has embarked on a series of new projects. David describes himself as 'an hylozoist' (in reference to the Old Ionian pre-Socratic philosophers) – 'one of Those-who-think-Matter-is-Alive'. Medalla introduced into sculpture the use of actual elements, not merely as adjuncts of objects but the elements themselves forming the major part of his truly original objects. David's main interest is matter in all its living manifestations. 'I am not a physicist', he says, 'but I like to think of myself as a poet who celebrates physics.'

Julio Herrera described David as 'a boy of wisdom, the ferocity of whose wraths is tempered always with the tenderness of his loves.' An apt description, say those who know David personally.

In Paris last month fellow-artist Takis, upon seeing David's sand machine, hailed him as a genius. 'If other artists understand what Medalla has discovered,' said Takis, 'then they too will be geniuses like Medalla himself.'

Much of David Medalla's new work is a direct continuation of his 'thermal sculptures'. The first of these thermal sculptures was the bubble machine which was included in last month's pilot show at the Centre's headquarters. Other new developments are the following projects, small models of which will be included in the second pilot show and in subsequent exhibitions of the Centre for Advanced Creative Study.

1. Smoke machines with flickering lights in which the smoke itself, with its varying shapes, colours and densities, is the actual sculpture.

2. Arctic columns: a series of sculptures in which water turns into icicles: the icicles dance, crackle and refract sunlight into a thousand rainbows; the icicles then melt into water and the process outlined above is repeated in an infinity of variations.

3. Floating sculptures which produce musical sounds when they hit each other while creating 'pelagic pictures' under water with electric lights. A small study for this project was exhibited at last month's pilot show.

4. Whirlpool sculptures: leaves and other floating things whirling in actual whirlpools.

5. Machines for making Instant-Poetry. With a twinkle in his eye David says that these machines should provide 'a sort of un-unified field theory of poetry somewhat analogous to the still missing unified field theory in physics which physicists have been trying to find for the last two or three thousand odd years'.

6. Sand, wind and rain sculptures: further developments of Medalla's sand mobiles. In these constructions sand is blown by winds in different directions while raindrops and running water make continuous patterns on sand. (Several people incidentally have noted the similarity of this concept to those of the sand gardens of Japan like the Ginkakuji in Kyoto and to the sand paintings of the Tacos Indians of North America.)

7. Hydroponic rooms: rooms with ceilings planted with a million edible mushrooms, rooms with melting walls of milk and butter, rooms with transparent floors containing herbariums.

8. Collapsible sculptures and sculptures in components incorporating actual living things such as snails, shrimps, ants. In one construction, snails pass over sensitive plates of metal which trigger off

certain modulated sounds. In another, ants travel in space through different lenses, the lenses magnifying and fragmenting into abstract patterns the ants' shapes. A third construction will present an underwater ballet of shrimps. In this set of projects living things are encouraged to express themselves. Medalla will thus confer the titles of 'musicians to the snails, artists to the ants and dancers to the shrimps'.

9. Radio-controlled flying sculptures, in which objects fly from a sort of gigantic 'hive' into different parts of a room, different parts of a house, and into the streets. The 'vagabond objects' will return to the hive at different intervals, at different hours of the day, even different days and months, from all parts of a city and maybe also the countryside, bringing with them all sorts of things such as envelopes, handkerchiefs, banners, buttons, banana peels.

10. Lightning-rod sculptures: sculptures to be set in the open air and on top of skyscrapers. The electricity which is 'picked' by the lightning rods is conducted and transmitted into picture-making machines.

Finally there are
11. The thermo-paintings, in which pictures on frost– and mist-covered glass are made and unmade purely by the warmth of human breath, ...

12. The machines for making mud pictures and sculptures.

13. The Braille sculptures: sculptures to be felt in the dark emitting incense, marjoram, thyme, mint, laurel, benjamin and other fragrances.
and

14. Transparent sculptures that sweat and perspire. When the spectator fans these sculptures, they cool down, reduce their volumes, change their colours, sizes, shapes. These perspiring sculptures also palpitate with the changing intensities of darkness and light.

From *Signals*, vol. 1, no. 1, London, August 1964.

DAVID MEDALLA **Mmmmmmm ... Manifesto**

(a fragment)

Mmmmmmm ... Mmmedalla! What do you dream of?

I dream of the day when I shall create sculptures that breathe, perspire, cough, laugh, yawn, smirk, wink, pant, dance, walk, crawl, ... and move among people as shadows move among people ... Sculptures that will retain a shadow's secret dimensions without a shadow's obsequious behaviour. ... Sculptures without hope, with waking and sleeping hours. ... Sculptures that, in certain seasons, will migrate *en masse* to the North Pole. Sculptures with a mirror's translucency minus the memory of a mirror!

Mmmmmmm ... Mmmedalla! What do you dream of?

I dream of the day when I shall go to the centre of the earth and in the earth's core place a flower-sculpture. ... Not a lotus, nor a rose, nor a flower of metal, ... nor yet a flower of ice and fire. ... But a *mohole*-flower, its petals curled like the crest of a tidal wave approaching the shore

Mmmmmmm ... Mmmedalla! What do you dream of?

I dream of a day when, from the capitals of the world, London Paris New York Madrid Rome, I shall release missile-sculptures. ... to fly – at nine times the speed of sound ... to fall – slim as a stork on a square in Peking ... bent, crushed – like a soldier's boot after an explosion – on an airport in Ecuador ... in splinters – on the fields of Omaha. ... A few – to cross interstellar space ... accumulating, as they wing along, asteroids, meteorites, magnetic fields, interstellar germs ... of a new life ... on their way from our galaxy to the Spiral Nebula. ... *Mmmmmmmmmmmmmmmmmmmm*

London, 1965

From *Signals*, vol. 1, no. 8, London, June-July 1965.

dom sylvester houédard **Concrete poetry**

[...] Concrete poetry is today: it is Afterbeat – history cycle of rhythm – form verse is closed –
Concrete poetry can be semantic (pure) or nonsemantic, mutatis mutandis however, each comes from
the 3 tendencies of modern art & is constrictive (contractive) constructive & coexistential. It reduces
language (verbiage & syntax) to a minimum, the LCM of nouns; it makes poem-objects; it overspills
in every direction, primarily to typography ('Ikon & Logos are one,' Hugo Ball, 12 June 1916) secon-
darily to all spatialising art today. New poetry is CONCRETE because it is a poetry of nouns, words for
concrete things: also because it makes poems that are concrete objects themselves, not windows into
souls; it is SPATIAL because it creates its own space. Pure (semantic) concrete is the poetry of Finlay,
of Gomringer, the Brazilians & Pierre Garnier, of the Japanese Kitasono Katue & Kobayashi.
CONSTRICTING language: concrete is part of 1963 scene: speaking & writing are getting shorter,
snappier, whole sentences packing into a word, long phrases into initials. Mutual exchange between
speaking & writing, often unnoticed in daily life, needs only to be pointed out & e.g. advertisements
(pictographs, slogans) become new poetry. This simplified talk, direct speech in sign-like new poetry
is making literature part of everybody's life (c.f. Hans Arp on Hugo Ball 1932 trans. Eugene Jolas
'thru language too man can grow into life'), it reasserts place in society of creative writers.
Absence of inflection & declension in words (infinitives used in French concrete); absence of syntax
that gums words together in sentences: syntax replaced by typographic arrangement of words on
page. As with ideograms, reader supplies missing links. Poem is kinetic, forces reader to cross border
& enter it. This syntax-absence (doubly oriental, like agglutinative Japanese, isolating Chinese) is very
like Headlines, Title Pages, Telegrams, Pidgin, Posters. Like contemplation, goal of dadaco poetry-
purge, was the wordless suprematist WHITE ON WHITE: POEME BLANC, concrete fractures
linguistics, atomises words into incoherence, constricting language to jewel-like semantic areas where
poet & reader meet in maximum communication with minimum words.
Words: hard & lovely as diamonds demand to be seen, freed in space words are wild, sentences tame
them. Every word is an abstract painting but words read quickly in a phrase get lost: in concrete, eye
sees words as objects that release sound/thought echoes in reader. Opposition PLANE/IRON
(AVION/FER) nothing to do with syllable count; difference between comfortable picture of *The tiger
on the river bank has come to quench its thirst,* & the power of TIGER. The Logos as one-word poem OM,
one-stroke timeless ikon.
CONSTRUCTIVE: concrete poems just ARE: have no outside reference; they are objects like TOYS &
TOOLS (toys can be tools); jewel-like concrete things-in-them-selves; preciosa; a placed comma; a
flower; a blank; something admired in the tokonoma. Constellations: the simplest possible in use of
words – just word-groups like star-groups. Concrete poetry is I-less Ego-less self-effacing, not mimetic
of the poet, not subjective (at least explicitly). Poet: dissolved, issues no *orders* to reader who has to
provide his own mind-gum syntax. Reader: not bossed – hence new poetry is new anarchy or free
symbiosis, like looking at non-demanding nature, viewer sees image of himself. Like mysticism, any
Zen, breakthrough in Oxford semantic problems. Like Ginsberg in Pa'lante: 'Give up any poem-
practice depending on living inside the structure of language – on words as the medium of conscious
being.' Existential source of contradiction (objectivity/subjectivity) disappears.
Concrete poetry communicates its own structure: is an object in & by itself. Its material: word (sound,
visual shape, semantical charge) – each word is an abstract painting; its problems: the function &
relation of this material; factors: nearness & similarity – gestalt psychology; rhythm: relational force.
Like cybernetics: the poem as self-regulating machine. Concrete poems can be dull amusing grand

satirical playful sad – everything except epic. 'Help serious thought & mind-play; concrete poet: play-expert making speech-rules' (Gomringer independently of Wittgenstein?). The constructed poem attracts: it is human, friendly, makes words move on the page – they move as quickly as the poem attracts. Eyeverse is not 'read' – it creates an impression through the gestalt shape of the whole toy-tool, architected, poem – through each word as the eye wanders over them in any order.

COEXISTENTIAL overspill & boundary blurring: concrete poetry begins by being aware of graphic space as its structural agent, as the cosmos in which it moves, the universe into which it turns the page, the book. A printed concrete poem is both typographic-poetry & poetic-typography – not just *a* poem in *this* layout, but a poem that is its own type arrangement. Hence, too, many type layouts are poems. A concrete poem, like ideograms, advertisements, posters, creates a specific linguistic area – *verbicovisual* – with the advantages of nonverbal communication. It advertises itself. Nonsemantically this overspills in direction of Diter Rot, of typograms & typikons.

Concrete poems: dynamic structures – exist to establish tension between poem-object & space-time: motorized semantic-poetry not around yet but concrete *is* mobile, kinetic-spatial, by its typographic life. Its effect on eyes: perceptive ambivalence. The shrinking world: contracted/constricted negatively by bomb & space fears, positively by jet-communications telstar space-probe. This makes coexistentialism inevitable, international: i.e. all arts merge, barriers crumble, are scrambled (*sculpture sonore*, motorized frescoes); new semantic eyeverse through new physiognomical typography & suprematist care for space, shares space-time spatial-kinetic concern of all forward-moving art. Battle of typograph & poet (form & content) is over – poet & typographer (soul & eye) must balance in same person: his the total responsibility before language, to create precise problems & solve them in terms of visible language. A general art of the word. [...]

Extracts from 'Concret and Ian Hamilton Finlay', *Typographica-8*, 1963.

Permission granted by the Prinknash Abbey Benedictines.

AGNES DENES Dust

Dust is particulate matter, the dispersed, disordered raw material from which everything ordered and coherent arises, and it is to dust that the complex decays.

From the beginning to the end, dust underlies all existence. It is the specks of light one sees flickering in a sunbeam, the molecules of gas dashing randomly in all directions. It is the atoms and molecules of matter that can be recombined and reshaped into something new such as the ordered array of atoms in a crystal or in a living cell, and it is the dusts of interstellar space that condensed to produce the sun and its planets and all the galaxies.

Everything that we understand as consistent, the living creature, the machine, the tree, are dust in its coherent phase, part of its continuous evolutionary cycle from order to disorder, from growth to decay repeated in seemingly endless variations.

According to the second law of thermodynamics, entropy is forever increasing in the universe, and with it the chaotic phase of dust, destined to triumph over order. Nonetheless, we see order arising out of chaos everywhere as the random dust of earth is assembled into complex living things.

This apparent negative entropy allows us to question if life has a quality that supersedes the laws of physics and negates the claims that this order is forever and irreversibly increasing. Life, however, is an integral part of the universe, and cannot be isolated from it. The price of organization is increased entropy everywhere, even if it is deferred or invisible.

Life is powered by a sun that has lived millions of times longer than humans and the cycles we see are tiny ripples in a system that takes billions of years to run down. These cycles are open-ended.

Every time a thing is born and later dies and decays, the world does not return to where it was before the cycle. The dust to which decay returns is greater than the dust that had created it. The cycles of life and death increase entropy; with each revolution the net disorder increases in the universe.

The disordered phase in the nature of dust grows at the expense of its ordered one.

Even the lives of stars seem cyclic. Our sun contains the debris of older generations of stars, and this cosmic recycling may last for ever. But even the life of a star is only a moment in the total life of our universe, and the birth and death of generations of stars increase disorder just as life does, and there will eventually be a final generation of stars after which there will be no more.

Pockets of dusts becoming organized and cycling through death and rejuvenation are local phenomena, pulsations immersed in a background of disorder, and are doomed to die out eventually. Even the universe may not be exempt from this principle. If the whole universe ultimately collapses and then rebounds to start over again, the next cycle will not be as energetic as this one was.

The entropy and disorder that are being produced in this universe are so fundamental that they are likely to survive the death of the universe and effect the next cycle.

The dusts of our universe are more than raw material being transformed back and forth between consistency and disarray. Within themselves they contain many levels of both organization and chaos. The nucleus of an atom can be located with high precision, but the electrons that create its envelope are in elusive disarray. The atoms are positioned precisely in molecules and arrange themselves in perfect arrays we call crystals. Most solid matter is crystalline, but consists of disordered microcrystals. Most dust particles have crystalline interiors, but the microcrystal in one speck of dust cannot co-ordinate its order with that of another grain, and the dust remains chaotic. Yet it is from these dusts that the complexities of our civilization are built. Dust on one level is chaotic, and orderly and precise on another.

As the universe evolves it creates new dusts for its various eras. At the beginning the dust of the universe was most likely high energy packed radiation. This soon decayed into a hot, compressed soup of quarks, which in turn condensed into the ordinary nuclei and matter of our present universe. Eventually all matter is likely to decay, and the only dusts larger than an electron will be black holes more massive than our sun. But even black holes decay, and if the universe lasts long enough the ultimate dust will be greatly diluted cold radiation in a vast vacuum.

Agnes Denes. *The Book of Dust: The Beginning and the End of Time and Thereafter.* Rochester, NY: Visual Studies Workshop Press, 1989.

AGNES DENES **Our Universe**

Age: 7–20 billion yrs (100–300 million human lifetimes)
Size: 7–20 billion light *ly*, visible universe (v.u.)
Life span: 100 billion yrs minimum — possibly infinite
Mass: 10^{56} g — for visible universe
Composition: hydrogen 75%, helium 23%, other elements 2%

	MICROSCOPIC	HUMAN SCALE	COSMIC
size	10^{-33} cm (Planck length)	200 cm (person)	10^{28} cm (universe)
velocity	10^{-7} cm/sec (continental drift)	100 cm/sec (man walking)	3×10^{10} cm/sec (velocity of light)
power	10^{-9} watts (neuron in brain)	10 – 20 watts (human heart)	4×10^{26} watts (sun)
numbers	less than 10 (kinds of stable particles)	10^{30} (atoms in human)	10^{80} (atoms in universe)
density	10^{-16} gm/cm3 (nucleus)	1 gm/cm3 (human)	5×10^{-30} gm/cm3 (universe)
mass	10^{-28} g (electron)	10^{5} g (human)	10^{45} gm (galaxy)
temperature	3 K (cosmic background radiation)	310 K (human body temperature)	10^{7} K (centre of sun)

That ultimate anthropocentric view that we are the centre of the universe is true in a sense. In this universe of extremes humanity is almost in the centre of its range of sizes, masses and temperatures. We are macroscopic, in the middle between cosmic and microscopic proportions. Our size is the geometric mean between atoms and the stars, 10 billion times larger than an atom, 10 billion times smaller than the sun. We are the mean between the ultra microscopic (quarks and Planck length), and the whole visible universe. Our world begins at the surface of our skin and we can peer inward and out to equal depths. Similarly, our body temperature, 300K, is the geometric mean between the 3K temperature of the universe and the 30,000K temperature of the hottest stars. Even our earth is a medium planet; there are four smaller and four larger in the solar system. We occupy a thin layer on the surface of the earth between its molten interior and frigid outer space.

Midway between these extremes of large and small numbers, in a hostile universe, we have found our narrow niche with a body large enough to develop the complicated mechanisms needed to generate intelligence, yet small enough not to be crushed by our own weight; at a temperature in which the molecules of our bodies simultaneously have the stability associated with low temperatures and the versatility for intricate reactions and complex chemistry without destroying themselves as they would at higher temperatures. The largest thing we know is the universe itself, 10^{28} cm., while the smallest is the Planck Length, the fundamental unit of quantum gravity, 10^{-33} cm. The geometric mean between the two, $[\sqrt{10^{28} \times 10^{-33}}] = 0.003$ cm, is the size of the average living cell, practically the size of man compared to the extremes that exist in the universe. Therefore life itself seems to be in the middle of existence, equidistant between two extremes.

Could our position in the centre of things be a selection effect, the consequence of our ability to measure things, or even to comprehend them? Perhaps the degree of our ability to measure the microscopic equals the extent to which we can measure the cosmic or megascopic, and we are in truth the geometric mean of the capacity of our measuring tools, placing us in a false centre of things. In that case we would believe ourselves to be in the centre of the universe no matter what our magnitude, and everywhere in the universe there must be a kind of anthropocentricity existing where everything perceives itself as the centre, from a microbe to a galaxy to a universe to a god.

Agnes Denes. *The Book of Dust: The Beginning and the End of Time and Thereafter.* Rochester, NY: Visual Studies Workshop Press, 1989.

PRIMO LEVI **Carbon**

The reader, at this point, will have realized for some time now that this is not a chemical treatise: my presumption does not reach so far – *'ma voix est faible, et même un peu profane'*. Nor is it an auto-biography, save in the partial and symbolic limits in which every piece of writing is autobiographical, indeed every human work; but it is in some fashion a history.

It is – or would have liked to be – a micro-history, the history of a trade and its defeats, victories, and miseries, such as everyone wants to tell when he feels close to concluding the arc of his career, and art ceases to be long. Having reached this point in life, what chemist, facing the Periodic Table, or the monumental indices of Beilstein or Landolt, does not perceive scattered among them the sad tatters, or trophies, of his own professional past? He only has to leaf through any treatise and memories rise up in bunches: there is among us he who has tied his destiny, indelibly, to bromine or to propylene, or the –NCO group, or glutamic acid; and every chemistry student, faced by almost any treatise, should be aware that on one of those pages, perhaps in a single line, formula, or word, his future is written in indecipherable characters, which, however, will become clear 'afterward': after success, error, or guilt, victory or defeat. Every no longer young chemist, turning again to the *verhängnisvoll* page in that same treatise, is struck by love or disgust, delights or despairs.

So it happens, therefore, that every element says something to someone (something different to each) like the mountain valleys or beaches visited in youth. One must perhaps make an exception for carbon, because it says everything to everyone, that is, it is not specific, in the same way that Adam is not specific as an ancestor – unless one discovers today (why not?) the chemist-stylite who has dedicated his life to graphite or the diamond. And yet it is exactly to this carbon that I have an old debt, contracted during what for me were decisive days. To carbon, the element of life, my first literary dream was turned, insistently dreamed in an hour and a place when my life was not worth much: yes, I wanted to tell the story of an atom of carbon.

It is right to speak of a 'particular' atom of carbon? For the chemist there exist some doubts, because until 1970 he did not have the techniques permitting him to see, or in any event isolate, a single atom; no doubts exist for the narrator, who therefore sets out to narrate.

Our character lies for hundreds of millions of years, bound to three atoms of oxygen and one of calcium, in the form of limestone: it already has a very long cosmic history behind it, but we shall ignore it. For it time does not exist, or exists only in the form of sluggish variations in temperature, daily or seasonal, if, for the good fortune of this tale, its position is not too far from the earth's surface. Its existence, whose monotony cannot be thought of without horror, is a pitiless alternation of hots and colds, that is, of oscillations (always of equal frequency) a trifle more restricted and a trifle more ample: an imprisonment, for this potentially living personage, worthy of the Catholic Hell.

To it, until this moment, the present tense is suited, which is that of description, rather than the past tense, which is that of narration – it is congealed in an eternal present, barely scratched by the moderate quivers of thermal agitation.

But, precisely for the good fortune of the narrator, whose story could otherwise have come to an end, the limestone rock ledge of which the atom forms a part lies on the surface. It lies within reach of man and his pickaxe (all honour to the pickaxe and its modern equivalents; they are still the most

important intermediaries in the millennial dialogue between the elements and man): at any moment – which I, the narrator, decide out of pure caprice to be the year 1840 – a blow of the pickaxe detached it and sent it on its way to the lime kiln, plunging it into the world of things that change. It was roasted until it separated from the calcium, which remained so to speak with its feet on the ground and went to meet a less brilliant destiny, which we shall not narrate. Still firmly clinging to two of its three former oxygen companions, it issued from the chimney and took the path of the air. Its story, which once was immobile, now turned tumultuous.

It was caught by the wind, flung down on the earth, lifted ten kilometres high. It was breathed in by a falcon, descending into its precipitous lungs, but did not penetrate its rich blood and was expelled. It dissolved three times in the water of the sea, once in the water of a cascading torrent, and again was expelled. It travelled with the wind for eight years: now high, now low, on the sea and among the clouds, over forests, deserts, and limitless expanses of ice; then it stumbled into capture and the organic adventure.

Carbon, in fact, is a singular element: it is the only element that can bind itself in long stable chains without a great expense of energy, and for life on earth (the only one we know so far) precisely long chains are required. Therefore carbon is the key element of living substance: but its promotion, its entry into the living world, is not easy and must follow an obligatory, intricate path, which has been clarified (and not yet definitively) only in recent years. If the elaboration of carbon were not a common daily occurrence, on the scale of billions of tons a week, wherever the green of a leaf appears, it would by full right deserve to be called a miracle.

The atom we are speaking of, accompanied by its two satellites which maintained it in a gaseous state, was therefore borne by the wind along a row of vines in the year 1848. It had the good fortune to brush against a leaf, penetrate it, and be nailed there by a ray of the sun. If my language here becomes imprecise and allusive, it is not only because of my ignorance: this decisive event, this instantaneous work a *tre* – of the carbon dioxide, the light, and the vegetal greenery – has not yet been described in definitive terms, and perhaps it will not be for a long time to come, so different is it from that other 'organic' chemistry which is the cumbersome, slow, and ponderous work of man: and yet this refined, minute, and quick-witted chemistry was 'invented' two or three billion years ago by our silent sisters, the plants, which do not experiment and do not discuss, and whose temperature is identical to that of the environment in which they live. If to comprehend is the same as forming an image, we will never form an image of a happening whose scale is a millionth of a millimetre, whose rhythm is a millionth of a second, and whose protagonists are in their essence invisible. Every verbal description must be inadequate, and one will be as good as the next, so let us settle for the following description.

Our atom of carbon enters the leaf, colliding with other innumerable (but here useless) molecules of nitrogen and oxygen. It adheres to a large and complicated molecule that activates it, and simultaneously receives the decisive message from the sky, in the flashing form of a packet of solar light: in an instant, like an insect caught by a spider, it is separated from its oxygen, combined with hydrogen and (one thinks) phosphorus, and finally inserted in a chain, whether long or short does not matter, but it is the chain of life. All this happens swiftly, in silence, at the temperature and pressure of the atmosphere, and gratis: dear colleagues, when we learn to do likewise we will be *sicut Deus*, and we will have also solved the problem of hunger in the world.

But there is more and worse, to our shame and that of our art. Carbon dioxide, that is, the aerial form of the carbon of which we have up till now spoken: this gas which constitutes the raw material of life, the permanent store upon which all that grows draws, and the ultimate destiny of all flesh, is not one of the principal components of air but rather a ridiculous remnant, an 'impurity', thirty times less abundant than argon, which nobody even notices. The air contains 0.03 per cent; if Italy was air, the only Italians fit to build life would be, for example, the fifteen thousand inhabitants of Milazzo in the province of Messina. This, on the human scale, is ironic acrobatics, a juggler's trick, an incomprehensible display of omnipotence-arrogance, since from this ever renewed impurity of the air we come, we animals and we plants, and we the human species, with our four billion discordant opinions, our millenniums of history, our wars and shames, nobility and pride. In any event, our very presence on the planet becomes laughable in geometric terms: if all of humanity, about 250 million tons, were distributed in a layer of homogeneous thickness on all the emergent lands, the 'stature of man' would not be visible to the naked eye; the thickness one would obtain would be around sixteen thousandths of a millimetre.

Now our atom is inserted: it is part of a structure, in an architectural sense; it has become related and tied to five companions so identical with it that only the fiction of the story permits me to distinguish them. It is a beautiful ring-shaped structure, an almost regular hexagon, which however is subjected to complicated exchanges and balances with the water in which it is dissolved; because by now it is dissolved in water, indeed in the sap of the vine, and this, to remain dissolved, is both the obligation and the privilege of all substances that are destined (I was about to say 'wish') to change. And if then anyone really wanted to find out why a ring, and why a hexagon, and why soluble in water, well, he need not worry: these are among the not many questions to which our doctrine can reply with a persuasive discourse, accessible to everyone, but out of place here.

It has entered to form part of a molecule of glucose, just to speak plainly: a fate that is neither fish, flesh, nor fowl, which is intermediary, which prepares it for its first contact with the animal world but does not authorize it to take on a higher responsibility: that of becoming part of a proteic edifice. Hence it travels, at the slow pace of vegetal juices, from the leaf through the pedicel and by the shoot to the trunk, and from here descends to the almost ripe bunch of grapes. What then follows is the province of the winemakers: we are only interested in pinpointing the fact that it escaped (to our advantage, since we would not know how to put it in words) the alcoholic fermentation, and reached the wine without changing its nature.

It is the destiny of wine to be drunk, and it is the destiny of glucose to be oxidized. But it was not oxidized immediately: its drinker kept it in his liver for more than a week, well curled up and tranquil, as a reserve aliment for a sudden effort; an effort that he was forced to make the following Sunday, pursuing a bolting horse. Farewell to the hexagonal structure: in the space of a few instants the skein was unwound and became glucose again, and this was dragged by the bloodstream all the way to a minute muscle fibre in the thigh, and here brutally split into two molecules of lactic acid, the grim harbinger of fatigue: only later, some minutes later, the panting of the lungs was able to supply the oxygen necessary to quietly oxidize the latter. So a new molecule of carbon dioxide returned to the atmosphere, and a parcel of the energy that the sun had handed to the vine-shoot passed from the state of chemical energy to that of mechanical energy, and thereafter settled down in the slothful condition of heat, warming up imperceptibly the air moved by the running and the blood of the runner. 'Such is

life', although rarely is it described in this manner: an inserting itself, a drawing off to its advantage, a parasitizing of the downward course, which leads to equilibrium and thus death, life draws a bend and nests in it.

Our atom is again carbon dioxide, for which we apologize: this too is an obligatory passage; one can imagine and invent others, but on earth that's the way it is. Once again the wind, which this time travels far; sails over the Apennines and the Adriatic, Greece, the Aegean, and Cyprus: we are over Lebanon, and the dance is repeated. The atom we are concerned with is now trapped in a structure that promises to last for a long time: it is the venerable trunk of a cedar, one of the last; it is passed again through the stages we have already described, and the glucose of which it is a part belongs, like the bead of a rosary, to a long chain of cellulose. This is no longer the hallucinatory and geological fixity of rock, this is no longer millions of years, but we can easily speak of centuries because the cedar is a tree of great longevity. It is our whim to abandon it for a year or five hundred years: let us say that after twenty years (we are in 1868) a woodworm has taken an interest in it. It has dug its tunnel between the trunk and the bark, with the obstinate and blind voracity of its race; as it drills it grows, and its tunnel grows with it. There it has swallowed and provided a setting for the subject of this story; then it has formed a pupa, and in the spring it has come out in the shape of an ugly gray moth which is now drying in the sun, confused and dazzled by the splendour of the day. Our atom is in one of the insect's thousand eyes, contributing to the summary and crude vision with which it orients itself in space. The insect is fecundated, lays its eggs, and dies: the small cadaver lies in the undergrowth of the woods, it is emptied of its fluids, but the chitin carapace resists for a long time, almost indestructible. The snow and sun return above it without injuring it: it is buried by the dead leaves and the loam, it has become a slough, a 'thing', but the death of atoms, unlike ours, is never irrevocable. Here are at work the omnipresent, untiring, and invisible gravediggers of the undergrowth, the micro-organisms of the humus. The carapace, with its eyes by now blind, has slowly disintegrated, and the ex-drinker, ex-cedar, ex-woodworm has once again taken wing.

We will let it fly three times around the world, until 1960, and in justification of so long an interval in respect to the human measure we will point out that it is, however, much shorter than the average: which, we understand, is two hundred years. Every two hundred years, every atom of carbon that is not congealed in materials by now stable (such as, precisely, limestone, or coal, or diamond, or certain plastics) enters and re-enters the cycle of life, through the narrow door of photosynthesis. Do other doors exist? Yes, some syntheses created by man; they are a title of nobility for man-the-maker, but until now their quantitative importance is negligible. They are doors still much narrower than that of the vegetal greenery; knowingly or not, man has not tried until now to compete with nature on this terrain, that is, he has not striven to draw from the carbon dioxide in the air the carbon that is necessary to nourish him, clothe him, warm him, and for the hundred other more sophisticated needs of modern life. He has not done it because he has not needed to: he has found, and is still finding (but for how many more decades?) gigantic reserves of carbon already organicized, or at least reduced. Besides the vegetable and animal worlds, these reserves are constituted by deposits of coal and petroleum: but these too are the inheritance of photosynthetic activity carried out in distant epochs, so that one can well affirm that photosynthesis is not only the sole path by which carbon becomes living matter, but also the sole path by which the sun's energy becomes chemically usable. It is possible to demonstrate that this completely arbitrary story is nevertheless true. I could tell

innumerable other stories, and they would all be true: all literally true, in the nature of the transitions, in their order and data. The number of atoms is so great that one could always be found whose story coincides with any capriciously invented story. I could recount an endless number of stories about carbon atoms that become colours or perfumes in flowers; of others which, from tiny algae to small crustaceans to fish, gradually return as carbon dioxide to the waters of the sea, in a perpetual, frightening round-dance of life and death, in which every devourer is immediately devoured; of others which instead attain a decorous semi-eternity in the yellowed pages of some archival document, or the canvas of a famous painter; or those to which fell the privilege of forming part of a grain of pollen and left their fossil imprint in the rocks for our curiosity; of others still that descended to become part of the mysterious shape-messengers of the human seed, and participated in the subtle process of division, duplication, and fusion from which each of us is born. Instead, I will tell just one more story, the most secret, and I will tell it with the humility and restraint of him who knows from the start that his theme is desperate, his means feeble, and the trade of clothing facts in words is bound by its very nature to fail.

It is again among us, in a glass of milk. It is inserted in a very complex, long chain, yet such that almost all of its links are acceptable to the human body. It is swallowed; and since every living structure harbours a savage distrust towards every contribution of any material of living origin, the chain is meticulously broken apart and the fragments, one by one, are accepted or rejected. One, the one that concerns us, crosses the intestinal threshold and enters the bloodstream: it migrates, knocks at the door of a nerve cell, enters, and supplants the carbon which was part of it. This cell belongs to a brain, and it is my brain, the brain of the me who is writing; and the cell in question, and within it the atom in question, is in charge of my writing, in a gigantic minuscule game which nobody has yet described. It is that which at this instant, issuing out of a labyrinthine tangle of yeses and nos, makes my hand run along a certain path on the paper, mark it with these volutes that are signs: a double snap, up and down, between two levels of energy, guides this hand of mine to impress on the paper this dot, here, this one.

Primo Levi. *The Periodic Table*. London: Penguin UK, 1986.

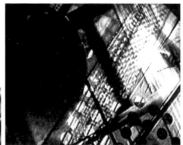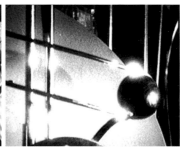

MARK NASH **The Art of Movement**

Guy Brett's exhibition and catalogue essay *Force Fields: The Century of Kinesthesia* reintroduces us to an investigation of movement in art which mid-20th-century became obscured by waves of more fashionable movements: Pop Art, Minimal Art, Conceptual Art etc. It also reintroduces us to the scientific investigations of artists – in particular a theme of cosmic speculation which he traces through the work of artists included in the exhibition. Both elements have been present throughout the century's production of art, and it would be interesting to explore why they have been so repressed in recent years. This is not really the place to do so, except to point out that the exhibition is ambitiously revisionist in its aim to reintroduce us to themes and preoccupations which were central to much 20th-century art practice.

Certainly my own introduction to contemporary art in the late 1960s came at a moment when both the art of movement and the parallels between investigations of scientists and artists were very much in the public eye, in Great Britain at least. While C.P. Snow elaborated on what he perceived as a widening gap between the sciences and the humanities,[1] scientists like embryologist C.H. Waddington pursued an almost inverse tack – exploring the connections between the scientific and artistic imagination.[2]

In this essay, however, I want to focus on a further paradox, the contribution of cinema to this art of movement, and to remind readers that there is another history of cinema than that classic cinema preserved in the major film archives such as the Cinémathèque Française or the British Film Institute, but instead represented in such collections as those of film Co-ops or the Collection of the Musée National d'Art Moderne in Paris – concerned with the art of movement.

To avoid being distracted by the flood of terms (experimental, avant-garde, underground etc.) which has accumulated over the years in discussion of this cinema, Jean-Michel Bouhours in his catalogue essay to introduce the Centre Georges Pompidou's collection[3] proposes a focus on the fundamental artistic preoccupation with movement in this 'other' cinema. He draws on Gilles Deleuze's argument that cinema repeats at a faster pace the revolution in philosophy that had taken place over several centuries from the pre-Socratics to Kant: "The subordination of time to movement was reversed, time ceases to be the measurement of normal movement, it appears increasingly for itself... The movement-image of the so-called classical cinema gave way in the post-war period to a direct time image."[4]

In his discussion of the movement-image, Deleuze in turn explores Henri Bergson's theses on movement. There are three. The first is that cinema gives us a false movement, reconstructing movement in line with Zeno's paradox of the flying arrow.[5] The second concerns cinema as the last descendant of the lineage of modern science in its "aspiration to take time as an independent variable". Here "the determining conditions of the cinema are... not merely the photo but the snapshot... the equidistance of snapshots; the transfer of this equidistance onto a framework which constitutes the 'film' (it was Edison and Dickson who perforated the film in the camera); a mechanism for moving on images (Lumiere's claws). It is in this sense that the cinema is the system which reproduces movement as a function of any-instance-whatever that is, as a function of equidistant instants, selected so as to create an impression of continuity." The third thesis, reduced to a formula, is that "not only is the instant an immobile section of movement, but movement is an immobile section of duration". In other words, not only are there the equidistant snapshots, instantaneous images, immobile sections of movement, but there are movement-images which are mobile sections of duration and finally time images "that is duration-images, change images, relation images ... which are beyond movement itself."[6]

As *Force Fields* demonstrates, the historic avant garde's questioning of the status of movement in the arts was just as important as their questioning of vision. Indeed movement was an integral part of what Bouhours calls Marcel Duchamp's "speculative exploration of non-Euclidian space and the fourth dimension"[7] in his *Rotoreliefs* and *Anémic cinéma* (1925). Marey's cinematographic gun, developed in 1892, seized an instant of time, producing a still from a moving image. When published in *Nature* Marey's images impressed both the Futurists Giacomo Balla and Arturo Bragaglia as well as Marcel Duchamp, whose painting *Nude Descending a Staircase* demonstrates how movement escapes space to become duration.

In its reconstitution of a key trajectory in 20th-century art, *Force Fields* also points to the contradictory position in which experimental and avant-garde cinema found itself from the 1920s on. On the one hand, cinema's founding principle of snapshot images in motion would appear to make it central to the exploration of movement in the visual arts more generally (as envisaged in the 1916 *Futurist Cinema Manifesto*). But on the other hand, the motion picture camera seemed destined to return us to Quattrocento perspective, as well as transmit 19th-century codes of realism into the 20th-century. The advent of the talkies from 1929 on, it is often argued, had the effect of sealing cinema in the novelistic and theatrical dramaturgy of the previous century, dominated by codes of realism and melodrama (the kind of cinema already dismissed in 1925 by Malevich as 'ciné-baiser' [cine-kiss, cine-fuck]).[8]

The involvement of the historic avant gardes – Futurists, Cubists, Dadaists and Surrealists – with experimental cinema is now relatively well documented (though museums and galleries have an uneven record in preserving and exhibiting this history). In his *A History of Experimental Film and Video*,[9] A. L. Rees suggests that early avant-garde films followed two routes –the abstract film, and the burlesque and parody of early 'pre-realist' film drama. Abstract film followed the Neo-Impressionist claim that a painting is a flat surface covered with colour –some of the earliest abstract avant-garde films were strips of film hand-painted by the Futurist artists Ginna (Arnaldo Ginanni Corradini) and Bruno Corra as early as 1910. Len Lye rediscovered the hand-painted film in the mid 1930s. Lye's later films *Free Radicals* (1958) and *Particles in Space* (1979) utilise the simplest of scratching techniques on the film emulsion and in so doing he opens depths and fields of energy which only his kinetic sculptures had been able to achieve until then.[10]

The comic and burlesque artists' cinema was also able to bypass realism, drawing on film-making devices which realist film largely excluded such as stop-frame, variable speed, reverse motion, etc. Both currents were, so to speak, a response to the consolidation of the silent narrative feature film in both mainstream and art house variants around a realist aesthetic.

London 1926. Virginia Woolf is in the cinema watching *The Cabinet of Dr Caligari* (1919): "A shadow shaped like a tadpole suddenly appeared at one corner of the screen. It swelled to an immense size, quivered, bulged, and sank back again into nonentity. For a moment it seemed to embody some monstrous, diseased imagination of the lunatic's brain. For a moment it seemed as if thought could be conveyed by shape more effectively than by words."

In her essay *The Cinema*[11] from which this quotation is taken, Woolf speculates about a secret language which we feel and see, but never speak. Could this be made visible to the eye, she asks? Is it possible to render thought visible without the help of words? "Yet if so much of our thinking and feeling is connected with seeing, some residue of visual emotion which is of no use to painter or to poet may still await the cinema. The symbols of this cinema, she imagines, will be quite unlike the real objects which we see before us". It will be abstract, "but how it is to be attempted much less achieved no one at the moment can tell us."

Woolf dismisses cinema's attempt to reproduce the experience of literature and theatre as redundant, rather imagining a cinema of abstract emotions. For her the serendipitous appearance of the tadpole is a pointer to a potential in cinema which even narrative art films such as *Caligari* cannot develop. Many writers and artists similarly decried mainstream cinema's dependence on outmoded forms. Picabia in 1932 compared it to a "poor man's Museé Grevin designed to appeal to the most base instincts of the public."[12]

Woolf had not yet seen the abstract and animated cinema that was then taking shape on the Continent in the work of, say, Hans Richter, Viking Eggeling or Oscar Fischinger premiered in Berlin in November 1925 –a programme of Dada, Cubist and Bauhaus artists which also included a presentation of a *Light-Play* projection work by Hirschfeld Mack, one of the originatory moments of abstract cinema. (Films by several of these artists are included in the *Force Fields* exhibition and supporting film programme.)

Synaesthesia/music

Bouhours traces the origin of abstract cinema to the long tradition of synaesthesia which finds its most notable expression in Richard Wagner's concept of the *Gesamtkunstwerk*.[13] This idea of the interpenetration of different art forms, and of music as, so to speak, a master discourse, was very influential in the early decades of the century.

Much abstract film was preoccupied with attaining what Walter Pater termed the 'condition of music'.[14] Walter Ruttman's *Lichtspiel Opus 1* (1921) is the first extant abstract film. In his own words: "This photo-dramatic work inaugurates a totally new genre of artistic creation... This young art elevates itself to a purity comparable to music. An optical symphony which until now was a speculation reserved for aesthetics."[15]

Both Eggeling and Richter tried to develop a visual equivalent to Ferrucio Busoni's musical counterpoint.[16] Oscar Fischinger pursued a complex, abstract but musically motivated cinema that was different from that of both Richter and Eggeling. William Moritz[17] points to Fischinger's interest in the meditative structures of Tibetan Buddhism, which were to be so important for James Whitney as well as Jordan Belson half a century later (Whitney's early works also developed under a musical paradigm – Shoenberg; and the electronic score for *Yantra* was prepared with Belson's help).

Ballet Mécanique, the film by Dudley Murphy (which traditionally bears Fernand Léger's name), is important here also. Of Murphy's previous visual symphonies – films synchronised to classical music – only one survives apart from *Ballet Mécanique*, which was synchronised to a 'musical engineering' score by George Antheil. Less than abstract, *Ballet Mécanique* connects with the French *cinepoème* movement: for instance Henri Chomette's *Cinq Minutes de Cinéma Pur (1925)*, which A.L. Rees describes as a "delirious travelogue of Paris", marked by the stress on rhythmic editing, or Germaine Dulac's *Etude Cinégraphique sur un Arabesque* (1929) which observed the beauty of machines and "no more abandoned referentiality than did the poems of Pound or Eliot or the paintings of Picasso or Braque".[18]

René Clair's more famous *Entr'acte* (1924) fully 'crosses over' to the non-abstract comic and burlesque artists' cinema. This more referential cinema is not the focus of *Force Fields*, but we do well to remember that individual film-makers crossed between more and less referential work. Norman McLaren is represented by his *Lines Vertical* (1960) and *Lines Horizontal* (1962), but works such as *Neighbours* (1952) – a pixillated comedy of nuclear war – embrace the high burlesque.

Light/Vision

Working at the same time as Man Ray, László Moholy-Nagy developed the idea of an art of light through photograms, films and sculptures. In *Lichtspiel Schwarz-weiss-grau* (Light Play: Black – White – Gray, 1930) he films the *Light-Space Modulator*. His recording of the light transmitted and reflected by the sculpture is more than documentary – it emphasises that the work of art consists of a play of light through the movement of forms. The film is an equivalent to the sculpture itself. It connects to a performative element in the post-war avant garde, of which Anthony McCall's luminous kinetic film sculptures such as *Line describing a Cone* (1973) or Nam Jun Paik's *Zen for Film* (1964) are the most emblematic. (Paik's film uses the Brownian motion of dust deposited on the film as it moves through the projector, McCall exhorts the audience to smoke during the performance, thereby gradually increasing the opacity of the luminous volume through which the projector light passes.)

In both the post-war art and avant-garde cinemas movement has been subordinated to time, to duration. While Deleuze's discussion of the movement-image embraces both the historic avant-gardes as well as the classic narrative pre-war cinema, his discussion of the time-image focuses on post-war art cinema, and does not adequately cover the full range of experimentation with time and the time image in the avant garde. Michael Snow's *Wavelength* (1966-1967) or Andy Warhol's early films present a time-image interspersed with faint traces of the movement-image, emblematic of the problematic of movement and time already investigated by Duchamp so many years before. (Warhol is present in the exhibition through Willard Maas's film of an ephemeral Warhol sculpture *Andy Warhol's Silver Flotations*; 1966).

The post-war avant garde's concern with movement and image is complex. Some, for example the *cinéma direct* of Stan Brakhage or Len Lye, continue the investigations of Man Ray's and Moholy-Nagy's rayograms. But many of the structuralist film makers, from Peter Kulbelka to Peter Gidal, search for a materiality in and of the image to create a new visual language specific to the cinema machine and distinct from 'natural' human perception, and where the issues of both movement and time are subordinated to a new research of vision. Many of the films of structural cinema bear a superficial resemblance to the investigations of the earlier abstract cinema; however, their resort to a visual aggressiveness (most notable in the films of Kulbelka or Paul Sharits), and their concern with work at the level of the frame or photogramme, mark a concern with optical and visual impression that finds an equivalent in the painting or sculpture of Bridget Riley or Victor Vasarely.

James Whitney's *Yantra* is constructed with patterns of dots at the level of the frame, but it is pre-eminently concerned with complex patterns of movement rather than with optical impression. And in its evocation of Buddhist mantras it is paradoxically more tied in to issues of reference than his brother John's films (which more simply reflect the computer machinery that generated them).[19]

Structural cinema is outside the remit of *Force Fields*, not because it is less speculative or less concerned with kinetic issues, which one could argue, but because theirs is really a different problematic. In their focus on the interaction of frames, on editing at the level of the photogramme, they are closest at a formal level to the pre-war experimental Soviet cinema, for example that of Dziga Vertov.

In recent years – perhaps under the influence of polemics such as Peter Wollen's 1976 'The Two Avant Gardes'[20] which argues for an avant garde which retained an element of representation and referentiality as well as a political discourse in its film-making – there has been a tendency to place all 'poetic', non- or anti-representational experimental cinema in one non-political 'avant-garde' camp. It is the hope of this *Force Fields* exhibition to single out one thread amongst several within the art of movement for serious aesthetic and political debate.

1 *The Two Cultures*. London; New York: Cambridge University Press, 1993.

2 *Behind Appearance*. Edinburgh: Edinburgh U.P., 1969.

3 *L'Art du Mouvement*. Paris: Centre Georges Pompidou, 1996.

4 *Cinema 2. The Time-Image*. London: Athlone, 1989, p. xi.

5 Zeno of Elea, the pupil and friend of Parmenides who, according to Aristotle, invented dialectic, and whose paradoxes concerning the analysis of motion include the fable of Achilles who should not be able to outrun the tortoise and the flying arrow "which is always opposite a length of ground equal to itself and is therefore at every moment at rest." For Zeno this paradox refuted the hypothesis that Being was composed of indivisible magnitudes. The regular film strip — divided into frames — appears to support Zeno's paradox, demonstrating that movement is divisible into moments at rest.

6 Bergson quoted in *Cinema 1. The Movement-Image*. London: Athlone, 1986, p. 4.

7 *L'Art du Mouvement*, p. 8.

8 Quoted in *L'Art du Mouvement*, p. 9.

9 London: British Film Institute, 1999.

10 Yann Beauvais. *L'Art du Mouvement*, p. 258.

11 First published in *Arts* June 1926. This version published in *The Captain's Deathbed and Other Essays*, and reprinted in Michael O'Pray, ed. *The British Avant-Garde Film 1926-1995*. Luton: Arts Council/John Libbey 1996.

12 *L'Art du Mouvement*, p. 8.

13 *L'Art du Mouvement*, p. 10.

14 "I have spoken of a certain interpenetration of the matter or subject of a work of art with the form of it, a condition realised absolutely only in music, as the condition to which every form of art is perpetually aspiring." Walter Pater. *The Renaissance*. London: 1873, p. 156.

15 Quoted in *L'Art du Mouvement*, p. 395.

16 Eggeling had exhibited paintings at the Cabaret Voltaire from 1916, where he was introduced by Tristan Tzara to Hans Richter with whom he later collaborated.

17 *L'Art du Mouvement*, p. 154.

18 *History of Experimental Cinema and Video*, p. 35.

19 In his essay on James Whitney (*L'Art du Mouvement*, p. 461) William Moritz attributes Whitney's use of the dot to his discovery that some of his engineering design work had inadvertently contributed to the Manhattan Project. As a result he decided to base his future films including *Lapis* and *Yantra* on the dot, eschewing the use of the line which had ended up in the atom bomb! The paradoxical atomic reference of these dots recalls the scientific reference that also occurs in Lye's *Free Radicals* and *Particles in Space*.

20 Reprinted in Peter Wollen *Readings and Writings*. London: Verso, 1982.

LIST OF WORKS

POL BURY
(Haine-Saint-Pierre, Belgium, 1922)

Surface Vibratile
(Stimulated Surface)
1960
Relief, nylon threads on wood, electric motor
61.5 x 60.9 x c. 9 cm
Wilhelm Lehmbruck Museum, Duisburg

1110 White Dots Leaving a Hole-Punctuation
1964
Wood, wire, electric motor
53 x 53 x 20 cm
Städtisches Museum, Gelsenkirchen

Septante-deux boules, grosses, petites et moyennes
(Seventy-two Balls, Large, Small and Medium)
1964
Wooden balls, wood, wire, electric motor mounted on board
80 x 62 x 11 cm
Collection of Patricia Phelps de Cisneros, Caracas

Ponctuation (points blancs)
(Punctuation [White Dots])
1965
Wood, painted nylon threads, electric motor
100 x 100 x 13 cm
Musée d'Art moderne et d'Art contemporain de la Ville de Liège

ALEXANDER CALDER
(Philadelphia, USA 1898 –
New York, USA, 1976)

A White Ball, A Black Ball ●
1930. Reconstructed 1969
Mobile, painted metal, steel, wood
Height: 242 cm
Fondation Marguerite et Aimé Maeght, Saint-Paul de Vence, France

Untitled
1933
Wood, wire, cord, aluminium sheet
120 x 74 x 55 cm
Collection of the MACBA. Fundació Museu d'Art Contemporani de Barcelona

Untitled
1933
Wood, wire, iron, tempera
180 x 110 x 120 cm
Collection of the MACBA. Fundació Museu d'Art Contemporani de Barcelona

SÉRGIO CAMARGO
(Rio de Janeiro, Brazil, 1930–1990)

Relief no. 289 A
1970
Wood painted white
100 x 100 cm
Collection of Michael A. Grossmann, São Paulo

LYGIA CLARK
(Belo Horizonte, Brazil, 1920 –
Rio de Janeiro, Brazil, 1988)

Caminhando ▲
(Walking)
1963
Participatory proposition. Paper strip, glue, scissors

Ar e pedra ▲
(Air and Stone)
1966
Participatory proposition. Stone, plastic bag, rubber band

Respire comigo ▲
(Breathe with Me)
1966
Participatory proposition. Rubber tube

Diálogo de mãos ▲
(Dialogue of Hands)
1966
Participatory proposition made jointly with Hélio Oiticica
Elastic Moebius band

GIANNI COLOMBO
(Milan, Italy, 1937–1993)

Spazio elastico
(Elastic Space)
1967
Elastic thread, black light, motors

400 x 400 x 400 cm
Venice Bienal, 1968. The version shown is a reconstruction made by the Galleria d'Arte Moderna e Contemporanea, Bergamo, on the occasion of the exhibition I Colombo, Bergamo, 1995. Galleria d'Arte Moderna e Contemporanea, Bergamo

LEANDRE CRISTÒFOL
(Os de Balaguer, Spain, 1908 –
Lleida, Spain, 1998)

Aparença excèntrica (Ralentí) ●
(Eccentric Appearance [Slow Motion])
1957
Steel, glass, cork, painted cork, rubber
51 x 28 x 25 cm
Museu d'Art Jaume Morera, Lleida

Ralentí ●
(Slow Motion)
1957
Steel, wood, cork
120 x 30 x 30 cm
Museu Nacional d'Art de Catalunya
(Museu d'Art Modern, Barcelona)

Ralentí ●
(Slow Motion)
1957
Cork, metal rod, steel, mother-of-pearl
36 x 71.5 x 38.5 cm
Museu d'Art Jaume Morera, Lleida

AGNES DENES
(Budapest, Hungary, 1931)

Snail People - The Vortex
1989
Indian ink on vellum
105 x 136 cm
From the Collection of John and Catherine Morse, New York

CHARLES DOCKUM
(Corsicana, Texas, USA, 1904-1977)

Documentary film of *Mobilcolor* V
(Kinetic light display projector)
1966-1970
Videotape
10 min., colour

● Artwork only exhibited in the Macba, Barcelona

▲ Artwork only exhibited in the Hayward Gallery, London

MARCEL DUCHAMP
(Blainville, France, 1887 –
Neuilly-sur-Seine, France, 1968)

Anémic cinéma
(Anaemic cinema)
1925–1926
16 mm, 7 min., black and white, silent
Courtesy Mme. Jacqueline Matisse-Monnier

(with Man Ray)
Rotative plaques-verre (optique de précision)
(Rotary Glass plates [Precision Optics])
1920. Replica made in 1961
Steel, acrylic, paint, electric motor
121 x 184 x 100 cm
Moderna Museet, Stockholm

Rotoreliefs (disques optiques)
(Rotoreliefs [Optical Discs])
1935
Series of 6 cardboard discs printed on both
sides
Ø 20 cm
Stedelijk Van AbbeMuseum, Eindhoven

LUCIO FONTANA
(Rosario de Santa Fe, Argentina, 1899 –
Varese, Italy, 1968)

Ricerca spaziale
(Spatial Research)
1946
Blue ball-point pen and pencil on paper
23.3 x 29.2 cm
Fondazione Lucio Fontana, Milan

Concetto spaziale (49 B2) ●
(Spatial Concept)
1949
Holes and scratches on untreated paper
mounted on canvas
100 x 100 cm
Fondazione Lucio Fontana, Milan

Concetto spaziale (51 B17)
(Spatial Concept)
1951
Oil, holes, sand on canvas
60 x 59 cm
Fondazione Lucio Fontana, Milan

Ricerca spaziale
(Spatial Research)
1951
Pencil on paper
23.2 x 29.3 cm
Fondazione Lucio Fontana, Milan

Ricerca spaziale
(Spatial Research)
1951
Pencil on paper
23.2 x 29 cm
Fondazione Lucio Fontana, Milan

Ricerca spaziale
(Spatial Research)
1951
Black and coloured inks, ball-point pen on
paper
28 x 22 cm
Fondazione Lucio Fontana, Milan

Concetto spaziale (52 B2) ▲
(Spatial Concept)
1952
Oil and glitter on paper, mounted on canvas
50 x 50 cm
Private collection, Europe

Concetto spaziale (52 B9) ●
(Spatial Concept)
1952
Oil and glitter on wallpaper
80 x 80 cm
Museo Nacional Centro de Arte Reina Sofía,
Madrid

GEGO (Gertrud Goldschmidt)
(Hamburg, Germany, 1912 –
Caracas, Venezuela, 1994)

Chorro no. 3
(Stream no. 3)
c. 1970
Anodized aluminium, with red painted
rods in the centre
340 x 60 x 45 cm (approx.)
Museo de Barquisimeto, Venezuela

Chorro no. 8
(Stream no. 8)
1970
Anodized aluminium
350 x 45 x 45 cm (approx.)
Museo de Barquisimeto, Venezuela

Chorro no. 9
(Stream no. 9)
1970
Anodized aluminium
470 x 60 x 60 cm
Museo de Barquisimeto, Venezuela

Chorro
(Stream)
1970
Aluminium rods

Height: 280 cm
Collection of Bárbara Gunz

Untitled
1970
Ink on paper
30 x 29 cm
Collection of the Fundación Gego,
Caracas

Untitled
1970
Ink on paper
65.5 x 50.2 cm
Collection of the Fundación Gego,
Caracas

Untitled
1970
Ink on paper
65.5 x 50.2 cm
Collection of the Fundación Gego,
Caracas

Untitled
1970
Ink on paper
29 x 29 cm
Collection of the Fundación Gego,
Caracas

Chorro – Tres agrupaciones
(Stream – Three Groupings)
c. 1970-1971
Aluminium rods and steel painted red and
black – group of three
240 x 8 x 6 cm / 2.4 x 12 x 20 cm / 2.4 x 20
x 15 cm
Collection of Tomás Gunz

Reticulárea cuadrada ●
(Square Reticularia)
1971-1972
Stainless steel wire, small tubes, metal rings
350 x 130 x 130 cm
Private collection

Chorro
(Stream)
1974
Aluminium rods
Height: 495 cm
Universidad Central de Venezuela

Dibujo sin papel 78/11
(Drawing without paper 78/11)
1978
Metal assemblage
37.9 x 40.5 x 2.5 cm
Collection of the Fundación Gego, Caracas

Dibujo sin papel 85/2
(Drawing without paper 85/2)
1985
Metal assemblage
38.3 x 49 x 0.5 cm
Collection of the Fundación Gego, Caracas

Dibujo sin papel 5
(Drawing without paper 5)
1985
Stainless steel wire, aluminium wire, metallic rods, red wire
77 x 71 x 5 cm
Collection of the Fundación Gego, Caracas

Chorro
(Stream)
1988
Treated steel wires
175 x 92 x 74 cm
Collection of Banco Mercantil, Venezuela

Untitled (From the series 'Dibujos sin papel' [Drawings without Paper])
c. 1988
Stainless steel, lead
94 x 68.6 x 7.6 cm
Collection of Patricia Phelps de Cisneros, Caracas

Dibujo sin papel 88/36
(Drawing without paper 88/36)
1988
Bronze rod and steel mesh
33 x 33 cm
Collection of the Fundación Gego, Caracas

GERHARD VON GRAEVENITZ
(Schilde, Mark Branderburg, Germany 1934-1983)

Kinetisches Objekt. Weiße, kurze, exzentrische Streifen auf Schwarz
(Kinetic Object. White, Short, Eccentric Strips on Black)
1963
Motorised relief
102 x 102 cm
Staatliches Museum, Schwerin

Kinetisches Objekt. Weiße Streifen auf Schwarz
(Kinetic Object. White Lines on Black)
1964
Motorised relief
82 x 82 x 10 cm
John and Mary McNeil

Kinetisches Objekt mit 37 weißen Scheiben auf weiß
(Kinetic Object with 37 White Discs on White)
1967
Motorised relief
Ø 202 cm
Staatliche Museum, Nationalgalerie, Berlin

GUTAI Group

Games Played with Human Beings and Objects (Manifestation at Expo 1970)
Videotape documentary
20 min., colour
Courtesy of Ashiya City Museum of Art & History

HANS HAACKE
(Cologne, Germany, 1936)

Condensation Cube
1963
Perspex, water, light
100 x 100 x 100 cm
Collection of the artist

Sphere in Oblique Air-Jet
1967
Balloon, electric fan, casing
Variable dimensions
Collection of the artist

Narrow White Flow
1967-1968. Reconstruction 2000
White fabric, electric fan
Variable dimensions
Collection of the artist

Circulation
1969. Reconstruction 2000
Clear plastic tubes, pump, water, air
Variable dimensions
Collection of the artist

P.K. HOENICH
(Czernowitz [Austro-Hungary], 1907 – Haifa, Israel, 1997)

Sun Paintings-Robot Art
Demonstration of the reflectors
1959-1997
Video documentary compilation
4.30 min., colour and black and white
Courtesy of Ruth Hoenich and Prof. Michael Burt

DOM SYLVESTER HOUÉDARD
(Guernsey, Great Britain, 1924-1991)

In Memoriam Konrad Bayer
1964
Typestract on paper
13.6 x 20.3 cm
The Ruth and Marvin Sackner Archive of Concrete and Visual Poetry

Untitled
1964
Typestract on paper
16.2 x 17.5 cm
The Ruth and Marvin Sackner Archive of Concrete and Visual Poetry

Moonblase – 3, crescent increscent
1967
Typestract on paper
15.7 x 20.3 cm
The Ruth and Marvin Sackner Archive of Concrete and Visual Poetry

Red Basket with Blue Womb of Mrs. Iyatiku God
1967
Typestract on paper
32.9 x 19.9 cm
The Ruth and Marvin Sackner Archive of Concrete and Visual Poetry

Shaman w/ 5 Chakras & Central Susumna Pole; 5 Shaman Worlds w/ Central Pole to Sky
1967
Typestract on paper
20.2 x 14.2 cm
The Ruth and Marvin Sackner Archive of Concrete and Visual Poetry

Untitled
1967
Typestract on paper
33 x 20.3 cm
The Ruth and Marvin Sackner Archive of Concrete and Visual Poetry

Untitled
1969
Typestract on paper
29.7 x 20.8 cm
The Ruth and Marvin Sackner Archive of Concrete and Visual Poetry

Untitled
1971
Typestract on paper
46.6 x 16 cm
The Ruth and Marvin Sackner Archive of Concrete and Visual Poetry

The Cosmic Easteregg of Brahman,
Svayambhu Lingam
1972
Typestract on paper
24.8 x 17.3 cm
The Ruth and Marvin Sackner Archive of
Concrete and Visual Poetry

YVES KLEIN
(Nice, France, 1928 – Paris, France, 1962)

Peinture feu sans titre (F. 25)
(Untitled Fire Painting)
1961
Burnt cardboard
152 x 200 cm
Private collection

Peinture feu "La Marque du Feu" (F. 85)
(Fire Painting "The Mark of Fire")
1961
Burnt cardboard
79 x 119 cm
Private collection

JOHN LATHAM
(Zimbabwe, Africa, 1921)

Five Noits (one second drawings)
1970
Wood, paint and spray paint mounted on board
62 x 155 cm
Collection of the artist

Four Noits (one-second drawings-red)
1975
Wood, paint and spray paint mounted on board
60.9 x 152.4 cm
Courtesy of Lisson Gallery, London

JULIO LE PARC
(Mendoza, Argentina, 1928)

Continuel-lumière-mobil
(Continuous-Light-Mobile)
1960-1966
Wood, metal, electric light
220 x 200 x 30 cm
Collection of the artist

Continuel-lumière-cylindre
(Continuous-Light-Cylinder)
1962
Wood, metal, electric motors, electric light
170 x 122 x 35 cm
Collection of the artist

SOL LEWITT
(Hartford, Connecticut, USA, 1928)

Straight Lines, Approximately 1 cm Long,
Not Touching
1970
Ink on paper
34 x 34 cm
Courtesy of Kasper Fischer Collection,
Düsseldorf

Untitled
1971
Graphite on woven paper
45.8 x 45.8 cm
National Gallery of Art, Washington, The
Dorothy and Herbert Vogel Collection, Ailsa
Mellon Bruce Fund, Patrons' Permanent Fund
and Gift of Dorothy and Herbert Vogel

Short Straight Lines, Not Touching, Drawn at
Random and Evenly Distributed over the Area
1972
Graphite on woven paper
27.8 x 27.8 cm
National Gallery of Art, Washington,
The Dorothy and Herbert Vogel Collection,
Ailsa Mellon Bruce Fund, Patrons' Permanent
Fund and Gift of Dorothy and Herbert Vogel

LI YUAN-CHIA
(Hsu, Kwangsi, China, 1929 –
Carlisle, Great Britain, 1994)

Untitled Folding Scroll
1963
Ink on fabric mounted on paper
44.5 x 504 cm
Collection Dino Gavina, Bologna

LILIANE LIJN
(New York, USA, 1939)

Liquid Reflections
1967
Perspex, acrylic, distilled water, liquid paraf-
fin, electric motor, light
Ø 86 cm
Collection of the artist

Liquid Reflections
1967
Perspex, acrylic, distilled water, liquid paraf-
fin, electric motor, light
Ø 101 cm
Collection of the artist

Liquid Reflections
1967
Perspex, acrylic, distilled water, liquid paraf-
fin, electric motor, light
Ø 122 cm
Collection of the artist

JOAQUIM LLUCIÀ
(Vidreres, Spain, 1929 –
Barcelona, Spain, 1973)

Untitled
1960
Charcoal on card
50 x 35 cm
Collection of Lluís Llucià

Relacions ●
(Relations)
1960
Collage
16 x 22 cm
Collection of Lluís Llucià

Untitled
1962
Charcoal on card
80 x 60 cm
Collection of Lluís Llucià

Untitled
1962
Charcoal on card
80 x 60 cm
Collection of Lluís Llucià

Untitled
1962
Ink on paper
65 x 51 cm
Museu Abelló – Fundació Municipal d'Art,
Mollet del Vallès

LEN LYE
(New Zealand, 1901-1980)

Free Radicals
1958
Animated film
5 min., black and white
Courtesy of the Len Lye Foundation and
Govett-Brewster Art Gallery, New Plymouth

Blade
1962-1976
Sprung steel, wood, cork, Formica, motor
Height: 206 cm / Ø 91 cm
Courtesy of the Len Lye Foundation and

Govett-Brewster Art Gallery, New Plymouth
Universe
1963-1976
Steel, cork, wood, Formica, electromagnets
209 x 270 cm x 28 cm
Courtesy of the Len Lye Foundation and
Govett-Brewster Art Gallery, New Plymouth

Particles in Space
1979
Animated film
4 min., black and white
Courtesy of the Len Lye Foundation and
Govett-Brewster Art Gallery, New Plymouth

PIERO MANZONI
(Soncino, Italy, 1933 – Milan, Italy, 1963)

Achrome
1961
Cotton and wool fibre on board
23.5 x 19.2 x 8.7 cm
Herning Kunstmuseum, Denmark

Achrome
1963
Polystyrene pellets on cardboard
50 x 70 cm
Private collection, Milan

Achrome
1963
Polystyrene pellets on canvas
60 x 40 cm
Private collection, Milan

GORDON MATTA-CLARK
(New York, USA, 1943-1978)

Energy-forms
1964
23 x 29.5 cm
Courtesy of The Estate of Gordon Matta-
Clark, New York, and Galerie Frank + Schulte,
Berlin
22 drawings: catalogue numbers 227-242,
244-249

Vectors (Ref. 169)
1973
Black ink and markers on paper
28.5 x 43.5 cm
Courtesy of David Zwirner, New York, and The
Estate of Gordon Matta-Clark

Arrows
1973-1974
Different coloured inks, coloured pencils
and markers on paper
48 x 61 cm
Courtesy of David Zwirner, New York,
and The Estate of Gordon Matta-Clark
2 drawings: catalogue numbers 162 and 176

DAVID MEDALLA
(Philippines, 1942)

Mud Machine
1967-2000
Steel, perspex, wire, electric motors, sponges,
mud, fluorescent lamps
Two parts each 200 x 200 cm
Collection of the artist

Sand Machine ●
1964-2000
Steel, perspex, sand, electric motor
Height: 170 cm
Collection of the artist

HENRI MICHAUX
(Namur, Belgium, 1899 –
Paris, France, 1984)

Dessin mescalinien
(Mescaline Drawing)
1954
Ink on paper
30.5 x 22.7 cm
Private collection

Dessin mescalinien
(Mescaline Drawing)
1956
Ink on paper
32 x 24 cm
Private collection

Dessin mescalinien
(Mescaline Drawing)
1956
Ink on paper
32 x 24 cm
Private collection

Dessin mescalinien
(Mescaline Drawing)
1956
Ink on paper
32 x 24 cm
Private collection

Dessin mescalinien
(Mescaline Drawing)
1956
Ink on paper
32 x 24 cm
Private collection

Dessin mescalinien
(Mescaline Drawing)
1958
Indian ink on paper
50.4 x 29.8 cm
Stedelijk Museum, Amsterdam

Dessin mescalinien
(Mescaline Drawing)
1958-1959
Black ink on paper
26.5 x 18 cm
Private collection, Paris

LÁSZLÓ MOHOLY-NAGY
(Bácsbársod, Hungary, 1895 –
Chicago, USA, 1946)

Licht-Raum Modulator
(Light-Space Modulator)
1922-1930. Reconstructed 1970
Glass, metal, wood, electric motor
78.4 x 50.5 x 8.7 cm
Stedelijk Van AbbeMuseum, Eindhoven

Untitled, Weimar ●
1923-1925
Photogram, silver chloride gelatin
24 x 17.9 cm
Museum Folkwang, Essen

Untitled, Dessau ▲
1925-1928
Photogram, silver bromide gelatin
23.8 x 17.9 cm
Museum Folkwang, Essen

Lichtspiel: Swartz-Weiss-Grau
(Lightplay: Black-White-Grey)
1930
Film
5.30 min., black and white
Courtesy Hattula Moholy-Nagy

Untitled, Chicago ▲
1939
Photogram, silver bromide gelatin
35.6 x 28.3 cm
Museum Folkwang, Essen

Untitled, Chicago ●
1940
Photogram, silver bromide gelatin
40.3 x 50.4 cm
Museum Folkwang, Essen

FRANÇOIS MORELLET
(Cholet, France, 1926)

*4 doubles trames traits minces
0°-22°5-45°-67°5-90°*
(4 Double Meshes Thin Lines
0°-22°5-45°-67°5-90)
1958
Oil on wood
80 x 80 cm
Collection of the artist

6 trames 0°-20°-70°-90°-110°-160°
(6 Meshes 0°-20°-70°-90°-110°-160°)
1959
Oil on canvas
140 x 140 cm
Collection of the artist

*22 trames 0°-8°-16°-24°-32°-41°-50°-58°-
66°-74°-82°-90°-98°-106°-114°-122°-131°-
140°-148°-156°-164°-172°*
(22 Meshes 0°-8°-16°-24°-32°-41°-50°-58°-
66°-74°-82°-90°-98°-106°-114°-122°-131°-
140°-148°-156°-164°-172°)
1960
Oil on wood
80 x 80 cm
Collection of the artist

Trames simples 0°-22°5-65°
(Simple Meshes 0°-22°5-65°)
1960
Oil on wood
80 x 80 cm
Collection of the artist

HÉLIO OITICICA
(Rio de Janeiro, Brazil, 1937-1980)

Bólide vidro 4 Terra ▲
(Glass Bolide 4 Earth)
1964
Glass, earth, gauze
Height: 40 cm / Ø 29 cm
Acervo Projeto Hélio Oiticica

Bólide caixa 9 ▲
(Box Bolide 9)
1964
Wood, paint, glass, pigment
58 x 41 x 71 cm
Acervo Projeto Hélio Oiticica

Studies for Bólides of the Estar series ▲
1965
Ink and pencil on paper
Acervo Projeto Hélio Oiticica

Bólide vidro 5 (Homenagem a Mondrian) ▲
(Glass Bolide 5 [Homage to Mondrian])
1965
Glass, paint, plastic, gauze, liquid
Height: 40 cm / Ø 30 cm
Acervo Projeto Hélio Oiticica

Bólide vidro 10 (Homenagem a Malevitch) ▲
(Glass Bolide 10 [Homage to Malevich])
1965
Glass, liquid
20 x 13 x 8.5 cm
Acervo Projeto Hélio Oiticica

Bólide vidro 14 (serie Estar 1) ▲
(Glass Bolide 14 ["To Be 1" series])
1965-1966
Glass, shells
Height: 19 cm / Ø 42 cm
Acervo Projeto Hélio Oiticica

PABLO PALAZUELO
(Madrid, Spain, 1915)

Untitled
1949-1950
Pencil and ink on paper
35 x 54.8 cm
Collection of the artist and courtesy of the
Galería de Arte Soledad Lorenzo

Estudio para alborada
(Study for dawn)
1950
Lead mine on paper
55 x 65 cm
Collection of the artist and courtesy of the
Galería de Arte Soledad Lorenzo

Estudio para alborada (2)
(Study for dawn [2])
1950
Lead mine on paper
29.5 x 41 cm
Collection of the artist and courtesy of the
Galería de Arte Soledad Lorenzo

Signos IV
(Signs)
1952
Chinese ink and pencil on paper
24.5 x 34 cm
Collection of the artist and courtesy of the
Galería de Arte Soledad Lorenzo

Composición (0)
(Composition [0])
1953
Pencil on paper
30.2 x 40.2 cm
Collection of the artist and courtesy of the
Galería de Arte Soledad Lorenzo

Curvas II
(Curves II)
1954
Lead mine on paper
48 x 29 cm
Collection of the artist and courtesy of the
Galería de Arte Soledad Lorenzo

Curvas IV
(Curves IV)
1954
Lead mine on paper
29.7 x 40.8 cm
Collection of the artist and courtesy of the
Galería de Arte Soledad Lorenzo

Untitled
1955
Lead mine on paper
50 x 32.5 cm
Collection of the artist and courtesy of the
Galería de Arte Soledad Lorenzo

Para un poema III
(For a poem III)
1977
Pen and chinese ink on paper
34.5 x 26.5 cm
Collection of the artist and courtesy of the
Galería de Arte Soledad Lorenzo

El número y las aguas
(The Number and the Waters)
1978
Gouache on paper
66 x 51 cm
Collection of the artist and courtesy of the
Galería de Arte Soledad Lorenzo

BERNARD RÉQUICHOT
(Sarthe, France, 1929 – Paris, France, 1961)

Untitled ▲
1960
Ball-point pen and watercolour on paper
50.8 x 64.9 cm
Collections Mnam/Cci, Centre Georges
Pompidou. Cliché phototèque de la
Documentation Génerale du Centre Georges
Pompidou/Musée national d'art moderne,
Paris

DIETER ROTH
(Hanover, Germany, 1930 –
Basle, Switzerland, 1998)

9 Zirkelkonstruktionen
(9 Circle Constructions)
1958
Ink on white card
65 x 65 cm
Kunstmuseum Solothurn

Untitled
1958-1959
White silk-screen on black card
53 x 71 cm
Dieter Roth Foundation, Hamburg

Dreh-Rasterbild – Scheibe nr. 2
(Gridded Rotary Frame – Disc no. 2)
1960
Black adhesive tape on glass plate on wooden
disc
Ø 81 cm
Dieter Roth Foundation, Hamburg

Gesammelte Werke, Band 4/Buch 4a und 5
(Collected Works, volume 4/books 4a and 5)
1961
Versions of the books published in Reykjavik
Ed. Hansjörg Mayer
Collection of the MACBA

Kugelbild Nr. 4/4
(Ball Painting no. 4/4)
1962
Table top, iron nails, wooden balls
Ø 100 cm
Dieter Roth Foundation, Hamburg

Gesammelte Werke, Band 9/Stupidogramme
(Collected Works, volume 9/Stupidogram)
1975
Printed copies of original series drawn by
hand between 1961 and 1966
Ed. Hansjörg Mayer
Collection of the MACBA

Gesammelte Werke, Band 16/Munduculum
(Collected Works, volume 16/Munduculum)
1975
Corrected and enlarged version of the books
published by DuMont Schanberg in Colonia in
1967
Collection of the MACBA

Gesammelte Werke, Band 8/2 Bücher ●
(Collected Works, volume 8/2 books)
1976
Reconstruction of two variants (A and B) of
the portofolios published in 1958-1961
Ed. Hansjörg Mayer
Collection of the MACBA

Gesammelte Werke, Band 1/ Bilderbuch ●
(Collected Works, volume 1/Picture Book)
1976
Version of the book published in Reykjavik in
1957
Ed. Hansjörg Mayer
Collection of the MACBA

Gesammelte Werke, Band 1 / Kinderbuch ●
(Collected Works, volume 1 / Children's Book)
1976
Version of the book published in Reykjavik in
1957
Ed. Hansjörg Mayer
Collection of the MACBA

MIRA SCHENDEL
(Zurich, Switzerland, 1919 –
São Paulo, Brazil, 1988)

Untitled
1964
5 monotypes. Rice paper on card
52.5 x 29.5 cm
Private collection, London

Droguinha
(Little Nothing)
1965
Rolled and knotted rice paper
Ø 38 cm
Private collection, London

Droguinha
(Little Nothing)
1965
Rolled and knotted rice paper
90 x 90 cm
Private collection, London

Droguinha
(Little Nothing)
1965
Rolled and knotted rice paper
Ø 28 cm
Private collection, London

ROBERT SMITHSON
(Passaic, New Jersey, USA, 1938 –
Amarillo, Texas, USA, 1973)

Crator
1966
Pencil on paper
27 x 21 cm
Gift of Ms. Nancy Holt and permanent deposit
of the FLAD in the Museu de Arte
Contemporãnea de Serralves, Porto

Crator
1966
Pencil on paper
27 x 21 cm
Gift of Ms. Nancy Holt and permanent deposit
of the FLAD in the Museu de Arte
Contemporãnea de Serralves, Porto

Crator with Dislocated Radiation
1966
Pencil and pastel on paper
27 x 21 cm
Gift of Ms. Nancy Holt and permanent deposit
of the FLAD in the Museu de Arte
Contemporãnea de Serralves, Porto

*Crator with Reflected Numbers on the
Hexagonal*
1966
Pencil on paper
27 x 21 cm
Gift of Ms. Nancy Holt and permanent deposit
of the FLAD in the Museu de Arte
Contemporãnea de Serralves, Porto

Four-sided Vortex
1967
Stainless steel and mirror
90.2 x 71.1 x 71.1 cm
Weltkunst Foundation / Lisson Gallery, London

JESÚS RAFAEL SOTO
(Ciudad Bolívar, Venezuela, 1923)

Vibración
(Vibration)
1959
Acrylic and wires on wood
70 x 250 x 13 cm

Collection of the artist
Vibración blanca
(White Vibration)
1959
Industrial paint on putty, wire and Masonite
81 x 65 x 9 cm
Collection of Patricia Phelps de Cisneros,
Caracas

Untitled
1960
Paint on agglomerate, plaster and metal
102 x 102 x 23 cm
Collection of Alain Gheerbrant

Hommage à Yves Klein
(Homage to Yves Klein)
1961
Iron wire, plate metal and industrial paint on
Masonite
55.3 x 95.7 x 15 cm
Collection of Patricia Phelps de Cisneros,
Caracas

Puntos de goma
(Rubber Points)
1961
Jute, lime, metal, polyethylene, pigments on
wood
72 x 72 x 20 cm
Collection of Juan Ignacio Parra Schlageter

Penetrable
(Penetrable)
2000
Plastic tubing, steel
455 x 750 x 750 cm
Collection of the artist

TAKIS
(Athens, Greece, 1925)

Télésculpture
(Telesculpture)
1959
Iron, magnet, cones
26 x 52 x 37 cm
Collection of the artist

Télésculpture
(Telesculpture)
1959
Iron, magnet, nails, red cone
23 x 10 cm
Collection of the artist

Télépeinture (blanche)
(Telepainting [white])
1959-1960
Canvas, iron frame, magnet, cones
34 x 41 x 29 cm
Collection of the artist

Télépeinture (noire)
(Telepainting [black])
1960
Canvas, iron frame, magnet, metal cones
34 x 41.5 x 29 cm
Collection of the artist

Télésculpture
(Telesculpture)
1960
Bakelite, magnet, metal cones
95 x 95 x 21 cm
Collection of the artist

Telemagnetic Installation
1960. Reconstruction by the artist, 2000
Installation, comprising two large magnets
and floating elements
Variable dimensions
Collection of the artist

Radar Solar System
1960
Aluminium, steel, metal cones, magnet
Ø 70 cm
Collection of the artist

Mur magnétique
(Magnetic Wall)
1961
Canvas, magnets, floating elements
350 x 175 cm
Collection of the artist

Télélumière "Une ligne verticale touchant une fleur"
(Telephoto "A vertical Line Touching a Flower")
1962
Assemblage with lamps, electromagnet
and plumb line
81 x 33 x 23 cm
Collection of the artist

Ballet magnétique
(Magnetic ballet)
1963
Electromagnet with floating ball
Ø 65 cm / Ø of ball: 32 cm
Private collection, London

Ballet magnétique
(Magnetic ballet)
1963
Electromagnet with two floating elements
Ø 33 cm
Private collection, London

Télélumière Relief no. 5
(Telephoto relief no. 5)
1963-1965
Mercury vapour lamp, steel, wood
66 x 72 x 20 cm
Private collection, London

Signal
1964
Metal, green lamp
Height: 260 cm
Collection of the artist

Signal
1964
Metal, green lamp
Height: 261 cm
Collection of the artist

Signal
1966
Metal, yellow lamp
Height: 215 cm
Collection of the artist

Signal
1966
Metal, yellow lamp
Height: 280 cm
Collection of the artist

Cadran
(Dial)
1969-1971
Wood, electronic instruments
50 x 100 cm
Collection of the artist

Signal
1974
Metal, green lamp and purple lamp
Height: 240 cm
Collection of the artist

Signal
1974
Metal, orange lamp and red 'stop' lamp
Height: 258 cm
Collection of the artist

Musical
1974
Wood
260 x 100 cm
Collection of the artist

Musical
1974
Wood
260 x 100 cm
Collection of the artist

Musical
1974
Wood
260 x 100 cm
Collection of the artist

Lignes parallèles ●
(Parallel Lines)
Reconstruction 2000
Two parts: A) Magnet, electromagnet,
elements, 20 min. tape / B) Magnet,
electromagnet, elements, 20 min. tape
Collection of the artist

Atsuko TANAKA
(Osaka, Japan, 1932)

Untitled (Study for Electric Dress)
1956
Ink on paper
77 x 55 cm
Gallery Ham, Nagoya
5 drawings: catalogue numbers G5, G6, G8,
G9, G13

JEAN TINGUELY
(Fribourg, Switzerland, 1925 –
Bern, Switzerland, 1991)

Trois points blancs (relief méta-mécanique)
(Three White Points [Meta-mechanical
relief])
1955
Painted wooden plate with metal elements,
electric motor
50 x 62.5 x 17 cm
Museum Jean Tinguely, Basel

Variations pour deux points
(Variations for Two Points)
1958
Metal, electric motor, white points
Ø 22.5 cm
Private collection, Switzerland

Méta-Matic no. 12 (Le Grand Charles) ●
(Meta-Matic no. 12 [The Great Charles])
1959
Mixed media, mild steel, wood and electrical
devices
216 x 145 x 61 cm
Private collection, Montréal

Totem IX / Monsieur X
(Totem IX / Mister X)
1960
Iron pieces, metal springs, wire, chain, stone,
isolating ceramic, electric motor
125 x 60 x 50 cm
Collection of Banca del Gottardo, Lugano

Baluba XIII
1961-1962
Iron, electric motor, assemblage
218 x 46.5 x 46.5 cm
Wilhelm Lehmbruck Museum, Duisburg

GEORGES VANTONGERLOO
(Antwerp, Belgium, 1886 –
Paris, France, 1965)

Variante
(Variant)
1939
Oil on Masonite
52.5 x 40 cm
IVAM, Institut Valencià d'Art Modern.
Generalitat Valenciana

Courbes ▲
(Curves)
1939
Oil on Masonite
60 x 42 cm
Chantal + Jakob Bill, Adligenswil

Élément cosmique
(Cosmic Element)
1945
Painted wood, nickel alloy
8 x 10 x 6 cm
Moderna Museet, Stockholm

Espace infini
(Infinite Space)
1945
Iron
21 x 20 x 17 cm
Chantal + Jakob Bill, Adligenswil

Spirale avec certaines tâches
(Spiral with Some Marks)
1946
Oil on Masonite
74 x 61 cm
Private collection, Antwerp

Un monstre
(A Monster)
1946
Wood, nickel alloy
33 x 31 x 8 cm
Chantal + Jakob Bill, Adligenswil

Peinture spatiale
(Spatial Painting)
1948
Painted perspex
4 x 13 x 7 cm
Kröller-Müller Museum, Oterloo

Deux zones de l'espace; action-réaction
(Two Zones of Space; Action-reaction)
1949
Oil on board
40 x 98 cm
Chantal + Jakob Bill, Adligenswil

Ensemble
1949
Oil on board
51 x 92 cm
Chantal + Jakob Bill, Adligenswil

Radiations de diverses zones
(Radiations from Diverse Zones)
1949
Oil on Masonite mounted on wood
34.9 x 34.9 cm
Collection of Patricia Phelps de Cisneros,
Caracas

Cocon, chrysalide, embryonnaire
(Cocoon, chrysalid, embryonic)
1950
Perspex
10 x 13 x 8 cm
Chantal + Jakob Bill, Adligenswil

Des formes et des couleurs dans l'espace
(Forms and Colours in Space)
1950
Perspex
58 x 52.5 x 40 cm
Chantal + Jakob Bill, Adligenswil

Énergie de l'Univers
(Energy of the Universe)
1952
Oil on wood
82.3 x 23 cm
Courtesy of Galerie Gmurzynska, Cologne

Radio-activité
(Radio-activity)
1952
Oil on canvas
95 x 66 cm
Chantal + Jakob Bill, Adligenswil

Des éléments (ligne fermée)
(Elements [Closed Line])
1954
Plastic
35 x 35 x 30 cm
Chantal + Jakob Bill, Adligenswil

Espace et couleur
(Space and Colour)
1956
Perspex
25 x 29 x 10 cm
Chantal + Jakob Bill, Adligenswil

Six cristaux (anisotrope)
(Six Crystals [Anisotropic])
1958
Plastic
16.5 x 14 x 10.5 cm
Chantal + Jakob Bill, Adligenswil

Le dôme
(The Dome)
1959
Perspex and prism
32 x 17 x 17 cm
Chantal + Jakob Bill, Adligenswil

Plusieurs éléments
(Several Elements)
1960
Plastic, prisms
29.5 x 13.5 x 11 cm
Chantal + Jakob Bill, Adligenswil

Un rayon lumineux dans un champ magnétique
(ou un champ de réaction)
(A Ray of Light in a Magnetic Field [or a
Field of Reaction])
1960
Plastic
14.5 x 15 x 17 cm
Kröller-Müller Museum, Oterloo

La comète
(The Comet)
1962
Perspex
7 x 7 x 30 cm
Chantal + Jakob Bill, Adligenswil

GRAZIA VARISCO
(Milan, Italy, 1937)

Variabile GH su AL (Mercuriale)
(Variable GH on AL [Mercurial])
1964-1965
Motorised relief with industrial glass
51.5 x 51.5 x 11 cm
Collection of the artist

JAMES WHITNEY
(Pasadena, California, USA, 1921 –
Los Angeles, California, USA, 1982)

Yantra
1950-1957
Animated Film
8 min., colour

Lapis
1963-1966
Animated Film
10 min., colour

WOLS (Alfred Wolfgang Schulze)
(Berlin, Germany, 1913 –
Paris, France, 1951)

Untitled
c. 1937-1950
Etching
10.5 x 7 cm
Tate Gallery

Untitled
c. 1937-1950
Etching
10.5 x 7 cm
Tate Gallery

Untitled
c. 1937-1950
Etching
10.5 x 7 cm
Tate Gallery

Untitled
c. 1937-1950
Etching
10.5 x 7 cm
Tate Gallery

Untitled
c. 1937-1950
Etching
10.5 x 7 cm
Tate Gallery

Untitled
c. 1937-1950
Etching
10.5 x 7 cm
Tate Gallery

Untitled
1940-1942
Pencil and Indian ink
20.5 x 28 cm
Private collection

Untitled
1940-1942
Pencil and Indian ink
26.7 x 17.8 cm
Private collection

Untitled (Foyers Actifs)
(Active Foci)
1942-1943
Ink on paper
27.6 x 21 cm
Graphische Sammlung, Staatsgalerie
Stuttgart

Untitled
1942-1945
Pen and ink heightened with gouache
24 x 16.2 cm
Private collection

Untitled (Ouranus)
1943
Graphite pencil and ink on paper
23.8 x 17 cm
Private collection

Untitled (Crâne de Poète)
(Poet's skull)
1944
Watercolour
17.5 x 13.2 cm
Private collection

Untitled (Tranche de foie – violoncello)
(Slice of liver – violincello)
1944
Watercolour
18.3 x 13.2 cm
Private collection

Untitled
1944-1945
Watercolour and gouache on paper
9.2 x 13.5 cm
Tate Gallery

DOCUMENTARY FILMS

Yves Klein
Peintures feu
1961
5 min., colour
Courtesy of Yves Klein Archive, Paris

Piero Manzoni
Scultura nello spazio
(Sculpture in Space)
1960-1961
Documentary film of Piero Manzoni working
on the sculpture at the Angli factory in
Herning
Video
c. 12 min.
Herning Kunstmuseum, Denmark

David Medalla
Mud Machine and other bio-kinetic works
1967
Extracted from I'll Never Forget What's is
Name, director Michael Winner, 1967
Courtesy Michael Winner, Scimitar Films
25 sec., colour

Hélio Oiticica
Bólides ▲
(Bolide)
1964-1966
Extracted from H.O. Suprasensorial, video
and CD-Rom, director Katia Maciel, Rio de
Janeiro, 1999
5 min., colour

Jean Tinguely
*Homage to Jean Tinguely's Homage to New
York*, director Robert Breer, 1960
10 min., black and white

La fin du monde
(The End of the World)
1962
David Brinkley's Journal, NBC Television
22 min., colour

REPRODUCED WORKS, NOT IN THE EXHIBITION

Alexander Calder
Two Speres within a Sphere
1931
Wire and painted wood
95.25 x 81.3 x 35.5 cm
Private collection
(p. 16)

Leandre Cristòfol
Metamorfosi constant (Ralentí)
(Continual Metamorphosis [Slow Motion])
1957
Steel, plastic, cork
85 x 32 x 23 cm
Museu d'Art Jaume Morera, Lleida
(p. 151)

Gordon Matta-Clark
Drawing (Arrows)
1973-1974
Different coloured inks, coloured pencils and
markers on paper
48 x 61 cm
Courtesy of David Zwirner, New York, and
The Estate of Gordon Matta-Clark
(p. 41)

Drawing (Arrows)
1973-1974
Different coloured inks, coloured pencils and
markers on paper
48 x 61 cm
Courtesy of David Zwirner, New York, and
The Estate of Gordon Matta-Clark
(p. 137)

Henri Michaux
Dessin de réagrégation
(Post-mescaline Drawing)
1966
Coloured ink on paper
32.5 x 23 cm
IVAM. Institut Valencià d'Art Modern.
Generalitat Valenciana
(p. 25)

Jean Tinguely
La folie
(Madness)
Metal base, iron springs, iron wires and bars,
feathers, electric motor
Height: 150 cm
Private collection
(p. 39)

Wols
Untitled (La plaie [The Wound])
1944-1945
Ink and watercolour on paper
20.5 x 13.2 cm
Private collection
(p. 81)

This catalogue has been published on the occasion of
the exhibition *Force Fields. Phases of the Kinetic*,
organised by the Museu d'Art Contemporani de
Barcelona (MACBA) (April 19 – June 18, 2000),
in association with the Hayward Gallery, London
(July 13 – September 17, 2000).

EXHIBITION

Project Director
Manuel J. Borja-Villel

Guest Curator
Guy Brett

Co-ordinators
Cristina Bonet
Anna Cestelli
Bàrbara Roig

Design Installation
Isabel Bachs

Conservation
Sílvia Noquer
Xavier Rossell

CATALOGUE

Conception
Guy Brett

Editing
Josep M. Muñoz (Spanish edition)
Suzanne Cotter and Cathy Douglas (English edition)

Research
Teresa Grandas

Additional Research
Michelle Gillard

Co-ordination
Anna Jiménez Jorquera

Graphic Design
Ramon Prat
Anja Tränkel

Translations
Glòria Bohigas, Gemma Galdon, Vesna Hardy,
Isabel Núñez, Jordi Palou, Marisa Presas, David
Alan Prescott, Luke Stobart, Graham Thomson,
Concha Varela, Stephen Wright

Production
Font i Prat, Ass.

Printing
Ingoprint, S.A.

Distribution
ACTAR
Roca i Batlle 2 08023 Barcelona
Tel. 93 418 77 59
Fax 93 418 67 07
e-mail: info@actar-mail.com
www.actar.es

ACKNOWLEDGMENTS

Alianza Editorial, Atelier Soto, Raquel Arnaud, Ashiya City Museum of Art & History (Japan), Georges Baines, Staatliches Museum – Bildarchiv Preussischer Kulturbesitz, Nationalgalerie (Berlin), Jakob and Chantal Bill, Marie-Agnès Benoit (Canadian Centre for Architecture, Montréal), Eugeni Bonet, Gloria Bosch, Sabine Breitwieser (Generali Foundation, Vienna), Greg Burke, Michael Burt, Pol Bury, Fundaçao Serralves (Oporto), Rina Carvajal, Evelyn Castro (Museo de Arte Contemporáneo de Caracas), Centre Georges Pompidou. Musée national d'art moderne (Paris), Cinzia Cerrato (Giulio Eunaidi Editore, Turin), Lourdes Cirlot, Piet Coessens, Collection of John and Catherine Morse, Collection of Banca del Gottardo (Lugano, Switzerland), Collection of Banco Mercantil, Collection of Bárbara Gunz, Collection of Tomás Gunz, Bernard Collin, Victoria Combalía, Jef Cornelis, Jane Crawford, Ester Crespin, Francine Dawans (Musée d'Art moderne et d'Art contemporain de la Ville de Liège), Agnes Denes, Dieter Roth Foundation (Hamburg), Ediciones Cátedra, Ediciones Akal, David Elliott, Valeria Ernesti, Estate of Gordon Matta-Cark, Faber and Faber Ltd., Vittorio Fagone (Director, Galleria d'Arte Moderna e Contemporanea, Bergamo), Russell Ferguson, Luciano Figueiredo, Martha Fleming, Nadia Forloni (Galleria Gio Marconi, Milan), Richard Francis, John Ferry (Buckmister Fuller Institute, Santa Barbara, CA), Fundació Antoni Tàpies (Barcelona), Galerie Denise René (Paris), Galerie der Stadt Esslingen (Villa Merkel), Galerie Frank + Schulte (Berlin), Galerie Gmurzynska (Cologne), Gallery Ham (Nagoya, Japan), Galerie nationale du Jeu de Paume, Ruben Gallo, Josep Miquel Garcia (Generalitat de Catalunya), Dino Gavina (Cologne), Alain Gheerbrant, Govett-Brewster Art Gallery, Antje von Graevenitz, Lars Grambye, Michael A. Grossmann, Philipp Gutbrod, Hans Haacke, Stella Halkyard (The John Rylands University Library, University of Manchester), Margrit Hahnloser, Keith Hartley, Hatje Cantz Publishers (Ostfildern/Ruit), Herning Kunstmuseum, Susan Hiller, Ruth Hoenich, Epicarmo Invernizzi, IVAM (Institut Valencià d'Art Modern. Generalitat Valenciana), Annely Juda (Annely Juda Fine Arts, London), Imma Julián, Kika Karadi, Kasper Fisher Collection (Düsseldorf), Kröller-Müller Museum (Oterloo), John Latham, Julio Le Parc, Baudoin Lebon, Sol LeWitt, Liliane Lijn, Nicholas Logsdail, Lluís Llucià, Soledad Lorenzo, Giorgio Marconi Collection (Milan), David Medalla, Franck Marlot (Klarform, Paris), Josefina Manrique (Fundación Gego, Caracas), Contessa Elena Manzoni di Chiosca, Daniel Moquay, William Moritz, Miles McKane (Lightcone, Paris), John and Mary McNeil, Marlborough Fine Art (London), François Morellet, Frances Morris, Christian Müller (Kunstmuseum Solothurn), Musée de Grenoble, Museo de Arte Moderna de Rio de Janeiro, Museo de Arte Contemporanea da Universidade São Paulo, Museu Abelló-Fundació Municipal d'Art (Mollet del Vallès, Barcelona), Museu d'Art Jaume Morera (Lleida), Museu Nacional d'Art de Catalunya (Museu d'Art Modern, Barcelona), Museum Folkwang (Essen), National Gallery of Art (Washington, D.C.), Alfred Pacquement, Pablo Palazuelo, Juan Ignacio Parra Schlageter, Rosalia Pasqualino di Marineo (Archivio Opera Piero Manzoni, Milan), Luis Pérez Oramas, Dr. Micheline Phankim, Clive Phillpot, Otto Piene, Frank Popper, Jean-Louis Prat (Fondation Marguerite et Aimé Maeght, Saint-Paul-de-Vence), Praeger Publishers Inc., Projeto Hélio Oiticica (Rio de Janeiro), Pamela Quick (MIT Press, Cambridge, MA), Ewalde Rathke, Jasia Reichardt, Reverend Father Abbot Dom Francis Baird (Prinknash Abbey Benedictines), Marvin Sackner, Ruth and Marvin Sackner Archive of Concrete and Visual Poetry, Guy Schraenen, Philippe Siauve (Yves Klein Archives, Paris), Carol Slattery-Gildea (Penguin UK, London), Sogestsu Art Museum, Solomon R. Guggenheim Museum (New York), Jesús Rafael Soto, Staatliche Museum (Schwerin), Stedelijk Museum (Amsterdam), Städtisches Museum (Gelsenkirchen), Staatsgalerie Stuttgart, Stefan Ståle (Moderna Museet, Stockholm), Takis, Atsuko Tanaka, Tate Gallery Publishing Limited, The Museum of Modern Art (New York), Mark Tutt (Lisson Gallery, London), Hans Ulrich Obrist, University of California Press, Grazia Varisco, Jessy van der Velde, Martin Wagner and Adam Finch (Offline Editing Co, London), Weltkunst Foundation, Wilhelm Lehmbruck Museum (Duisburg), Evan Webb (Director, Len Lye Foundation, New Plymouth), Barbara Wien, Witte de With, center for contemporary art (Rotterdam), Claire Wüest (Museum Jean Tinguely, Basel), Renos Xippas, Betty Zambrano (Fundación Patricia Phelps de Cisneros, Caracas), David Zwirner

and to all of those who preferred to remain anonymous.